THE WORLD'S GRE D1586946

Publisher and Creative Director: Nick Wells Project Editor: Claire Walker Designer: Colin Rudderham Picture Researchers: Frances Bodiam, Melinda Révész

Special thanks to: Andrea Belloli, Karen Fitzpatrick, Sarah Goulding, Chris Herbert, Patrick O'Brien, Sara Robson, Polly Willis

FLAME TREE PUBLISHING

Crabtree Hall, Crabtree Lane Fulham, London, SW6 6TY United Kingdom

www.flametreepublishing.com

First published 2004

05 07 06 04

13579108642

Flame Tree is part of the Foundry Creative Media Company Limited

© 2004 Flame Tree Publishing

All rights reserved. No part of this publication may be reproduced or transmitted, in any form or by any means, without the prior permission in writing of the publisher.

The CIP record for this book is available from the British Library.

ISBN 1844511413

Every effort has been made to contact copyright holders. We apologize in advance for any omissions and would be pleased to insert the appropriate acknowledgement in subsequent editions of this publication.

While every endeavour has been made to ensure the accuracy of the reproduction of the images in this book, we would be grateful to receive any comments or suggestions for inclusion in future reprints.

Printed in China

THE WORLD'S GREATEST ART

General Editor: Dr Robert Belton • Foreword by Richard Humphreys

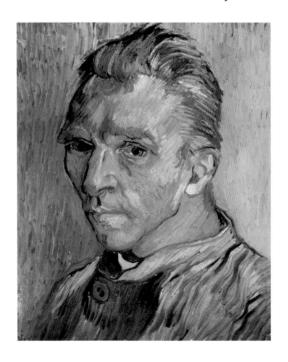

FLAME TREE PUBLISHING

Contents

How To Use This Book Foreword Introduction	
13th-15th Centuries: The Gothic & Medieval Era	20
I 6 th Century: The Renaissance Era	44

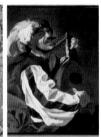

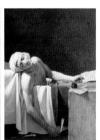

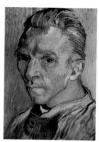

Author Biographies	
Bibliography	
Index by Artist	
Index by Painting	

How To Use This Book

The reader is encouraged to use this book in a variety of ways, each of which caters for a range of interests, knowledge and uses.

- The book is organized by era: Gothic and Medieval; Renaissance; Baroque & Rococco;
 Neoclassicism & Romanticism; Impressionism; Post-Impressionism; and Modern.
- The chronological format allows the reader to explore the progression and development
 of style within each era.
- The chronological format also enables the reader to discover unusual or unknown art amongst more well-known artists of familiar periods.
- The text provides the reader with a snapshot of an artist's lifetime and allows further
 exploration of influences that can be discovered elsowhere in the book.
- The Introduction gives an interesting perspective on our notion of what art is, and shows the reader how to gain more insight into a painting than merely appreciating it for its aesthetic appeal.

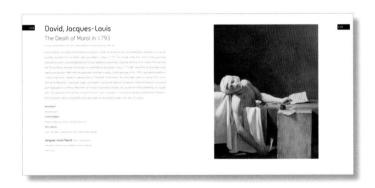

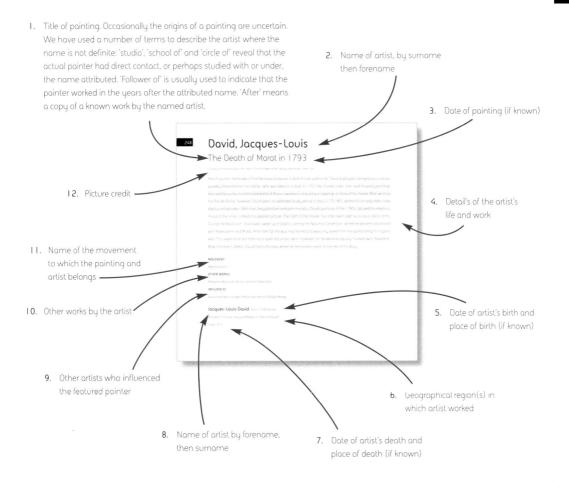

Foreword

Become A Curator And See The World

Curators know about and look after art and seek to form judgements about it. The best way to get to understand something about art is to look at a lot of it, over a long period of time and without too much concern for where it's from and who says what about it. A trip to your local art school's annual degree show or to a nearby church to see the dusty monuments is as important as an outing to Tate Britain or to the Louvre. You can become as good a curator as anyone else and the more you absorb and get involved with looking, brooding and comparing, the more successful your secret career and the deeper and more convincing your judgement will be. You will at the same time find out about much more than art, while forming a stronger understanding of how many artists work.

You should look at things you think you don't like as well as at your favourites. Once looking becomes a habit like any other, you will quickly have built a store of images which grows and changes as you discover more and think more. Journeys and books, TV programmes and conversations are all opportunities to create this personal art gallery. You will find that all sorts of objects will happily reside alongside one another – Japanese woodblock prints, oil paintings, comic strip imagery, sculptures, photographs, bits of graffiti, maps, old master drawings, African masks, movies and adverts. They are all part of the promiscuous visual world we live in now and all feed off one another and affect our perceptions and feelings.

This personal picture gallery will change its size, layout and atmosphere as some things get brought up from the cellars, some get demoted to distant stores and as you create new rooms for your collection. Your research and education programmes will involve finding out

about biographies, social history, techniques, literature, geography, science, religion, languages and a host of other subjects you may not have thought of before, as art becomes the focus for new and unexpected interests. Each image becomes in itself a store of knowledge and new experience.

This is probably how most artists go about acquiring their knowledge of art and developing their personal vision. They are not art historians in an academic sense but rather live through visual images, with no artificial boundaries of taste and meaning to dampen their enthusiasms.

This is certainly the sort of book which artists will enjoy and which will become heavily used, covered in paint and coffee stains and casually dropped on the studio floor. It is a rich gallery of images from around the world, organised by simple historical period, which are all powerful and memorable visual statements. From The Birth of Sin to that of Venus, from Chop Suey to a basket of onions, an array of sacred and profane works are on offer which all celebrate life and looking and demand further acquaintance. Some artists are so well-known you wonder if they ever really existed, others you, and I, won't have heard of. Whoever they are, look hard, read the words and trust yourself.

Richard Humphreys
Senior Curator, Tate

Introduction

For most people the process of viewing something aesthetically pleasing can be a momentarily life-enriching experience. The same people might also feel that there is a big difference between looking at a painting for its own sake, and accepting the concept of art as a medium conveying a set of intellectual theories and arguments, and many would ask why should we bother with art? The enjoyment provided by the visual is an acceptable motivation in itself. However, it does not tell us very much about anything - after all, sweets can provide enjoyment too. Unlike sweets, though, art has the potential to enrich life in a manner that goes well beyond mere enjoyment, agreeable décor or a more superficial gratification through popular imagery. Moreover, because the art of our own time often simply reaffirms our own values and expectations, being familiar with the art of other times and places is a useful portal into others' aesthetics, ideologies, morals, philosophies, politics and social customs. This familiarity, in turn, may well invite us to question our own ideologies and social customs; in fact, much art was never meant to be enjoyed at all, in the common sense of the word. Art's most fundamental importance is therefore not as décor but as an avenue of intellectual communication. This makes insight into art an invaluable part of an advanced comprehensive education.

For a long time there was little doubt that one of the higher expressions of a culture was its advanced visual art. For the

layperson, the word 'Renaissance' remains to this day more likely to conjure up the works of Leonardo da Vinci and Michelangelo than those of, for example, the composers Heinrich Isaac and Josquin des Préz. However, it is difficult to say the same of the visual art of our own time, unless we are speaking specifically of the mass media. With a few notable exceptions, such as Picasso, modern and contemporary art is much less likely than that of the Renaissance to spring to average people's minds as an example of their own culture's higher accomplishments. For the purposes of this book, when we talk about art we are really referring to paintings, since for most 'lay' people paintings act as their first serious introduction into art interpretation, and for many it is the medium that they find most accessible.

WHY IS ART DIFFICULT?

Why is it that much recent art — even that deemed very important by the critical community of visual arts professionals — simply does not engage the imagination of the average person in the same way as traditional art? One conventional explanation is that over the past 150 years art has increasingly moved away from the familiarity and comfort of resemblance, in part because artists felt photography and film freed them from having to stick to straightforward representation. Another is that instead of clarity in the discourse around new and

unfamiliar work, explanations are increasingly, and deliberately, obscure. This implies that what went into the making of the art object is more important than what it says to, or the effect it has on, an observer.

The development of the mass media means that a larger proportion of the population is exposed to visual art on a daily basis, and consequently exposed to the accompanying argument. In other words, art that was once intellectually challenging is now part of mainstream culture, and in order for those artists pursuing art as a pure 'academic' exercise to push the boundaries of learning, the questions they ask have to become more cryptic. Yet another reason that more recent art fails to engage the populace is a general mistrust for the people who create the art, and a perception of them and their work as elitist, only inviting in a narrow section of the population to engage in the discourse.

The average person's apparent alienation from the advanced art of the late twentieth and early twenty-first centuries puzzles the professionals, for it seems to be based on several faulty assumptions. The most basic of these is that what makes art 'art' is how accurately it resembles something. This misapprehension ignores the fact that part of what makes even traditional art 'art' is its symbolism, codes and composition, regardless of the accuracy of its representation. A well-crafted object with nothing to say is impoverished as art, whereas something that shows intelligence, imagination and creativity

can sometimes be good art even if its technique is ostensibly poor. Attributing too high a value to the making of art is clearly what lies behind frequently heard objections like 'my five-year-old daughter could do that', but these are not complaints that have been levelled solely at difficult contemporary art. The nineteenth-century sculptor Harriet Hosmer was criticized for her figures of heroines from history and literature because she did not make the final stone versions of her sculptures with her own hands. She defended herself by explaining that art is not the technique but the 'design' – the intellectual component of the work. The average person's resistance to art is based on the presumption that art is not the design but the technique – that what makes art 'art' is its 'craft', glorifying the means over the end.

A related faulty assumption is that because the art of the last century is almost invariably accompanied and explained by words, the meaning of the piece resides in the words rather than the object itself. This position fails to recognize that traditional art was often accompanied by words and that the words themselves are merely a part of the context in which the piece exists. More will be said about this context presently. As for class-based mistrust, yes, there are those who traffic in very expensive art less as expressions of an artist's motives than as trophies of their own status, but this is also true of other signs of material wealth and it has no bearing on the meaning or intrinsic value of the art itself. In other words, this too is merely an expression of a contextual matrix surrounding the art.

WHAT IS ART AND WHAT IS ART FOR?

We must begin by asking several questions about context, the most basic of which are 'What is art?' and 'What is art for?'. The average person might say, 'Art is decoration' or, more awkwardly, 'Art is the technically skilful representation of something absent in such a way as to create an illusion of its presence.' However, these answers ignore a host of important pieces that are not particularly attractive, realistic or well made. The history of art is filled with brilliant examples of disturbing and violent imagery, stylized or inaccurate likenesses, and objects that require constant care in order to prevent deterioration.

All the definitions of art offered over the centuries include some notion of human agency, whether through manual skills (the art of sailing, painting or photography), intellectual manipulation (the art of politics) or public or personal expression (the art of conversation). As such, the word is related to 'artificial' — that is, produced by human beings rather than by nature. But it doesn't stop there: this definition of art is correct in a limited way but it is also essentially flawed because it does not allow one to distinguish the defined term from something else that correctly exemplifies the definition.

'A vacuum cleaner is a household appliance' is insufficient as a definition of a vacuum cleaner because 'vacuum cleaner' can be correctly replaced with 'refrigerator', and a vacuum cleaner is not a refrigerator. Saying 'Art equals artificial equals human-made things' fails to distinguish art from other things produced by human beings. It gives us a start, however, for it

makes it clear that infinitely realistic painting would simply replicate the world. In so doing, realistic painting says nothing much about human agency and thereby ceases to be art in all but the most bankrupt way. It would be similarly unsatisfactory to try to understand art while limiting oneself to only one or two of the ends above. 'Art is decoration' fails to distinguish advanced art from simple ornament, and 'Art is the exhibition of technical skill' fails to distinguish art from sports and woodworking.

To fail to remain open to the wide range of art's purposes is to be indifferent to its contextual variations, even before we get to the seemingly infinite variety of means and ends. This cripples one's understanding of and openness to art. For example, those who say that art's goal is accurate representation ignore many cultures (such as African, indigenous Australian and Islamic, not just the modern West) in which realism is subordinate to emotional exuberance, imaginative visions anchored in faith or the expression of an idea. Some would declare that art, by definition, has to be beautiful, arbitrarily excluding innumerable depictions of social injustice, violence and tragedy. Still others might maintain that art's only real identity lies in redefining what constitutes art, but that is surely not what was on the mind of an artist whose work is effectively an anguished outburst.

INTERPRETING ART

So, the answers to the questions 'What is art?' and 'What is art for?' are that art is a particular way of saying something or

producing an effect in an observer, and art is 'for' whatever it says or produces as an effect in an observer. The judges of what art is for must be the observers themselves, who are in some ways interpreters of this art. It does not follow, however, that one interpretation is just as good as the next one. Historians and older academics tend to encourage interpreters to 'perform the art' (the word 'interpret' means 'to perform' in some languages) subject to the constraints provided by the work itself. They do so because they believe that this produces more of a statement about the work itself than about the observer. However, observers have the right to interpret as they feel - like a musician improvising around a theme, i.e., they can pretty much refuse to 'perform the art' subject to its constraints, allowing themselves to be inspired in a way that produces more of a statement about themselves than about the work. Both attitudes, and every position between them, can be seen in current writing about art. This might all seem complicated, but bear in mind that there are in fact only three categories of statements one can make about a work of art: Context. Form and Content. However, there are numerous possibilities for interaction between the elements within each category (for example, Form to Form), exponentially more possibilities for interaction between the categories themselves (e.g, between Form and Content) and virtually infinite possibilities brought to one layer in one of the categories (Context), so let's look at each of these in turn.

CONTEXT

'Context' refers to the circumstances surrounding the production and reception of a work of art rather than anything physically present in the work itself. Whether an artist was a man or a woman, religious or secular, academically trained or self-taught, is not something in the work, but it provides additional information that can certainly affect our understanding of the work. Whether the work was produced for public consumption in a religious establishment or for the cabinet of a private collector also affects our interpretation and understanding of the piece. We would have to interpret a work made during the time of the Spanish Inquisition differently from a hypothetically identical one made, say, during the expansion of the railways in the New World because we would need to keep in mind the very different cultural expectations behind them.

Recognizing a contextual code can help an observer understand a lot more about a piece of art. In the absence of this knowledge, a conventionally representational painting might still give us something to look at, even though we do not really understand it at all. In a work that departs from the conventional – for example, art that uses scratchy, unpolished-looking graffiti marks and codes – we do not even have the comfortable familiarity of the contemporary Zeitgeist on art. If we do not know that a certain mark means 'the people who live here are friendly to the homeless', for example, then we do not understand the piece and we may have no meaningful

experience of it. Without contextual information our interpretation is likely to be insufficient at best and faulty at worst.

Information about the artist is one of the major factors in the Context category. Although some might argue that details about the artist's social world are more significant, society in general did not produce the actual work, however much it may have influenced or affected its creation. Since no work would exist without its maker, primary Context describes the circumstances of the work's production at the individual artist's level. Contextual information is not a description of the production of the piece of art itself; it is the artist's attitudes and beliefs, education and training, gender and sexual preference, likes and dislikes, lifestyle and philosophy, politics and religion, social standing and personal wealth. As with all Context, none of these things has to appear in the work, but they all affect our understanding of it. For example, Artemisia Gentileschi (1593-1653) did not paint her experience of rape by her tutor Agostino Tassi in 1612, but knowing this detail of her life gives us license to interpret her depictions of male decapitations in a certain way.

We can consider secondary Context to be the broader cultural expectations, such as the philosophy, politics and religion of the observers or patrons of the work, which of course the artist might have shared. Again, none of these things appear in the work, but they can change our interpretation of it. For example, it can help us to understand that a swastika – a Greek cross with its arms bent in the same rotary direction – can be interpreted in one way

in twentieth-century Europe where it is associated with Nazism, and in a completely different way in ancient China, India and Tibet where it is inextricably linked to Buddhism, Jainism and Hinduism. The information we gain about a piece of art's context must be accurate and relevant (the sexual assault mentioned before is relevant, for example, whereas knowing that that artist was fond of a particular type of cheese would not be). One of the fascinating things about art history, however, is the way that later generations of observers sometimes retrieve and re-use an aspect of Context that an earlier generation found irrelevant. Every observer brings to a work his or her own secondary Context, and in this way the art is a reflection of ourselves. Secondary Context is theoretically infinite, unless we arbitrarily restrict our interpretations to a given range – for example, the lifetime of the artist or the patron. Because we have difficulty deciding where the boundary falls between acceptable and unacceptable circumstantial evidence, the proliferation of secondary Context makes the meanings of art seem inexhaustible.

FORM

Form differs fundamentally from Context. While the latter does not appear in the work, Form is the work and its constituent elements, independent of any meaning they might have. A work's colour, light, medium, shape, size, technique and texture are all aspects of Form. The basic formal elements are primary when they are treated in isolation. For example, to

speak of the character of a single shape in a painting as organic, geometric, static or dynamic is to refer to an aspect of primary Form. When we say something about how that shape relates to another shape, we shift to a secondary level of Form, in which elements relate to each other, as in balance, composition, contrast, distance, perspective, space, and so on. When we recognize shapes as particular things with particular identities identifying an arrangement of coloured stripes as a flag - we assign them a meaning and move from Form to Content. The mechanism that makes the change in the flag example is Context: we know that certain stripes (Form) indicate a flag (Content) within the horizon of expectations of a particular culture. Moving from Form to Content is so natural to us that we find it difficult to distinguish between the categories. It is, however, a useful exercise, for Form, however interesting on its own, plays an important role in actually creating Content.

CONTENT

Content refers to what a work says and the effects it produces in an observer. Some may actually be 'meanings' (in the sense that the artist meant or intended to convey them), and some may be better described as 'significances' (pseudo-meanings not intended or controlled by the artist but peculiar to an individual observer). Like the other categories, Content has primary and secondary levels. Primary Content corresponds approximately to the literal level of language — attributes, events, facts, objects,

people, places and things, all representing what they appear to represent, as opposed to symbolizing something else. As soon as we point out that one thing symbolizes or stands for something else, we shift to a secondary level of Content. Every competent performer of a language instinctively understands that figurative expressions are not to be taken as literal. 'She was on cloud nine' does not refer to someone floating in the sky; it pushes beyond the primary to a secondary layer of Content, 'happiness'. This is the core flaw in the theory that the value of art lies in its ability to render something accurately: to praise a work solely for its realism is to ignore the codes that may be obvious to an observer who shares its artist's horizon of expectations. In other words, what you see may not be what you (are supposed to) get.

There are several mechanisms by which primary Content becomes secondary Content. Probably the most common of these is symbolism – the comparison of a literal element in the picture to another element, whether present or implied, until a different level of meaning emerges. Devices such as the metaphor work in exactly this way. A child blowing a bubble is just that if we take the scene literally, but if we are prepared to see it as a comparison of the child and the bubble, a metaphor is produced. The understood characteristics of the bubble – its beauty and fragility – imply something less immediately apparent but no less true about the child. A good many of these tropes, as they are known, are conventional and widely understood by the culture or society in which the work has been produced. 'She was on cloud

nine' would not be figuratively meaningful in a culture that had not standardized the expression. Other tropes are invented by the artist rather than borrowed from culture in general. Observers may recognize these spontaneously, or they may have to work at understanding them by filling in the gaps in their knowledge of the artist. That an observer's knowledge of the artist is never complete is another of the many ways in which the meanings of art seem to be inexhoustible.

RELATIONSHIPS BETWEEN CONTEXT, FORM AND CONTENT

That Form consists of elements independent of meaning does not mean that it does not affect the meaning of a piece of art. Just as Context influences Content, pushing it from primary to secondary, Form also affects Content, although it uses a less familiar method of category-shifting that we might call 'paralinguistic'. Though the term strictly applies to the spoken language, the same principles can be applied to the visual image. The term refers to the way changes in individual delivery (or performance) of a statement lead to changes in our understanding of what is meant. If one changes the Form of a literal image (that is, the way in which it is delivered or performed), one can produce a corresponding change of the literal meaning of the image to a metaphorical one. Like tropes, some of these shifts can be conventional, evoking an immediate response that is mediated by secondary Context. For example, in Western culture everyone spontaneously recognizes the difference between the look, sound, and meaning of 'fire' spoken

normally and 'FIRE!' screamed loudly, even though the core meaning is the same. Moreover, everyone can tell the difference between 'fire!' yelled in a crowded theatre and 'fire!' shouted next to a line of aiming soldiers. Someone who fails to understand the difference has overlooked something important about the culture in which the expressions have achieved currency.

Rather than limiting themselves to illustrating paralinguistic shifts that are already part of the popular culture, artists reinvent them for expressive and aesthetic purposes. Let us look at an expressionist work, Van Gogh's Starry Night. Because of the painting's departure from conventional depictions of the night sky (and from Van Gogh's own usual style), it seems to evoke a deeply emotional response, and the scene almost cries out in mystical ecstasy. Trying to unravel the meaning-effects of contextual codes and formal nuances without falling prey to the assumption that good art is realistic, is key to understanding art as art, rather than art as craft.

No matter how complicated, then, all works of art involve the interplay of these three categories. This realization provides a way to create a workable definition of visual art that brings us at least a little closer to sufficiency. That is, visual art is the manipulation and interrelation of visible Form, invisible Context and primary Content to create secondary Content – that is, to say something or to produce an effect in the observer that goes beyond the literal – for the purpose of accomplishing one or more of the various ends listed above.

WHAT IS GOOD ART?

The new definition of art carefully avoids the question 'What is good art?'. This is because definitions of 'good' are always mediated by the values of secondary Context, the circumstances in which the piece is seen rather than in which it is created. One set of secondary cultural expectations sees goodness as 'quality', for example. But in one culture quality is defined as formal orderliness whether or not it is really appropriate for the Content, and in another culture quality is interpreted as whether or not artists have achieved what they set out to achieve. Where some cultures have not seemed to care whether an artist's use of symbolism is purely conventional or original, another culture highly prizes 'innovation' - the deliberate striving of the artist to invent a new and unconventional way of expressing something. Today, innovation is in the ascendant and it is manifest in only about three ways. First, artists can innovate by portraying primary Content with Form that is unexpected and, ideally, previously unused in this connection in such a way that new secondary Content is produced. As raw subject matter, Picasso's famous weeping women are nothing new, but his inventive Form shifts them until they say something new and produce a new effect in the observer. Second, artists innovate by making unusual combinations of secondary Context, Judy Chicago's famous Dinner Party of 1979 (in which place-settings are decorated with flower motifs that pun on female genitalia) retrieves old associations – for example, women's art as flower painting – and

reinvents them within the set of cultural assumptions that constitutes feminism. Third, artists innovate by developing and depicting idiosyncratic aspects of primary Context. Because this involves personal motivations that are often difficult to pinpoint, this third way to innovate is another contribution to the impression that art's meanings are inexhaustible.

HOW TO READ THIS BOOK

We invite readers to use this book in any way they see fit. We do, however, ask them to keep in mind that its final purpose is to see art as a way to exercise our hearts, imaginations and minds, not only to expand our knowledge of others' ideologies and social customs but also to question our own. These poles of respect and critique provide the parameters within which this book will achieve its purpose.

You may find that you end up reading this book, or at least sections of it, more than once. Dipping into the entries selectively will allow you to be drawn into the subject of art through the artists, or pieces, that most appeal to you. Finally, don't think of the book's selection of works as the final word on the subject – art history's canonical 'greatest hits', as it were. Think of them instead as exercises to prepare you for the great adventure of art – to explore a world that could never be encapsulated within the covers of one book.

13th-15th Centuries

The Gothic & Medieval Era

Cimabue, Giovanni

Angels from the Santa Trinita Altarpiece, 1280–90

Courtesy of Galleria Deali Uffizi, Florence, Italy/Bridgeman Art Library

Cimabue was the nickname of Genni di Pepo or Peppi, who was born in Florence around 1240. He began his career by imitating the Byzantine styles then prevalent, but soon developed a style of his own which earned for him the title of 'Father of Italian Painting'. There were certainly distinctive Italian painters before his time, but he was the outstanding artist of his generation and a role model for his successors. His fame rested mainly on the enormous altarpiece in the chapel of the Rucellai in Santa Maria Novella, Florence, although this was later proven to have been painted by Duccio. Works that are definitely attributed to him include the frescoes in the church of St Francis of Assisi and a number of paintings of the Madonna. He was the precursor of Giotto, whom he is supposed to have discovered as a 10-year-old shepherd-boy and recognized his artistic potential.

MOVEMENT

Florentine School

OTHER WORKS

St John (Pisa Cathedral)

INFLUENCES

Byzantine, Romanesque

Cimabue Born c. 1240 Florence, Italy

Pointed in Florence

Died c. 1302 Florence

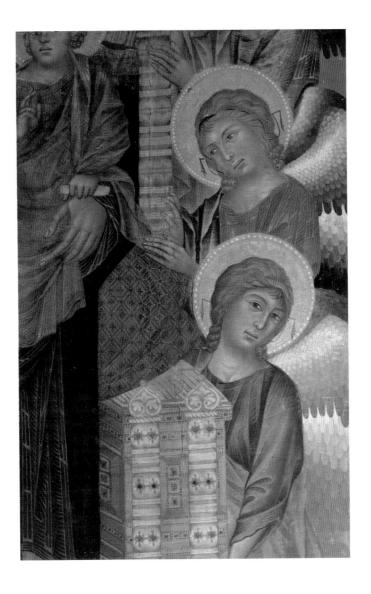

Giotto (Giotto di Bondone)

Lamentation of Christ, c. 1305

Courtesy of Scrovegni (Arena) Chapel, Padua, Italy/Bridgeman Giraudon

One of the founding fathers of the Renaissance, Giotto was revered by early commentators as the greatest artist since antiquity, and it is clear that he was still influencing painters more than a century after his death. His greatest achievement was to rid Italian art of the repetitive stylizations deriving from Byzantine painting. In the process, he became one of the first Western artists to stamp his own personality on his work. In particular, Giotto displayed an unparalleled degree of naturalism, both in his ability to depict solid, three dimensional forms and in his grasp of human psychology. He was also a gifted storyteller, conveying his religious narratives with absolute clarity and simplicity.

The details of Giotto's own life are, however a mystery. There is a tale that his master, Cimabue, first spotted his talent when he saw him as a shepherd-boy, sketching a lamb on a slab of rock. This is probably apocryphal, however, and the identification of Giotto's pictures presents even greater problems. The marvellous frescoes in the Arena Chapel, Padua, are usually cited as his masterpiece, but most other attributions are hotly disputed. Even his three signed altarpieces may only be workshop pieces.

MOVEMENT

Renaissance

OTHER WORKS

Arena Chapel Frescos; Madonna and Child; Ognissanti Madonna

INFLUENCES

Cimabue, Pietro Cavallini

Giotto Born c. 1267

Painted in Italy

Died 1337

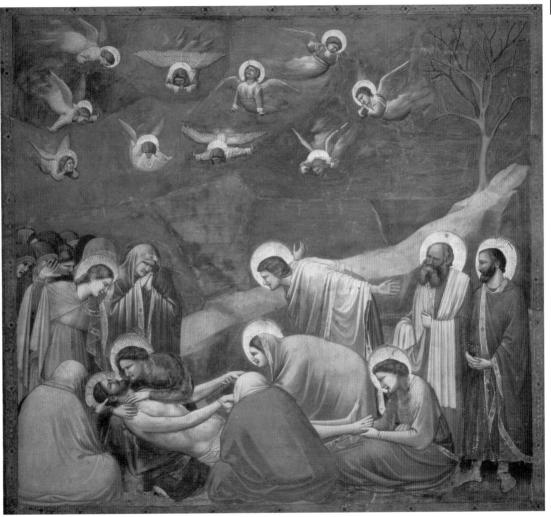

Duccio di Buonisegna

Madonna and Child, c. 1315

Courtesy of National Gallery, London, UK/Bridgeman Art Library

Western art begins with Duccio di Buonisegna, who learned his craft from studying the illuminated manuscripts created by unknown Byzantine limners. His earliest recorded work, dating about 1278, was to decorate the cases in which the municipal records of Sienna were stored. In 1285 he was commissioned to paint a large Madonna for the church of Santa Maria Novella. This is now known as the Rucellai Madonna, for centuries attributed to Cimabue. Duccio painted the magnificent double altarpiece for the Cathedral of Siena, regarded as his masterpiece and one of the greatest paintings of all time. Many other works documented in the Sienese records have been lost, but sufficient remain to establish Duccio as the last and greatest of the artists working in the Byzantine tradition, as well as the founder of the Sienese School, and thus the progenitor of modern art. In his hands the degenerate painting of the Gothic style was transformed and the principles of expressive portraiture established.

MOVEMENT

Sienese School, Italy

OTHER WORKS

The Crucifixion; Majestas; Madonna with Three Franciscans

INFLUENCES

Byzantine illuminations

Duccio di Buonisegna Born c. 1255 Siena, Italy

Painted in Siena and Florence

Died 1319 Siena

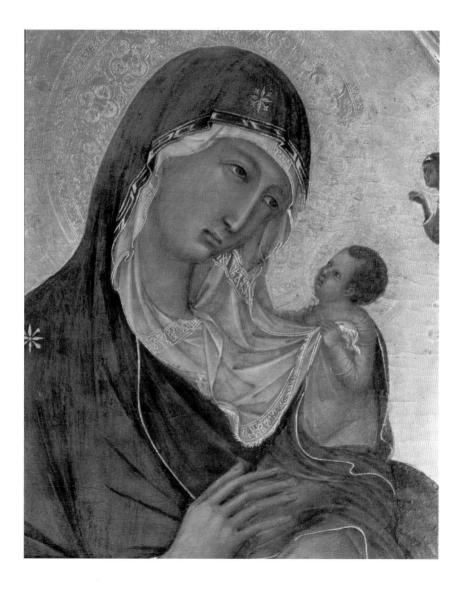

Rublev, Andrei

The Holy Trinity, 1420s

Courtesy of Tretyakov Gallery, Moscow, Russia/Bridgeman Art Library

Rublev (or Rublyov) was born in Russia around the middle of the fourteenth century, during the upsurge of church building in Russia and the desire for extravagant murals, mosaics and, above all, icons, whose human scale appealed to the Russian psyche far more than large frescoes. In Russia the icon was liberated from the strictures imposed upon it by the Greek Orthodox hierarchy and became much more humanist. To Rublev, a humble monk in the Andryonikov monastery near Moscow, fell the honour of transforming the icon and raising it to the status of fine art, combining intense realism with serenity and a sense of absolute devotion. Nothing is known about his origins, but his aptitude for drawing and painting came to the attention of the Greek master icon painter Theophanes, under whom Rublev worked from 1405 till 1422. He then settled in the Troitsky Sergieva monastery, where he produced his greatest works, establishing a reputation as the greatest icon painter of his era.

MOVEMENT

Russian Icon Painting

OTHER WORKS

The Saviour; The Trinity

INFLUENCES

Theophanes

Andrei Rublev Born c. 1360 Russia

Painted in Moscow

Died c. 1430 Moscow

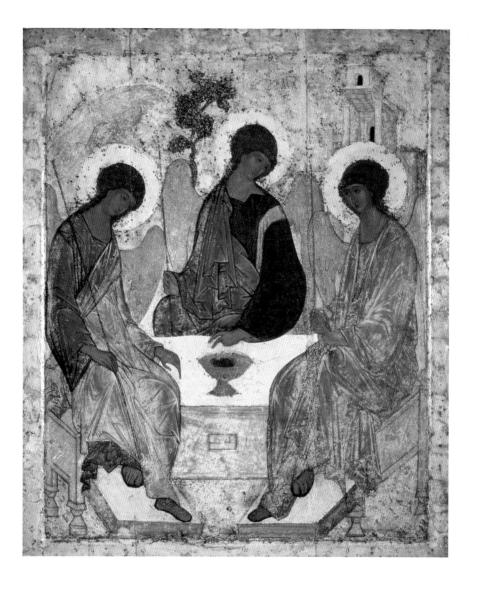

Van Eyck, Jan

Portrait of Giovanni Arnolfini and Wife (Arnolfini Marr). 1434

Courtesy of National Gallery, London, UK/Bridgeman Art Library

Jan van Eyck settled in Bruges in 1431, where he became the leading painter of his generation and founder of the Bruges School. He and his elder brother Hubert are credited with the invention of oil painting. Van Eyck's paintings have a startlingly fresh quality about them, not only in the dazzling use of light and colour but also in their expression and realism, which was something of a quantum leap in portraiture. Van Eyck was very much a pillar of the establishment, being successively court painter to John of Bavaria, Count of Holland, and Philip the Good of Burgundy. He was equally versatile in painting interiors and outdoor scenes, and exhibited a greater attention to detail than in the works of his predecessors. It is not surprising that he should not only sign and date his paintings but add his motto Als ich kan ('As I can').

MOVEMENT

Bruges School of Flemish Painting

OTHER WORKS

A Man in a Turban

INFLUENCES

Hubert van Eyck

Jan van Eyck Born c. 1389 Maastricht, Holland

Painted in Maastricht and Bruges

Died 1441 Bruges

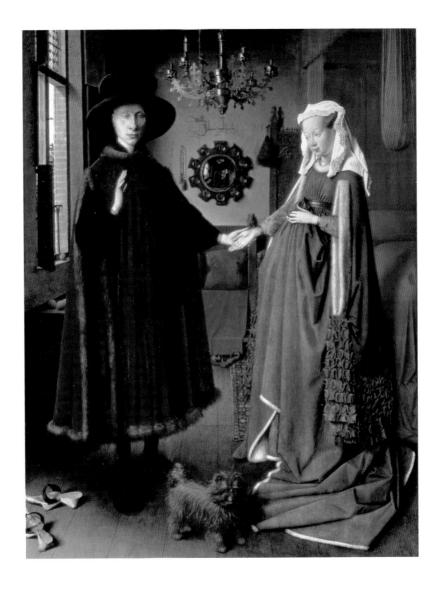

Fouquet, Jean

The Nativity, c. 1445

Courtesy of British Library, London, UK/Bridgeman Art Library

The most representative French painter of the fifteenth century, Jean Fouquet originally came under the influence of Van Eyck, but a period in Italy – where he was commissioned to paint the portrait of Pope Eugenius IV – brought him in contact with the new styles emerging in Tuscany. On his return to France he combined the Flemish and Tuscan elements to create a wholly distinctive French style. Highly influential on the succeeding generation of French artists, Fouquet's supreme importance was not fully realized until 1904, when his surviving works were brought together for an exhibition in Paris. His painting combines the skills and precision acquired during his early career as a limner and miniaturist with a new-found expressiveness that places him in the forefront of the painters who could get behind the eyes of their subjects and reveal the underlying character.

MOVEMENT

French Primitives

OTHER WORKS

Virgin and Child; Saint Margaret and Olibrius; Jouvenal des Ursins

INFLUENCES

Van Eyck, Piero della Francesca

Jean Fouquet Born c. 1420 Tours, France

Painted in France and Italy

Died c. 1481 Tours, France

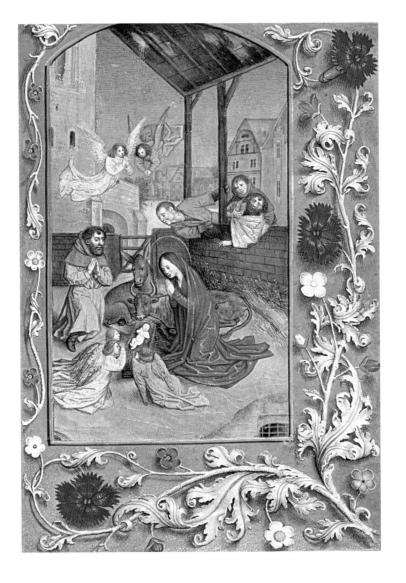

Van der Weyden, Rogier

Crucifixion, 1468

Courtesy of Prado, Madrid, Spain/Bridgeman Art Library

Rogier van der Weyden studied under Robert Campin in his native city of Tournai before going to Brussels, where he made his mark both as an artist and as a prominent citizen. From 1436 he was the official painter to the city as well as the Burgundian Court. Although he visited Rome in 1450 it had no impact on his style. A very accomplished technician, he excelled not only in form and composition but also in his use of colour. But his main contribution to the progress of art was in his highly expressive portraiture, one of the first painters to convey the character and psychological profile of the model or the subject. He combined deep religious feeling with a desire to make the maximum impact on the spectator and in this he succeeded admirably. He wielded enormous influence over his contemporaries and the ensuing generation of Flemish artists.

MOVEMENT

Flemish School

OTHER WORKS

Deposition; The Last Judgment

INFLUENCES

Robert Campin

Rogier van der Weyden Born 1399 Belgium

Painted in Tournai and Brussels

Died 1464 Brussels, Belgium

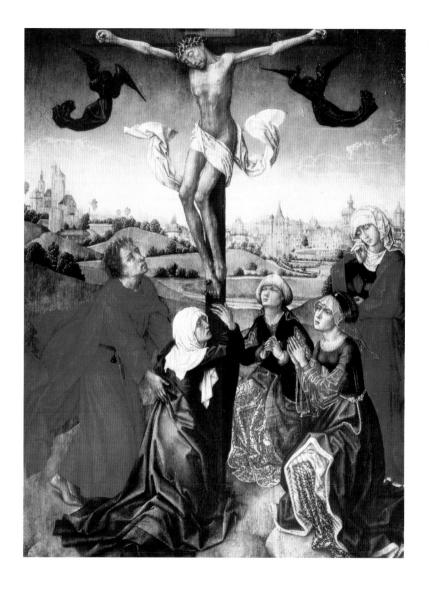

Memling, Hans

Adoration of the Magi (Central panel of triptych), c. 1470

Courtesy of Prado, Madrid, Spain/Bridgeman Art Library

Although born in Germany Memling spent most of his life in Bruges (now in Belgium), where he was probably a pupil of Rogier van der Weyden. This is borne out by the great triptych, whose central panel was painted by Rogier but the wings by 'Master Hans'. Bruges, which had been the commercial centre of the duchy of Burgundy, was then in decline and it has been said that Memling's genius alone brought lustre to the city. He was certainly residing in Bruges by I 463 and four years later enrolled in the painters' guild. In I 468 he painted the triptych showing the Virgin enthroned, flanked by the family of the donor, Sir John Donne, who was in Burgundy for the wedding of Charles the Bold that year. Although best known for his altarpieces and other religious paintings, Memling also produced a number of secular pieces, mostly portraits of his contemporaries. His paintings are characterized by an air of serenity and gentle piety enhanced by the use of vivid colours and sumptuous texture.

MOVEMENT

Flemish School

OTHER WORKS

The Mystic Marriage of St Catherine; The Virgin Enthroned

INFLUENCES

Rogier van der Weyden

Hans Memling Born c. 1433, Germany

Painted in Bruges, Belgium

Died 1494 Bruges

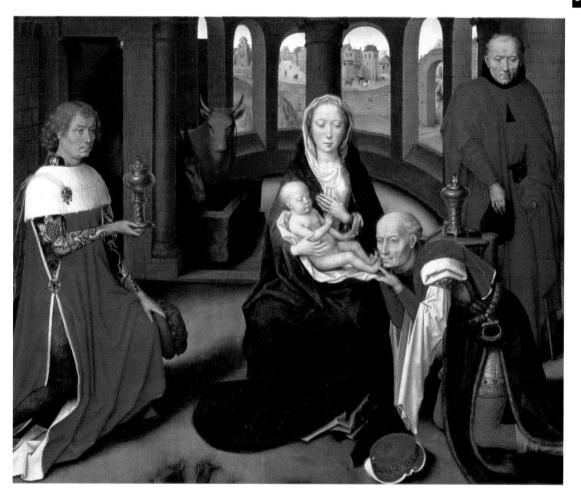

Van der Goes, Hugo

The Fall, after 1479

Courtesy of Kunsthistorisches Museum, Vienna, Austria/Bridgeman Art Library

Hugo van der Goes was the Dean of the painters' guild in that city from 1 467 to 1 475, before retiring to the monastery of Rouge Cloître near Brussels, where he continued to execute religious paintings. The outstanding Flemish artist of his generation, his reputation rests mainly on a single work: the magnificent altarpiece which was commissioned by Tommaso Portinari for the chapel in the hospital of Santa Maria in Florence. It is a vast triptych, crammed with figures, the great centrepiece representing the Adoration of the Shepherds, while the wings portray Portinari and his sons praying under the protection of Saints Anthony and Matthew and Protinari's wife and daughters on the other, protected by Saints Margaret and Mary Magdalen. A number of easel paintings have been attributed to this artist, while he also designed stained glass windows and frescoes.

MOVEMENT

Flemish School

OTHER WORKS

Fall and Deposition; Adoration of the Magi; Death of the Virgin

INFLUENCES

Rogier van der Weyden

Hugo van der Goes Born c. 1440 Ghent, Belgium

Painted in Ghent

Died 1482 Ghent

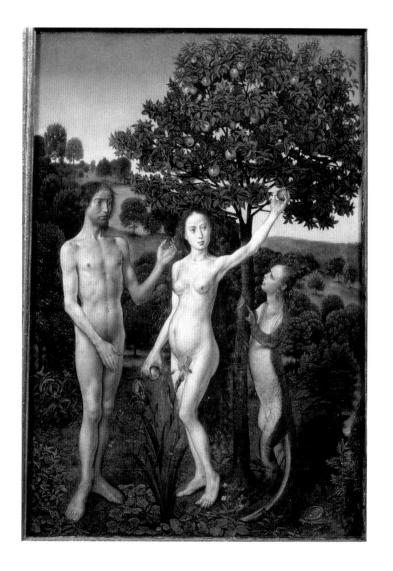

Bosch, Hieronymus

The Garden of Earthly Delights, (detail) c. 1500

Courtesy of Prado, Madrid, Spain/Bridgeman Art Library

Born Jerome van Aken but known by the Latin version of his first name and a surname from the shortened form of his birthplace 's Hertogenbosch in North Brabant, where he spent his entire life, he painted great allegorical, mystical and fantastic works that combined the grotesque with the macabre. His oils are crammed with devils and demons, weird monsters, dwarves and hideous creatures, barely recognizable in human form. His quasi-religious and allegorical compositions must have struck terror in the hearts of those who first beheld them, but centuries later he would have a profound influence on the Surrealists. In more recent times there have been attempts to analyse his paintings in Jungian or Freudian terms, the theory being that he tried to put his more lurid nightmares onto his wood panels. This is his best known work, executed on four folding panels, in which he develops the story of the Creation and the expulsion of Adam and Eve. At the core of the work is a vast sexual orgy, symbolizing the sins of the flesh that caused man's downfall.

MOVEMENT

Surreolism

OTHER WORKS

The Temptation of St Anthony; Last Judgment

INFLUENCES

Gothic art

Hieronymus Bosch Born c. 1450, Hertogenbosch, Holland (now in Belgium)

Painted in Hertogenbosch, Holland

Died 1516 Hertogenbosch, Holland

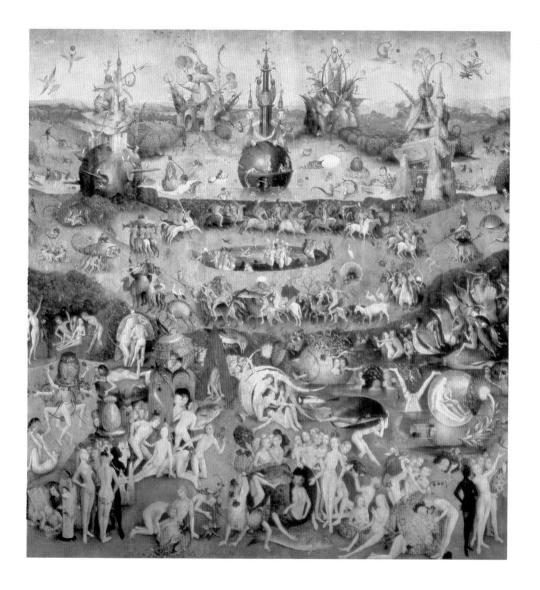

Grünewald, Matthias

Mary Magdalene from the Isenheim Altarpiece, 1510–15

Courtesy of Musee d'Unterlinden, Colmar, France/Bridgeman Giraudon

Born Mathis Gothardt-Neithardt, probably in Würzburg, he flourished at Frankfurt, Mainz, Aschaffenburg and Upper Alsace between 1500 and 1528, where he worked as an architect and engineer. Very little is known of his origins and early life, and he only came to artistic prominence in 1508 when he was appointed court painter at Mainz, taking up a similar post at the court of the Elector of Brandenburg in 1515. It was during the latter period that he undertook the great altarpiece at Isenheim, now preserved in the Colmar Musem. In his heyday he was ranked equal with Dürer and Cranach and is regarded as the last great exponent of German Gothic art, at a time when the ideas of the Italian Renaissance were making inroads into northern Europe.

MOVEMENT

German Gothic

OTHER WORKS

The Crucifixion; The Mocking of Christ

INFLUENCES

Albrecht Dürer

Matthias Grünewald Born c. 1470 Bavaria, Germany

Painted in Frankfurt, Aschaffenburg, Mainz, and Colmar

Died 1528 Halle

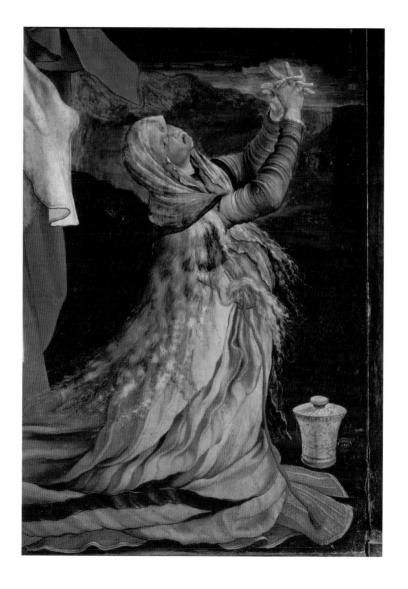

16th Century

The Renaissance Era

Angelico, Fra (Guido di Pietro)

The Annunciation (detail) c. 1420

Courtesy of Prado, Madrid, Spain/Bridgeman Art Library/Christie's Images

Fra Angelico was one of a select band of Renaissance artists who combined the monastic life with a career as a professional painter. Little is known about his early years, apart from the fact that he was born at Vicchio, near Florence, and that his real name was Guido di Pietro. He became a Dominican friar c. 1418–21, entering the monastery of San Domenico in Fiesole. For the remainder of his life, he placed his art at the service of his faith, earning the nickname 'Angelic', by which he has become known to posterity.

Angelico's earliest surviving works are small-scale and betray an astonishing eye for detail, suggesting that he may have begun his career as a manuscript illuminator. They also display the influence of the International Gothic style, which was starting to fall out of fashion. The painter-monk learned quickly, however, absorbing Tommaso Masaccio's revolutionary ideas about the organization of space and perspective. He also tackled the most prestigious form of religious art: frescoe painting. In this field, Angelico's greatest achievement was a magnificent cycle of frescoes at the newly restored monastery of San Marco in Florence (c. 1438–45).

MOVEMENT

Renaissance

OTHER WORKS

Linaiuoli Triptych; Coronation of the Virgin

INFLUENCES

Masaccio, Monaco

Fra Angelico Born c. 1400

Painted in Italy

Died 1459

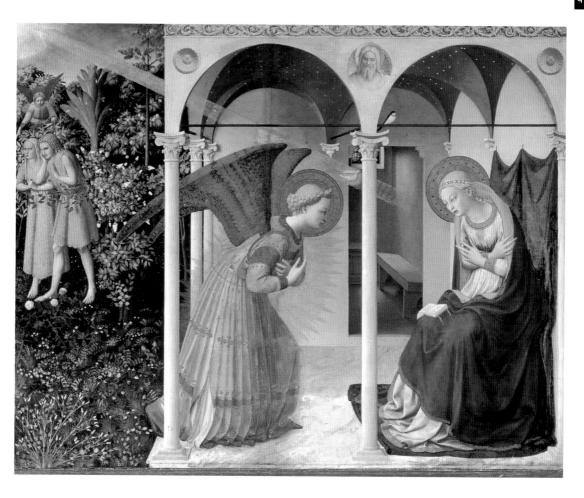

Fabriano, Gentile Da

The Adoration of the Magi, detail of Virgin and Child with Three Kings, 1423

Courtesy of Galleria Degli Uffizi, Florence, Italy/Bridgeman Art Library

Born in the little north Italian town of Fabriano, Gentile worked as a painter mainly in Venice and later Brescia before settling in Rome in about 1419, although subsequently he also worked in Florence and Siena. There he executed a great number of religious paintings although, regrettably, comparatively few of these works appear to have survived. His most important work was probably carried out in Florence where he enjoyed the patronage of Palla Strozzi, the richest magnate of the city in his day. About 1423 Strozzi commissioned him to paint the magnificent altarpiece depicting the Adoration of the Magi for the sacristy-chapel in the church of the Holy Trinity, intended by the patron as a memorial to his father Onofrio Strozzi. This is Gentile's undoubted masterpiece. The very epitome of the Italian Renaissance, it is now preserved in the Uffizi Gallery. It is an extraordinary work, crammed with figures – among whom we may discern the Strozzi family and their friends.

MOVEMENT

Florentine School

OTHER WORKS

Madonna and Child; Madonna with Angels

INFLUENCES

Filippo Brunneleschi

Gentile da Fabriano Born c. 1370 Fabriano, Italy

Painted in Venice, Brescia, Rome, Florence and Siena

Died c. 1427 Venice

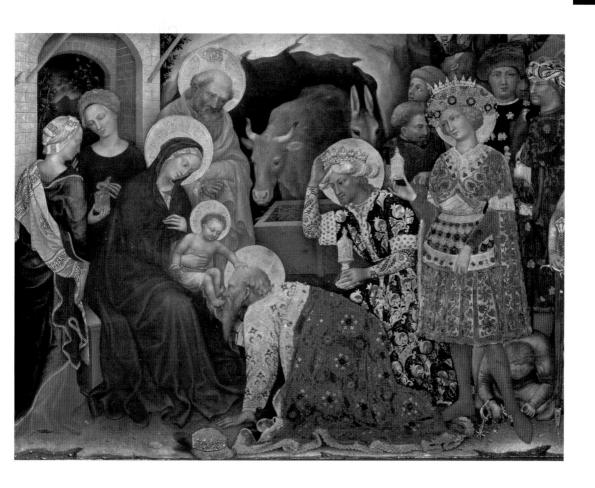

Masaccio, Tommaso

Madonna Casini, after 1426

Courtesy of Galleria Degli Uffizi, Florence, Italy/Bridgeman Art Library

Born Tommaso de Giovanni di Simone Guidi at Castel San Giovanni di Altura in the duchy of Milan, he was nicknamed Masaccio ('massive') to distinguish him from another Tommaso who worked in the same studio. Who taught him is not recorded, but Masaccio was one of the most brilliant innovators of his generation, ranking with Brunelleschi and Donatello in revolutionizing painting in Italy. Biblical figures and scenes became infinitely more realistic in his hands. The human body is more fully rounded than before and Masaccio's handling of perspective is a marked improvement over his predecessors. He wielded enormous influence over his contemporaries and successors, notably Michelangelo. His greatest work consisted of the series of frescoes for the Brancacci Chapel in the Church of Santa Maria del Carmine in Florence (1424–27).

MOVEMENTS

Italian Renaissance, Florentine School

OTHER WORKS

The Virgin and Child; The Trinity with the Virgin and St John

INFLUENCES

Donatello

Tommaso Masaccio Born 1401 Castel San Giovanni di Alturo, Italy

Pointed in Milan and Florence

Died 1428 Rome

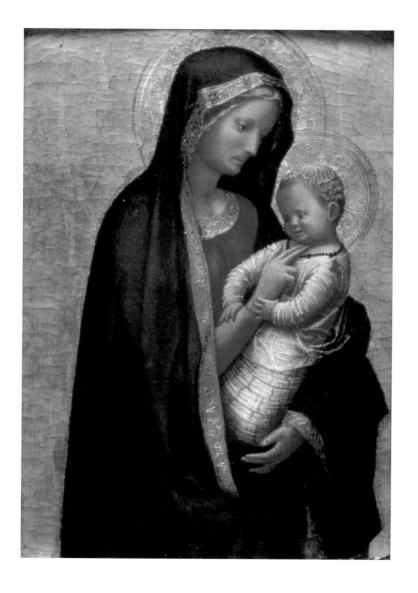

Uccello, Paolo

The Flood and the Subsidence of the Waters, 1447–8

Courtesy of Santa Maria Novella, Florence, Italy/Bridgeman Art Library

Paolo di Dono acquired his nickname from his love of painting birds. At the age of 10 he was apprenticed to Lorenzo Ghiberti, who was then working on the doors of the Florentine Baptistry, but it is not known from whom Paolo received his instruction in painting. He went to Venice in 1425 and worked on mosaics. In 1433 he painted the figure of Sir John Hawkswood, a fourteenth century knight errant, for Florence cathedral, the first equestrian painting of the Renaissance. Most of his work consisted of frescoes, few of which have survived intact, but he also painted tempera on pane, sufficient of which have come down to posterity to reveal Uccello as a master of perspective and foreshortening. He also made a major contribution to the art of showing natural objects in three-dimensional space.

MOVEMENT

Florentine School

OTHER WORKS

The Battle of San Romano; St George and the Dragon

INFLUENCES

Donatello

Paolo Uccello Born 1397 Pratovecchio, Italy

Painted in Florence and Venice

Died 1475 Florence

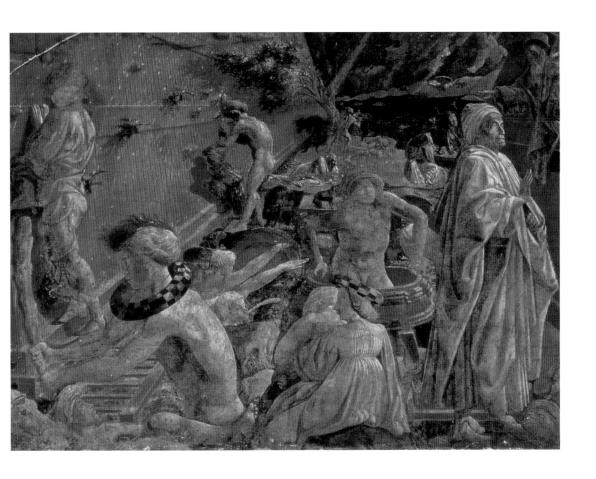

Piero della Francesca

Baptism of Christ, 1450s

Courtesy of National Gallery, UK/Bridgeman Art Library

Piero della Francesca began his coreer as a pupil of Veneziano in Florence, although he spent most of his working life in his home town of Borgo San Sepolcro, where he attained some eminence in civic affairs. Although strongly influenced by Donatello, Masaccio and Uccello, he was fascinated with mathematics and problems of perspective. Indeed, from 1470 onwards, he abandoned painting and concentrated on these subjects, writing treatises dealing with geometry and perspective. He was a rather slow, perhaps dilatory, artist who took a long time to complete commissions – one of his greatest masterpieces being the unfinished *Nativity* now in the National Gallery, London. His work was neglected and underrated for many years, but he was rediscovered in the nineteenth century and his stature as one of the major artists of the Renaissance has been re-established.

MOVEMENT

Florentine School

OTHER WORKS

Resurrection; The Legend of the True Cross; Constantine's Dream

INFLUENCES

Veneziano, Donatello, Masaccio, Uccello

Piero della Francesca Born c. 1420 Italy

Painted in Florence and Borgo San Sepolcro

Died 1492 Borgo San Sepolcro

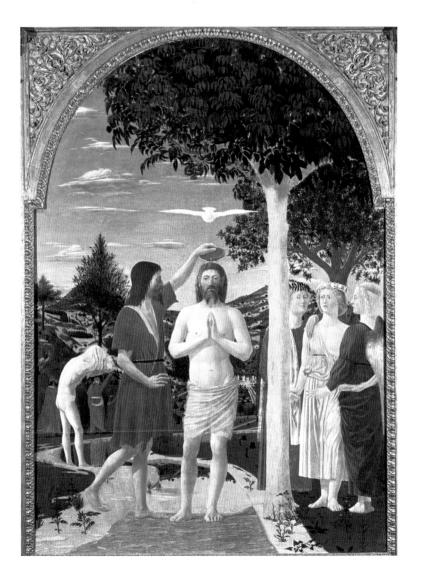

Gozzoli, Benozzo

Angels, c. 1459

Courtesy of K & B News Foto, Florence/Bridgeman Art Library/Christie's Images

Born Benozzo di Lese di Sandro, he studied painting under Fra Angelico and assisted his master in the decoration of the Palazzo Medici-Riccardi in 1 456–60. Gozzoli's major contribution was the *Journey of the Magi*, an ambitious work crammed with the portraits of the Florentine council and members of the Medici family. Later he moved with his master to Rome and later worked in Orvieto, also executing numerous frescoes and large murals for churches in Gimignano and Pisa. After leaving Angelico he went to Montefalco in Umbria, where he painted a number of smaller, individual works and altarpieces. As well as the obligatory religious subjects he painted a number of portraits, including Dante, Petrarch and Giotto. His paintings are characterized by their light, lively appearance, their vivacity enhanced by his use of bright, brilliant colours.

MOVEMENT

Florentine School

OTHER WORKS

St Thomas Receiving the Girdle of the Virgin

INFLUENCES

Fra Angelico

Benozzo Gozzoli Born 1420 Florence, Italy

Painted in Florence, Rome, Orvieto and Montefalco Gimignano and Pisa

Died 1497 Pistoia

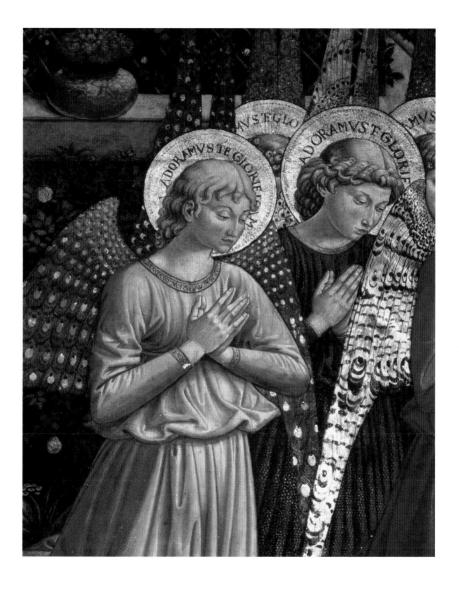

Messina, Antonello da

Portrait of a Man, c. 1475

Courtesy of National Gallery, London/Bridgeman Art Library

Probably born at Messina, Sicily, whence he derived his surname, Antonello travelled in north-western Europe and spent some time in the Netherlands where he studied the techniques of the pupils of Jan Van Eyck, taking them back to Messina about 1465. Subsequently he worked in Milan and then, in 1472, settled in Venice, where he executed commissions for the Council of Ten. His paintings are remarkable for their blend of Italian simplicity and the Flemish delight in meticulous detail, although some of his earlier works do not always result in a perfect blend of techniques. The majority of his extant authenticated works are religious subjects, mainly painted in oils on wood panels, but he also produced a number of half-length portraits of Venetian dignitaries in the last years of his life. By introducing Flemish characteristics Antonello transformed Italian painting, notably in the use of oil paints, which revolutionized technique.

MOVEMENT

Italian Renaissance

OTHER WORKS

Ecce Homo: Madonna

INFLUENCES

Jan Van Eyck, the Flemish School

Antonello da Messina Born c. 1430 Italy

Painted in Messina and Venice

Died 1479 Messina

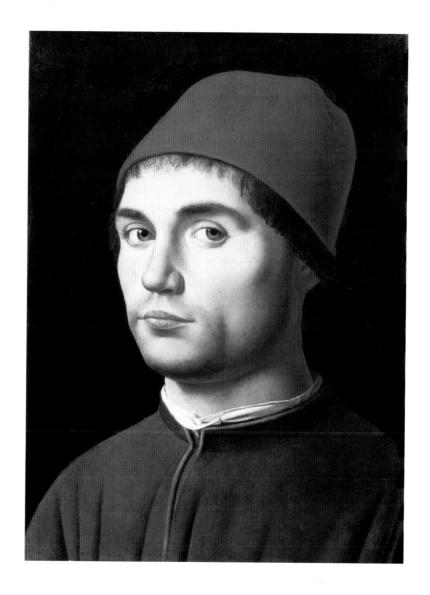

Botticelli, Sandro

The Birth of Venus, c. 1485

Courtesy of Galleria Degli Uffizi, Florence/Bridgeman Art Library/Christie's Images

Born Alessandro Di Mariano dei Filipepi, he acquired his nickname ('little barrel') from his brother Giovanni, who raised him and who was himself thus named. From 1458 to 1467 he worked in the studio of Fra Lippo Lippi before branching out on his own. By 1480 he was working on the frescoes for the Sistine Chapel and his lesser works consist mainly of religious paintings, although it is for his treatment of allegorical and mythological subjects that he is best remembered. Outstanding in this group are his paintings *Primavera* (1477) and *The Birth of Venus* (1485), both now in the Uffizi. He also excelled as a portraitist and provided the illustrations for Dante's *Divine Comedy*, which he executed in pen and ink and silver-point (1402–5).

MOVEMENT

Florentine School

OTHER WORKS

Venus and Mars

INFLUENCES

Fra Lippo Lippi, Verrocchio

Sandro Botticelli Born 1445 Florence, Italy

Painted in Florence and Rome

Died 1510 Florence

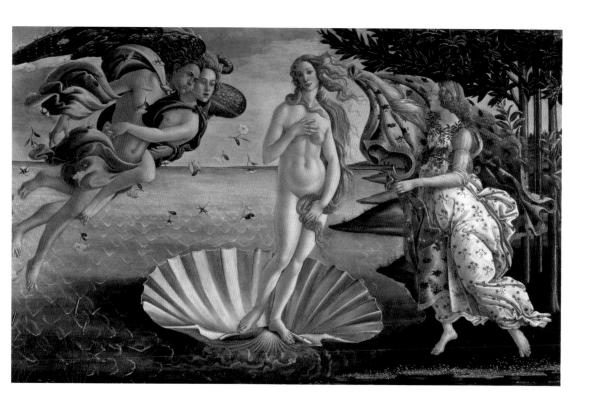

Ghirlandaio, Domenico

Portrait of a Young Man, c. 1490

Courtesy of Ashmolean Museum, Oxford, UK/Bridgeman Art Library

Domenico Ghirlandaio was the son of Tommaso Bigordi, under whom he trained as a goldsmith; he later studied painting and the art of mosaic under his uncle Alesso Bigordi. None of his early works have survived, but from 1475 onwards he was renowned as a pointer of wood panels and frescoes mainly for church decoration. In 1481 Pope Sixtus VI summoned him to Rome, where he painted a number of frescoes as well as individual religious works in which the subject was placed in a secular setting, often with figures of contemporary personalities as spectators on the sidelines. Ghirlandaio ran a large workshop, employing many pupils including the young Michelangelo. Although these frescoes incorporate numerous portraits, there are relatively few individual works by Ghirlandaio in this genre. The best of these, however, is the touching portrait of an old man with his grandson; the identity of the sitters is unknown.

MOVEMENT

Florentine School

OTHER WORKS

Adoration of the Magi; The Visitation; Virgin and Saints

INFLUENCES

Alesso Bigordi

Domenico Ghirlandaio Born 1449 Italy

Painted in Florence and Rome

Died 1494 Florence

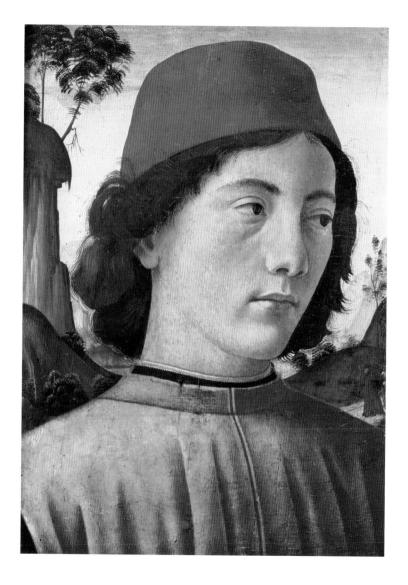

Perugino, Pietro

Madonna and Child with Two Angels, late fifteenth century

Courtesy of Private Collection/Christie's Images

Born Pietro di Cristoforo Vannucci, he is better known by his nickname, from Perugia, the chief city of the district where he grew up and spent much of his working life. Apprenticed to a Perugian painter at the tender age of nine, he showed precocious aptitude. Later he worked under Piero della Francesca in Arrezzo and then was a fellow-pupil of Leonardo under Verrocchio in Florence. From 1480-82 he worked on the frescoes in the Sistine Chapel, Rome, before returning to Perugia, but thereafter worked on various church commissions, occasionally in Rome but mainly in Florence where he had Raphael as one of his pupils for several years. Apart from frescoes and altarpieces he was a prolific painter of individual works, mainly religious subjects but also including a few contemporary portraits.

MOVEMENT

Umbrian School

OTHER WORKS

The Virgin and Child with Saints; Francesco dell Opera

INFLUENCES

Piero della Francesco, Andrea del Verrocchio

Pietro Perugino Born c. 1450 Città delle Pieve, Umbria, Italy

Painted in Parma, Florence and Rome

Died 1523 Fontigano, Italy

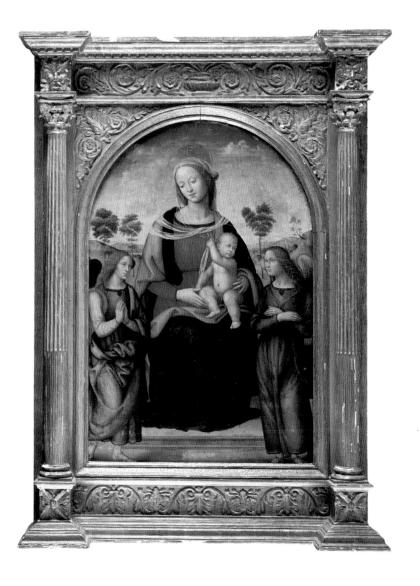

Piero di Cosimo

A Young Man

Courtesy of Dulwich Picture Gallery, London, UK/Bridgeman Art Library

Born Piero di Lorenzo, he was a pupil of Cosimo Rosselli, whose name he adopted. In 1482 he accompanied his master to Rome, where they worked on the frescoes of the Sistine Chapel, and it was during this period that he became imbued with the images of classical mythology which, along with the obligatory religious themes, dominated much of his later work. He also painted a number of portraits and landscapes which are notable for their cheerful accessories. His later style was influenced to some extent by Signorelli and Leonardo da Vinci, although he developed his own highly distinctive approach which his contemporaries regarded as rather eccentric; his interpretation of certain subject matter being at times rather strange. His reclusive character and diet of hard-boiled eggs tended to reinforce this opinion. Nevertheless, his paintings are distinguished by their mastery of light and composition.

MOVEMENT

Florentine School

OTHER WORKS

A Satyr Mourning Over a Nymph; Immaculate Conception

INFLUENCES

Cosimo Rosselli, Luca Signorelli, Leonardo da Vinci

Piero di Cosimo Born c. 1462 Florence, Italy

Painted in Florence and Rome

Died c. 1521 Florence

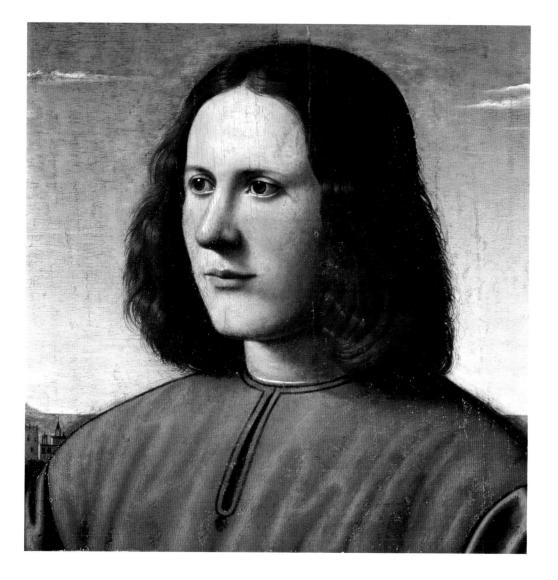

Mantegna, Andrea

Adoration of the Magi, 1495

Courtesu of Private Collection/Christie's Images

Andrea Mantegna was originally apprenticed to Francisco Squarcione, a tailor in Padua who later adopted him. Squarcione was a self-taught painter and it was from him that the young Mantegna learned the rudiments of art. About 1450 he completed an altarpiece for the church of Santa Lucia, which immediately established his reputation. Later he studied the works of Donatello in Florence and Castagno in Venice and mastered the newly developed techniques of perspective. He worked in Verona and elsewhere, executing religious paintings. In 1459 he was recruited by Ludvico Gonzaga, Duke of Mantua, to decorate his palaces and to the subsequent period belong his great masterpieces. Among these is the series of tempera paintings of the Triumph of Caesar executed between 1482 and 1492, later purchased by Charles I and now preserved at Hampton Court.

MOVEMENT

Italian Renaissance

OTHER WORKS

The Dead Christ; The Agony in the Garden

INFLUENCES

Francisco Squarcione, Andrea del Castagno, Donatello

Andrea Mantegna Born c. 1431 Venice, Italy

Painted in Italy

Died 1506 Mantua, Italy

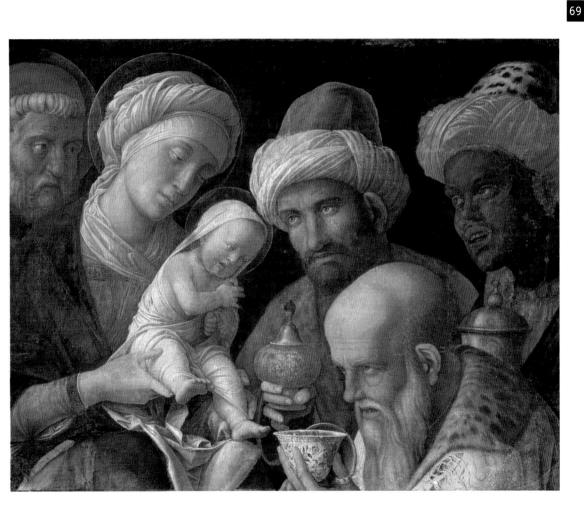

Leonardo da Vinci

Mona Lisa, c. 1503-06

Courtesy of Louvre, Paris/Bridgeman Art Library/Christie's Images

Florentine painter, scientist and inventor; the supreme genius of the Renaissance. Leonardo was the illegitimate son of a notary and probably trained under Verrocchio. In 1482 he moved to Milan, where he worked for the Sforzas. His chief work from this period was a majestic version of *The Last Supper*. The composition dazzled contemporaries, but Leonardo's experimental frescoe technique failed and the picture deteriorated rapidly. This was symptomatic of Leonardo's attitude to painting: the intellectual challenge of creation fascinated him, but the execution was a chore and many of his artistic projects were left unfinished. Leonardo returned to Florence in 1500, where he produced some of his most famous pictures, most notably the *Mona Lisa*. These were particularly remarkable for their *sfumato* – a blending of tones so exquisite that the forms seem to have no lines or borders. Leonardo spent a second period in Milan, before ending his days in France. Leonardo's genius lay in the breadth of his interests and his infinite curiosity. In addition to his art, his notebooks display a fascination for aeronautics, engineering, mathematics and the natural world.

MOVEMENT

Renaissance

OTHER WORKS

Mona Lisa; Virgin of the Rocks; The Last Supper

INFLUENCES

Verrocchio

Leonardo da Vinci Born 1452 Italy

Painted in Italy and France

Died 1519

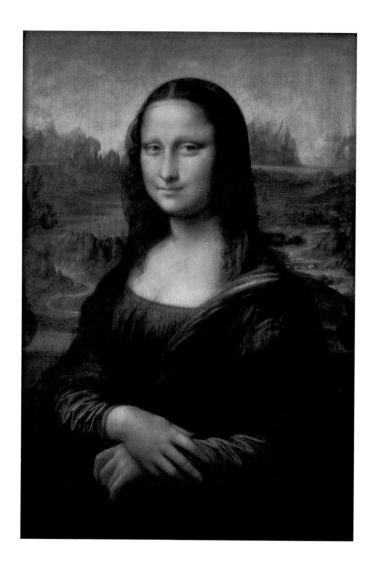

Yin, Tang

The Immortal Ge Changgeng Sitting on his Three-legged Toad, 1506–10

Courtesy of Private Collection/Bridgeman Art Library

An exact contemporary of Wen Zhengming, Tang Yin came from a prosperous middle-class family and had a brilliant academic education. Under the patronage of Wen Lin (Wen Zhengming's father) he seemed destined for the highest ranks in the civil service but he was caught trying to bribe the examiner, imprisoned and later returned to Suzhou in disgrace. His hopes of becoming a mandarin now dashed, Tang Yin took up painting and excelled to such an extent that he came to be regarded as one of the Four Great Masters of the Wu School. Studying under Zhou Chen, he achieved mastery of a very wide range of styles and subjects. Apart from handscrolls and wall hangings, Tang Yin was adept at the difficult art of painting on bamboo. He painted landscapes, scenes from Chinese mythology and portraits of beautiful women with equal skill. Most of his work was executed on paper using pen and ink with restrained use of colour, but combined with poetry and calligraphy in the finest tradition of the scholar-painters.

MOVEMENT

Wu School of China

OTHER WORKS

Moon Goddess Chang-e

INFLUENCES

Zhou Chen, Wen Zhengming

Tang Yin Born 1470 Suzhou, China

Painted in Suzhou

Died 1524 Suzhou

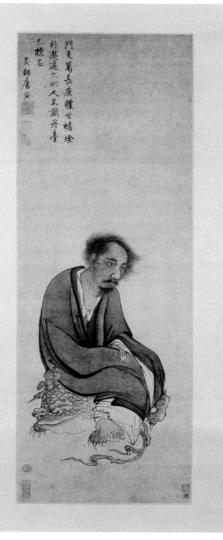

Giorgione

The Three Philosophers, c 1508

Courtesy of Kunsthistorisches Museum, Vienna, Austria/Bridgeman Art Library

Born in Castelfranco, Italy he is sometimes known as Giorgio da Castelfranco or even Giorgio Barbarelli, from the unsubstantiated legend that he was the natural son of the scion of the powerful family of that name. Giorgione (often spelled Zorzon in the Venetian dialect) is a somewhat shadowy figure, a man of apparently considerable musical and poetic talents whose career was cut short by the plague. His output consisted largely of frescoes which have not survived, but his reputation rests mainly on the small, intimate paintings of Christ, the saints and some contemporary figures. He was also responsible for great improvements in the depiction of figures in landscapes and an ability to convey senses and moods in these pictures. He learned his craft from Bellini and, in turn, passed on his expertise to Titian. Many paintings once attributed to Giorgione have since been disproved, but the few that remain confirm his position among the foremost artists of the early sixteenth century.

MOVEMENT

Venetian School

OTHER WORKS

The Sleeping Venus; The Tempest

INFLUENCES

Giovanni Bellini

Giorgione Born c. 1478 Castelfranco, Italy

Pointed in Venice

Died 1510 Venice

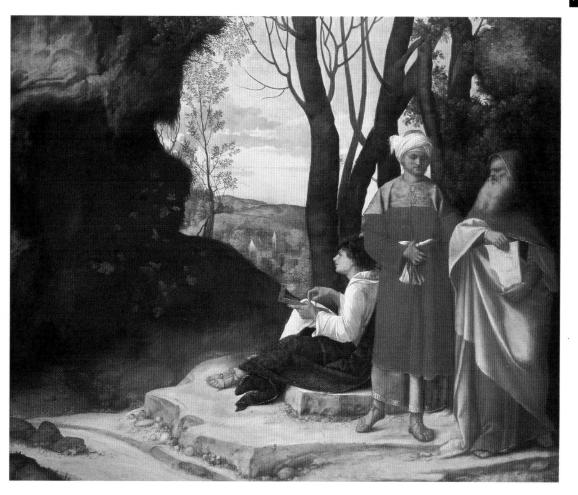

Michelangelo

Creation of Adam, Sistine Chapel detail, 1510

Courtesy of Vatican Museums and Galleries, Rome, Bridgeman Art Library/Christie's Images

Italian painter, sculptor and poet, one of the greatest artists of the Renaissance and a forerunner of Mannerism. Michelangelo was raised in Florence, where he trained briefly under Ghirlandaio. Soon his obvious talent brought him to the notice of important patrons. By 1490, he was producing sculpture for Lorenzo di Medici and, a few years later, he began his long association with the papacy.

Michelangelo's fame proved a double-edged sword. He was often inveigled into accepting huge commissions, which either lasted years or went unfinished. The most notorious of these projects was the Tomb of Julius II, which occupied the artist for over 40 years. Michelangelo always considered himself primarily a sculptor and he was extremely reluctant to take on the decoration of the Sistine Chapel. Fortunately he was persuaded, and the resulting frescoes are among the greatest creations in Western art. The ceiling alone took four years (1508–12), while the Last Judgment (1536–41) was added later on the altar wall. In these, Michelangelo displayed the sculptural forms and the terribilità ('awesome power'), which made him the most revered artist of his time.

MOVEMENTS

Renaissance, Mannerism

OTHER WORKS

David: Pietà

INFLUENCES

Ghirlandaio, Giotto, Masaccio

Michelangelo Born 1475 Italy

Painted in Italy

Died | 564 Italy

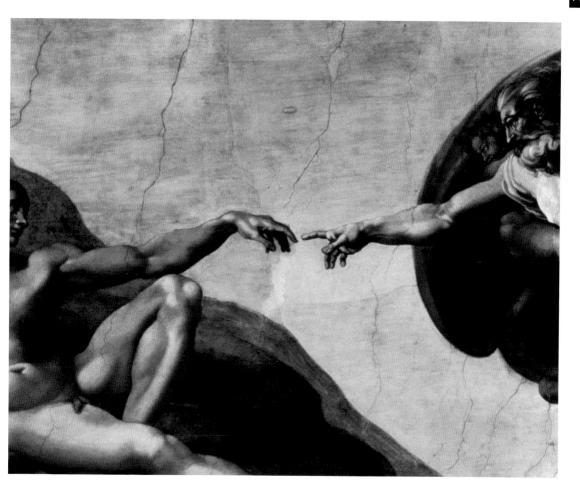

Raphael (Raffaello Sanzio)

School of Athens, 1510-11

Courtesy of Vatican Museums and Galleries, Vatican City, Italy/Bridgeman Art Library

The archetypal artist of the High Renaissance, Raphael received his education in Perugino. In 1504 he moved to Florence, where he received many commissions for portraits and pictures of the Virgin and Child. Soon, his reputation reached the ears of Pope Julius II, who summoned him to Rome in 1508. Deeply influenced by Michelangelo he added a new sense of grandeur to his compositions and greater solidity to his figures. Michelangelo grew jealous of his young rival, accusing him of stealing his ideas, but Raphael's charming manner won him powerful friends and numerous commissions.

The most prestigious of these was the decoration of the Stanze, the papal apartments in the Vatican. This was a huge task, which occupied the artist for the remainder of his life. *The School of Athens* is the most famous of these frescoes. Other commissions included a majestic series of cartoons for a set of tapestries destined for the Sistine Chapel and a cycle of frescoes for the banker, Agostino Chigi. In the midst of this frantic activity, however, Raphael caught a fever and died, at the tragically young age of 37.

MOVEMENT

Renaissance

OTHER WORKS

Galatea: The Sistine Madonna

INFLUENCES

Pietro Perugino, Leonardo da Vinci, Michelangelo

Raphael Born 1483 Urbino, Italy

Painted in Italy

Died 1520

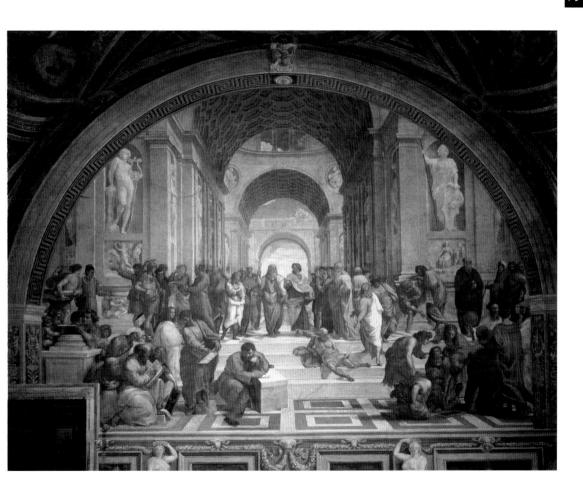

Dürer, Albrecht

Melancholia, 1514

Courtesy of Private Collection/Christie's Images

Albrecht Dürer was the son of a goldsmith who taught him the art of drawing in silver-point. In 1484 he was apprenticed to the leading Nuremberg painter and book illustrator of his time, Michael Wolgemut (1434–1519), from whom he learned the techniques of woodcut engraving. He then travelled extensively in Italy, where the works of Leonardo, Bellini and Mantegna had a profound influence on his later career, both as a practicing artist and as an art theorist who wrote extensively on the subject. Dürer was thus responsible for introducing many of the ideas of the Italian Renaissance to northern Europe. Although now remembered chiefly for his engravings (including the *Triumphal Car*, at nine square metres the world's largest woodcut), he was an accomplished painter whose mastery of detail and acute observation have seldom been surpassed.

MOVEMENT

German School

OTHER WORKS

Wing of a Hooded Crow

INFLUENCES

Leonardo da Vinci, Bellini, Mantegna

Albrecht Dürer Born 147 | Nuremberg, Germanu

Painted in Nuremberg

Died 1528 Nuremberg

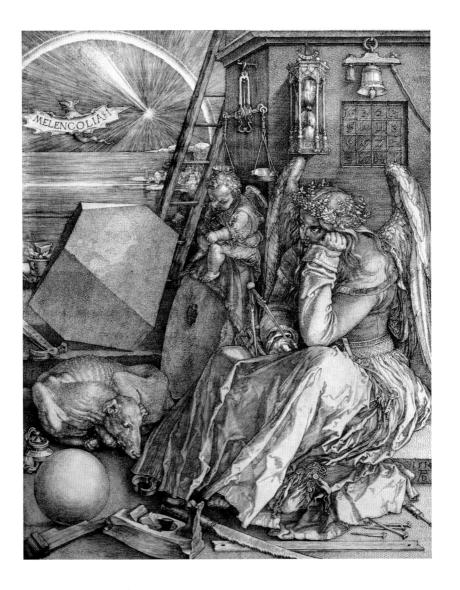

Altdorfer, Albrecht

Landscape with Footbridge, c. 1518-20

Courtesy of National Gallery, London/Bridgeman Art Library

Albrecht Altdorfer was born in Regensburg, Bavaria about 1480 and spent his whole life there. A Renaissance man in the true sense, he trained as an architect and was responsible for the design of many of the buildings in his native city, as well as rising to prominence in the city council. He also worked as an engraver, strongly influenced by Dürer, and was a pioneer of the technique of copperplate etching, but it is for his landscapes painted in oils on wood that he is best remembered. He specialized in biblical and historical subjects set in backgrounds, that gave free rein to his fertile imagination. After a prolonged tour of the Alps and Danube basin in 1511, however, he tended to concentrate on more realistic landscapes that were unusual for the time in that they were devoid of human figures and vividly conveyed a sense of atmosphere.

MOVEMENT

Danube School of German painting

OTHER WORKS

St George; Battle of Arbela; Landscape at Regensburg

INFLUENCES

Lucas Cranach, Albrecht Dürer

Albrecht Altdorfer Born c. 1480 Regensburg, Bavaria

Painted in Regensburg

Died 1538 Regensburg

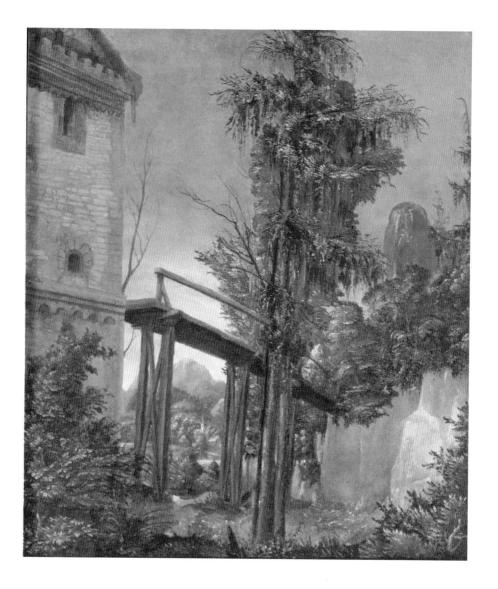

Andrea del Sarto

The Virgin and Child with a Saint and an Angel, c. 1513

Courtesy of Prado, Madrid, Spain/Bridgeman Art Library

The son of a tailor (*sarto*), hence his nickname, Andrea was originally apprenticed to a goldsmith but his early aptitude for drawing led to him being sent to Piero di Cosimo for training in draughtsmanship and colouring. The measure of how well he learned his lessons is evident, not only in his surviving works but also in the epithet applied to him in his lifetime as 'Andrea the Unerring'. Between 1509 and 1514 he was employed by the Brotherhood of the Servites to paint a series of frescoes illustrating the life of the Servite saint Filippo Benizzi, and this established his reputation for his extraordinary mastery of colour and tone. Widely regarded as the finest fresco painter of his generation, Sarto was later commissioned by François I of France and spent some time in Paris before returning to Florence, where most of his later religious paintings were executed. As well as large wall paintings he excelled in smaller, more intimate portraits and he would undoubtedly have gone on to greater things had he not been struck down by the plague at a relatively young age.

MOVEMENT

Florentine School

OTHER WORKS

Baptism of Christ; Dance of the Daughter of Herodias

INFLUENCES

Leonardo, Michelangelo, Franciabigio

Andrea del Sarto Born 1486 Florence, Italy

Painted in Florence and Paris

Died 1530 Florence

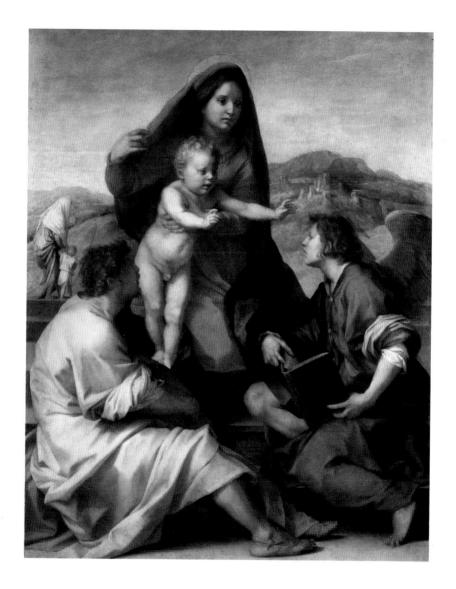

Qiu Ying

Zhao Mengfu Writing the Heart Sutra in Exchange for Tea

Courtesy of Private Collection/Bridgeman Art Library

Regarded as one of the Four Great Masters of the Ming Dynasty (along with Shen Zhou, Wen Zhengming and Tang Yin), Qiu Ying was by far the most versatile of the four. In contrast to his great contemporaries, he was born of humble peasant parents, but his aptitude enabled him to study painting in the Wu School at Suzhou. Unlike the scholar-painters, he relied solely on commissions from wealthy patrons and for that reason he was always more alive to the slightest change in fashion or taste. He painted flowers, gardens, figures, religious subjects and landscapes that revelled in colour and form, very much in line with the sensuousness then prevailing in Ming society. A prolific artist, he frequently copied works of earlier masters or incorporated elements of their work into his own. His technique likewise varied considerably and his palette ranged from the deep, bright colours which give his sensuous and erotic paintings a jewel-like quality, to the paler, more muted shades found in many of his scroll paintings of landscapes, imparting a poetic or contemplative character.

MOVEMENT

Chinese Landscape School

OTHER WORKS

Golden Valley Garden; Landscape after Li Tang

INFLUENCES

Shen Zhou, Zhou Chen

Qiu Ying Born c. 1494, Taicang, Jiangsu, China

Painted in Suzhou, China

Died c. 1552, Suzhou

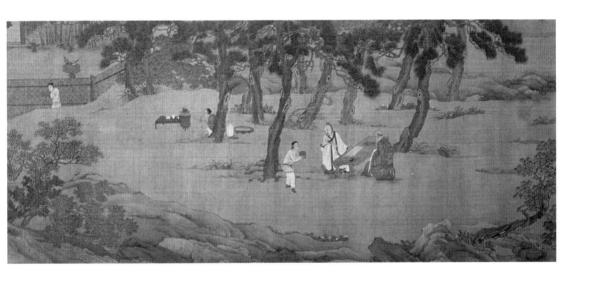

Wen Zhengming (and Qui Ying)

The Student Chang bidding farewell to his lover Ying Ying at the Rest Pavilion

Courtesy of Private Collection/Bridgeman Art Library

Although he pursued his career as a mandarin (senior civil servant), Wen Zhengming retired early to devote the rest of his life to art, which had hitherto merely been a leisure pursuit. He was fortunate to study under Shen Zhou, the great master of the Wu School, and eventually emerged as one of the greatest scholar-painters of the Ming Dynasty. His early work was eclectic, drawing on many different periods, sources and styles for inspiration and, in effect, creating an extraordinary – if subconscious – commentary on the art of his predecessors. His artistic career, however, reflects the transition from the relatively small range of muted colours to a much more colourful style of realism in landscape painting, ultimately employing colour to convey a sense of perspective, a radical departure from traditional techniques in composition. This was a major breakthrough, opening up new aspects of pictorial representation which would be more fully developed by later generations of Chinese painters.

MOVEMENT

Chinese Landscape School

OTHER WORKS

Lofty Leisure Below a Sheer Cliff

INFLUENCES

Shen Zhou, Ni Zan

Wen Zhengming 1470–1559

(Qui Ying 1494–1552)

Painted in China

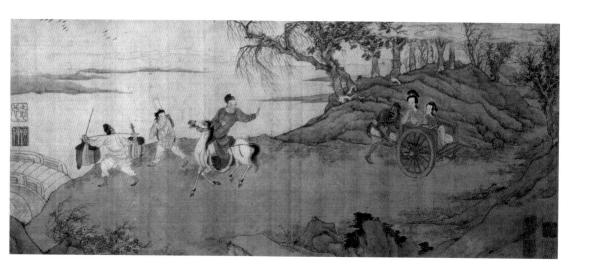

Parmigiano

Self Portrait at the Mirror, c. 1524

Courtesy of Kunsthistorisches Museum, Vienna, Austria/Ali Meyer/Bridgeman Art Library

Girolamo Francesco Maria Mazzola was generally known as Parmigianino ('the little Parmesan') or Parmigiano from his birthplace of Parma. His father and two uncles were painters and from them he learned his craft. Later he followed the style of Correggio, who settled in Parma, and they worked together on a number of frescoes for churches in Parma. Around 1523 he went to Rome, where he worked on the ceiling of the Sala dei Pontifici and painted his earliest individual work, *Vision of St Jerome*. Following the sack of Rome in 1527 he fled to Bologna, where he painted the great Madonna altarpiece for the convent of St Margaret. He returned to Parma in 1531 and was commissioned to paint a series of church frescoes, but defaulting on the job resulted in his imprisonment. On his release he decamped to Cremona, where he died in 1540. His few surviving paintings are distinguished by their grace and serenity.

MOVEMENT

Lombard School

OTHER WORKS

Madonna with St Zacharias; Madonna with the Long Neck

INFLUENCES

Correggio, El Greco

Parmigiano Born 1503 Parma, Italy

Painted in Parma, Rome and Bologona

Died 1540 Cremona, Italy

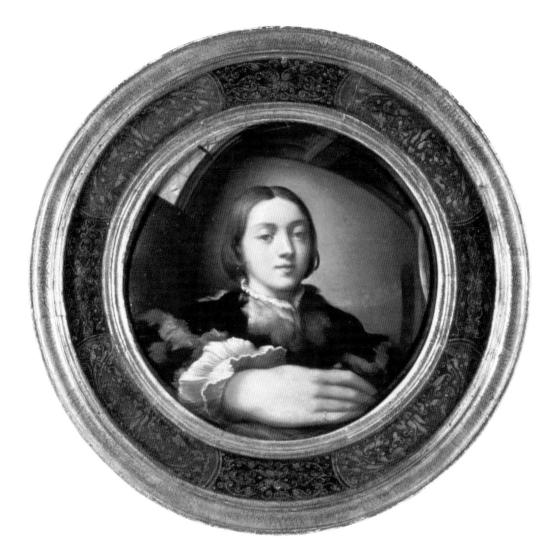

Cranach, Lucas

Venus with Cupid the Honey Thief, 1530

Courtesy of Private Collection/Christie's Images

Born at Kronach in Germany, whence he derived his surname, Cranach learned draughtsmanship from his father. In 1504 his paintings came to the attention of the Elector of Saxony, who appointed him court painter at Wittenberg. Thereafter he designed altarpieces, etched copper, produced woodcuts and engraved the coinage and medal dies for the Saxon mint. In 1509 he visited the Netherlands and painted the portraits of the Emperor Maximilian and his son, the future Charles V. Although Cranach produced many religious paintings, it should be noted that he sided with the reformers and painted the earliest authentic likeness of Martin Luther, while also executing numerous paintings of an allegorical or mythological character. Nevertheless, it is as a painter of very life-like portraits that he is chiefly remembered, especially as a chronicler in oils of the leading personalities of the German Reformation. All three of his sons, including Lucas Cranach the Younger, were painters.

MOVEMENT

German School

OTHER WORKS

Jealousy; The Crucifixion

INFLUENCES

Albrecht Dürer

Lucas Cranach Born 1472 Kronach, Germany

Painted in Saxony

Died 1553 Weimar, Germany

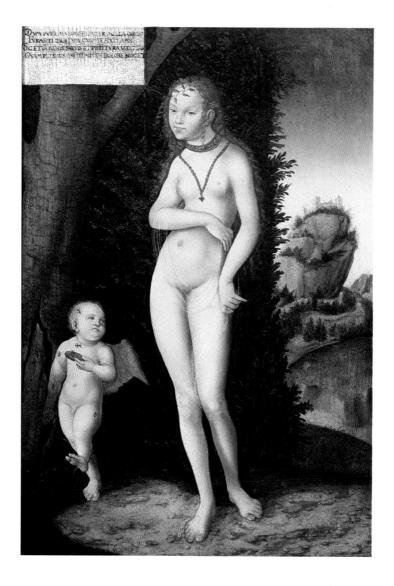

Correggio

Noli Me Tangere, c. 1534

Courtesy of Prado, Madrid, Spain/Bridgeman Art Library

Antonio Allegri, known to posterity by his nickname of Correggio, was born in the town of that name in the duchy of Modena. Originally he began training as a physician and surgeon, and studied anatomy under Giovanni Battista Lombardi – believed to be the doctor portrayed in the painting entitled *Correggio's Physician*. In 1518 he embarked on his epic series of frescoes for the Convent of San Paolo in Parma and followed this with the decoration of Parma Cathedral. He was the first Italian artist to paint the interior of a cupola, producing *The Ascension* for the church of San Giovanni in Parma. He also executed numerous religious and biblical paintings, but also occasionally drew on classical mythology for inspiration. His wife Girolama (b 1504) is believed to have been his model for the *Madonna Reposing*, sometimes known as *Zingarella* ('Gipsy Girl').

MOVEMENT

Parma Schoo

OTHER WORKS

Mystic Marriage of Saint Catherine: Ecce Homo

INFLUENCES

Leonardo da Vinci, Andrea Mantegna, Lorenzo Costa

Correggio Born 1494 Correggio, Italy

Painted in Correggio and Parma

Died 1534 Correggio

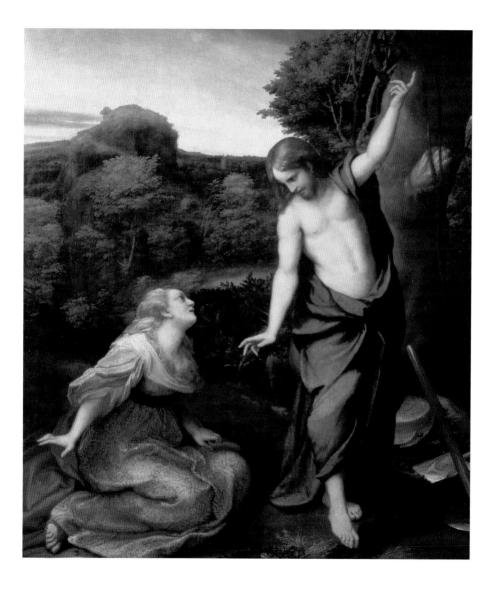

Bronzino, Il

Madonna and Child with Infant Saint John the Baptist

Courtesy of Private Collection/Christie's Images

Born Agnolo di Cosimo di Mariano, he became the leading court painter of the Florentine School in the mid-sixteenth century. He studied under Raffaellino del Garbo and Jacopo da Pontormo (working with the latter on religious frescoes) as well as being strongly influenced by Michelangelo. He spent his entire working life in Florence where he was court painter to Cosmo I, Duke of Tuscany. Second only to Andrea del Sarto among the Florentine portraitists, he also excelled as a painter of religious works. His talents extended to the written word, for he was also a notable poet and a member of the Florentine Academy. From Pontormo he developed a passion for light, resulting in the rich, brilliant colours that dominate his paintings. These are also striking on account of their fascination for the female nude, without precedent or parallel up to that time.

MOVEMENT

Mannerism

OTHER WORKS

Guidobaldo della Rovere; Eleanora Toledo and her Son

INFLUENCES

Raffaeline del Garbo, Jacope da Pontormo, Michelangelo

Il Bronzino Born 1503 Monticelli, Florence, Italy

Painted in Florence

Died 1572 Florence

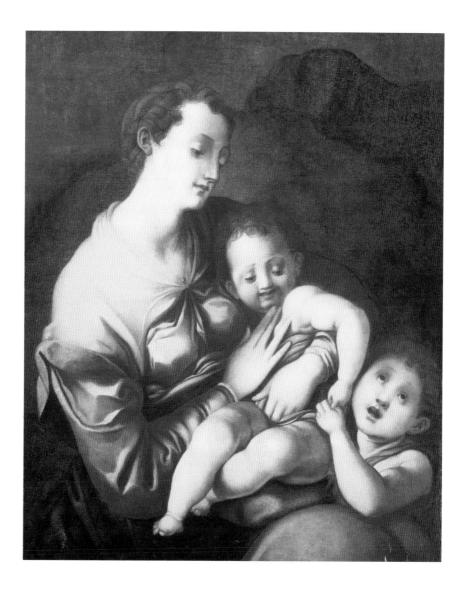

Holbein, Hans

(after) Henry VIII, c. 1540s

Courtesy of Private Collection/Christie's Images

Born at Augsburg, Germany, the son of Hans Holbein the Elder, he studied under his father and then went to Basle with his brother Ambrosius as apprentice to Hans Herbst. Subsequently he worked also in Zurich and Lucerne. He returned to Basle in 1519, married and settled there. To his Swiss period belong his mostly religious works. In 1524 he went to France and thence to England in 1526, where he finally took up residence six years later. There being no demand for religious paintings in England at that time, he concentrated on portraiture, producing outstanding portraits of Sir Thomas More and Henry VIII, whose service he entered officially in 1537. From then until his death he produced numerous sensitive and lively studies of the King and his wives, his courtiers and high officials of state. He also designed stained-glass windows and executed woodcuts.

MOVEMENT

German School

OTHER WORKS

Dead Christ; The Triumphs of Wealth and Poverty,

INFLUENCES

Hans Holbein the Elder, Hans Herbst

Hans Holbein Born 1497 Augsburg, Germany

Painted in Germany. Switzerland, France and England

Died 1543 London, England

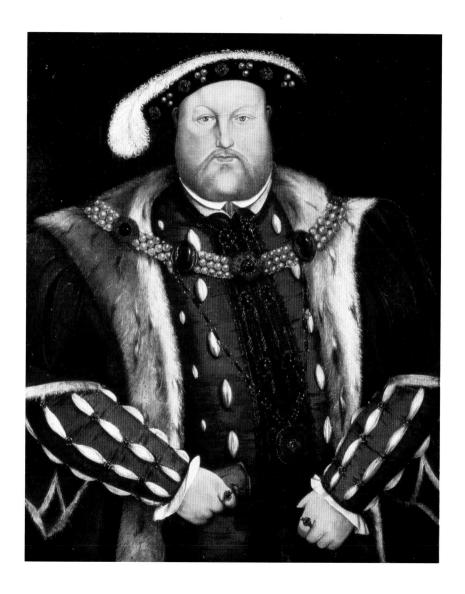

Titian (Tiziano Vecellio)

Venus and Adonis, 1555-60

Courtesy of Private Collection/Christie's Images

The greatest and most versatile artist of the Venetian Renaissance, Titian excelled equally at portroiture, religious pictures and mythological scenes. Born in the Dolomite region, he arrived in Venice as a boy and was apprenticed to a mosaicist. Turning to painting, he entered the studio of Giovanni Bellini, before joining forces with Giorgione. After Giorgione's premature death in 1510, Titian's star rose quickly. In 1511, he gained a major commission for frescoes in Padua, and in 1516 was appointed as the official painter of the Venetian Republic.

This honour enhanced Titian's international reputation and soon, offers of work began to flow in from the princely rulers of Ferrara, Urbino and Mantua. The painter did not always accept these commissions, as he was notoriously reluctant to travel, but some patrons could not be refused. The most distinguished of these was the Emperor Charles V. After their initial meeting in 1529, Titian was appointed Court Painter in 1533 and given the rank of Count Palatine. In 1548, he worked at the Imperial Court at Augsburg and his services were also prized by Charles's successor, Philip II.

MOVEMENT

Renaissance

OTHER WORKS

Bacchus and Ariadne; Man with a Glove; Sacred and Profane Love

INFLUENCES

Bellini, Giorgione

Titian Born c. 1485

Painted in Italy and Germany

Died 1576

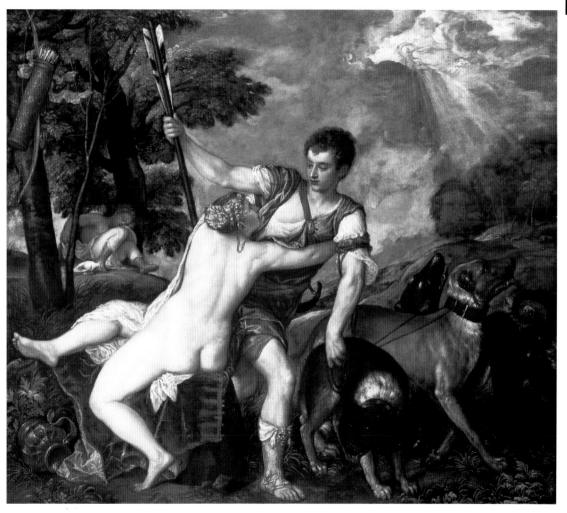

Anguissola, Sofonisba

Self Portrait, 1556

Courtesy of Muzeum Zamek, Lancut, Poland/Bridgeman Art Library

Sofonisba Anguissola was born into an aristocratic family. Her mother died when she was quite young, but her enlightened fother ensured that Sofonisba and her four clever sisters received a sound classical education, including lessons in pointing. Her extraordinary talent enabled her to overcome contemporary prejudices against female artists, reflected in the subterfuge of pretending that this self portrait was the work of a male artist, and eventually her lifelike portraits secured her an appointment at the Spanish court. Her paintings range from formal studies of Spanish grandees to charming genre subjects, notably her earlier pieces, in which her sisters provided the models. It is these which are now most highly regarded, not only on account of the lively rendering of their subjects but also because of the attention to detail in dress and background. Anguissola remained active almost to the end of her very long life.

MOVEMENT

Spanish School of Portraiture

OTHER WORKS

Three Sisters Playing Chess; Portrait of a Young Nobleman

INFLUENCES

Titian, El Greco

Sofonisba Anguissola Born c. 1527 Cremona, Italy

Painted in Cremona and Madrid

Died 1625 Palermo, Italy

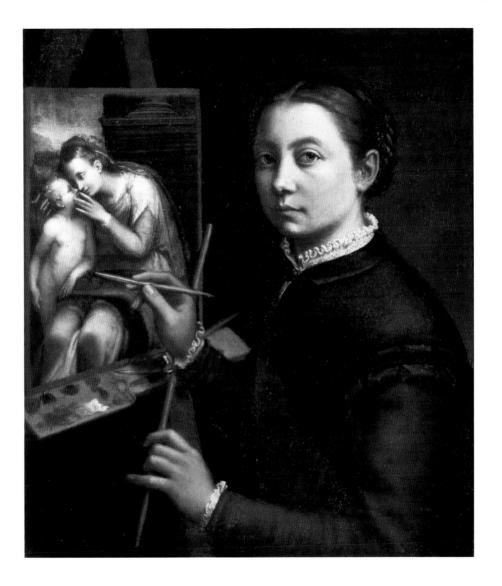

Tintoretto

The Concert of Muses

Courtesy of Private Collection/Christie's Images

Born Jacopo Robusti, he derived his nickname, meaning 'little dyer', from his father's trade. He was very briefly a pupil of Titian (who is said to have been jealous of the boy's talents) and though largely self-taught, was influenced by his master as well as Michelangelo and Sansovino. Apart from two trips to Mantua he spent his entire working life in Venice, painting religious subjects and contemporary portraits. His most ambitious project was the series of 50 paintings for the Church and School of San Rocco, but his fame rests on the spectacular *Paradise* (1588), a huge work crammed with figures. He was a master of dark tones illumined by adroit gleams of light. Three of his children became artists, including his daughter Marietta, known as La Tintoretta. His output was phenomenal and he painted with great rapidity and sureness of brushstrokes, earning him a second nickname of 'll Furioso'.

MOVEMENT

Venetion School

OTHER WORKS

The Annunciation; The Last Supper; The Nine Muses

INFLUENCES

Michelangelo, Titian, Sansovino

Tintoretto Born 1518 Venice, Italy

Painted in Venice and Mantua

Died 1594 Venice

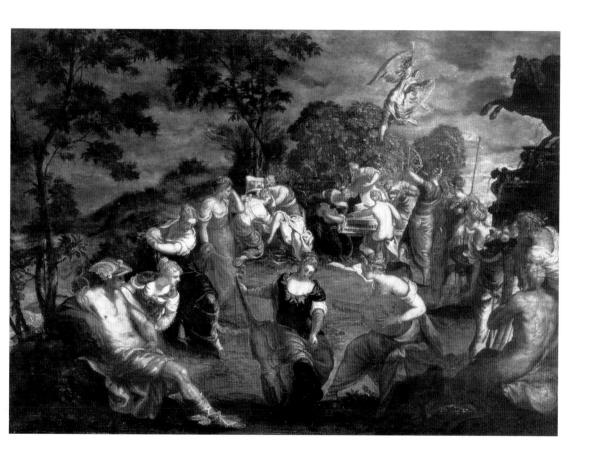

Veronese, Paolo

Christ and the Widow of Nain/Woman Taken in Adultery

Courtesy of Christie's Images

Paolo Caliari or Cagliari is invariably known by his birthplace. He was the son of a stone-cutter and originally trained as a stone-carver, but he showed more of an aptitude for painting and therefore switched to the profession of his uncle, Antonio Badile. According to Vasari he studied under Giovanni Caroto – though this left no mark on his style. He worked in Verona and Mantua before settling in Venice in 1555, where he ranked with Titian and Tintoretto in his range and technical virtuosity, reinforced by a visit to Rome in 1560. He was a skilful master of genre subjects, which he used to imbue his religious works with humanity, but as a result of his painting *The Feast in the House of Levi* (1573), he fell foul of the Inquisition on a charge of trivializing religious subjects. His undoubted masterpiece is the colossal *Marriage at Cana*, which has over 120 portraits, including royalty and celebrities of the period.

MOVEMENT

Venetian School

OTHER WORKS

The Adoration of the Magi; The Holy Family and St John

INFLUENCES

Domenico Brussasorci, Paolo Farinato

Paolo Veronese Born 1528 Verona, Italy

Painted in Verona, Mantua and Venice

Died 1588 Venice

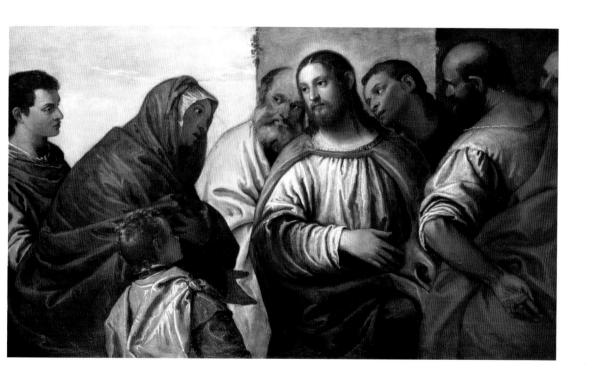

Brueghel, Pieter

Hunters in the Snow, 1565

Courtesy of Kunsthistoriches Museum, Vienna/Bridgeman Art Library/Christie's Images

Also known as Brueghel the Elder to distinguish him from his son Pieter and younger son Jan, Pieter Brueghel was probably born about 1520 in the village of the same name near Breda. He studied under Pieter Coecke van Aelst (1502–50) and was greatly influenced by Hieronymous Bosch, from whom he developed his own peculiar style of late-medieval Gothic fantasy. About 1550 he travelled in France and Italy before returning to Brussels, where his most important paintings were executed. He was nicknamed 'Peasant Brueghel' from his custom of disguising himself in order to mingle with the peasants and beggars who formed the subjects of his rural paintings. Although he was a master of genre subjects his reputation rests mainly on his large and complex works, involving fantastic scenery and elaborate architecture, imbued with atmosphere and a sensitivity seldom achieved earlier.

MOVEMENT

Flemish School

OTHER WORKS

Tower of Babel; Peasant Wedding

INFLUENCES

Pieter Coecke, Hieronymus Bosch

Pieter Brueghel Born c. 1520 Brögel, Holland

Painted in Breda and Brussels, Belgium

Died 1569 Brussels

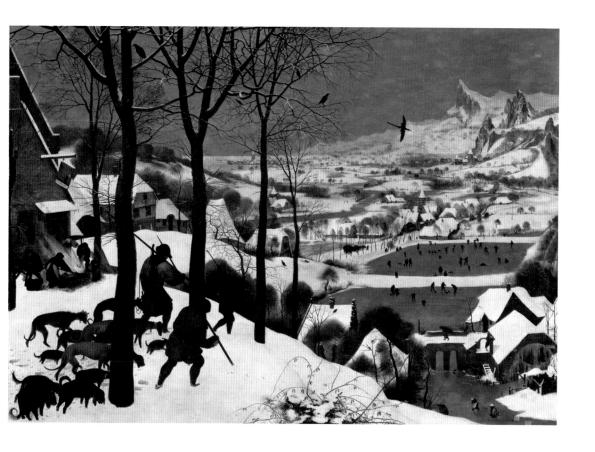

Arcimboldo, Giuseppe

Winter, 1573

Courtesy of Kunsthistoriches Museum, Vienna/Bridgeman Art Library

Giuseppe Arcimboldo began his artistic career by working on the stained-glass windows in the Duomo (Cathedral) in Milan. Later he moved to Prague which, under Charles V, became for a time the centre of the Holy Roman Empire. Here he was employed by the Habsburg rulers as an architect (of the civic waterworks among other public projects), impresario of state occasions, curator of the imperial art collection and interior designer. It was in Prague that he painted the works on which his reputation now rests. In his exploration of human portraits composed of non-human and inanimate objects he was far ahead of his time, anticipating the Surrealists by several centuries. His fantastic heads symbolizing the four seasons were made up of pieces of landscape, flowers, vegetables and animals, even pots and pans and other mundane articles from everyday life, all executed in brilliant colours with an extraordinary attention to detail.

MOVEMENT

Surrealism

OTHER WORKS

Summer

INFLUENCES

Medieval stained glass

Giuseppe Arcimboldo Born 1527 Milan, Italy

Painted in Milan and Prague

Died 1593 Milan

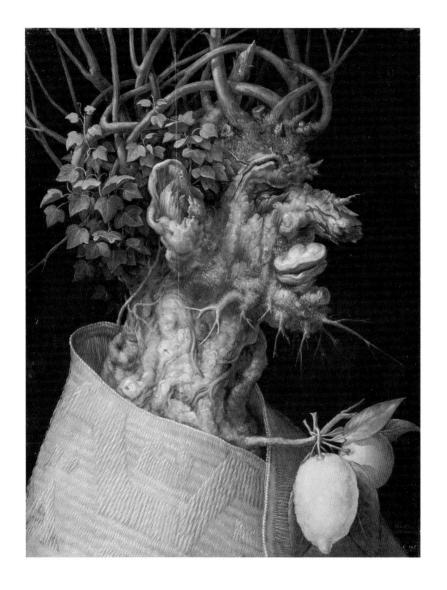

Basawan

Akbar Assisting in the Quarrel of the Ascetics, from the 'Akbarnama'

Courtesy of Victoria & Albert Museum, London/Bridgeman Art Library

Very little is known of this Hindu artist who flourished during the reign of Akbar the Great (1556–1605), but his name appears in the list of the top 17 painters in the Mughal Empire, compiled about 1590 by Abul Fazl, Akbar's chief minister, which presupposes that he was born around the middle of the century. Of the 17 artists, no fewer than 13 were Hindus and the others Muslims, revealing the grafting of Persian art onto the much older Indian stock. Akbar, raised a Muslim, took his role as Emperor of India very seriously and strove to unite his Hindu and Muslim subjects, art being one of the more obvious ways in which this was achieved. Basawan was the foremost of these painters, renowned for the utmost delicacy of his brushwork and the sumptuous quality of his colours. He contributed miniature paintings to virtually all of the collections commissioned by the Emperor, detailing the history and legends of both cultures in pictures full of action and crammed with detail.

MOVEMENT

Mughal or Indo-Persian School

OTHER WORKS

Razm Nama; Tuti Nama; Hamza Nama

INFLUENCES

Daswanth Kahar

Basawan Born c. 1550 Delhi, India

Painted in Delhi

Died c. 1610 Delhi

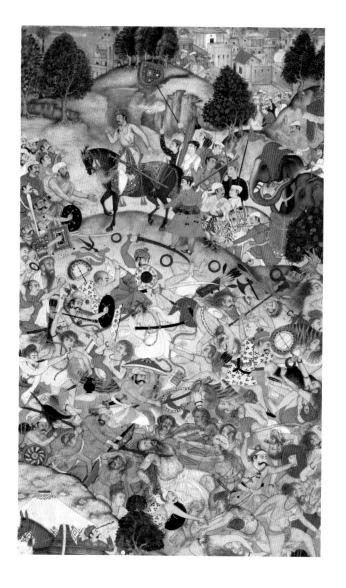

Caravaggio, Michelangelo Merisi da

The Young Bacchus, c. 1591-93

Courtesy of Galleria Degli Uffizi, Florence/Bridgeman Art Library/Christie's Images

Born Michelangelo Merisi in the village of Caravaggio, Italy, he studied in Milan and Venice before going to Rome to work under the patronage of Cardinal del Monte on altarpieces and religious paintings. His patron was startled not only by Caravaggio's scandalous behaviour but also by his rejection of the Roman ideals and techniques in painting. Instead, Caravaggio headed the *Naturalisti* (imitators of nature in the raw), developing a mastery of light and shade and concentrating on realism, regardless of theological correctness. As a result, some of his major commissions were rejected and in 1606, after he had killed a man in an argument, he fled from Rome to Naples and thence to Malta. On his return to Italy in 1609 he contracted a fever and died at Porto Ercole, Sicily. The years of exile produced one of his greatest portraits, the full-length *Grand Master of the Knights*.

MOVEMENT

Baroque

OTHER WORKS

Christ at Emmaus; The Card Players

INFLUENCES

Annibale Carracci

Caravaggio Born c. 1572 Caravaggio, Italy

Painted in Venice, Rome and Malta

Died 1610 Porto Ercole, Sicily

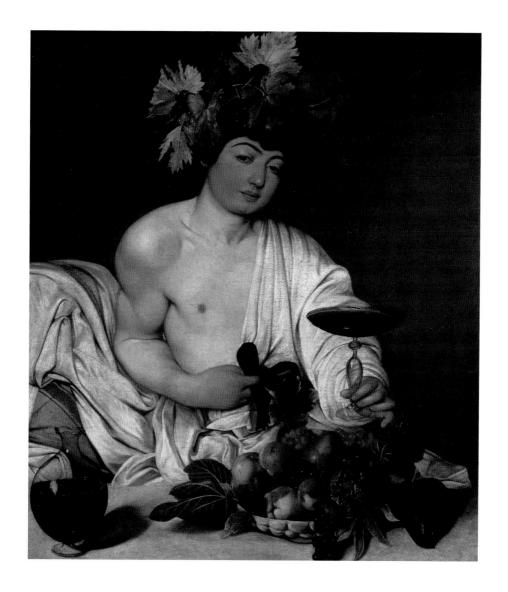

El Greco

Christ on the Cross, c. 1600-10

Courtesy of Private Collection/Christie's Images

This nickname, meaning 'the Greek' in Spanish, is the epithet by which Domenikos Theotokopoulos is better known. Born at Candia, Crete, which was then ruled by the Venetians, he worked as a painter of icons in the Byzantine tradition before moving to Italy, where he is believed to have become a pupil of Titian. He then settled at Toledo in Spain. His early portraits show the Venetian influence of his early training, but in Spain he evolved his own highly distinctive, mannered approach to portraiture, characterized by the elongation and distortion of the face and figure, combined with his penchant for sombre colours. These aspects are seen at their most dramatic and solemn in his large religious paintings, but they are also present to a lesser extent in his portraits of his contemporaries. Inevitably, his treatment of his sitters' portraits was considered controversial at the time. Many of his extant works are preserved in the Museo El Greco in Toledo where he spent the last 44 years of his life.

MOVEMENT

Spanish School

OTHER WORKS

Disrobing of Christ; Burial of Count Orgaz

INFLUENCES

Tition, Tintoretto

El Greco Born 1541 Candia, Crete

Painted in Toledo, Spain

Died 1614 Toledo

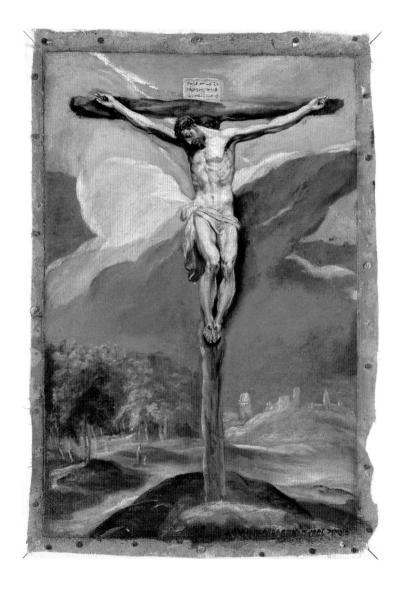

118

17th Century

The Baroque & Rococo Era

Carracci, Annibale

The Veil of Saint Veronica

Courtesy of Private Collection/Christie's Images

The greatest of a talented family which included his brother Agostino and his cousin Ludovico, Annibale Carracci was self-taught to some extent, although he was influenced by Correggio and Raphael. The three Carraccis founded an academy of painting in Bologna in 1585 and exerted a tremendous influence on Baroque artists of the next generation. In 1595 Annibale went to Rome, where he was employed by Cardinal Farnese in the decoration of his palace with a series of great frescoes whose motifs were mainly derived from classical mythology – an achievement which is surpassed only by Michelangelo's work in the Sistine Chapel. Carracci also produced numerous paintings of religious subjects, often placing the Madonna and saints in somewhat idealized classical landscapes. He thus combined the traditions of classicism with the advances in naturalism in the late sixteenth century.

MOVEMENT

Neoclassical

OTHER WORKS

The Assumption of the Virgin; The Virgin Mourning Christ

INFLUENCES

Correggio, Raphael, Titian

Annibale Carracci Born 1560 Bologna, Italy

Painted in Bologna and Rome

Died 1609 Rome

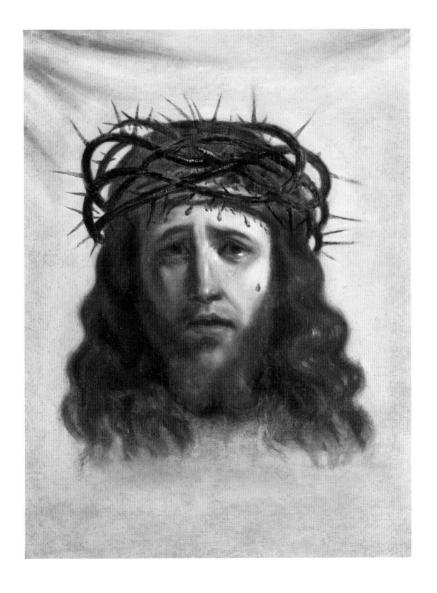

Reni, Guido

Saint John the Baptist

Courtesy of Private Collection/Christie's Images

Guido Reni studied at the Carracci Academy in his native city of Bologna and acquired a mostery of drawing from life. In 1600 he went to Rome, where he studied the works of Raphael, but he was also strongly influenced by the paintings of other masters working on classical and mythological themes. Reni later painted frescoes, of which his *Aurora and the Hours* (1613–14) for the Borghese family is regarded as his masterpiece. After Carracci's death Reni became the most fashionable painter in Bologna and operated a large studio with numerous assistants. The pious sentimentality of his great religious canvasses had an enormous impact on later generations, although he went on to eclipse in the nineteenth century and has been restored to favour in more recent times, his technical mastery of lighting and composition being appreciated once more.

MOVEMENT

Bolognese School

OTHER WORKS

Massacre of the Innocents; Saint Jerome and the Angel; The Nativity

INFLUENCES

Raphael, Annibale Carracci

Guido Reni Born 1575 Bologna, Italy

Painted in Bologna

Died 1642 Bologna

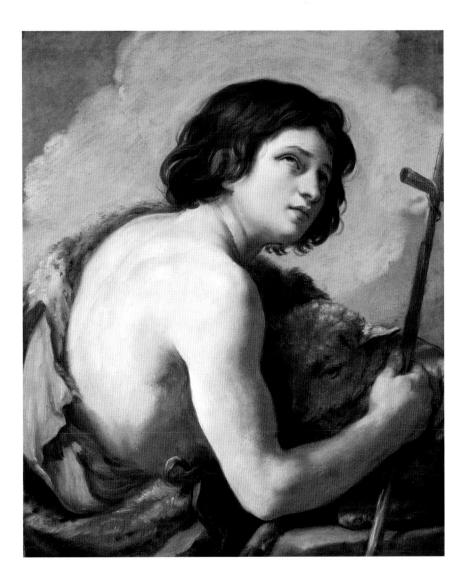

Rubens, Peter Paul

(attributed to) Two Saints

Courtesy of Private Collection/Christie's Images

Born at Siegen, Westphalia, now part of Germany, Peter Paul Rubens was brought up in Antwerp in the Spanish Netherlands. Originally intended for the law, he studied painting under Tobias Verhaecht, Adam Van Noort and Otto Vaenius and was admitted into the Antwerp painters' guild in 1598. From 1600 to 1608 he was court painter to Vincenzo Gonzaga, Duke of Mantua, and travelled all over Italy and Spain, furthering his studies and also executing paintings for various churches. Shortly after his return to Antwerp he was appointed court painter to Archduke Albrecht of the Netherlands. In the last years of his life he combined painting with diplomatic missions which took him to France, Spain and England and resulted in many fine portraits, as well as his larger religious pieces. He was knighted by both Charles I and Philip IV of Spain. In 1630 he retired from the court to Steen and devoted the last years of his life to landscape painting.

MOVEMENT

Flemish School

OTHER WORKS

Samson and Delilah: The Descent from the Cross; Peace and War

INFLUENCES

Tobias Verhaecht, Adam Van Noort

Peter Paul Rubens Born 1577 Siegen, Germany

Painted in Antwerp, Rome, Madrid, Paris and London

Died | 640 Antwerp, Belgium

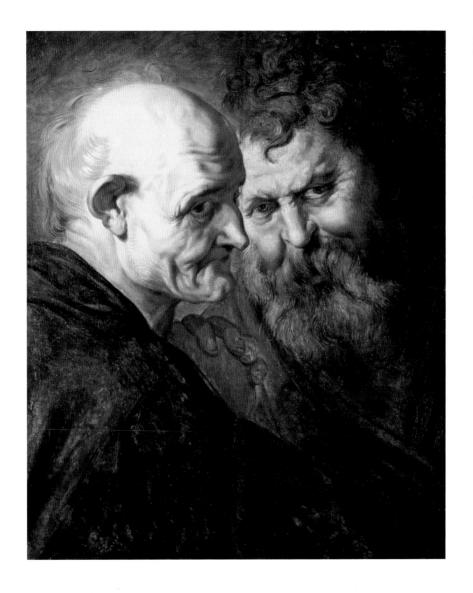

Hasan, Abul

Squirrels on a Plane Tree, c. 1610

Courtesy of British Library, UK/Bridgeman Art Library

Very little is known about the life of Abul Hasan, other than that he was one of the leading Muslim painters at the court of the Mughal emperors and was particularly esteemed by the Emperor Jahangir (1605–27), who conferred on him the special title of Nadir-uz-zaman. He appears to have been born about 1570 and came to prominence in the last years of the Emperor Akbar, but continued to paint in the reign of Shah Jahan (1627–58). He painted portraits of the emperors, courtiers and officials, as well as genre subjects and charming little studies of birds and animals. His technique matured from 1610 onwards and he was undoubtedly responsible for raising the standards of Indo-Persian painting to new levels. The old aggressive colouring was toned down and a general refinement of style and execution was cultivated. In the portraits of men and animals a little shading was introduced by a few delicate strokes, just enough to suggest solidity and roundness, in marked contrast to the flat, two-dimensional profile painting of the previous generation.

MOVEMENT

Indo-Persian School

OTHER WORKS

Elephant in a Palace Courtyard

INFLUENCES

Daswanth, Basawan

Abul Hasan Born c. 1570 India

Painted in India

Died c. 1640 Delhi, India

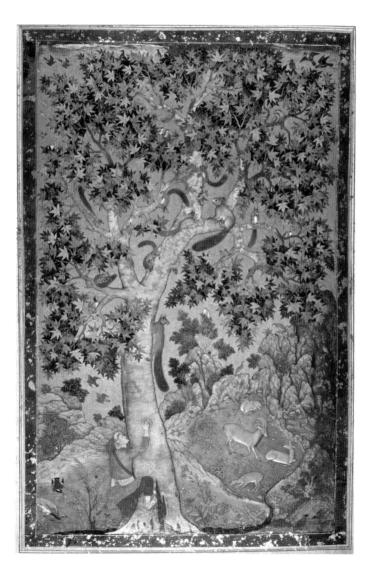

Sotatsu, Tawaraya

Herons and Grasses

Courtesy of British Library. London, UK/Bridgeman Art Library

Tawaraya Sotatsu operated a print shop in Kyoto that specialized in painted fans, but in 1621 he was commissioned to paint a set of sliding screens depicting pine trees and this appears to have been a major turning point in his career. Later he was closely associated with Ogata Korin in the Rinpa School, but as a result his own contribution to the development of Japanese art in the early seventeenth century was largely overlooked until relatively recently. A pair of two-fold screens depicting the gods of thunder and wind, however, reveals quite a radical departure from the style of the Momoyama painters, much bolder and ascetic, with greater emphasis on asymmetry and overall simplicity, coupled with greater use of colour. Rejecting the styles imported from China, he went back to earlier Japanese traditions both in subject matter and treatment. He also collaborated with Honami Koetsu in founding Takagamine, an artists' colony which reinvigorated Japanese art.

MOVEMENT

Rinpa School, Japan

OTHER WORKS

Deer Scroll; Zen Priest Choka; The Tale of Genji

INFLUENCES

Ogata Korin, Honami Koetsu

Tawaraya Sotatsu Born 1576 Kyoto, Japan

Painted in Kyoto

Died 1643 Kyoto

Gentileschi, Artemisia

Judith Slaying Holofernes, c. 1612-21

Courtesy of Galleria Degli Uffizi, Florence, Italy/Bridgeman Art Library

Regarded by many as the finest of all female artists, Artemisia was born in Rome, where she was trained by her father, Orazio. Both artists were heavily influenced by Caravaggio, sharing his fondness for unflinching realism and dramatic lighting effects. During her lifetime, Gentileschi was best known as a portraitist, but she has since become more famous for her powerful religious scenes. In these, she tended to focus on biblical women such as Susanna, Bathsheba and Esther, but her favourite subject was Judith, the Jewish heroine who saved her people by killing an enemy general. Gentileschi produced at least six versions of this story and, although the theme was popular with other female artists of the time, hers are undoubtedly the goriest. This has often been ascribed to a trauma in her own life for, at the age of 19, she claimed that she was raped by an artist from her father's workshop. A five-month trial ensued, during which Gentileschi was tortured with thumbscrews in order to 'verify' her evidence.

During her career, Artemisia worked in Florence, Naples, Venice, and also spent some time in London helping her father complete a commission for Charles I.

MOVEMENTS

Baroque, Caravaggism

OTHER WORKS

Susanna and the Elders; Self-Portrait as the Allegory of Painting

INFLUENCES

Caravaggio, Orazio Gentileschi, the Carracci Academy

Artemisia Gentileschi Born 1593 Rome, Italy

Painted in Italy and England

Died c. 1652

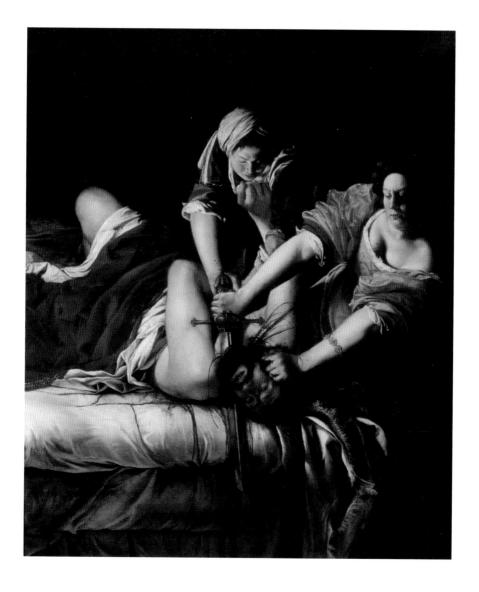

Ribera, Jusepe

Saint Peter in Penitence

Courtesy of Private Collection/Christie's Images

Jusepe Ribera, nicknamed Lo Spagnoletto ('the little Spaniard'), studied under Francisco Ribalta in Valencia and then went to Rome to study the frescoes of Raphael, and to Parma to learn from Correggio's works. He settled at Naples, where his paintings caught the eye of the Spanish viceroy. As a result his career was assured and he became a prolific painter of intensely realistic religious and genre subjects. He delighted in the gory details of the martyrdom of the saints, thus provoking Lord Byron in *Don Juan* to quip that 'Spagnoletto tainted his brush with all the blood of all the sainted'. He was also fascinated with the bizarre or grotesque in contemporary life; but by the 1630s his work assumed a more reflective, tranquil approach. Nevertheless it was the fervent spirituality of his earlier paintings that appealed to his predominantly Spanish clientele.

MOVEMENT

Spanish and Neapolitan Schools

OTHER WORKS

Saint Paul the Hermit; Portrait of a Bearded Woman

INFLUENCES

Raphael, Correggio

Jusepe Ribera Born 1591 Jeatiba, Spain

Painted in Naples, Italy

Died 1652 Naples

Honthorst, Gerrit van

An Arcadian Double Portrait of Two Ladies as Shepherdesses

Courtesy of Christie's Images / Bridgeman Art Library

Gerard or Gerrit van Honthorst studied under Bloemart in Utrecht, then went to Italy where he studied the naturalism of Caravaggio. Returning to Holland in 1620 he entered the Guild of St. Luke, of which he became Dean. Queen Elizabeth of Bohemia, then in exile in Holland, employed him to teach her children drawing and, through her, Honthorst was introduced to her brother Charles I. During two periods in England he painted the royal family and members of the royal court in the style of Van Dyck, as well as a huge allegory of Diana, Apollo and Mercury with the Bohemian rulers and the Duke of Buckingham, now at Hampton Court. At Utrecht in 1631 he completed a large work of the Bohemian royal family. At the other end of the spectrum he also painted genre scenes of candlelit taverns and their customers in the style of Caravaggio which were renowned for their realism.

MOVEMENT

Dutch School

OTHER WORKS

Christ Before Pilate; Charles I and Queen Henrietta Maria

INFLUENCES

Caravaggio, Van Dyck

Gerrit van Honthorst Born 1590 Utrecht, Holland

Painted in Holland, Italy and England

Died 1656 Utrecht

Terbrugghen, Hendrick

A Lute Player, 1626

Courtesy of Private Collection/Christie's Images

Hendrick Terbrugghen studied in Utrecht and in around 1612 went to Italy, where he was influenced by the paintings of Caravaggio and Lorenzo Lotto. Returning to the Netherlands in 1615 he settled in Utrecht, where he built up a reputation for his religious and genre paintings. He and Gerrit van Honthorst were mainly responsible for importing to the Netherlands the techniques of chiaroscuro and the dramatic use of light and shade which they had seen in Rome. Terbrugghen made a thorough study of anatomy, which he put to good advantage in his paintings and this, with his attention to detail in such matters as clothing and drapery, brought a new realism to Dutch painting. Dutch paintings in the early seventeenth century tended to have some underlying allegorical concept and it may be that *The Flute Player*, Terbrugghen's most famous work, executed towards the end of his career, was meant to symbolise music.

MOVEMENT

Utrecht School

OTHER WORKS

Jacob and Laban

INFLUENCES

Lorenzo Lotto, Caravaggio

Hendrick Terbrugghen Born c. 1588 Holland

Painted in Utrecht, Holland

Died 1629 Utrecht

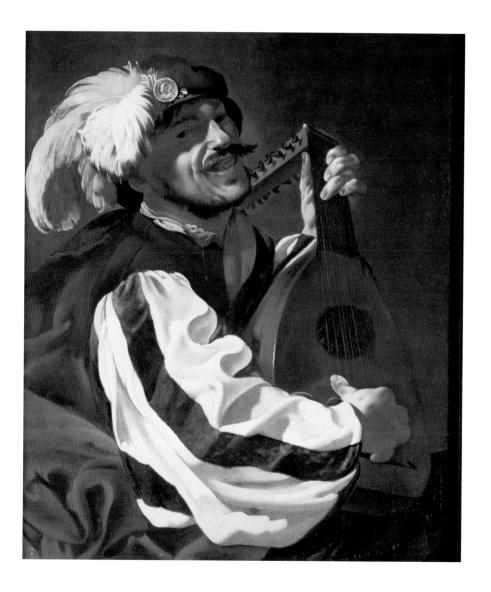

Poussin, Nicolas

The Triumph of David, c. 1631-3

Courtesy of Dulwich Picture Gallery, London, UK/Bridgeman Art Library

One of the leading exponents of Baroque painting, Nicolas Poussin settled in Paris in 1612. Ignoring the Mannerist painting then fashionable, he took Raphael as his model and studied the great Classical works of the Italian Renaissance. He left Paris in 1623 and began travelling in Italy, studying the works of the Italian masters at first hand. He settled in Rome the following year. Apart from a brief sojourn in Paris (1640–42) he spent the rest of his life in Rome, executing commissions for Cardinal Barberini. Eschewing the increasingly popular Baroque style, he clung to the Classical style and became its greatest French exponent. He drew upon the rich store of Greek and Roman mythology for his subjects, while utilizing the techniques of colour developed by Titian. His greatest canvasses deal with vast subjects, crowd scenes crammed with action and detail. Later on he tended to concentrate more on landscapes, although still steeped in the Classical tradition.

MOVEMENT

Classicism

OTHER WORKS

The Rape of the Sabines; The Worship of the Golden Calf

INFLUENCES

Raphael, Bernini

Nicolas Poussin Born 1594 Les Andelys, France

Painted in Paris and Rome

Died 1665 Rome

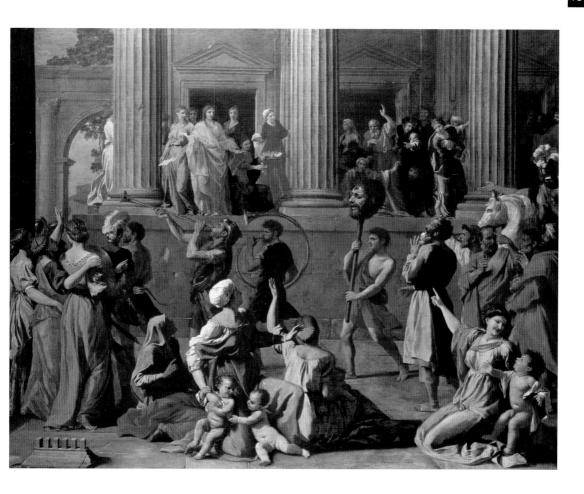

Guercino, Il

Saint Luke

Courtesy of Private Collection/Christie's Images

Born Giovanni Francesco Barbieri, he is invariably known by his nickname, which means 'squint-eyed', but in spite of this handicap he showed early promise for sketching and drawing. He was trained in the rigorous classical mode at the Carracci Academy but was later influenced by the realism of Caravaggio, whose lighting techniques he modified by the richness of his colours. Like most artists of his generation he specialized in religious works – his major project being the fresco of *Aurora* which decorated the ceiling at the Villa Ludovisi, commissioned by Pope Gregory XV. From 1642 onwards he was the leading painter in Bologna, where he died. His oil paintings matched the rich density of their colours with the knack of conveying a wide range of emotions which heighten the dramatic impact of his work. There is invariably a dominant central figure, set against a background in the best Baroque tradition.

MOVEMENT

School of Bologna

OTHER WORKS

Jacob Receiving Joseph's Coat

INFLUENCES

Caravaggio

Il Guercino Born 1602 Cento, Italy

Painted in Rome and Bologna

Died 1666 Bologna

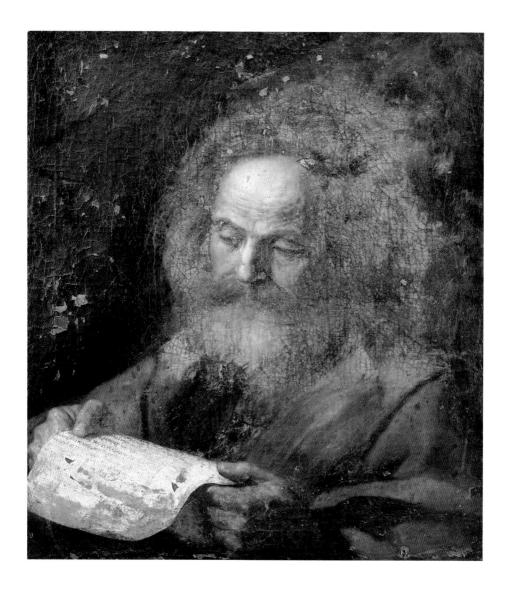

Van Dyck, Sir Anthony

(circle of) Self Portrait with a Sunflower, after 1632

Courtesy of Private Collection/Philip Mould, Historical Portraits Ltd, London, UK/Bridgeman Art Library

Anthony Van Dyck worked under Rubens and later travelled all over Italy, where he painted portraits and religious subjects. He first visited England in 1620 and was invited back in 1632 by King Charles I, who knighted him and appointed him Painter-in-Ordinary. Apart from a two-year period (1634–35) when he was back in Antwerp, Van Dyck spent the rest of his life in England and on his return to London he embarked on the most prolific phase of his career. He not only painted numerous portraits of King Charles, Queen Henrietta Maria and their children, but also many pictures of courtiers and other notable figures, creating a veritable portrait gallery of the great and good of the period. His immense popularity was due not only to his technical mastery, but also his ability to give his sitters an expressiveness, grace and elegance, which few other artists have ever equalled.

MOVEMENT

Flemish School

OTHER WORKS

Charles I in Hunting Dress; The Three Royal Children

INFLUENCES

Peter Paul Rubens

Sir Anthony Van Dyck Born 1599 Belgium

Painted in Antwerp and London

Died 1641 London

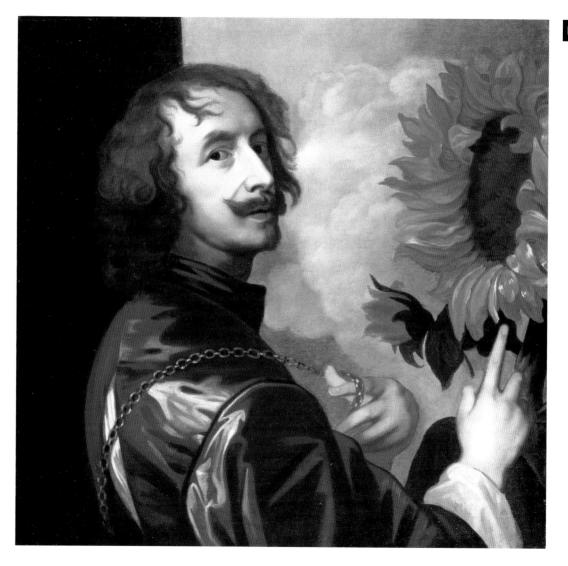

Jordaens, Jakob

The Four Doctors of the Church

Courtesy of Private Collection/Christie's Images

Born at Antwerp in the Spanish Netherlands (now Belgium), Jakob Jordaens studied under Adam Van Noort, whose daughter he married in 1616. Unlike his fellow pupil Rubens, he did not go to Italy to further his studies but remained in Antwerp, where he continued to paint in the purely Flemish convention of exaggerated form and rather earthy humour, characterized by warm, glowing colour and the ruddy faces of the subjects. Although a Protestant by religion he gladly accepted commissions from the King of Spain for religious paintings and altarpieces for Catholic churches. Later he produced large canvasses of historic scenes and in 1652 painted the heroic frescoes for the Huis ten Bosch near The Hague. After the death of Rubens in 1640 he was regarded as the greatest artist in Flanders. He also produced designs for tapestries and engravings.

MOVEMENT

Flemish School

OTHER WORKS

The Four Evangelists; The Victory of Time

INFLUENCES

Adam Van Noort, Rubens

Jakob Jordaens Born 1593 Antwerp, Belgium

Painted in Antwerp

Died 1678 Antwerp

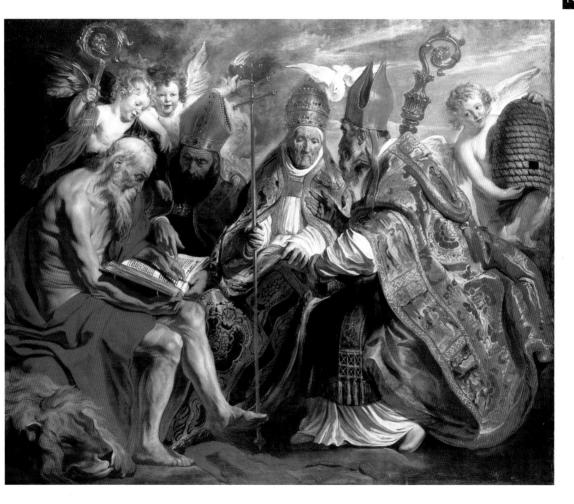

Van Goyen, Jan

River Landscape with Lime Kilns, 1640s

Courtesy of Private Collection/Christie's Images

Jan van Goyen visited France in his youth and may have been influenced by the painters in that country, but he also travelled all over Holland and imbibed the ideas of his older contemporaries. With Salomon van Ruysdael he helped to establish the Dutch School of landscape painters and he had numerous pupils and imitators. In his travels he made countless sketches and drawings that formed the basis of his later oil paintings. He was a prolific artist but a poor businessman and died in debt. His landscapes divide into two periods, those dating from 1630 onwards being in more muted colours, predominantly shades of brown, but much more atmospheric. Towards the end of his life he began using a much greater range of colours again, coupled with that poetic sensibility which was the hallmark of the next generation of Dutch artists.

MOVEMENT

Dutch School

OTHER WORKS

A Castle by a River with Shipping at a Quay

INFLUENCES

Esaias van de Velde, Jan Porcellis

Jan van Goyen Born 1596 Leyden, Holland

Painted in Leyden and The Hague

Died 1656 The Hague

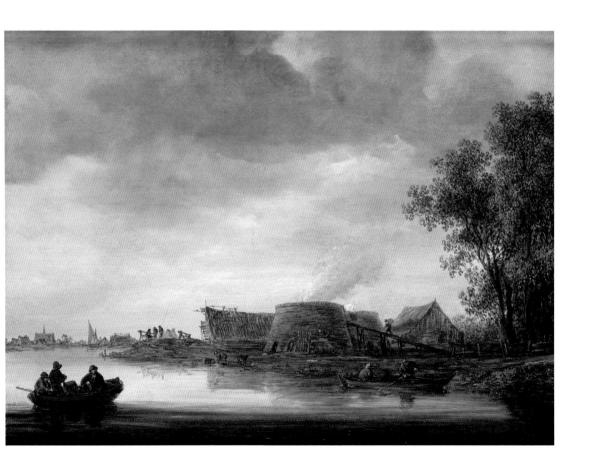

Claesz, Pieter

A Vanitas Still Life, 1645

Courtesy of Johnny van Haeften Gallery, London, UK/Bridgeman Art Library

Born at Haarlem in the Netherlands in 1597 or 1598, Pieter Claesz grew up in a town which was the centre of the Dutch flower trade, so it was not surprising that he developed an early interest in floral painting. He grew up at a time when this style was being introduced to Holland by Flemish refugees, notably Ambrosius Bosschaert the Elder and Balthasar van der Alst. Claesz went on to develop the type of still life known as the breakfast or banquet picture – much less ebullient than the colourful flower paintings with more somber tones suited to the intimate atmosphere of domestic interiors. Claesz in fact took this further than his contemporaries, creating an almost monochrome effect and relying on the precise juxtaposition of each object which then took on a symbolic meaning. He pioneered a style that was emulated by many Dutch artists of the succeeding generation.

MOVEMENT

Dutch School

OTHER WORKS

Still Life with a Condle

INFLUENCES

Ambrosius Bosschaert, Balthasar van der Alst, Caravaggio

Pieter Claesz Born c. 1597 Haarlem, Holland

Pointed in Hoorlem

Died 1660 Haarlem

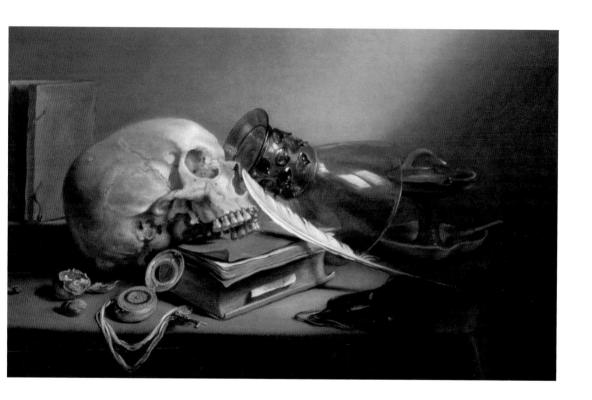

Bol, Ferdinand

A Philosopher in his Study

Courtesy of Private Collection/Christie's Images

Ferdinand Bol was the son of a master surgeon and was originally intended to follow in his footsteps. He learned the rudiments of painting from Jacob Cuyp (father of Albert Cuyp) in Utrecht and also studied for a time under Rembrandt in Amsterdam in the late 1630s. Bol established his own studio in Amsterdam by 1642 and soon built up a reputation for his portraits and large groups as well as allegorical, religious and classical works. He was Rembrandt's most talented pupil and painted in a style so close to that of his master that some of his paintings have been wrongly attributed to Rembrandt. As well as executing paintings for wealthy patrons he received a number of major civic commissions, including the decorations for the town hall, leper asylum and admiralty building. Bol was a prominent member of the Guild of St Luke, and became its governor in 1665. He appears to have painted nothing after 1669 when he married a wealthy widow and thereafter devoted himself to business and civic affairs.

MOVEMENT

Dutch School

OTHER WORKS

Vertumnus; Pyrrhus and Fabricius; Bacchus and Ariadne,

INFLUENCES

Jacob Cuyp, Rembrandt

Ferdinand Bol Born 1616 Dordrecht, Holland

Painted in Dordrecht, Utrecht and Amsterdam

Died 1680 Amsterdam

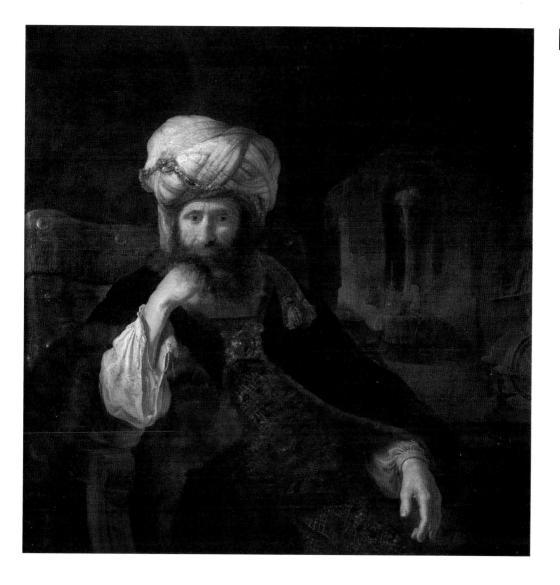

Tour, Georges De La

The Newborn Child, late 1640s

Courtesy of Musee des Beaux-Arts, Rennes, France/Bridgeman Art Library

Born at Vic-sur-Seille, France, in 1593, Georges de la Tour established himself at Luneville about 1620, where he received many important commissions from the Duke of Lorraine. He also presented one of his paintings to King Louis XIII, who was so enchanted by it that he decided to remove paintings by all other artists from his private apartments. De la Tour concentrated on religious subjects, many of which were rather sombre with large areas of dark shadows and muted colours subtly illumined by a candle to create dark, dramatic and essentially realistic scenes. In this regard he was heavily influenced by Caravaggio and was, indeed, the leading French exponent of his particular brand of naturalism, although eschewing Caravaggio's penchant for the macabre. De la Tour's paintings exude serenity in keeping with their subject matter. Like his paintings, however, he languished in obscurity for many years and was not rediscovered until 1915.

MOVEMENT

French School

OTHER WORKS

St Peter Denying Christ

INFLUENCES

Caravaggio

Georges de la Tour Born 1593 France

Painted in Luneville and Paris

Died 1652 Paris

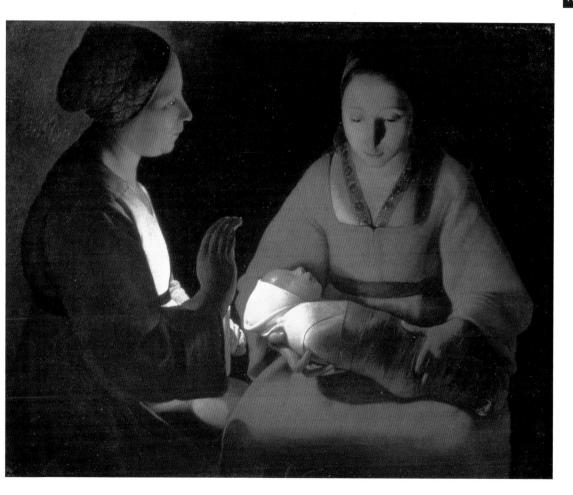

Leyster, Judith

Laughing Children with Cat, 1649

Courtesy Private Collection/Christie's Images

Judith Leyster was a child prodigy, but nothing is known about her formal art training, although after her family moved to Utrecht in 1628 she came under the influence of Terbrugghen and Honthorst. On her return to Haarlem the following year she studied under Frans Hals. She became a member of the Guild of St Luke in 1633 and by 1635 had several pupils of her own. In 1636 she married fellow artist Jan Miense Molenaer and they moved to Amsterdam. She specialized in genre subjects noted for the spontaneity of expression and her realism, heightened by her skilful control of light, tone and texture. These paintings ranged from little moments of domestic drama to exuberant scenes of revelry which have an underlying humour that sometimes bordered on the risqué. In addition she painted a few half-length portraits.

MOVEMENT

Dutch School

OTHER WORKS

Self Portrait; The Flute Player; The Gay Cavaliers

INFLUENCES

Hendrick Terbrugghen, Gerrit van Honthorst

Judith Leyster Born 1609 Haarlem, Holland

Painted in Haarlem, Utrecht and Amsterdam

Died 1660 Amsterdam, Holland

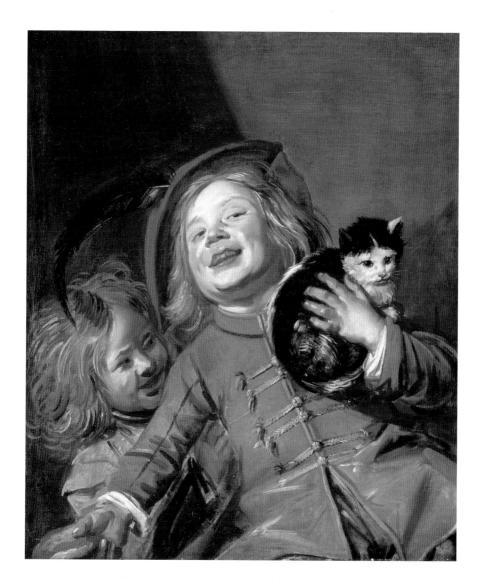

Fabritius, Carel

An Artist in his Studio

Courtesy of Private Collection/Bridgeman Art Library

Carel Fabritius studied under Rembrandt in Amsterdam before settling in Delft in around 1650. His life was tragically cut short when he was killed in the great explosion which destroyed the arsenal and much of the town of Delft in 1654. The influence of his master is very evident in his paintings, although Fabritius developed the technique of lighting the subjects in order to convey an almost three-dimensional quality. His mature work was also characterized by sensitive brushwork and great care in composition. Though arguably the most talented of Rembrandt's pupils in portraiture, Fabritius also excelled in interiors and landscapes, noted for their careful proportions and perspectives.

MOVEMENT

Dutch Schoo

OTHER WORKS

View of Delft with a Music Instrument Seller's Stall

INFLUENCES

Rembrandt

Carel Fabritius Born 1622 Amsterdam, Holland

Painted in Amsterdam and Delft

Died 1654 Delft

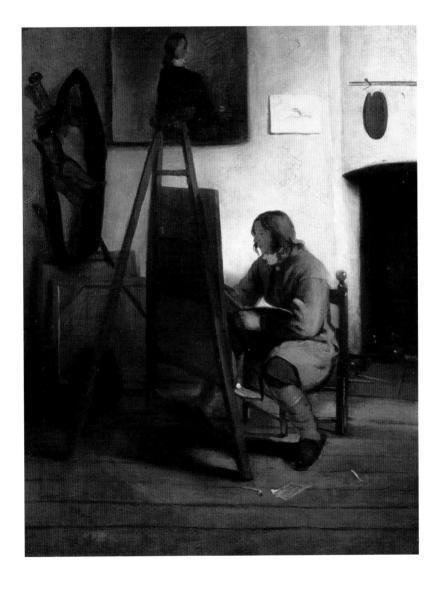

Hals, Frans

Portrait of a Gentleman, c. 1650-52

Courtesy of Private Collection/Christie's Images

Born at Antwerp about 1580, Frans Hals moved with his family to Haarlem at an early age and spent the whole of his life there. It is believed that he received his earliest instruction from Adam Van Noort in Antwerp but continued his studies under Van Mander. None of his earliest works appears to have survived, but from 1618 onwards, when he painted *Two Boys Playing* and *Arquebusiers of St George*, his works show great technical mastery allied to that spirit and passion which made him the equal of Rembrandt in portraiture. His most famous work, *The Laughing Cavalier* is universally recognized, but it is only one of many expressive portraits, distinguished by a liveliness that was far ahead of its time and anticipating the work of the Impressionists. After 1640 his work mellowed and he adopted a darker and more contemplative style.

MOVEMENT

Dutch School

OTHER WORKS

Man with a Cane; Regents of the Company of St Elisabeth

INFLUENCES

Van Noort, Van Mander

Frans Hals Born c. 1580 Antwerp, Holland

Painted in Antwerp and Haarlem

Died | 666 Haarlem

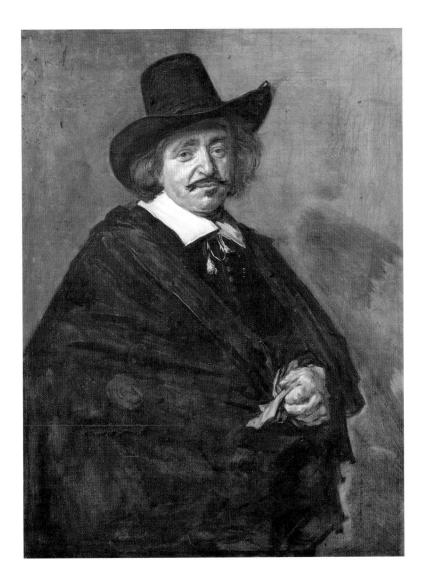

Lely, Sir Peter

Portrait of Hon. Mary Wharton

Courtesy of Private Collection/Christie's Images

Born Pieter van der Faes at Soest, Holland, he studied under Pieter de Gebber at Haarlem before settling in London in 1641, where he anglicized his name and adopted his father's nickname Lely as a surname. He rapidly became one of the most fashionable artists of the mid seventeenth century and managed to steer clear of politics, being patronized by both Charles I and subsequently Oliver Cromwell. In this early period he concentrated mainly on landscapes or historical and religious subjects, although a hint of things to come was given by his sensitive studies of the royal family during their imprisonment at Hampton Court. Following the restoration of the monarchy in 1660 he was appointed court painter by Charles II in 1661 and changed his style of painting. Thereafter portraiture became the dominant theme, evinced in the magnificent series of *Windsor Beauties* now at Hampton Court and the 13 portraits of British admirals at Greenwich. Lely was knighted in 1679.

MOVEMENT

English School

OTHER WORKS

Two Ladies of the Lake Family; Flagmen; Susannah and the Elders

INFLUENCES

Pieter de Gebber, Van Dyck

Sir Peter Lely Born 1618 Soest, Holland

Painted in London, England

Died 1680 London

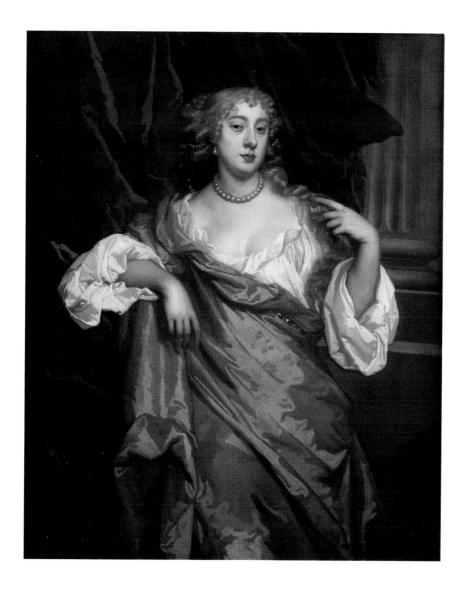

Velázquez, Diego

Portrait of Juan de Pareja, 1650

Courtesy of Christie's Images

Diego Rodriguez de Silva y Velázquez was the son of a prominent lawyer and studied languages and philosophy with the intention of following his father, but his aptitude for drawing induced him to become the pupil of Herera and then Pacheco, whose daughter he married in 1618. His earliest works were domestic genre subjects but after he moved to Madrid in 1623, and especially as a result of a visit to Italy (1629–31), he adopted a much more colourful approach. As the leading court painter of his day he produced numerous portraits of the Spanish royal family and nobility as well as scenes derived from classical mythology. Considering that he is now regarded as one of the greatest painters of all time, it is surprising that his work was little known outside Spain until the early nineteenth century, but his mastery of light and atmosphere had enormous impact on the Impressionists.

MOVEMENT

Spanish School

OTHER WORKS

The Tapestry Weavers; Venus and Cupid

INFLUENCES

Francisco Pacheco

Diego Velázquez Born 1599 Seville, Spain

Painted in Seville and Madrid

Died 1660 Modrid

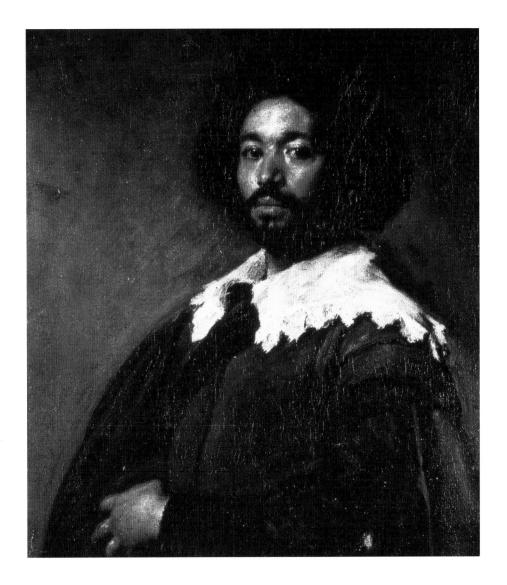

Shouping, Yun

Lotus Flower

Courtesy of Osaka Museum of Fine Arts, Japan/Bridgeman Art Library

A notable poet and calligrapher, Yun Shouping was second only to Wu Li among the Chinese painters who were neither orthodox nor individualist, and therefore he does not fit into any exact category. He has often been dismissed merely as a flower painter, but this does not do justice to his art as a landscape painter. Of course, more than any other artist of his period, he loved to decorate his pictures with masses of flowers, but this does not detract from the fact that his landscapes themselves are among the most serenely beautiful and perfect productions among the later Chinese artists. In his studies of flowers and plants as such, however, he was unsurpassed for the delicacy and clarity of his draughtsmanship and the care he took with his compositions. He preferred a very wet brush so that the ink flowed freely, producing a very sharp, clean-cut line. His landscape paintings are very similar to those of the four Wangs and Wu Li, but it is in his use of floral ornament that he stands out from his contemporaries.

MOVEMENT

Early Ming Period

OTHER WORKS

Bamboo and Old Tree: Peonies: Plum Blossoms

INFLUENCES

Wang Yuanqi, Wang Hui, Wu Li

Yun Shouping Born 1633 Wujin, Jiangsu, China

Painted in Changzhou, China

Died 1690 Changzhou

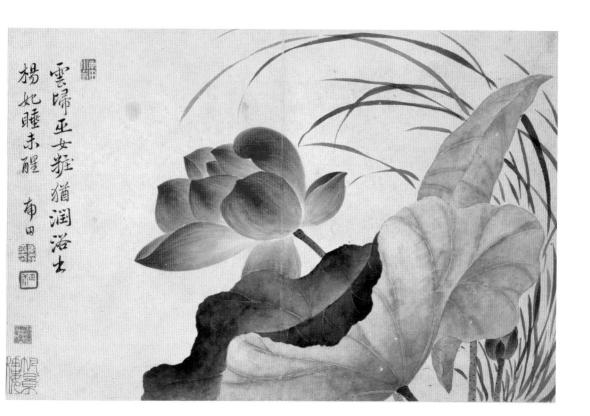

Luc, Frère

Saint Bonaventure, c. 1655

Courtesy of National Gallery of Canada, Ottawa

Born Claude François, Luc trained under Simon Vouet between 1627 and 1634, when he went to Rome to study the great masters. He returned to Paris in 1639, working on the decoration of the Louvre. In 1641 he joined the Franciscan Order, taking the name of Frère Luc and thereafter most of his paintings were devoted to the life and works of St Francis of Assisi, which he executed for various monasteries. In 1670 he went to Quebec, mainly as the architect in charge of the rebuilding of the monastery there. At the end of 1671 he returned to Paris and resumed his work as a painter of religious works. He is now chiefly of interest for the work he produced whilst in Quebec. These paintings influenced later generations of French-Canadian artists.

MOVEMENT

French-Canadian School

OTHER WORKS

Assumption; Guardian Angel

INFLUENCES

Raphael, Guido Reni, Girolamo Muziano

Frère Luc Born 1614 Amiens, France

Painted in France, Italy and Canada

Died 1685 Paris, France

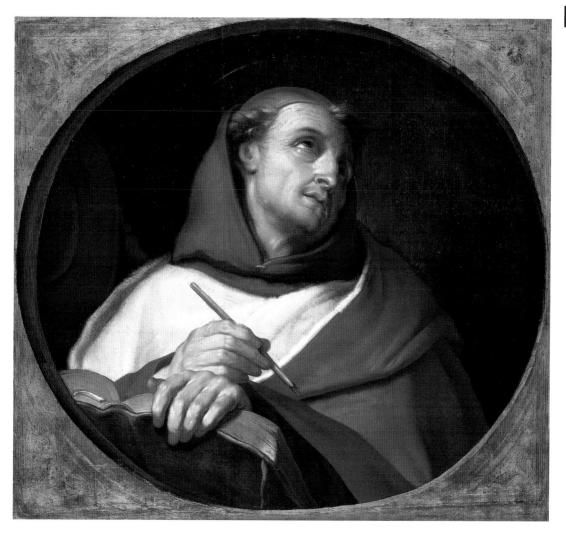

Xian, Gong

Fantastic Mountains, 1655

Courtesy of Private Collection/Christie's Images

Born in China about 1619, Gong Xian is ranked among the greatest of the Individualists working in the Qing period. Although his was the most limited style, it was also the most forceful and dramatic in impact. His paintings have been described as gloomy, funereal and full of foreboding, peopled by ghosts and wraiths; or alternatively as the expression of a monumental genius of somber and passionate temperament. His preferred medium was the hanging scroll, painted in the richest, deepest, most sumptuous shades of black to be found in any Chinese painting, shading subtly in tones of grey, and contrasting with the sunless whites of clouds and mists. He painted empty landscapes; no figures either human or animal disturb the scene. In his experiments with light and shade he went far beyond any of his contemporaries, far less his predecessors and it has been suggested that this reveals the influence of Western artists whose work was beginning to enter China in his lifetime.

MOVEMENTS

Individualist School, Qing Dynasty

OTHER WORKS

A Thousand Peaks and Myriad Ravines

INFLUENCES

Yuan Ji, Zhu Da, Kun-Can

Gong Xian Born c. 1619 China

Painted in China

Died 1689 China

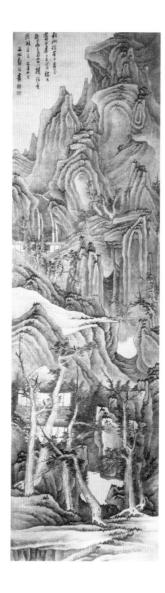

Cuyp, Albert

The Maas at Dordrecht with Fishing Boats

Courtesy of Private Collection/Christie's Images

Albert Cuyp, or Cuijp, was the son of the painter Jacob Gerritsz Cuyp (1594–c. 1652), scion of a well-to-do family. Controversy continues to rage over the extent of his work, many paintings, particularly of still life, being merely signed with the initials AC. On the other hand, those paintings signed 'A Cuyp' are generally landscapes, whose startling lighting effects are very characteristic of his work. As the signed canvasses belong to his later period, it has been argued that the AC paintings are from his earliest years as a painter. He never strayed beyond the Netherlands and his landscapes are bounded by the Maas and the Rhine, but what the flatness of the scenery lacks in variety is more than compensated for by Cuyp's mastery of conveying the different seasons and even different times of day, at their best suffusing the figures of humans and animals with brilliant sunshine.

MOVEMENT

Dutch School

OTHER WORKS

Dordrecht Evening; Cattle with Horseman and Peasants

INFLUENCES

Van Goyen and Jan Both

Albert Cuyp Born 1620 Dordrecht, Holland

Pointed in Dordrecht

Died 1691 Dordrecht

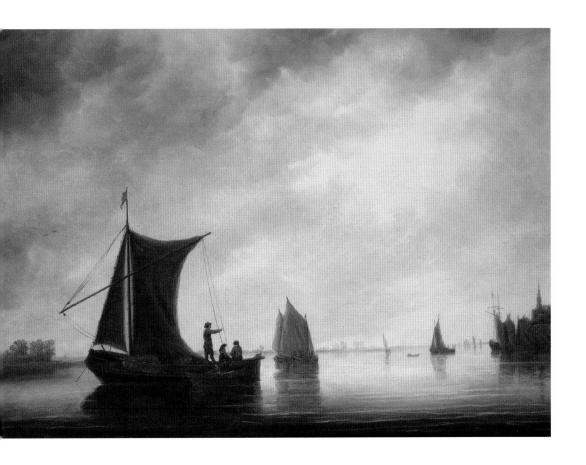

Hooch, Pieter de

The Courtyard of a House in Delft, 1658

Courtesy of Noortman, Maastricht, Netherlands/Bridgeman Art Library

Pieter de Hooch spent his early life in Rotterdam but when he married in 1654 he settled in Delft. Here he came under the influence of Carel Fabritius shortly before the latter's untimely death in the explosion of the Delft Arsenal. De Hooch was subsequently influenced by the late artist's gifted pupil Jan Vermeer. De Hooch himself became one of the leading masters of paintings showing domestic interiors or courtyard scenes, with the emphasis on order, domestic virtue, cleanliness to the point of ascetism and benign tranquillity, shown through the careful arrangement of furniture and figures. His pictures are characterized by a dark foreground, often a doorway or gateway, leading to a bright interior suffused with light and colour. He was an accomplished technician, noted for his complete mastery of perspective which enabled him to create an almost three-dimensional effect.

MOVEMENT

Dutch School

OTHER WORKS

Woman and a Maid with a Pail in a Courtyard

INFLUENCES

Carel Fabritius, Vermeer

Pieter de Hooch Born 1629 Rotterdam, Holland

Painted in Rotterdam and Delft, Holland

Died 1684 Amsterdom

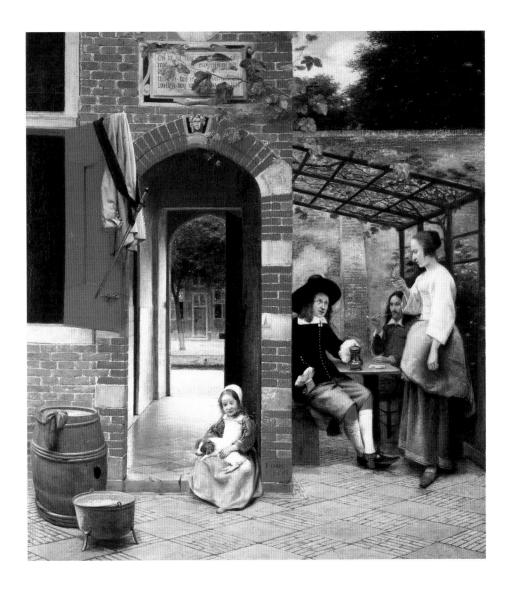

Kalf, Willem

A Kitchen with Vegetables

Courtesy of Private Collection/Christie's Images

Willem Kalf had a conventional art training in Rotterdam and then settled in Amsterdam, where he worked throughout his long but surprisingly undistinguished career. Very little is known of his life and work, and although he had some recognition in his lifetime, he appears to have not been particularly efficient at selling himself or his paintings. His work was all but forgotten until the twentieth century, when art historians restored his reputation. He is believed to have been influenced by his younger contemporary Jan Vermeer, whose own reputation had suffered similar vagaries in subsequent centuries. Kalf specialized in still-life compositions in which he delighted in placing unusual and exotic objects in unlikely juxtaposition. Rich, dark backgrounds contrast with the subtly lit objects pointed in brilliant colours and exhibiting a wonderful mastery of intricate detail. The filigree work on silver armament or the rich jewels set against a Turkish carpet really come to life and jump off the canvas in their intense realism — the kind of subjects which would have appealed to the rich bourgeoisie of seventeenth century Holland.

MOVEMENT

Dutch Schoo

OTHER WORKS

Still Life with Lobster; Drinking Horn and Glasses

INFLUENCES

Vermeer, Pieter Claesz

Willem Kalf Born 1622 Rotterdam, Holland

Painted in Rotterdam and Amsterdam

Died 1693 Amsterdam

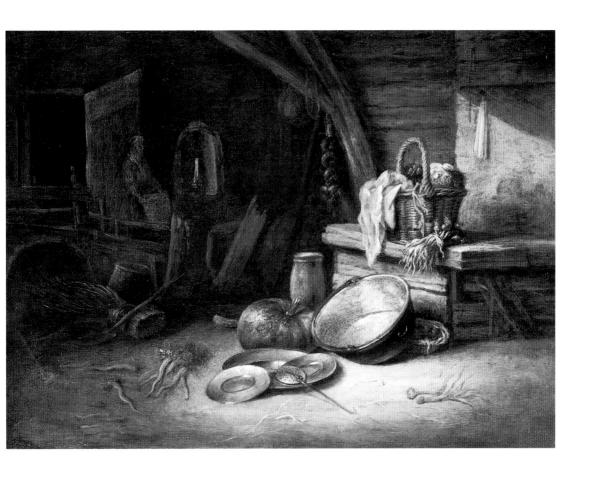

Rembrandt, Harmensz van Rijn

Self Portrait, 1658

Courtesy of Prado, Madrid/Bridgeman Art Library/Christie's Images

One of Holland's greatest and most versatile artists, Rembrandt trained under several painters, the most influential of these being Pieter Lastman. For a time he shared a studio with Jan Lievens, but by the early 1630s he had moved to Amsterdam, where he established a formidable reputation as a portraitist. Rembrandt's approach to group portraiture, in particular, was extremely ambitious. He showed the anatomist, Dr Tulp actually performing a dissection, while his most famous canvas, *The Night Watch*, is a stunningly complex composition portraying a local militia group.

As the 1640s progressed, Rembrandt's art entered a more reflective phase. He painted fewer fashionable portraits, preferring instead to depict the inner life. This can be seen in his magnificent religious paintings, in his intimate, unidealized portrayals of his two wives, Saskia and Hendrickje, and in a penetrating series of self-portraits – perhaps the finest ever produced by any artist. Rembrandt's later work was less commercially successful and, although this led to insolvency, the popular image of him as a reclusive pauper is entirely fictitious.

MOVEMENT

Baroque

OTHER WORKS

The Night Watch; The Anatomy Lesson of Dr. Tulp; The Jewish Bride

INFLUENCES

Pieter Lastman, Jan Lievens, Rubens

Rembrandt Born 1606 Leiden, Holland

Painted in Holland

Died 1669

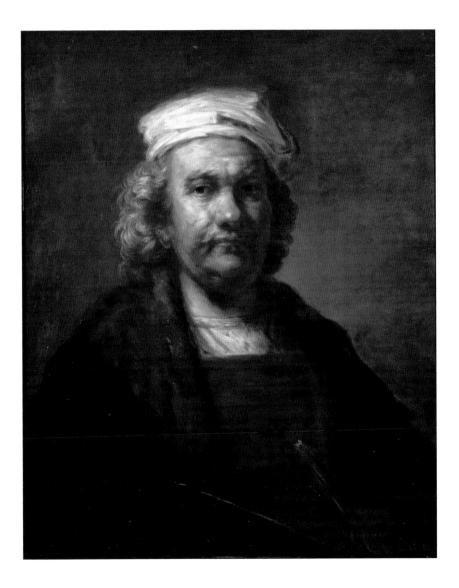

Hobbema, Meindert

A River Landscape with a Ruined Building and Figures, c. 1660s

Courtesy of Private Collection/Christie's Images

Originally named Meindert Lubbertszoon, Hobbema studied under Jacob van Ruysdael in his native city. They were close friends and often painted the same subjects; as Hobbema lacked his master's genius in raising the dramatic temperature in his landscapes, Hobbema languished in his shadow. This must also have been the attitude of the picture-buying public at the time, for eventually Hobbema was obliged to forsake painting and work as an excise man, an arduous occupation that left him little time or inclination for art. While it is true that many of his paintings are not particularly distinguished, Hobbema at his best could be sublime and in recent times his painting has been the subject of considerable re-appraisal. It is generally recognized that his greatest achievement was *The Avenue*, *Middelharnis* – deceptively simple, yet a painting of immense subtlety and complex detail.

MOVEMENT

Dutch School

OTHER WORKS

Stormy Landscape; Road on a Dyke; Watermill with a Red Roof

INFLUENCES

Jacob and Salomon van Ruysdael

Meindert Hobbema Born 1638 Amsterdam, Holland

Painted in Amsterdam

Died 1709 Amsterdam

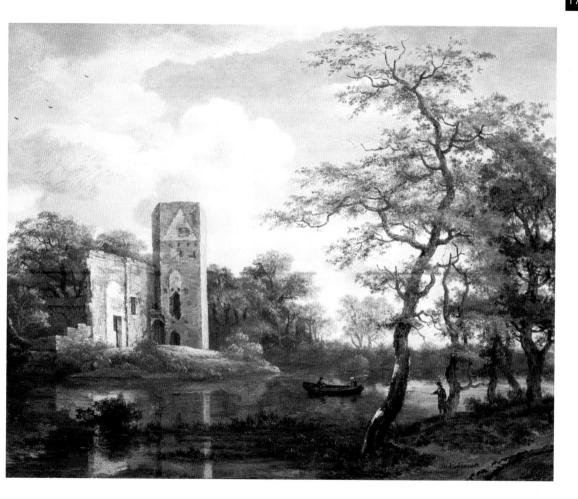

Cooper, Samuel

Miniature of James II as the Duke of York, 1661

Courtesy of Victoria & Albert Museum, London, UK/Bridgeman Art Library

Samuel Cooper is often regarded as the greatest painter of miniatures who ever lived; certainly he was instrumental in raising the status of miniature painting to new heights. He learned his skills from his uncle, John Hoskins. Pepys mentions Cooper frequently in his diaries and noted that he was a fine musician and a good linguist in addition to his artistic talents. He lived through turbulent times and had the distinction of holding official appointments both under the Commonwealth and later the Crown following the Restoration of 1660. He painted several portraits of both Oliver Cromwell and King Charles II, including the effigy of the King used for the coinage. As well as miniatures, painted on ivory or fine parchment, he was also a prolific draughtsman, his collection of chalk drawings being preserved in the University Gallery, Oxford.

MOVEMENT

English Miniaturists

OTHER WORKS

John Aubrey; Mrs Pepys; Self Portrait

INFLUENCES

John Hoskins

Samuel Cooper Born 1609 London, England

Painted in London

Died 1672 London

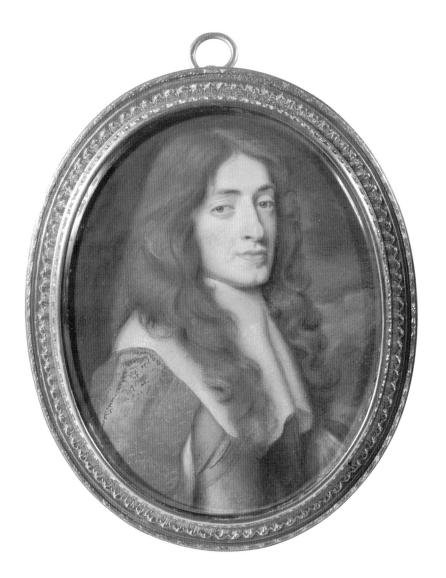

Murillo, Bartolomé Estebán

Immaculate Conception, 1661

Courtesy of Private Collection/Christie's Images

A great master of sentimental religious paintings, Bartolomé Estebán Murillo received his brief artistic training from Juan de Castillo, but when his master moved to Cadiz Murillo scraped a living by painting cheap religious daubs, howked at public fairs. It was an inauspicious start for the man who would co-found the Seville Academy in 1660 and become its first president. His career took off in 1648 when he went to Madrid and met his fellow townsman Velázquez, who not only helped him but also introduced his work to the royal court. Many of his earlier paintings were portraits of Franciscan saints, executed for the Franciscan monastery in Seville, but he went on to produce numerous works of a more general religious nature. In addition he produced many genre subjects, such as beggars, street urchins, fruit-sellers and other aspects of low life which reflect the hardships of his youth. He died from injuries sustained in a fall from scaffolding while painting an altarpiece at Cadiz in 1682.

MOVEMENT

Spanish School

OTHER WORKS

The Immaculate Conception of the Escorial

INFLUENCES

Juan de Castillo, Velázquez

Bartolomé Estebán Murillo Born 1618 Seville, Spain

Painted in Seville

Died 1682 Seville

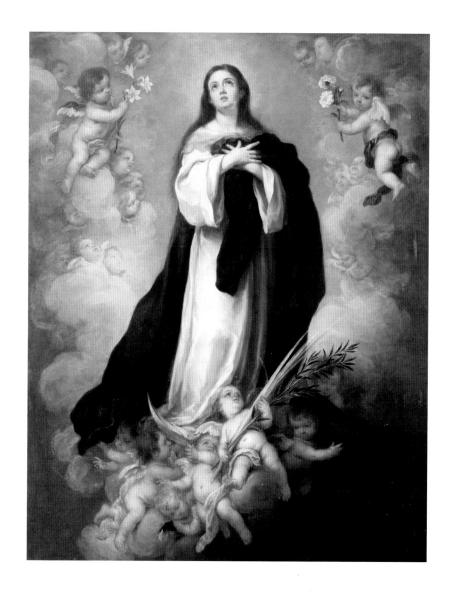

Ruysdael, Salomon van

A Wooded Landscape with Cattle and Drovers on a Ferry, 1663

Courtesy of Private Collection/Christie's Images

Born at Naarden in Gooiland, Salomon Jacobsz van Ruysdael was originally Salomon de Gooyer, but he and his brother Isaack (1599–77) adopted the name 'Ruysdael' from a castle near their father's home. Salomon joined the Painters' Guild at Haarlem in 1623, becoming Dean in 1648. From 1651 he also had a business supplying blue dyes to the Haarlem bleachworks. His earliest dated works belong to 1626 and within two years of this his reputation as a landscape painter was assured. Although he remained in Haarlem all his life, he made occasional forays to other parts of the Netherlands in search of landscape subjects, noted for their fine tonal qualities, and laying the foundations for the great paintings of his much more famous nephew Jacob van Ruysdael. As well as his tranquil landscapes and river scenes, he produced a number of still-life paintings towards the end of his career.

MOVEMENT

Dutch School

OTHER WORKS

Utrecht; Still Life

INFLUENCES

Esaias van de Velde, Jan van Goyen

Salomon van Ruysdael Born c. 1600 Holland

Painted in Haarlem, Holland

Died 1670 Haarlem

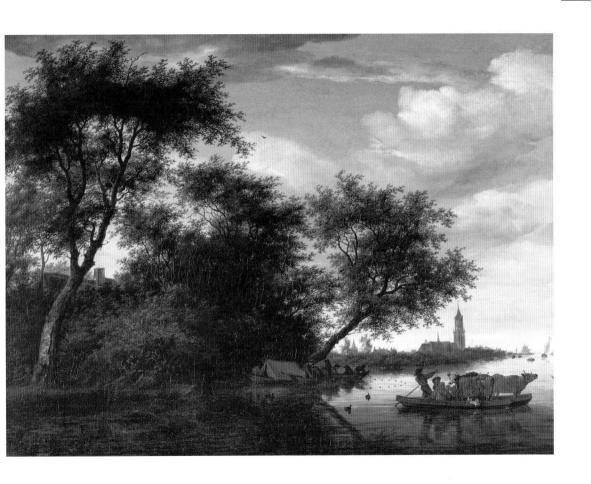

Vermeer, Jan

Girl with a Pearl Earring, c. 1665-6

Courtesy of Mauritshuis, The Hague, Netherlands/Bridgeman Art Library

Jan Vermeer studied painting under Carel Fabritius. In 1653 he entered the Guild of St Luke taking the role of head there in 1662 and 1670. Diffident and a poor businessman, he died young, leaving a widow and eight children destitute. He was almost entirely forgotten until 1860, when he was rediscovered and works which had previously been attributed to other artists were properly identified as coming from his brush. He specialized in small paintings of domestic scenes, distinguished by their perspective and clever use of light to create subtle tones, as well as the fact that, unusual for the time, the figures in them are self-absorbed. Only about 40 paintings have definitely been credited to him, but they are sufficient to establish him as one of the more original and innovative painters of his time – second only to Rembrandt.

MOVEMENT

Dutch School

OTHER WORKS

Lady Seated at a Virginal; The Painter in his Studio; View of Delft

INFLUENCES

Carel Fabritius

Jan Vermeer Born 1632 Delft, Holland

Painted in Delft

Died 1675 Delft

Korin, Ogata

Pampas Grass

© 1992 The Detroit Institute of Arts

Born at Edo (now Tokyo), Ogata Korin came from an upper-middle-class Japanese merchant family, noted for their wealth and ostentation. He was once reprimanded by the court for flamboyant extravagance when at a party he wrote verses on gold leaf and floated them down a stream. He represented the rise of the merchant class in the Genroku era (1688–1703), which resulted in a distinctive culture and art forms. His paintings were carefully constructed and his brushwork shows great discipline, characterized by precise delineation and the even distribution of colour. His great masterpieces are the pair of six-fold screens featuring irises now preserved in the Nezu Art Museum, Tokyo. Like his kinsman and predecessor Koetsu, Korin worked in lacquer and ceramics as well as paint, producing boxes for writing implements or the tea ceremony, with delicate figure compositions worked in gold.

MOVEMENT

Rinpa School of Japanese Decorative Painting

OTHER WORKS

Irises; Birds; White and Red Prunus in the Spring

INFLUENCES

Honami Koetsu, Tawaraya Sotatsu

Ogata Korin Born 1658 Edo (now Tokyo), Japan

Painted in Edo

Died 1716 Edo

Ruysch, Rachel

A Carnation Morning Glory with Other Flowers, c. 1695

Courtesy of Private Collection/Christie's Images

Rachel Ruysch had a conventional art education in the Classicist tradition, but was strongly influenced by Willem Kalf and Jan Vermeer — not only in the techniques of light and shade, but also in subject matter. Nevertheless she added her own distinctive contribution to the art of the still life, specializing in bouquets or vases of flowers made more interesting by the subtle inclusion of bees, butterflies or other insects. The vivid colours of the blossom contrasted with the muted tones of the backgrounds, which often featured classical buildings. She excelled in the painting of crystal vases, which positively sparkle and exquisitely set off the flowers, whose meticulous detail gives them an intensely realistic appearance and explains the popularity of Ruysch's work right up to the present time. Floral paintings were very fashionable in Holland in the late seventeenth and early eighteenth centuries, symbolizing the brevity of all life that is doomed to death and decay. Ruysch's bouquets have a sumptuous quality that has become timeless. She spent her entire life in Amsterdam.

MOVEMENT

Dutch School

OTHER WORKS

Still Life of Flowers

INFLUENCES

Willem Kalf, Vermeer

Rachel Ruysch Born 1664 Amsterdam, Holland

Painted in Amsterdam

Died 1750 Amsterdam

Pozzo, Andrea

The Entry of Saint Ignatius into Paradise, c. 1707

Courtesy of Church of St Ignatius, Rome, Italy/Bridgeman Art Library

One of the most brilliant painters and architects of his generation, Andrea Pozzo was the pupil of an unknown master whom he accompanied to Milan, where he became a Jesuit lay brother. In this connection he was responsible for the decorations of religious festivals and from this graduated to theatrical sets. In 1676 he painted the frescoes for the church of San Francisco Saverio in Modovi, a masterpiece of trompe l'oeil. This was a foretaste of his greatest illusionistic masterpiece, the ceiling of the church of St Ignatius in Rome which, by an ingenious use of perspective, appears to expand the interior by hundreds of feet. In this immense achievement he united his talents as painter, architect and sculptor to great effect. In 1695 he designed the elaborate tomb of Ignatius Loyola, founder of the Society of Jesus. He worked on the decoration of many other churches in Italy and from 1703 onwards was similarly employed in Vienna.

MOVEMENT

Italian Baroque

OTHER WORKS

St Francis Xavier Preaching; Investiture of St Francesco Borgia

INFLUENCES

Andrea Sacchi, Pietro da Cortona, Bernini

Andrea Pozzo Born 1642 Trento, Italy

Painted in Mondovi, Rome and Vienna, Austria

Died 1709 Vienna

Watteau, Jean-Antoine

Les Plaisir du Bal, c. 1714

Courtesy of Dulwich Picture Gallery, London, UK/Bridgeman Art Library

Jean-Antoine Watteau studied under Gérin but learned more from the paintings of Ostade and Teniers. On his master's death, Watteau went to Paris, where he worked for the scene-painter Métayer and then in a factory where he turned out cheap religious pictures by the dozen. He was rescued from this drudgery by Claude Gillot and later worked under Claude Audran. The turning point came when he won second prize in a Prix de Rome competition in 1709. He became an associate of the Academy in 1712 and a full member in 1717. He led the revolt against the pompous classicism of the Louis XIV period and broke new ground with his realism and lively imagination. His early works were mainly military subjects, but later he concentrated on rustic idylls which were very fashionable in the early eighteenth century.

MOVEMENT

French School

OTHER WORKS

The Music Party; Embarkation for the Isle of Cythera

INFLUENCES

Claude Audran, David Teniers

Jean-Antoine Watteau Born 1684 France

Painted in Valenciennes and Paris

Died 1721 Nogent-sur-Marne, France

Carriera, Rosalba

Portrait of Prince Charles Edward Stuart

Courtesy of Private Collection/Christie's Images

The daughter of the painter Andrea Carriera, Rosalba was taught by her father and worked in pastels and oils. She painted mostly miniature portraits in oils on ivory both for framing and mounting in snuff-boxes, but by the beginning of the eighteenth century she had diversified into larger portraits mainly executed in pastels. Soon gaining a high reputation in this medium, she was admitted to the Academy of St Luke at Rome in 1705. As well as formal portraits she painted genre subjects, mainly dealing with the everyday lives of women, latterly she also painted allegorical scenes and figures from classical mythology. Her style matured significantly from about 1711, and her portraits became much more expressive of the sitter's character. In 1720–22 she worked in Paris and was admitted to membership of the Académie Royale. From 1723 onwards she was much in demand at the courts of Europe to paint royal portraits.

MOVEMENT

Venetian School

OTHER WORKS

Antoine Watteau; Empress Amalia; Lady Cutting her Hair

INFLUENCES

Andrea Carriera, Federico Bencovich, Giovanni Pellegrini

Rosalba Carriera Born 1675 Venice, Italy

Painted in Italy, France, Germany and Austria

Died 1757 Venice

Yan, Hua

Falcon Hunting Prey, 1726

Courtesy of Private Collection/Christie's Images

Hua Yan painted horses and figures, usually set in misty or windy weather. This created an atmospheric sense which was very rare in Chinese painting prior to that time, but had immense impact on the artists of the eighteenth and nineteenth centuries. His paintings evoked a realism and immediacy that was radically opposed to the timeless quality for which the painters of the classical tradition invariably strove. Hua Yan was one of the new generation of artists who were not employed in court circles and were thus free from the constraints of their predecessors, and therefore known as the Eccentrics. His works appealed to the rising middle classes of China and, unlike the dilettante artists in court circles, he had a keen sense of the value of his paintings. They found a ready market and he apparently made a fortune from the small pictures which he turned out in vast quantities.

MOVEMENT

Chinese Eccentric School

OTHER WORKS

The Red Bird

INFLUENCES

Wang Fu, Badashanren, Shi Tao

Hua Yan Born 1682 near Yangzhou, China

Painted in Yangzhou

Died 1756 Yangzhou

Hogarth, William

Beggars Opera, 1728-31

Courtesy of Private Collection/Christie's Images

William Hogarth became the greatest English satirical artist of his generation. He was apprenticed to a silver-plate engraver, Ellis Gamble, and established his own business in 1720. Seeking to diversify into the more lucrative business of copper-plate engraving, however he took lessons in draughtsmanship under Sir James Thornhill. His early work consisted mainly of ornamental bill-heads and business cards, but by 1724 he was designing plates for booksellers and from this he progressed to individual prints, before turning to portrait painting by 1730. Within a few years he had begun to concentrate on the great satirical works on which his reputation now rests. His canvasses are absolutely crammed with figures and minute detail, sub-plots and side issues to the main theme. Following a visit to Paris in 1743 he produced several prints of low life and moral subjects. He also executed a number of portraits and oils of genre subjects.

MOVEMENT

English School

OTHER WORKS

Marriage à la Mode; Industry and Idleness; Garrick as Richard III

INFLUENCES

Sir James Thornhill

William Hogarth Born 1697 London, England

Painted in London

Died 1764 London

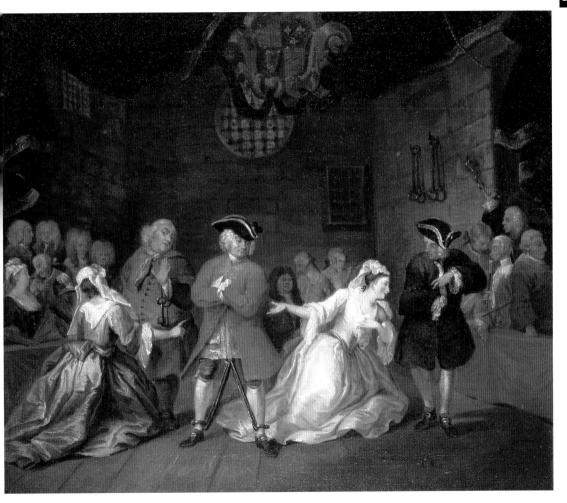

Chardin, Jean-Baptiste-Siméon

Still Life with Ray and Basket of Onions, 1731

Courtesy of Private Collection/Christie's Images

French painter, specializing in still life and genre scenes. Chardin was born in Paris, where he spent most of his life. His father was a carpenter and, initially, he seemed destined to follow this trade, until his aptitude for painting became apparent. As a youth, Chardin trained under two very minor history painters, Pierre Cazes and Noel-Nicolas Coypel, buthis real education came from copying Dutch and Flemish paintings in private art collections. These prompted him to concentrate on still-life pictures — a brave decision, since this type of painting had a low reputation and was very poorly paid.

Despite these drawbacks, Chardin's career flourished. In 1728, *The Skate* won such acclaim at a Paris exhibition that he was invited to become a full member of the Academy, an unprecedented honour for a still life artist. Chardin was delighted and became a stalwart of the institution, holding the post of Treasurer for 20 years. Even so, he found it hard to make a living and, accordingly, extended his repertoire to include simple domestic scenes. These wonderful vignettes of everyday life displayed none of the affectation of the prevailing Rococo style and proved enormously popular with the public.

MOVEMENT

Still life and genre

OTHER WORKS

Saying Grace, The Brioche

INFLUENCES

Nicolaes Maes; Jean-Baptiste Oudry

Jean-Baptiste-Siméon Chardin Born 1699 Paris, France

Painted in France

Died 1779 Paris

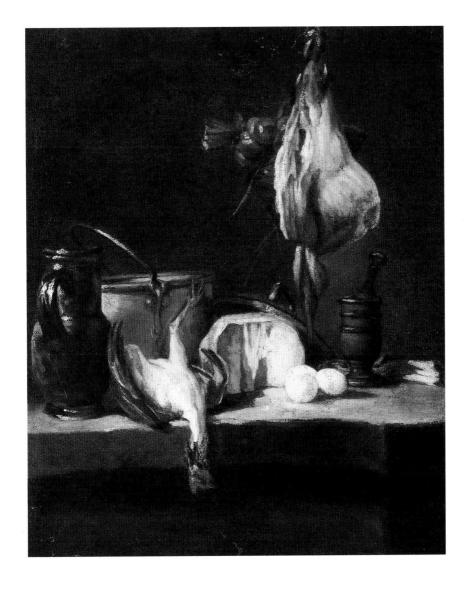

Canaletto

Grand Canal, c. 1740

Courtesy of Private Collection/Christie's Images

Originally named Giovanni Antonio Canale, Canaletto was the son of a scene-painter in whose footsteps he at first followed. In 1719 he went to Rome to study architecture and on his return to Venice he began painting those great architectural masterpieces with which he has been associated ever since. Although most of his paintings illustrate the buildings and canals of his native city – executed as souvenirs for wealthy patrons from England making the Grand Tour – he lived mainly in London from 1746 to 1753. This is reflected in his paintings of the Thames and the City, and other views in the Home Counties. He then returned to Venice where he became a member of the Academy in 1763. He established a style of architectural painting that was widely imitated by the next generation of Italian artists, notably Francesco Guardi and his own nephew Bernardo Bellotto, who slavishly imitated him and even signed his works 'Canaletto'.

MOVEMENT

Venetian School

OTHER WORKS

Piazza San Marco; Regatta on the Grand Canal

INFLUENCES

Tiepolo

Canaletto Born 1697 Venice, Italy

Painted in Venice and Landon

Died 1768 Venice

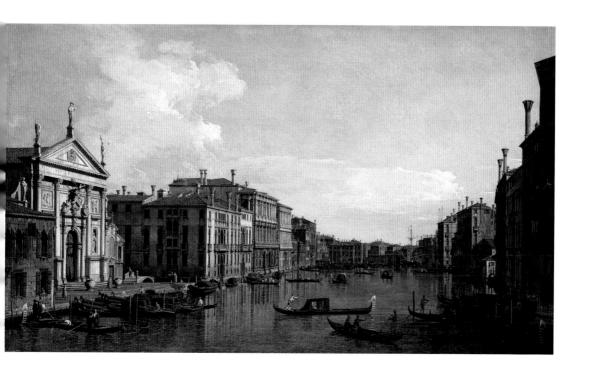

Guardi, Francesco

Still Life

Courtesy of Private Collection/Christie's Images

Francesco Guardi was a near-contemporary of Canaletto and probably also studied under him; certainly the latter's influence was strongly evident in Guardi's numerous paintings of Venetian scenes, but exceeding his master in his deft handling of lighting effects and above all his application of dazzling colours. Apart from his landscapes, Guardi excelled in interiors and architectural subjects, although he was also a master of the large and majestic subject, notably his paintings of great contemporary spectacles such as the Doge embarking in his state barge or the early balloon ascents of fellow-Venetian Vincenzo Lunardi. Guardi departed from the mathematical precision of Canaletto and developed a more impressionistic approach, anticipating the paintings of Turner. Guardi also produced a number of religious works in collaboration with his brother Giovanni. His brother-in-law was Giovanni Battista Tiepolo.

MOVEMENT

Venetian School

OTHER WORKS

Masquerade in the Ridotto

INFLUENCES

Canaletto

Francesco Guardi Born 1712, Venice, Italy

Pointed in Venice

Died 1793, Venice

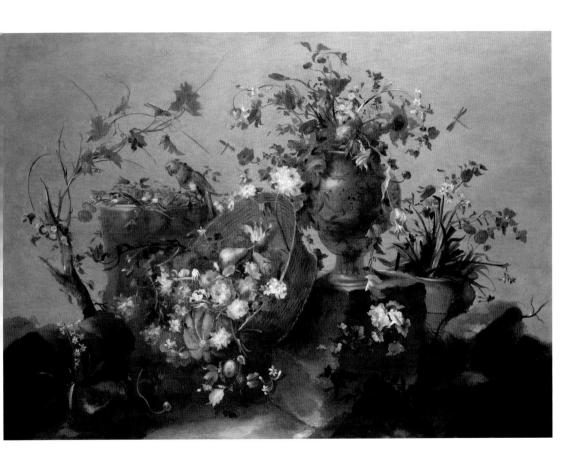

Boucher, François

(attr. to) La Cible D'Amour (The Target of Love), 1758

Courtesy of Private Collection/Christie's Images

French painter and designer, one of the greatest masters of the Rococo style. Born in Paris, Boucher was the son of a versatile, not particularly successful, artist and craftsman. As a result, he learned a wide variety of artistic techniques in his father's workshop before training more formally under François Lemoyne. Boucher's first significant job was to produce a set of engravings after Watteau's drawings, but he also found time to paint, winning the Prix de Rome in 1723. After making the traditional study-tour of Italy (1727–31), he began to gain official plaudits for his work. In 1735 he was granted his first royal commission and this secured his position as a court artist. This role governed the nature of Boucher's art. There were no grand, intellectual themes or moral dramas in his pictures. Instead, he painted light-hearted mythologies and pastoral idylls, which could serve equally well as paintings, tapestry designs or porcelain decoration. This is also evident in Boucher's work for his most distinguished patron, Madame de Pompadour. He immortalized her in a series of dazzling portraits, but also decorated her palace and designed sets for her private theatre.

MOVEMENT

Rococo

OTHER WORKS

The Triumph of Venus; Mademoiselle O'Murphy

INFLUENCES

Watteau, Abraham Bloemaert, François Lemoyne

François Boucher Born 1703, Paris

Painted in France and Italy

Died 1770

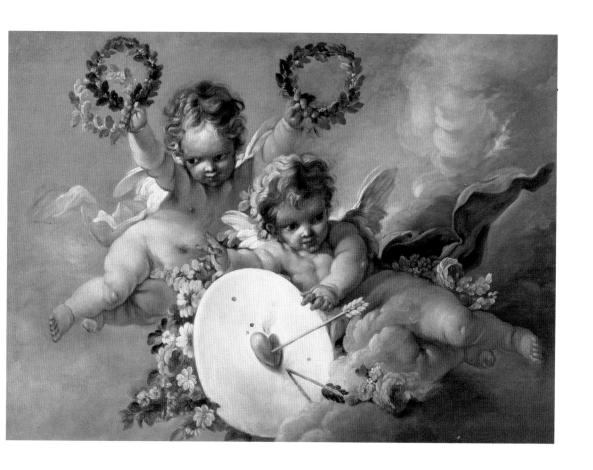

Wright, Joseph

Experiment with an Air Pump, 1768

Courtesy of National Gallery, London, UK/Bridgeman Art Library

Known as Wright of Derby because he spent his entire life in that town, Joseph Wright was the first English painter of any significance to work in the provinces, although even he had to go to London for his formal art education. He established his own studio, where he flourished as a portraitist, and it was probably as a result of his contact with the rising industrialists of the 1760s and 1770s, such as Richard Arkwright and Josiah Wedgwood (whose portraits he painted), that his career eventually changed direction quite dramatically. Wright, in fact, was the artist of the Industrial Revolution, the right man in the right place at the right time, and it is for his spectacular canvasses depicting the wonders of modern science and technology in their infancy that he is chiefly remembered. His attention to the details of machinery was matched by his uncanny mastery of artificial lighting, which he used to good effect.

MOVEMENT

British School

OTHER WORKS

The Air Pump; A Philosopher Giving a Lecture on the Orrery

INFLUENCES

Gerrit van Honthorst

Joseph Wright Born 1734 Derby, England

Painted in Derby

Died 1797 Derby

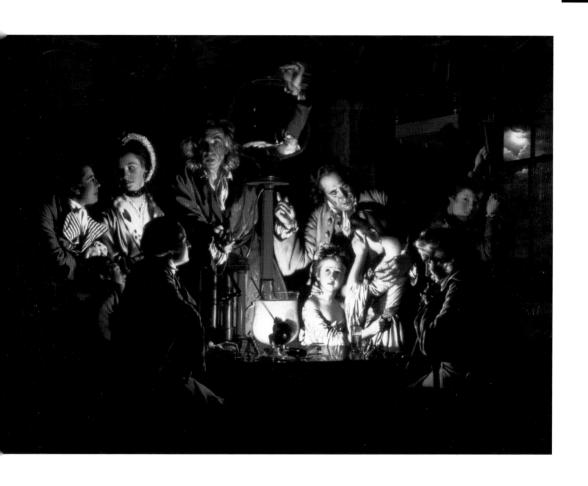

Gainsborough, Thomas

Portrait of David Garrick, exhibited 1770

Courtesy of Private Collection/Christie's Images

Born in Sudbury, Suffolk Gainsborough displayed precocious artistic skills. According to family legend, he helped catch a pear thief in a neighbour's orchard by accurately sketching the culprit. Recognizing his obvious talent, his family sent him to London at the age of 13, where he was trained by the French Rococo artist Hubert Gravelot. In 1745, Gainsborough set up in business hoping to make a living selling landscapes, but the venture failed and he returned to Suffolk. Gainsborough preferred landscapes to 'face-painting', but found that portraiture was far more profitable. With this in mind, he eventually moved from Suffolk to the fashionable resort of Bath, where he was employed by a rich and illustrious clientele. Here, Gainsborough honed his skills to perfection, often painting by candlelight, in order to give his brushwork its distinctive, flickering appearance. By 1768, he was so famous that he was invited to become one of the founder members of the Royal Academy. Gainsborough accepted, and spent the final years of his career in London vying with Reynolds for supremacy in the field of portraiture.

MOVEMENT

Rococo

OTHER WORKS

The Morning Walk; The Painter's Daughters Chasing a Butterfly

INFLUENCES

Hubert Gravelot, Van Dyck, Francis Hayman

Thomas Gainsborough Born 1727 England

Painted in England

Died 1788

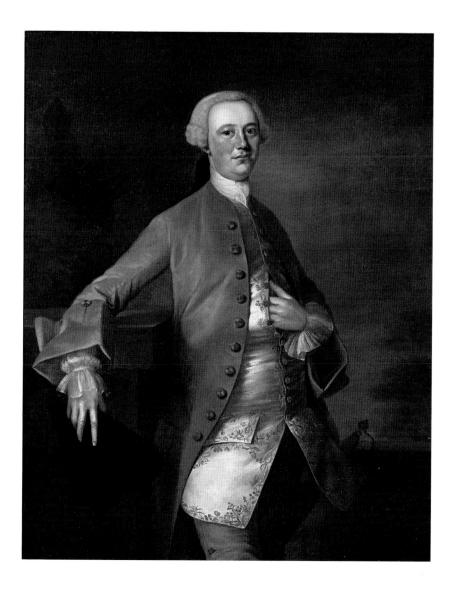

Fragonard, Jean-Honoré

Portrait of Mademoiselle Guimard as Terpsichore, 1773-75

Courtesy of Private Collection/Christie's Images

A leading exponent of the light-hearted Rococo style, Fragonard trained under Boucher (Madame de Pompadour's favourite artist) and won the Prix de Rome, both of which seemed to mark him out for a conventional career as a history painter. But he was too ill-disciplined to enjoy the business of copying old masters and his studies in Rome (1756–60) did not progress well. Instead, the Italian countryside awakened Fragonard's interest in landscape painting while, on his return to France, the success of *The Swing* led his art in a different direction.

The Swing demonstrated Fragonard's undoubted gift for playful eroticism, and it brought him a series of commissions for similar 'boudoir' pictures. Patrons were attracted by his dazzling, vivacious style and by his innate sense of taste, which strayed close to the margins of decency, but never crossed them. In this sense, Fragonard became the archetypal painter of the Ancien Régime and ultimately shared its fate. By the 1780s, Neoclassicism had all but supplanted the Rococo style and, although he received help from David after the Revolution in 1789, Fragonard's later years were marred by poverty and neglect.

MOVEMENT

Rococo

OTHER WORKS

The Progress of Love; The Bolt; The Love Letter

INFLUENCES

François Boucher, Hubert Robert, Tiepolo

Jean-Honoré Fragonard Born 1732 France

Painted in France and Italy

Died 1806

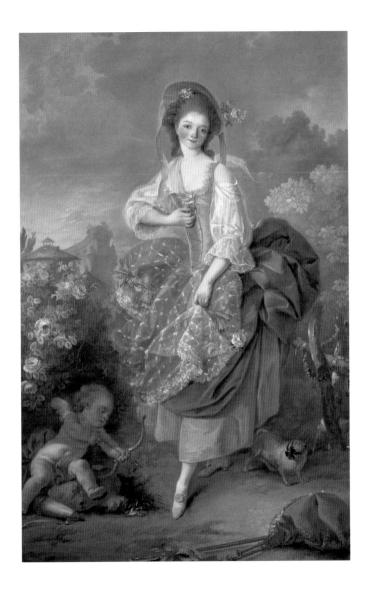

18th Century

The Era of Neoclassicism & Romanticism

Ramsay, Allan

Portrait of Sir Edward and Lady Turner, 1740

Courtesy of Private Collection/Christie's Images

The son of the celebrated Scottish poet of the same name, Allan Ramsay was raised in Edinburgh and was one of the best-educated and most intellectual artists of his day in Europe. He trained in Edinburgh and Rome and was influenced by Pompeo Batoni, the most fashionable of the Italian portraitists. Ramsay settled in London in 1762 and was appointed Principal Painter to King George III in 1767. The following year he became one of the co-founders of the Royal Academy. Ramsay was one of the outstanding portrait painters of his generation, the rival of Reynolds and Gainsborough.

In his lifetime he enjoyed an international reputation for the sensitive and expressive qualities of his portraits, especially of women. However, Ramsay was not content with mere likeness but conveyed the feelings and emotions of his subjects in a manner which had seldom been achieved before. He was a prolific artist whose canvasses are a veritable portrait gallery of British society, and also include a number of European celebrities. Living in the shadow of his father, Ramsay had literary ambitions and published a number of polemical and philosophical essays.

MOVEMENT

British School of Portraiture

OTHER WORKS

Queen Charlotte and her Children; David Hume

INFLUENCES

François Boucher, Pompeo Batoni

Allan Ramsay Born 1713 Edinburgh

Painted in Edinburgh, London, Rome and Paris

Died 1784 Dover, England

Reynolds, Sir Joshua

George Townshend

Courtesy of Private Collection/Christie's Images

Born in Plympton, Devon, Joshua Reynolds was apprenticed in London to Thomas Hudson, a second-rate portrait painter, from whom he learned the rudiments of his craft. In 1743 Reynolds settled in Plymouth, but in 1744 he returned to London where his portrait of Captain John Hamilton, brought him recognition. Reynolds spent two years in Rome perfecting his technique, then visited other Italian art centres, before returning to England in 1752. By 1760 he was the most fashionable portrait painter in London, becoming the first President of the Royal Academy in 1768 and knighted a year later. A prolific artist, he produced over 2,000 portraits, many of which were subsequently published as engravings that further enhanced his reputation.

MOVEMENT

English School

OTHER WORKS

Nelly O'Brien; Samuel Johnson

INFLUENCES

Thomas Hudson, Sir Peter Lely

Sir Joshua Reynolds Born 1723 England

Painted in London, England

Died 1792 London

Greuze, Jean-Baptiste

Girl with Pet Dog

Courtesy of Private Collection/Christie's Images

Specializing in sentimental and melodramatic genre scenes. Greuze was taught by Grandon in Lyan, before completing his artistic training at the Académie in Paris. Apart from a brief spell in Italy (1755–57), Greuze's career revolved around his exhibits at the Salon. There, he achieved his first notable success in 1755 and soon carved out a niche for himself. Profiting from the contemporary cult of sensibility, he created a unique combination of Dutch-style domesticity and lachrymose sentiment or sermonizing. This approach caught the mood of the times and it won the approval of the influential critic Diderot, who described Greuze's pictures as 'morality in paint'. These moralizing overtones were somewhat ironic, given that the artist's own marriage was a disaster due to the extravagance and infidelity of his wife. The vogue for Greuze's work was short-lived. Conscious of the growing popularity of sober Neoclassical themes, he tried to emulate this in *Septimus Severus*, but the move backfired. The picture was universally mocked and Greuze was only admitted to the Academy in the demeaning category of 'genre painter'. By the time of the Revolution, he was a forgotten man.

MOVEMENT

Rococo, Neoclassicism

OTHER WORKS

A Father's Curse; Girl with a Dead Bird

INFLUENCES

Chardin, François Boucher, Joseph-Marie Vien

Jean-Baptiste Greuze Born 1725 France

Painted in France and Italy

Robert, Hubert

Un Paysage Montagneux avec un Obelisque

Courtesy of Christie's Images

Hubert Robert was trained in the Classical tradition but grew up in a world in which the Rocco style was at the height of fashion. Coming under the influence of Watteau, Boucher and Fragonard in turn, his style gradually developed away from the Rocco to a greater realism. Although his skill in composition and mastery of colour were acknowledged, Robert's chief contribution to French art in the latter part of the 18th century was his incisiveness and the liveliness with which he presented his subjects. He made an immense impression on his contemporaries, not the least of whom was Voltaire, who commissioned Robert to decorate his theatre at Ferney as well as design sets. Robert painted portraits and genre subjects, but it was his skill as a landscape artist and creator of historical tableaux that had the greatest impact and many of his larger canvasses are preserved in the Louvre.

MOVEMENT

French School

OTHER WORKS

Landscape with Ruins; The Mouth of a Cave

INFLUENCES

Jean-Antoine Watteau, François Boucher, Jean-Honoré Fragonard

Hubert Robert Born 1733 Paris, France

Painted in France

Died 1808 Paris

Kauffmann, Angelica

Portrait of a Lady as the Muse Enterpe

Courtesy of Private Collection/Christie's Images

Maria Anna Catharina Angelica Kauffmann was a child prodigy, whose reputation as an artist and musician was well established by the age of 11. Taught by her father, John Joseph Kauffmann, with whom she travelled to Italy, she developed her own highly distinctive version of Rococo portraiture. In 1766 she came to London where she was befriended by Sir Joshua Reynolds (they painted each other's portrait) and became a pillar of the artistic establishment and a founder member of the Royal Academy in 1769. In 1781 she married the Venetian artist Antonio Zucchi and returned with him to Italy soon afterwards, settling in Rome. As well as a large number of portraits, she executed a number of wall paintings for Robert Adam; she also decorated St Paul's Cathedral and the Royal Academy's lecture room at Somerset House.

MOVEMENT

Rococo and Classicism

OTHER WORKS

David Garrick; Joshua Reynolds Aged 48

INFLUENCES

Sir Joshua Reynolds

Angelica Kauffmann Born 1741 Switzerland

Painted in Switzerland, Rome and London

Died 1807 Rome, Italy

West, Benjamin

A Group Portrait of a Lady and Her Two Children

Courtesy of Christie's Images, London, UK/Bridgeman Art Library

Born at Springfield, Pennsylvania in 1738, Benjamin West came from an old Quaker family originating in Buckinghamshire. He showed a talent for drawing when very young, and at the age of 18 settled in Philadelphia as a portrait painter. Later he worked in New York and in 1760 travelled to Italy, where he lived for almost three years. In 1763 he settled in London as a painter specializing in historical subjects which brought him the patronage of King George III, who appointed him his historical painter in 1772. In 1768 he was one of the four artists who submitted a plan to the King for the establishment of the Royal Academy, which came to fruition the following year. In 1792 he succeeded Reynolds as President and was for many years a prominent figure in the English art establishment, producing numerous religious, allegorical and historical works. His adoption of modern dress in his great masterpiece *The Death of General Wolfe* was an innovation in English historical painting.

MOVEMENT

English School

OTHER WORKS

Self Portrait; Treaty of William Penn with the Indians

INFLUENCES

John Smibert, John Wollaston

Benjamin West Born 1738 Pennsylvania, USA

Painted in Philadelphia, New York and London

Died 1820 London

Copley, John Singleton

Portrait of Colonel Baker, 1781

Courtesy of Private Collection/Christie's Images

Born in Boston, Massachusetts of Irish parents, John Singleton Copley was self-taught as an artist but by the late 1750s had established himself as a portraitist in his native city. A small painting of a boy with a squirrel was exhibited at the Royal Society of Arts, London in 1760 and helped to spread his reputation across the Atlantic. In 1774 he visited Italy and arrived in England just as the American War of Independence was erupting. Consequently he settled in London, became an associate of the Royal Academy in 1777 and an academician in 1783 following the exhibition of his best-known work, the dramatic *The Death of Chatham*. He is esteemed on both sides of the Atlantic, for his portraits of the British royal family and for his studies of the leading political and military figures in Boston society in the late-colonial period.

MOVEMENT

English School

OTHER WORKS

The Death of Major Pierson

INFLUENCES

Sir Joshua Reynolds

John Singleton Copley Born 1737 Boston USA

Painted in Boston, USA and London, England

Died 1815 London

Fuseli, Henry (Johann Heinrich Füssli)

The Birth of Sin

Courtesy of Private Collection/Christie's Images

Swiss painter and graphic artist; a key figure in the English Romantic movement. Born in Zurich, the son of a town clerk and amateur painter, Fuseli trained as a minister in the Swiss Reformed Church. He was ordained in 1761, but turned to art in 1768, after receiving encouragement from Sir Joshua Reynolds. Pursuing this ambition, he spent several years in Italy (1770–78), where he was impressed, above all, by Michelangelo's vision of the Sublime – a mood which he tried to capture in many of his own paintings.

In 1778, Fuseli moved to London, making this his principal artistic base. He cemented his reputation with *The Nightmare*, which was exhibited at the Royal Academy in 1782. Fuseli made several versions of this haunting image, which is undoubtedly his most famous work. Although the picture may have had a purely personal meaning for him – the expression of his unrequited passion for a Swiss girl – it has become one of the landmarks of Romanticism. In it, as in his other works, the artist focused on the darker side of the imagination, weaving together elements of horror, fantasy and eroticism.

MOVEMENT

Romanticism

OTHER WORKS

Titania's Awakening; The Ladies of Hastings

INFLUENCES

Michelangelo, William Blake, Sir Joshua Reynolds

Henry Fuseli Born 1741 Switzerland

Painted in England, Italy, Switzerland and Germany

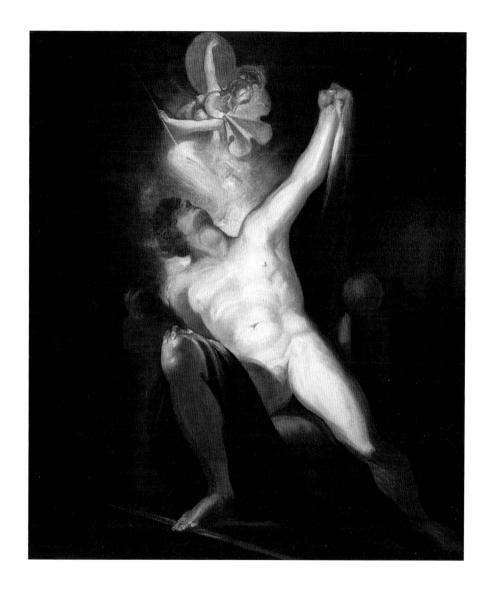

Utamaro, Kitagawa

Act IX of Chusugiwa (detail)

Courtesy of Private Collection/Christie's Images

Kitagawa Nebsuyoshi received a conventional art training but raised it to an entirely new level, earning for him the epithet of *Ukiyo-ye Chuko-no-so* ('great master of the popular school'). A versatile artist who painted flowers, birds, fish and insects in meticulous detail as well as great sweeping landscapes, he specialized in portraits and genre scenes involving the ladies of the court. No one ever surpassed him in the precise delineation of faces, figures and flowing robes that capture the gracefulness and elegance of the courtesans and professional beauties of the Shogunate at the height of its prestige. Though he painted in oils, his fame rests mainly on the colour prints, which had immense appeal not only for the Japanese but also for the Dutch community at Nagasaki. This led to his work being brought to Europe, and it had a tremendous influence on many artists of the nineteenth century.

MOVEMENT

Ukiyo-e

OTHER WORKS

Lovers; Girl Playing Glass Flute; Women Working in the Kitchen

INFLUENCES

Hishikawa Moronobu, Ando Hiroshige

Kitagawa Utamaro Born 1753 Kawayoye near Edo (now Tokyo), Japan

Painted in Edo

Died 1806 Edo

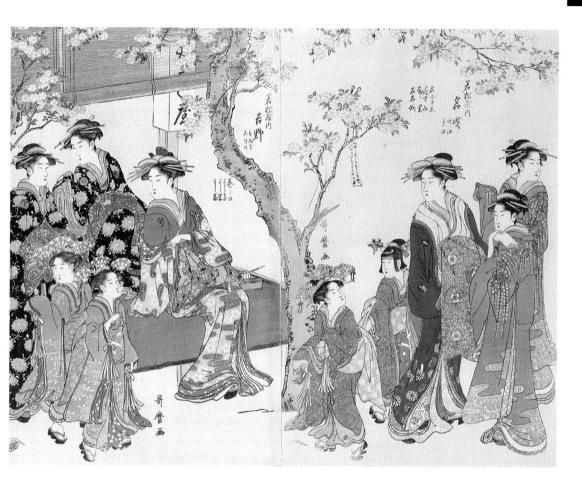

Raeburn, Sir Henry

The Reverend Robert Walker Skating on Duddington Loch, 1784

Courtesy of National Gallery of Scotland, Edinburgh, Scotland/Bridgeman Art Library

Henry Raeburn was originally apprenticed to a goldsmith but began painting portrait miniatures and soon expanded to full-scale oil paintings, though entirely self-taught. After marrying one of his sitters, a wealthy widow, he was enabled to travel to Italy to study for two years, mainly under Pompeo Batoni. He returned to Edinburgh in 1787 and established himself as the most fashionable portraitist of his generation. Unlike Ramsay, he spent most of his life in Edinburgh and seldom visited London. He became a full member of the Royal Academy in 1815. In 1823 he was appointed His Majesty's Limner for Scotland and was knighted the same year. Although his contemporaries judged him less successful in his female subjects, his portraits of both men and women are full of vigour and liveliness and had a profound influence on the development of Scottish art in the nineteenth century.

MOVEMENT

British School of Portraiture

OTHER WORKS

Self Portroit: Sir Walter Scott: Mrs Robert Bell

INFLUENCES

Allan Ramsay, Pompeo Batoni, Sir Joshua Reynolds

Sir Henry Raeburn Born 1756 Scotland

Painted in Edinburgh and Rome

Died 1823 Edinburgh

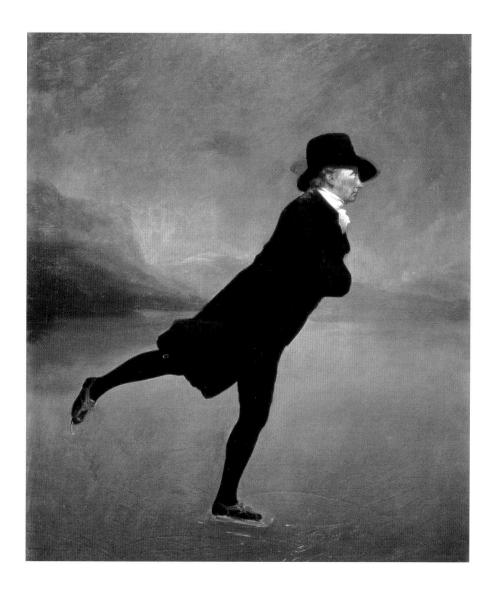

Kiyonaga, Torii

Viewing the Cherry Blossom at Asukayama, c. 1785

Courtesy of British Library, UK/Bridgeman Art Library

The son of an Edo (Tokyo) bookseller, Kiyonaga was the star pupil of Kiyomitsu, last of the great masters of the Torii line. In due course he succeeded as head of the Torii school, his adopted names reflecting the great influences on him. A very large part of his prolific output consisted of prints of the Kabuki theatre but he also pointed genre subjects of everyday life in the capital. Kiyonaga introduced a note of greater realism and less idealism which revolutionized ukiyo-e ('pictures of the passing world') and paved the way for the mordant style of Sharaku and his followers. By the late 1770s Kiyonaga was spearheading the movement for a more naturalistic approach, with figures that were much more fully rounded and better proportioned than previously. It was Kiyonaga's style that influenced Utamaro, but when the latter overtook him in the 1790s Kiyonaga returned to Kabuki paintings and produced very few prints in his later years.

MOVEMENT

Ukiyo-e

OTHER WORKS

Kabuki Scene; Ladies and Young Man Walking

INFLUENCES

Kiyomitsu

Torii Kiyonaga Born 1752 Edo (now Tokyo) Japan

Painted in Edo

Died 1815 Edo

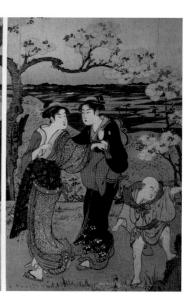

Romney, George

Portrait of Emma, Lady Hamilton, 1786

Courtesy of Philip Mould, Historical Portraits Ltd, London, UK/Bridgeman Art Library

An English painter specializing in portraits, Romney was born in Lancashire, the son of a cabinet maker, and trained under an itinerant portraitist named Christopher Steele. For a time, he picked up commissions by travelling from town to town, before making his base in Kendal. Moving to London in 1762, he established a reputation as a fashionable portrait painter, although his style did not really mature until after his tour of Italy (1773–75). There, his study of Classical and Renaissance art paid huge dividends and most of his best paintings were produced in the decade after his return to England.

Romney, like Gainsborough, was deeply dissatisfied with portraiture. His ambition of becoming a history painter was never fulfilled, perhaps partly because of his nervous, introspective character and partly because of his reluctance to exhibit. His later career was marred by his obsession with Emma Hart, later to become Lady Hamilton and Nelson's mistress. Romney met her in 1781, and in the years that followed produced dozens of pictures of her, usually masquerading as a character from mythology. As his reputation began to wane, the artist returned to Kendal, where he suffered a serious mental docline.

MOVEMENTS

Neoclassicism, Romanticism

OTHER WORKS

The Parson's Daughter; The Beaumont Family; Lady Rodbard

INFLUENCES

Sir Joshua Reynolds, Henry Fuseli, Joseph Highmore

George Romney Born 1734 England

Painted in England and Italy

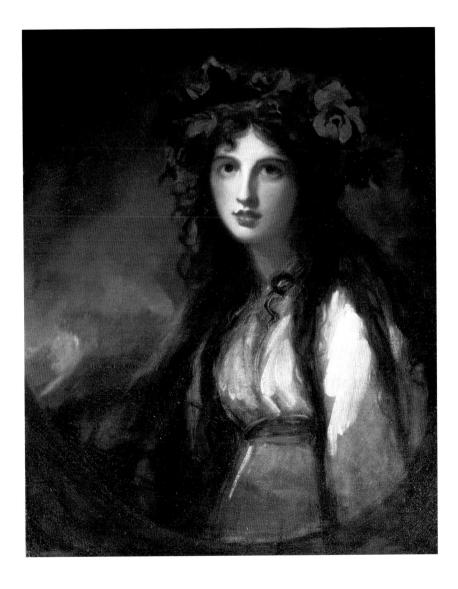

Vigée-Lebrun, (Marie Louise) Elisabeth

Marie Antoinette and her Four Children, 1787

Courtesy of Chateau de Versailles, France/Bridgeman Art Library

Marie Louise Elisabeth Vigée-Lebrun was the daughter of an artist from whom she received her early training, hut later benefited from the help of several fellow-painters. By the age of 20 she had already made her mark with portraits of Count Orloff and the Duchess of Orleans. In 1783 she was admitted to the Academy on the strength of her allegorical masterpiece *Peace Bringing Back Abundance*. Following the outbreak of the Revolution she fled to Italy and worked in Rome and Naples, later visiting Vienna, Berlin and St Petersburg. She returned briefly to Paris in 1802 but went to London the same year, where she painted the Prince of Wales and Lord Byron. She was a prolific portraitist and a score of her paintings portray Marie Antoinette alone.

MOVEMENT

French School

OTHER WORKS

Portrait of the Artist and her Daughter

INFLUENCES

Joseph Vernet, Jean Baptiste Grueze, Charles Lebrun

Elisabeth Vigée-Lebrun Born 1755 France

Painted in France, England and Europe

Died 1842 Paris

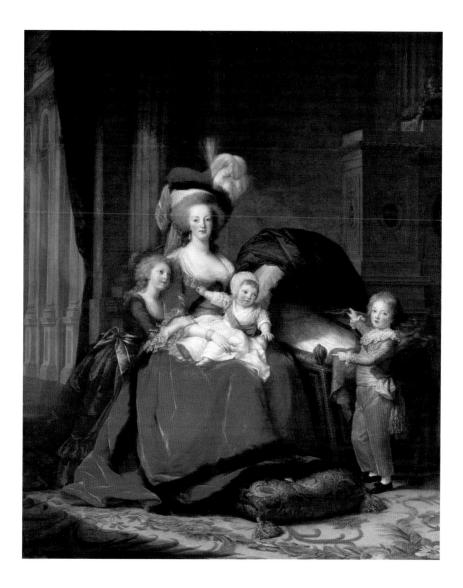

Cozens, John Robert

Cetaro, Gulf of Salerno, 1790

Courtesy of Christie's Images, London, UK/Bridgeman Art Library

An artist whose background was more colourful than his paintings, Cozens' artist father Alexander is believed to have been the illegitimate son of Peter the Great by an English girl while the Tsar was learning the shipbuilding trade at Deptford. John Robert Cozens studied under his father, the drawing master at Eton who wrote treatises on watercolours and is best remembered for his technique of incorporating accidental blots into his landscapes. In turn, his son evolved a style of watercolour painting that departed from his predecessors: impressionistic and decidedly atmospheric. He was thus the forerunner of Girtin and Turner, the latter freely admitting his indebtedness to Cozens, while Constable's regard for his talent was effusive: "the greatest genius that ever touched landscape". In 1776 and 1782 Cozens travelled overland to Italy, sketching and painting prolifically en route and providing the basis for his great landscapes and historical works. His colours were muted, often somber, and there is a dark, foreboding element in his paintings which reflect the severe depressive illness which led to his incarceration in a lunatic asylum in the last years of his relatively short life.

MOVEMENT

English Landscape School

OTHER WORKS

Landscape with Hannibal on his March over the Alps

INFLUENCES

Alexander Cozens

John Robert Cozens Born 1752, London,

Painted in England, Switzerland, Italy

Died 1797, London

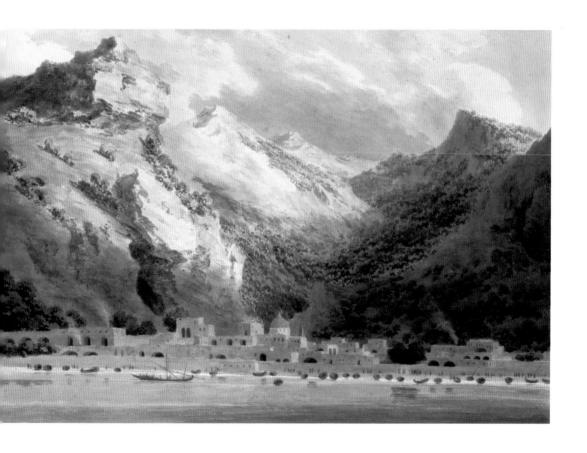

Blake, William

Relief-Etched plate from "America, A Prophesy", printed 1793

Courtesy of Private Collection/Christie's Images

Visionary poet and painter, Blake was one of the most individual talents to emerge from the Romantic movement. Living in London for most of his life, Blake trained as a commercial engraver and briefly attended the Royal Academy Schools, although he soon felt stifled by the life classes; for him, the imagination was always far more important than the imitation of nature. Stylistically, Blake's art bore some of the hallmarks of Neoclassicism — particularly in its linear approach and its dramatic intent — but a classical sense of restraint was notably absent. His figures, meanwhile, owed much to the example of Michelangelo. Blake's technique was highly inventive. He devised a system of 'illuminated printing' which enabled him to produce lavish editions of his books of poetry, and pioneered a form of tempera painting in place of oils. His subject matter was largely drawn from the complex, personal mythology outlined in his verses. This baffled many of his contemporaries, who regarded him as an eccentric. Blake did have his admirers, however, which included the group of young artists known as the Ancients.

MOVEMENT

Romanticism, Neoclassicism

OTHER WORKS

Glad Day; God Judging Adam; God Creating the Universe

INFLUENCES

Michelangelo, Henry Fuseli, John Flaxman

William Blake Born 1757 London

Painted in England

David, Jacques-Louis

The Death of Marat in 1793

Courtesy of Musee des Beaux-Arts, Reims, France/Bridgeman Art Library/credit: Roger-Viollet, Paris

French painter, the leader of the Neoclassical revival. In both his art and his life, David displayed a tempestuous nature, possibly inherited from his father, who was killed in a duel in 1757. He trained under Vien and his early paintings featured the same uncomfortable blend of Rococo sweetness and antique trappings as those of his master. After winning the Prix de Rome, however, David spent an extended study period in Italy (1775–80), where his art acquired a new dignity and grandeur. With their fiery patriotism and stern morality, David's paintings of the 1780s captured the rebellious mood of the times. Indeed, his greatest picture, *The Oath of the Horatii*, has often been seen as a visual call to arms. During the Revolution, David was swept up in politics, joining the National Convention, where he became associated with Robespierre and Marat. After their fall, he was imprisoned and was only saved from the guillotine by his rayalist wife. This experience did nothing to quell the artist's spirit, however, for he became equally involved with Napoleon. After the latter's defeat, David fled to Brussels where he remained in exile for the rest of his days.

MOVEMENT

Neoclassicism

OTHER WORKS

Madame Récamier; Brutus and his Dead Sons

INFLUENCES

Gavin Hamilton, Joseph-Marie Vien, Anton Raffael Mengs

Jacques-Louis David Born 1748 France

Painted in France, Italy and Belgium (then Holland)

Sharaku, Toshusai

Portrait of Sakata Hangoro III as Fujikawa Mizuema, 1794

Courtesy of Private Collection/Christie's Images

Nothing appears to be known regarding the origins or early career of Toshusai Sharaku, other than that he came from a noble family and had been an actor in the Kabuki theatre before taking up art. In a brief period of only 10 months in 1794–95, he produced some 159 caricatures and portraits of Kabuki actors, drawn with extraordinary power and originality, coupled with savage satirical qualities which had not been witnessed in Japanese art since the Kamakura period (1185–1333). Sharaku mastered the new technique of tinted mica backgrounds extremely effectively, so that the silhouettes of the posturing actors almost jump out at the spectator. Sharaku's harsh, uncompromising pictures shocked the public, who were more accustomed to the simpering beauties of Masanobu or Utamaro, and not surprisingly they were unpopular. The exaggerated features of the subjects may have given offence to the actors themselves and perhaps concerted action on their part helped bring Sharaku's enterprise to an abrupt end.

MOVEMENT

Ukiyo-e

OTHER WORKS

Otani Oniji III as Edohei; Iwai Hanshiro IV as Shigenoi

INFLUENCES

Kitagawa Utamaro, Suzuki Harunobu

Toshusai Sharaku Born c. 1750 Edo (now Tokyo), Japan

Painted in Edo

Died | 80 | Edo

Girtin, Thomas

Dunstanborough Castle, c. 1797

Courtesy of Private Collection/Christie's Images

Thomas Girtin served his apprenticeship in London as a mezzotint engraver under Edward Dayes, through whom he made the acquaintance of J. M. W. Turner who, being shown Girtin's architectural and topographical sketches, encouraged him to develop his talents as a landscape painter. His early death in 1802 from tuberculosis brought a very promising career to an untimely end, but even by then he had established a high reputation as an etcher. Hitherto, watercolours had been used almost entirely for tinting engravings, but to Girtin goes the credit for establishing watercolour painting as a major art form in its own right. From 1794 onwards he exhibited his great watercolour landscapes at the annual Royal Academy exhibitions and this helped to develop the fashion for this medium from the beginning of the nineteenth century. Girtin collaborated with Turner in making a series of copies of architectural paintings for Dr Monro, notably works by Canaletto.

MOVEMENT

English School

OTHER WORKS

A Winding Estuary; Porte St Denis

INFLUENCES

Turner

Thomas Girtin Born 1775 London, England

Painted in London

Died 1802 London

Benoist, Marie-Guillemine

Portrait of a Negress, 1799-1800

Courtesy of Louvre, Paris/Bridgeman Art Library

Marie-Guillemine Benoist was the daughter of a government official who recognized her talent and enrolled her as a pupil of Vigée-Lebrun in 1791; the latter's influence is very evident in Benoist's early works, mainly portraits done in pastels. Later she studied under Jacques-Louis David and as a result she began producing more ambitious works in oils. She made her debut at the Salon with two historical scenes and thereafter painted both portraits and historical subjects. She achieved a high reputation and received a gold medal and an annual government grant. Napoleon commissioned portraits of himself and his family from her. In the early 1800s she switched to painting genre subjects and sentimental domestic scenes which were immensely popular. Her best-known painting, a remarkable portrait of a young black woman painted in 1800, is believed to have been inspired by the decree of 1794 abolishing slavery.

MOVEMENT

French Romantic School

OTHER WORKS

Napoleon Bonaparte; The Imperial Family

INFLUENCES

Vigée-Lebrun, David

Marie-Guillemine Benoist Born 1768 Paris

Painted in Paris

Died 1826 Paris

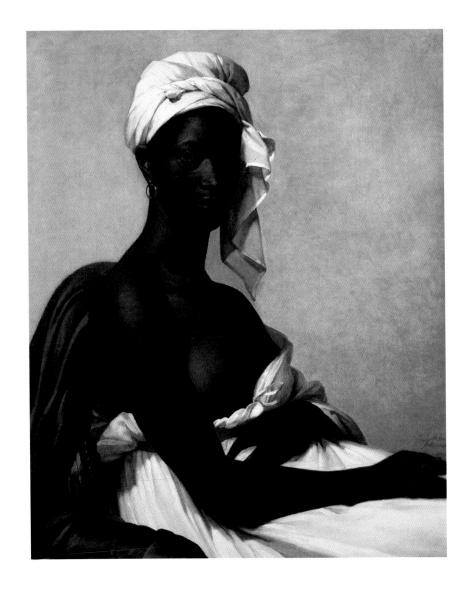

Gros, Antoine-Jean

Napoleon Bonaparte Visiting the Plague Stricken of Jaffa. I 799

Courtesy of Louvre, Paris, France/Bridgeman Art Library

The son of a miniature pointer, Antoine-Jean Gros studied under Jacques-Louis David. Following the death of his father in 1791 he went to Italy and it was there that he met Josephine Beauharnais, who introduced him to Napoleon, whom he accompanied on his Italian campaign. He was an eye-witness of the dramatic scene when Bonaparte planted the Tricolour on the bridge at Arcole in November 1796 and the dramatic painting that recorded this incident gave Gros a sense of purpose. Thereafter, as a war artist, he chronicled on canvas the exploits of the Napoleonic army down to the campaign of 1811, and it is on these heroic paintings that his reputation is largely based, earning him the Napoleonic title of Baron in the process. The downfall of Napoleon robbed Gros of his true vocation. In the aftermath of Waterloo he returned to his classicist roots and concentrated on such works as *Hercules and Diomedes*, but by now he was fighting a losing battle against the rising tide of Romanticism.

MOVEMENT

French Classicism

OTHER WORKS

The Departure of Louis XVIII

INFLUENCES

David

Antoine-Jean Gros Born 1771 Paris, France

Painted in France and Italy

Died 1835 Bas-Meudon, France

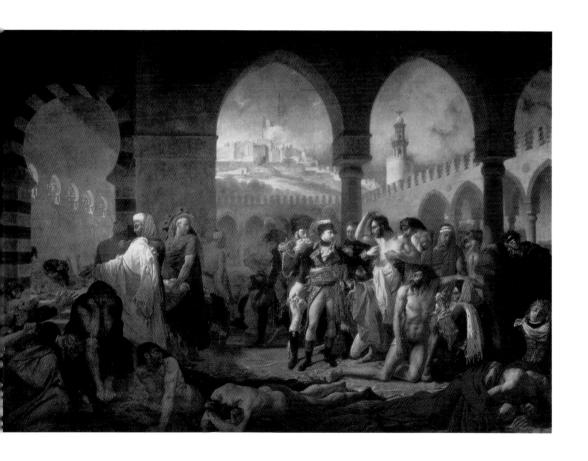

Beg, Farrukh

Humayun Hunting near Kabul, (copy) c. 1800

Courtesy of Victoria and Albert Museum, London / Bridgeman Art Library

Farrukh Beg is often referred to as Farrukh the Qalmak (Kalmuck), which suggests that he hailed from that region of the Mughal Empire. Like other painters of the Indo-Persian School, little is known of his life, but he was one of the four Muslim artists named by Abul Fazl in the list of 17 court painters. Farrukh contributed excellent miniature paintings to the Akbar Nama and was the author of a remarkable painting in three scenes, occupying a full page on the reverse of a folio in the Oriental collection at the British Library. He painted in the Persian manner, characterized by flatness and a fondness for surface patterns, extreme elegance in line and decorative detail. Farrukh excelled in portraiture, reflecting the Emperor Akbar's total disregard of orthodox Muslim teaching, which forbade representation of living creatures, human or animal.

MOVEMENT

Mughal or Indo-Persian School

OTHER WORKS

Akbar Nama; Babur Nama; Sufi Pir at the Tavern Door

INFLUENCES

Mir Sayyid Ali, Abdus Samad

Farrukh Beg Born c. 1550 Qalmakia, Persia

Painted in India

Died c. 1610 Delhi, India

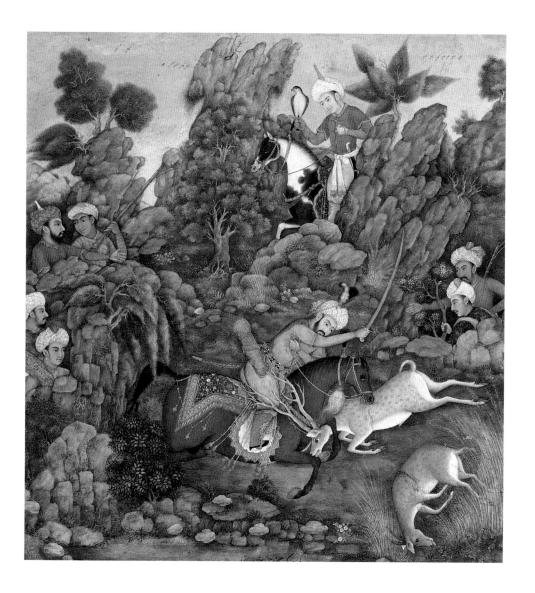

Crome, John

Gibraltar Watering Place, Heigham

Courtesy of Private Collection/Christie's Images

English landscape painter, a leading member of the Norwich School. Crome was apprenticed to a coach-and-sign painter at the age of 15, before moving to London in 1790. There he learned his trade by copying pictures in the collection of his patron, Thomas Harvey. These included British artists Wilson and Gainsborough and the Dutch landscapists Ruisdael and Hobbema.

Crome travelled to Paris in 1814 to view the artworks looted by Napoleon, but the greater part of his career was spent in East Anglia. In 1803, he became one of the founder members of the Norwich Society of Artists, serving as its President for many years. Despite his growing reputation, however, Crome still had to rely on teaching for much of his income. Stylistically, he was a transitional artist. Paintings such as his *Old Houses at Norwich* were still very much in the Picturesque tradition, though he also produced lyrical, moonlit scenes, which displayed a budding Romantic sensibility. He was often known to his contemporaries as Old Crome, to distinguish him from his son – another John – who was also an artist.

MOVEMENT

Romanticism, Norwich School

OTHER WORKS

Yarmouth Jetty; Mousehold Heath: Mill and Donkeys

INFLUENCES

Richard Wilson, Gainsborough, Hobbema

John Crome Born 1768

Painted in England

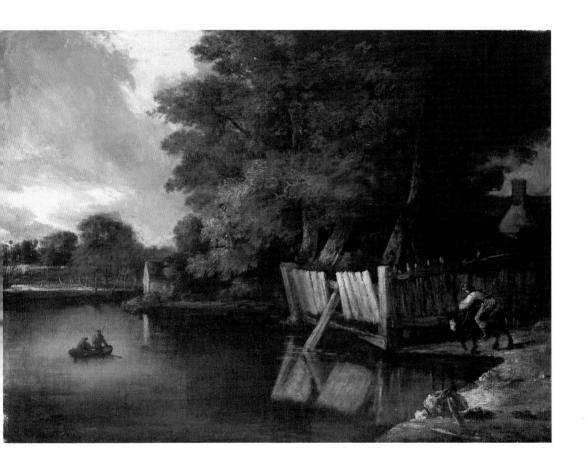

Goya, Francisco

The Clothed Maja, c. 1800-05

Courtesy of Prado, Madrid, Bridgeman Art Library/Christie's Images

Francisco José de Goya y Lucientes was raised in the small town of Fuendetodos near Saragossa, Spain. Frequently involved in parochial gang fights, he fled to Madrid in 1765 after a brawl in which three youths were killed. As a result of continued sparring he left Madrid precipitately, joining a troupe of itinerant bull-fighters and eventually reaching Rome, where he resumed his studies in art. In 1798 he returned to Spain as a designer for the royal tapestry factory and executed a number of frescoes drawn from contemporary life, as well as a series of satirical etchings. In 1799 he was appointed court painter to Charles IV, which resulted in some of his most notable portraits. After the French invasion in 1808 he sided at first with the invaders, but secretly sketched their atrocities, which resulted in both full-scale canvasses and numerous etchings. In 1824 he moved to Bordeaux where, in old age, he produced some of his finest genre paintings.

MOVEMENT

Spanish School

OTHER WORKS

Execution of the Defenders of Madrid; The Naked Maja

INFLUENCES

Anton Raphael Mengs, Tiepolo

Francisco Goya Born 1746 Fuendetodos, Spain

Painted in Madrid and Bordeaux

Died 1828 Bordeaux

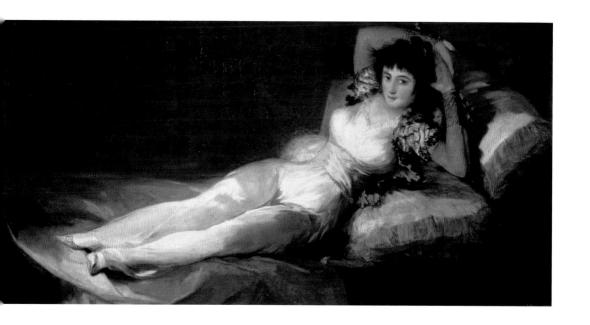

Lawrence, Sir Thomas

Portrait of Mrs Robert Burne-Jones

Courtesy of Private Collection/Christie's Images

The son of an innkeeper, Thomas Lawrence amazed and amused guests from the age of six by sketching their portraits. When his father became bankrupt four years later, it was the infant prodigy who became the family's breadwinner. At the age of 18 he went to London to study at the Royal Academy and exhibited almost immediately. On the death of Reynolds in 1792 he was appointed Painter-in-Ordinary to King George III and became the most fashionable portrait painter of the ensuing decades. He was knighted in 1815 and embarked on a European career, during which he painted all the royalty and most of the nobility of the continent. As President of the Royal Academy (1820–30) he was the leader of the British art establishment. Ironically, he was no better a businessman than his father and his prolific output barely kept pace with his immense debts.

MOVEMENT

British School

OTHER WORKS

The Duke of Wellington; Pinkie; Mrs Siddons; Princess Lieven

INFLUENCES

Sir Joshua Reynolds

Sir Thomas Lawrence Born 1769 Bristol, England

Painted in England and Europe

Died 1830 London, England

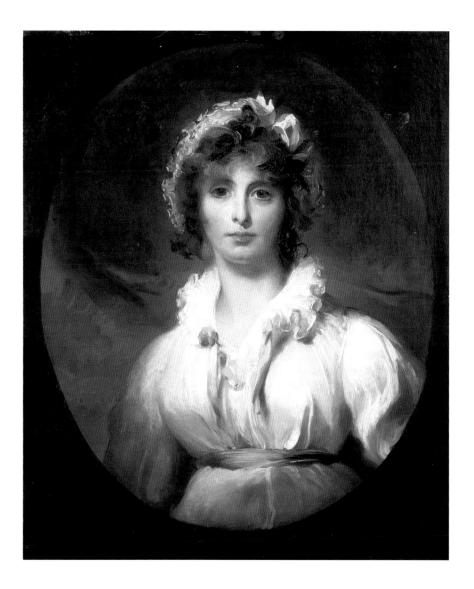

Constable, John

Lock on the Stour

Courtesy of Private Collection/Christie's Images

A pioneering British artist who, together with Turner, raised the status of landscape painting in England. Constable enjoyed a happy childhood in his native Suffalk and this region became the focus for most of his paintings. In Constable's day, however, landscape painting was a poorly paid profession and both his family and that of his lover, Maria Bicknell, were appalled by his choice of career. For many years, the couple were forced to meet in secret, until they eventually married in 1816. Constable's struggle for success was as difficult as his father had feared and, for a time, he was obliged to paint portraits for a living. In part, this was because he did not seek out romantic or picturesque views, but preferred to paint his local area, even though many regarded it as dull, agricultural land. He also paid unprecedented attention to atmospheric conditions, making copious sketches of individual clouds. These were so realistic that one critic joked that Constable's paintings always made him want to reach for his umbrella. Eventually, he found success with his 'six-footers' (i.e. six feet wide), gaining membership of the Royal Academy and winning a gold medal at the Paris Salon.

MOVEMENT

Romanticism

OTHER WORKS

The Hay Wain; Flatford Mill; Salisbury Cathedral

INFLUENCES

Thomas Gainsborough, Jacob van Ruisdael, Claude Lorrain

John Constable Born 1776, Suffolk, England

Painted in England

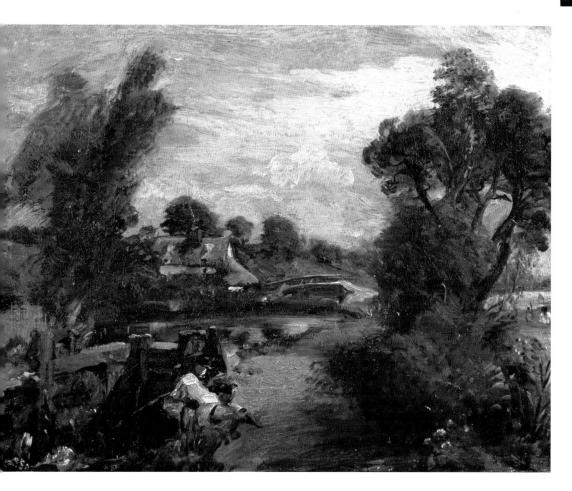

Ingres, Jean-Auguste-Dominique

Jupiter and Thetis, 1811

Courtesy of Private Collection/Christie's Images

French painter and draughtsman, a champion of academic art. Ingres' father was a minor painter and sculptor and, with parental encouragement, he displayed a talent for both drawing and music at a very early age. Opting for the former, he moved to Paris in 1797 and entered David's studio. There, inspired by his teacher and by Flaxman's engravings of antique vases, Ingres developed a meticulous Neo-classical style, notable for impeccable draughtsmanship and a smooth, enamel-like finish. This helped him to win the Prix de Rome in 1801 and brought him a succession of lucrative portrait commissions.

Ingres worked extensively in Italy after 1806, although he continued to exhibit at the Salon and rapidly became the epitome of the academic establishment. This was most obvious in the 1820s, when his pictures were contrasted with those of Delacroix, in the 'battle' between Classicism and Romanticism. While his style was a model of classical correctness, however, Ingres' subject matter was often distinctly Romantic. This is particularly evident in the exotic eroticism of Oriental scenes, such as *La Grande Odalisque* and *The Turkish Bath*.

MOVEMENT

Neoclassicism, Romanticism

OTHER WORKS

Madame Moitessier; The Apotheosis of Homer

INFLUENCES

David, Raphael, John Flaxman

Jean-Auguste-Dominique Ingres Born 1780

Painted in France and Italy

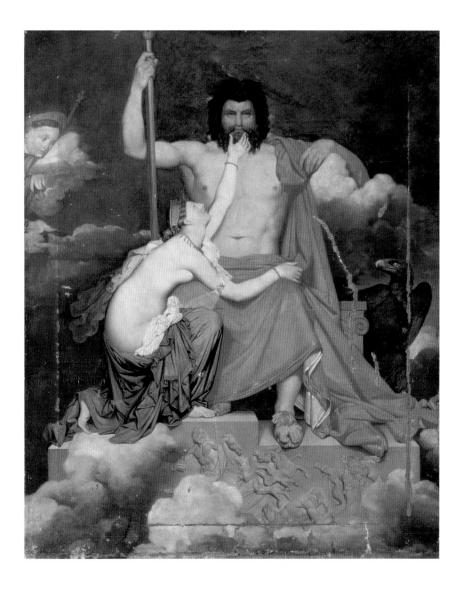

Cotman, John Sell

Fishing Boats off Yarmouth

Courtesy of Christie's Images/Bridgeman Art Library

John Sell Cotman received his art training in London before returning to his native Norwich in 1806, where he became the foremost watercolourist among the group of East Anglian artists who came to be known as the Norwich School. In the early years of the nineteenth century he travelled extensively in England and Wales and his best work belongs to this period. Although chiefly remembered for his work in this medium he also executed a number of fine oil paintings during the time he resided at Great Yarmouth from 1811–23. Failing in business, however, he was forced to sell all his paintings and etchings and return to London, where he obtained a position as drawing master at King's College. There is an uncompromisingly austere character to his landscapes, very much ahead of his time and not at all in step with the fashions prevailing in Regency England, but his handling of light and shade was to have a profound influence on his followers.

MOVEMENT

English Landscape School

OTHER WORKS

Greta Bridge; Chirk Aqueduct; Duncombe Park

INFLUENCES

Thomas Girtin, Turner

John Sell Cotman Born 1782, Norfolk, England

Painted in Norwich and London

Died 1842 London

Turner, J. M. W.

Farnley Hall from above Otley

Courtesy of Private Collection/Christie's Images

Joseph Mallord William Turner entered the Royal Academy School in 1789 and began exhibiting the following year. He travelled all over England, filling sketch-books with drawings of scenery and landmarks which would later provide the raw material for his oils and watercolours. He collaborated with Girtin on a three-year watercolour project but later turned to oils. After his first trip to Italy in 1819 his paintings showed a marked Classical influence, and following his second trip in 1829 his art entered its greatest phase with paintings such as *Rain* and *Steam and Speed* (1844), which were the precursors of Impressionism. A solitary, rather reclusive man who never married, Turner bequeathed over 300 oils and some 20,000 watercolours and drawings to the nation. A prolific artist, he ranks with Constable as one of the greatest British landscape painters of all time and his career marks a turning-point in the development of modern British art.

MOVEMENT

English School

OTHER WORKS

The Fighting Téméraire; Norham Castle; Sunrise with Sea Monsters

INFLUENCES

Claude Lorraine

J. M. W. Turner Born 1775 London, England

Painted in England

Died 1851 London

Friedrich, Caspar David

The Wanderer above the Sea of Clouds, 1818

Courtesy of Hamburg Kunsthalle, Hamburg, Germany/Bridgeman Art Library

Caspar David Friedrich studied drawing under J. G. Quistorp in Greifswald before going to the Copenhagen Academy between 1794–98. On his return to Germany he settled in Dresden, where he spent the rest of his life. His drawings in pen and ink were admired by Goethe and won him a Weimar Art Society prize in 1805. His first major commission came two years later in the form of an altarpiece for Count Thun's castle in Teschen, Silesia, entitled *Crucifixion in Mountain Scenery*. This set the tone of many later works, in which dramatic landscapes expressed moods, emotions and atmosphere. Appointed a professor of the Dresden Academy in 1824, he influenced many of the young German and Scandinavian artists of the mid-nineteenth century and as a result he ranks high among the formative figures of the Romantic movement. For many years his works were neglected, but in the early 1900s they were rediscovered and revived.

MOVEMENT

Romanticism

OTHER WORKS

The Wreck of the Hope; The Stages of Life; Graveyard in Snow

INFLUENCES

Albrecht Altdorfer, Turner

Caspar David Friedrich Born 1774 Germany

Painted in Dresden, Germany

Died 1840 Dresden

Girodet de Roussy-Trioson, Anne-Louis

Portrait of Mustapha, 1819

Courtesy of Musée Girodet, Montargis, France/Bridgeman Art Library

Versatile French painter and illustrator. Girodet was probably the illegitimate son of a Dr Trioson, adopting his surname in 1806. After a false start in architecture, he trained as a painter under David, rapidly becoming one of his most talented followers. Girodet won the Prix de Rome in 1789, working in Italy until 1795. His smooth, sculptural finish linked him with Neoclassicism, but his choice of subject matter became increasingly Romantic. He often opted for poetic, nocturnal themes or for literary subjects, such as Chateaubriand's story of Atala. More Romantic still was his most famous picture *Ossian*, which was commissioned for Bonaparte's country retreat at Malmaison. This exploited the contemporary craze for Celtic matters and depicted a misty scene with a bard-like figure welcoming Napoleon's generals into paradise. Girodet also produced coolly erotic nudes, which betrayed his fondness for Mannerist artists such as Correggio. Girodet had a waspish personality, which occasionally landed him in trouble. There were frequent clashes with David and his scurrilous portrait of Mademoiselle Lange created a public scandal. In later life, he inherited a considerable fortune and his artistic output diminished.

MOVEMENT

Neoclassicism, Romanticism

OTHER WORKS

The Entombment of Atala; Mademoiselle Lange as Danaë

INFLUENCES

David, Prud'hon, Correggio, Primaticcio

Anne-Louis Girodet de Roussy-Trioson Born 1767

Painted in France and Italy

Géricault, Théodore

Homme Nu a Mi-Corps (Man Naked to the Waist)

Courtesy of Private Collection/Christie's Images

Jean Louis André Théodore Géricault studied under Carle Vernet and Pierre Narcisse Guérin, although he was frequently at odds with the latter because of his passion for Rubens and his unconventional approach in interpreting nature. He made his debut at the Salan of 1812 with his spirited portrait of a cavalry officer on horseback, and followed this with the *Wounded Cuirassier* in 1814, subjects which were immensely popular at the height of the Napoleonic Empire. During the Hundred Days, he served as a volunteer in a Royalist regiment, witnessing soldiers and horses at close quarters. He travelled and studied in Italy from 1816–19, and on his return to Paris embarked on the large-scale works which established his reputation as one of the leading French Romantics. For an artist renowned for his equestrian subjects it is ironic that he died as the result of a fall from his horse.

MOVEMENT

Romanticism

OTHER WORKS

Officer of the Hussars; Coirse des Chevaux Libres

INFLUENCES

Carle Vernet, Pierre Narcisse Guérin

Théodore Géricault Born 1791 Rouen, France

Painted in Paris

Died 1824 Rouen

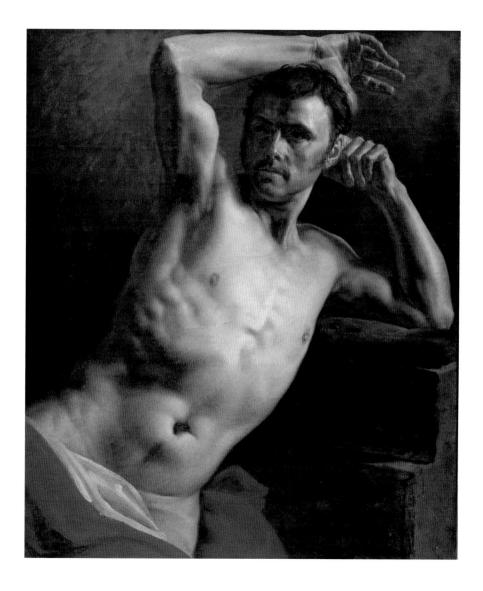

Wilkie, Sir David

The Death of the Red Deer, 1821

Courtesy of Private Collection/Christie's Images

The son of the parish minister of Cults in Fife, David Wilkie enrolled at the Trustees' Academy, Edinburgh in 1799 and was strongly influenced by Alexander Carse and David Allan, who were the first Scottish artists to paint scenes of peasant life. Wilkie frequented markets and country fairs, sketching the raw material for his great genre paintings. In 1805 he went to London and studied in the Royal Academy schools, making his debut in 1806 with *Village Politicians*. In 1830 he succeeded Sir Thomas Lawrence as Painter-in-Ordinary to King William IV and was knighted six years later. Wilkie did not flatter his sitters, but injected a note of realism into his portraiture, which had a marked effect on the next generation of British artists. His reputation rests mainly on his genre paintings, noted for their detail, somber colours and wry humour tinged with pathos.

MOVEMENT

British School

OTHER WORKS

Blind Fiddler; Rent Day, Card-players; The Penny Wedding

INFLUENCES

David Teniers, Adriaen van Ostade, David Allan

Sir David Wilkie Born 1785 Cults, Fife, Scotland

Painted in Scotland and England

Died 1841 off Gibraltar

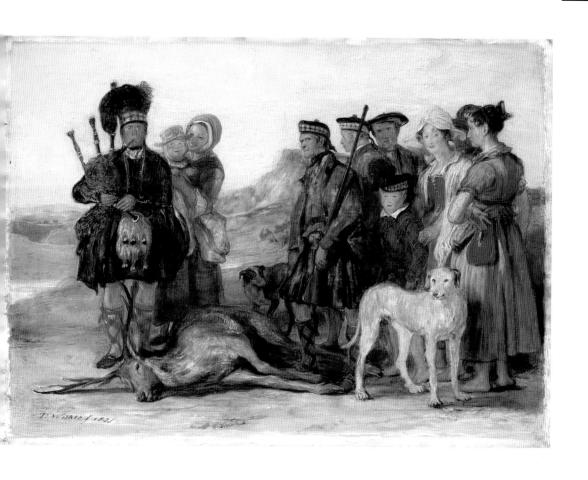

Hokusai, Katsushika

In the Well of the Great Wave, 1823-29

Courtesy of Private Collection/Christie's Images

Born at Edo (now Tokyo), the son of a mirror maker, Hokusai learned the craft of wood-engraving before entering the studio of the painter Katsugawa Shunsho. Disagreement with his master over artistic techniques and principles resulted in his dismissal in 1785. Thereafter he worked on his own as a book illustrator and print maker, using the Japanese techniques of block printing. His illustrations of everyday life executed for the encyclopaedic Mangwa established his reputation as the leading exponent of ukiyo-e ('pictures of the passing world') whose charm is exceeded only by their technical accomplishment. Of his prolific series of colour prints, the best known are *Thirty-six Views of Mount Fuji* (1823–29) and *Hundred Views of Mount Fuji* (1834–35), but he also produced several shorter sets and individual works. His prints had a tremendous impact on the Western world. Quite by chance, some of his prints were used as packing material for some china sent to Felix Bracquemond in 1856, triggering off the enthusiasm for Japanese art which strongly influenced the Impressionists.

MOVEMENT

Ukiyo-e

OTHER WORKS

The Dream of the Fisherman's Wife

INFLUENCES

Hishikawa Moronobu, Ando Hiroshige

Katsushika Hokusai Born 1760 Edo (now Tokyo), Japan

Pointed in Edo

Died 1849 Edo

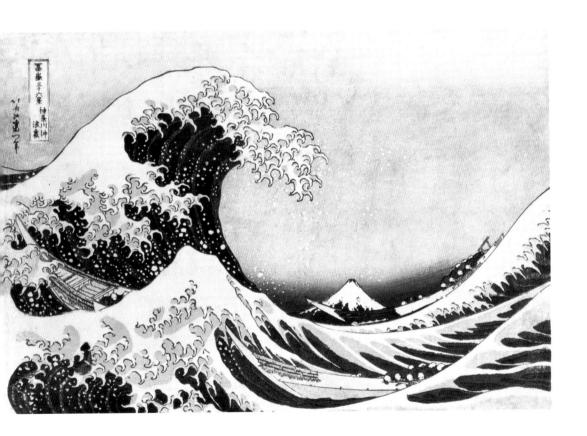

Bonington, Richard Parkes

Cottages by a Stream

Courtesy of Private Collection/Christie's Images

An English Romantic artist mainly active in France, Bonington was born near Nottingham and migrated to France with his family in 1817. He learned watercolour techniques from Louis Francia before completing his training under Antoine-Jean Gros at the École des Beaux-Arts. While in Paris, he met Eugene Delacroix, with whom he later shared a studio. Both men were greatly impressed by John Constable's exhibits at the 1824 Salon and they travelled together to England in the following year. By this stage, Bonington had already made his mark at the Salon, where he won a gold medal for his landscapes. These were acclaimed for their freshness, spontaneity and feeling for atmospheric effects — qualities which the artist had developed by making copious *pochades* (outdoor oil sketches). In addition to his landscapes, Bonington also produced a series of costume paintings illustrating picturesque anecdotes from British history.

Bonington's promising career was cut short by ill health. He contracted tuberculosis and died in London shortly before his twenty-sixth birthday.

MOVEMENTS

Romanticism

OTHER WORKS

Fish Market near Boulogne; Scene on the Coast of Picardy

INFLUENCES

Louis Francia, Eugene Delacroix, John Constable

Richard Parkes Bonington Born 1802

Painted in France, England, Italy and the Low Countries

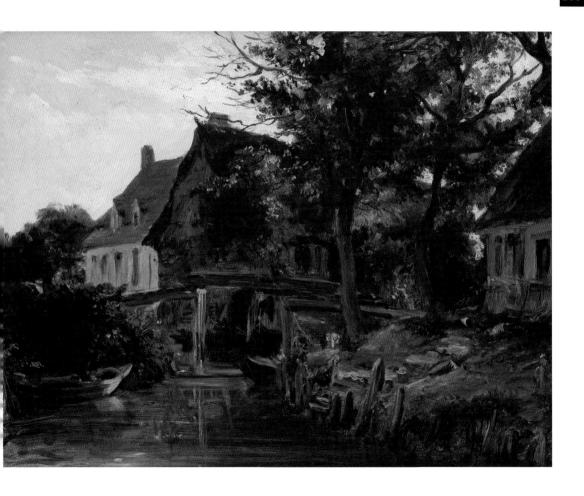

Cole, Thomas

Mountain Sunrise, 1826

Courtesy of Private Collection/Christie's Images

Born in Lancashire, England, Thomas Cole served his apprenticeship as an engraver of textile designs for calico printing. He emigrated with his family in 1818 and worked briefly as an engraver in Philadelphia before settling in Steubenville, Ohio, where he took lessons from an unknown travelling artist. In 1823 he returned to Philadelphia and enrolled at the Pennsylvania Academy of Fine Arts, then moved to New York in 1825. He began sketching along the Hudson River and through the Catskill Mountains, and his paintings of the American wilderness brought him fame and fortune. In 1829–32 he travelled all over Europe painting landscapes and classical ruins. On his return to New York he embarked on a colossal project – a series of large paintings that would chronicle the rise and fall of civilization. He took immense pride in his allegories and deprecated the landscapes which made his fortune and on which his reputation still rests.

MOVEMENT

Hudson River School

OTHER WORKS

Expulsion from the Garden of Eden; The Course of Empire

INFLUENCES

Washington Alliston

Thomas Cole Born 1801, Lancashire, England

Painted in North America and Europe

Died 1848 Catskill, New York, USA

Hiroshige, Ando

Nagakubo, c. 1830s

Courtesu of Private Collection/Christie's Images

Hiroshige's family name was Ando Tokitaro, but according to the custom of the time, his professional name was derived from the fact that he was a pupil of Toyohiro. He was a child prodigy, whose sketch of a procession, drawn at the age of 10, was regarded as one of the marvels of the Japanese capital in the early nineteenth century. On the death of his master in 1828, Hiroshige established his own studio but, discouraged by the lack of custom, he moved to Kyoto where he produced a series of landscapes. Returning to Edo (now Tokyo) he became immensely popular and widely imitated. His landscapes in the style of Hokusai (whom he greatly admired) were executed as prints with clearly incised lines and solid blocks of colour which featured every aspect of the scenery along the Tokaido road linking Edo to Kyoto, as well as landmarks in and around the cities where he worked.

MOVEMENT

Ukiyo-e

OTHER WORKS

Moonlight at Nagakubo; Fifty-Three Stages of the Tokaido

INFLUENCES

Hokusai

Ando Hiroshige Born 1797 Edo (Tokyo), Japan

Painted in Edo and Kyoto, Japan

Martin, John

Sunset over Rocky Bay, 1830

Courtesy of Private Collection/Christie's Images

John Martin trained as a heraldic painter in Newcastle, producing coats of arms for the nobility and gentry, and mainly worked in enamels to decorate their coach panels. Influenced by the flaming sunsets of his native Northumberland and inspired by the Book of Revelations and the apocalyptic poetry of Juhin Millun, Lie began creating vast paintings which captured the end of the world and earned for him the nickname of Mad Martin. He made his debut at the Royal Academy annual exhibition in 1812 with Sadak in Search of the Waters of Oblivion in which the hero appeared as a tiny figure at the foot of the canvas, overwhelmed by mountains and beetling crags suffused with fiery light. His later paintings have all the qualities of some Hollywood epic and had immense appeal to the English Romantics. He also illustrated editions of Milton and produced a series of biblical illustrations.

MOVEMENT

English Romantic School

OTHER WORKS

The Great Day of His Wrath; Eve of the Deluge; Belshazzar's Feast

INFLUENCES

Hieronymus Bosch

John Martin Born 1789 Northumberland, England

Painted in Northumberland and Isle of Man

Died 1854 Douglas, Isle of Man

Delacroix, Eugène

Le Puits de la Casbah Tanger

Courtesy of Private Collection/Christie's Images

A champion of the Romantic cause, Delacroix was legally the son of a politician but in reality he was probably the illegitimate child of Talleyrand, a celebrated diplomat. He trained under Guérin, a respected Neoclassical painter, but the dominant influence on his style came from Géricault, a fellow pupil. Delacroix watched the latter creating *The Raft of the Medusa*, one of the seminal works of the Romantic movement, and was overwhelmed by its raw, emotional power. He swiftly began to emulate this in his own canvasses, achieving his breakthrough with *The Massacre of Chios*.

Critics attacked Delacroix for his apparent fixation with violence and his lack of finish. They accused him of wallowing in scenes of brutality, rather than acts of heroism. In addition, they denounced his pictures as 'sketches', because he abandoned the smooth, linear finish of the Neoclassical style, preferring to build up his compositions with small dabs of colour. Like most Romantics, Delacroix was fascinated with the exotic but, unusually, he actually visited the Arab world. As a result, his Orientalist paintings were more sober and realistic than most European fantasies.

MOVEMENT

Romanticism

OTHER WORKS

The Massacre at Chios; Women of Algiers; The Death of Sardanapalus

INFLUENCES

Rubens, Géricault, Constable

Eugène Delacroix Born 1798

Painted in France, England, Morocco, Spain, Algeria

Landseer, Sir Edwin

Saint Bernard Dogs

Courtesy of Private Collection, Christie's Images

Edwin Henry Landseer was taught by his father to sketch animals from life. From the age of 13 he exhibited at the Royal Academy and became one of the most fashionable painters of the mid-Victorian period, specializing in pictures of dogs with humanoid expressions and deer, usually set in misty, romantic Highland glens or moorland made popular by the novels of Sir Walter Scott and Queen Victoria's passion for Balmoral. Landseer's paintings attained even wider prominence as a result of the fine engravings of them produced by his brother Thomas. One of the Queen's favourite artists, he was knighted in 1850. He modelled the four lions, cast in bronze, which sit at the foot of Nelson's Column in Trafalgar Square, London, unveiled in 1867. Landseer's posthumous reputation was dented by accusations of sentimentalizing animals and, in more recent years, of political incorrectness in glorifying blood sports, but he wielded enormous influence on a later generation of British artists.

MOVEMENT

English School

OTHER WORKS

Monarch of the Glen; The Old Shepherd's Chief Mourner

INFLUENCES

George Stubbs

Sir Edwin Landseer Born 1802 London

Painted in London

Died 1873 London

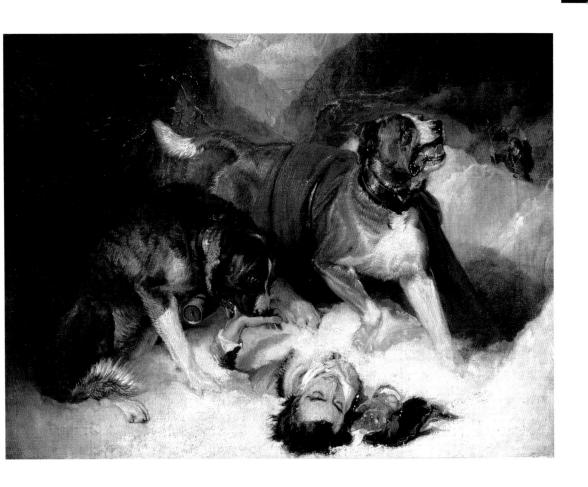

Johnston, Joshua

Portrait of Henry Long, c. 1814-16

© The Newark Museum/Art Resource, New York

Nothing is known of the birth or origins of Joshua Johnston and it is likely that he was born into slavery. He may have been a slave owned by the Peale family and perhaps received his artistic training from Charles Peale Polk, whose style he closely resembles. He first appears in the Baltimore directories in 1796, and by that time must have purchased his freedom. From then until 1824 he is listed as a limner or portrait painter, and many of his paintings are still in the possession of Baltimore's oldest families. He is regarded as the first African American to become a professional artist. The portraits have a curiously naive appearance, the figures very rigid, the faces expressionless with eyes staring straight off the canvas and tightly-pursed lips. What Johnston lacked in conveying the expression of his figures was compensated in the detail of clothing and furniture in the background, and the resulting portraits and groups have a definite charm.

MOVEMENT

American School of Portraiture

OTHER WORKS

Letitia Grace McCurdy; The Westwood Children

INFLUENCES

Charles Peale Polk, Charles Wilson Peale, Rembrandt

Joshua Johnston Born c. 1770

Painted in Maryland, USA

Died 1832 Baltimore, Maryland

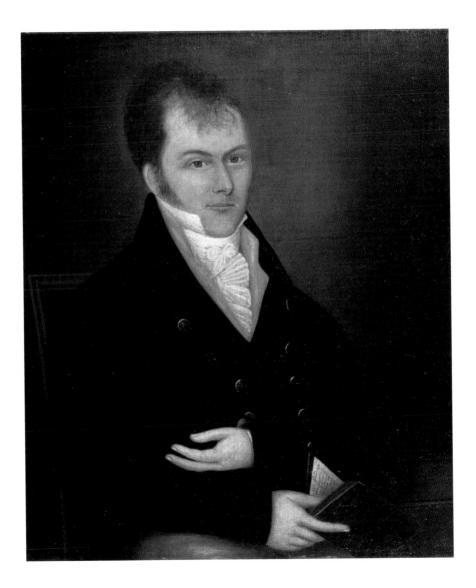

Bingham, George Caleb

Fur Traders Descending the Missouri, 1845

Courtesy of Metropolitan Museum of Art, New York/Bridgeman Art Library

One of the leading artists of the American West, George Caleb Bingham trained at the Pennsylvania Academy of Fine Arts in Philadelphia. His education was rounded off by a trip to Europe, followed by extensive travel round North America before he settled in Missouri, then on the western frontier. From here he explored the wilderness, recording landscape, sights and scenes of a rapidly vanishing way of life, although he is best remembered for his genre scenes of boatmen and trappers in Missouri. Regrettably he returned to Europe to improve his style, but the time spent in Düsseldorf had the opposite effect, stifling the homespun character of his painting with the rather stereotyped academicism of mid-nineteenth century Germany. As far back as 1848 he had been elected to the state legislature and by the time of the American Civil War he abandoned his palette altogether to concentrate on politics.

MOVEMENT

North American Frontier style

OTHER WORKS

Raftsmen Playing Cards; The Country Election

INFLUENCES

George Catlin, Seth Eastman

George Caleb Bingham Born 1811 Augusta, USA

Painted in Missouri, USA

Died 1879 Kansas City, USA

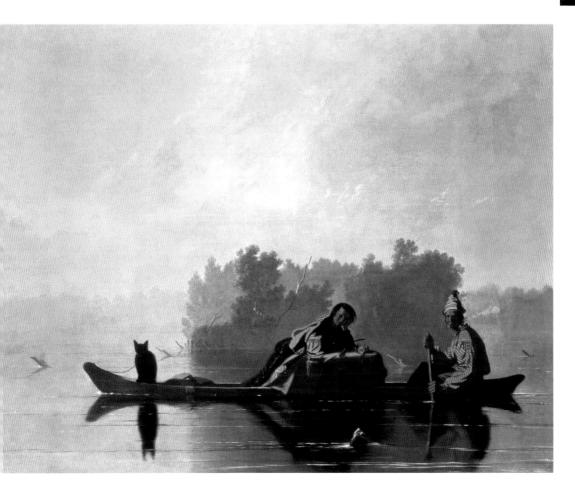

Rousseau, Théodore

A Wooded Landscape at Sunset with a Faggot Gatherer

Courtesy of Christie's Images

A French landscape painter, Rousseau is hailed as the leader of the Barbizon School. The son of a clothier, Rousseau developed a deep love of the countryside at an early age. After working briefly in a sawmill, he decided to take up landscape painting and trained with Joseph Rémond. The latter produced classical landscapes, however, and Rousseau's naturalistic tendencies were better served by the study of foreign artists, such as Ruisdael and Constable. He adopted the practice of making sketches outdoor - a foretaste of Impressionism - although he still preferred to finish his paintings in the studio.

Rousseau's favourite location was the Barbizon region, at the edge of the Forest of Fontainebleau. By the late 1840s, this area had become the focus for a group of like-minded artists known as the Barbizon School. Headed by Rousseau, this circle included Corot, Daubigny, Diaz and Millet. In the 1850s, Rousseau's work achieved widespread recognition, fetching high prices, but he preferred to remain in Barbizon, campaigning to preserve the character of the forest. He died in his cottage, in the arms of fellow landscapist Jean-François Millet.

MOVEMENT

Barbizon School

OTHER WORKS

Edge of a Forest – Sunset; Farm in the Landes

INFLUENCES

Jacob van Ruisdael, Constable

Théodore Rousseau Born 1812 Paris, France

Painted in France

Died 1867 Paris

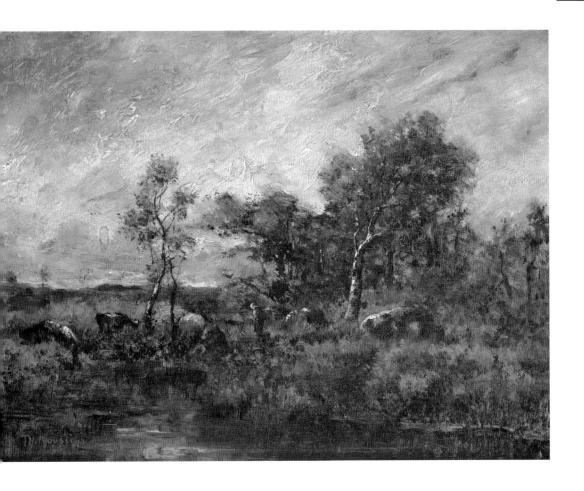

Duncanson, Robert

Fruit Piece, 1849

Courtesy of The Detroit Institute of Arts, USA/Bridgeman Art Library

Born in upstate New York, the son of a Canadian Scot and a black mother, Robert Stuart Duncanson was taken to Canada as a boy and raised there by his father. It is believed that he received part of his education in Scotland before returning to America in 1841, when he went to live with his mother in Cincinnati. He was by that time an accomplished artist who showed three of his paintings in the art exhibition of 1842. He was a skilled and versatile artist, equally proficient in portraits as in the landscapes for which he is famous. He was the first African American to become a professional painter, producing a wide range of work, from still life to genre subjects. A grant from the Anti-Slavery League enabled him to travel to Italy, France and England in 1853 to further his studies. He was also an early exponent of photography, which he used as an aid to his landscapes.

MOVEMENT

American School

OTHER WORKS

Mount Healthy; Ohio; Belmont Murals

INFLUENCES

Thomas Cole

Robert Duncanson Born c. 1817 New York USA

Pointed in Cincinnoti

Died 1872 Cincinnati

Delaroche, Paul

Napoleon Crossing the Alps, 1850

Courtesy of Private Collection/Christie's Images

A French painter and sculptor specializing in historical scenes, Delaroche trained initially as a landscapist but turned to figure painting in 1817 after failing to win the Prix de Rome. He entered the studio of Gros and began exhibiting at the Salon in the early 1820s – at the very time when the rivalry between Romanticism and Classicism was at its fiercest. Delaroche steered a middle course between these two extremes. His historical subjects, which aimed at poignancy rather than grandeur, were typical of the Romantics, but were handled in a bland academic manner.

Neoclassical painters had taken their historical themes from ancient Greece and Rome, but for the Romantics British subjects were more appealing. This was largely due to the popularity of the novels of Sir Walter Scott. Certain themes also had a particular resonance for French spectators. Cromwell was often seen as a forerunner of Napoleon, while the beheading of Lady Jane Grey evoked memories of the French Revolution. After Delaroche's death, his melodramatic style fell completely out of favour although, in recent years, his reputation has undergone a minor revival.

MOVEMENT

Romanticism

OTHER WORKS

The Death of Queen Elizabeth; The Princes in the Tower

INFLUENCES

Antoine-Jean Gros, Richard Parkes Bonington

Paul Delaroche Born 1797 France

Painted in France and Italy

19th Century

The Era of Impressionism

Krieghoff, Cornelius

Indian Hunter in the Snow, 1850s

Courtesy of Christie's Images/Bridgeman Art Library

Cornelius David Krieghoff was taught by his father, but in around 1830 he enrolled at the Academy of Fine Arts in Düsseldorf, Germany. Five years later he immigrated to the USA and joined the army, but in 1840 he settled in Montreal as a painter and musician. He later worked in Rochester, New York (1842–43) and studied in Paris (1844–45) before returning to Canada, where he worked at various times in Toronto, Montreal and Quebec City. From 1864 to 1867 he was in Paris and Munich, but continued to paint Canadian scenes there. Subsequently he worked in Quebec, concentrating on genre subjects. Though chiefly renowned for his landscapes, notably the panoramic murals in the Quebec Parliament building, he produced lively and colourful paintings of French-Canadian and Native American life in a style reminiscent of the seventeenth century Dutch masters, importing a romantic flavour which has never been equalled. He also painted portraits of leading Canadian figures.

MOVEMENT

Nineteenth Century Canadian School

OTHER WORKS

Merrymaking; Gentlemen's Sleigh; Lorette Falls near Quebec

INFLUENCES

Jacob van Ruysdael, Gerrit van Honthorst

Cornelius Krieghoff Born 1815 Holland

Painted in Canada and USA

Died 1872 Chicago, Illinois, USA

Courbet, Gustave

Bonjour Monsieur Courbet, 1854

Courtesy of Musée Fabre, Montpelier, France/Bridgeman Art Library

A French painter, Courbet was the leader of the Realist movement. Born at Ornans in the Jura region, Courbet remained fiercely loyal to this area throughout his life, featuring it prominently in his paintings. Although he later claimed to be self-taught, he actually studied under a succession of minor artists, but learned more from copying old masters in the Louvre. Initially, Courbet aimed for conventional success by exhibiting at the Salon, even winning a gold medal for his 1849 entry. After he showed *The Burial at Ornans*, however, official approval evaporated. Instead, this landmark realist picture was savagely criticized for being too large, too ugly and too meaningless. Worse still, in the light of the recent 1848 Revolution, the artist was suspected of having a political agenda.

Courbet revelled in the furore. In the following years, he gained greater recognition abroad, but remained antagonistic towards the French Establishment. He refused to exhibit at the 1855 World Fair, turned down the offer of a Legion of Honour and served as a Councillor in the Paris Commune. The latter proved his undoing and he was forced to spend his final years exiled in Switzerland.

MOVEMENT

Realism

OTHER WORKS

The Painter's Studio; The Bathers

INFLUENCES

The Le Nain brothers, Velázquez, Millet

Gustave Courbet Born 1819 France

Painted in France, Switzerland and Germany

Corot, Jean-Baptiste-Camille

Etretat Un Moulin à Vent, 1855

Courtesy of Private Collection/Christie's Images

Corot, a French painter, specialized in landscapes in the classical tradition. Born in Paris, Corot was the son of a cloth merchant and initially followed his father's trade. For a time, he worked at The Caliph of Bagdad, a luxury fabric shop. Turning to art, he trained under Michallon and Bertin, both of whom were renowned for their classical landscapes. Indeed, Michallon was the first winner of the Historical Landscape category in the Prix de Rome, when it was introduced in 1817. This genre, which Corot was to make his own, consisted of idealized views, set in the ancient, classical world, and was inspired by the 17th century paintings of Poussin and Claude Lorrain.

Corot's distinctive style stemmed from his unique blend of modern and traditional techniques. Each summer, he made lengthy sketching trips around Europe, working these studies up into paintings in the winter, in his Paris studio. He combined this traditional practice with a fascination for the latest developments in photography. The shimmering appearance of his foliage, for example, was inspired by the *halation* or blurring effects, which could be found in contemporary photographs.

MOVEMENT

Romanticism, Barbizon School

OTHER WORKS

The Bridge at Narni; Gust of Wind; Recollection of Mortefontaine

INFLUENCES

Achille-Etna Michallon, Claude Lorrain, Constable

Jean-Baptiste-Camille Corot Born 1796

Painted in France, Italy, Switzerland, England and the Low Countries

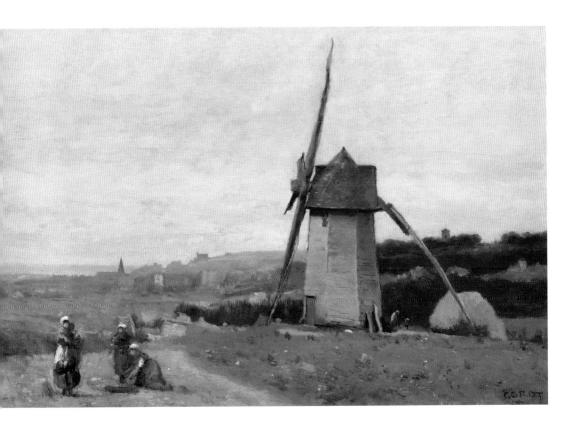

Daumier, Honoré

Deux Buveurs, c. 1857-60

Courtesy of Private Collection/Christie's Images

French graphic artist, painter and sculptor, noted above all for his stinging caricatures. Daumier had a deprived childhood, which fuelled the campaigning nature of much of his art. His first job, in a bailiff's office, also left him with a permanent loathing for lawyers and bureaucrats. After learning lithography, however, he was soon in great demand as a political cartoonist, working principally for *Le Charivari* and *La Caricature*. A scurrilous drawing of Louis-Philippe in the guise of Gargantua made Daumier notorious, and also earned him a spell of imprisonment. Undounted, he branched out into social satire, illustrating the foibles of contemporary society. During his lifetime, Daumier's paintings were virtually unknown and never provided him with a viable living. In their general outlook, as objective depictions of modern Parisian life, they can be linked with Courbet's Realist movement. Stylistically, however, Daumier was an isolated figure. His paintings were shaped by his graphic work, displaying a bold economy of form, subtle characterization and an overall lack of finish. In later years, his eyesight failed and he was only saved from absolute penury by the generosity of fellow painter, Corot.

MOVEMENT

Realism

OTHER WORKS

The Refugees; Chess Players; Ecce Homo

INFLUENCES

Charles Philipon, Gustave Courbet, Rembrandt

Honoré Daumier Born 1808 France

Painted in France

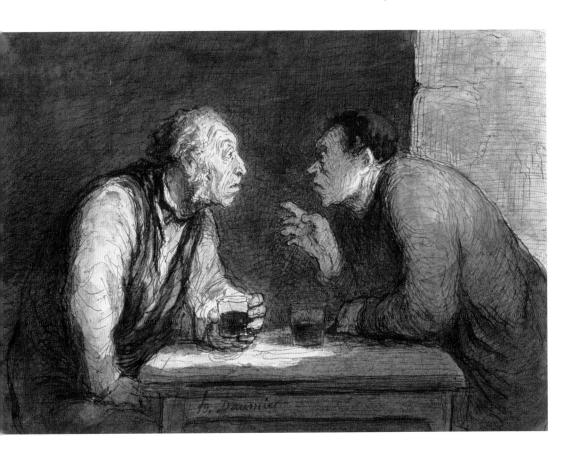

Doré, Gustave

The Beggar Children

Courtesy of Private Collection/Christie's Images

Doré was the most prolific and successful French illustrator of his age. Initially, he was drawn to caricature, spurred on by the encouragement of Philipon. As a teenager, Doré visited the Paris shop of this noted cartoonist and was briefly employed by him. He also began producing humorous drawings for *Le Journal pour Rire*. These precocious skills proved invaluable, when, following the death of his father in 1849 he became the family's main breadwinner.

Doré soon progressed to book illustrations. During the 1860s, his wood engravings for Dante's *Inferno* and Cervantes' *Don Quixote* made him famous. Stylistically, he owed much to the Romantics, excelling at depictions of the exotic and the macabre. This is particularly evident from his strange, glacial landscapes in the *Rime of the Ancient Mariner* and the grotesque beasts in the *Inferno*. Yet Doré could also be brutally realistic. His unflinching portrayal of the London slums attracted widespread praise and captured the imagination of the young Van Gogh. In later life, Doré produced some paintings and sculpture, but these are less highly regarded. His most successful venture in this field was the monument to his friend, the novelist Alexandre Dumas.

MOVEMENT

Romanticism

OTHER WORKS

London: A Pilgrimage

INFLUENCES

Charles Meryon, Grandville, Charles Philipon

Gustave Doré Born 1832, France

Worked in France and England

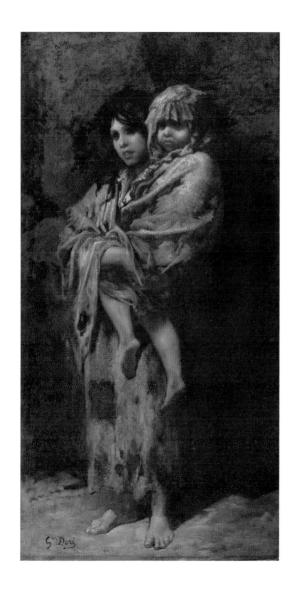

Millet, Jean-François

La Cardeuse, c. 1858

Courtesy of Private Collection/Christie's Images

Millet was born near the city of Cherbourg, which granted him a scholarship to train in Paris, under Delaroche. His early paintings were mainly portraits or pastoral idylls, but by the 1840s he was producing more naturalistic scenes of the countryside. These drew on his own experience, since he came from peasant stock, but the pictures disturbed some critics, because of their unalamorous view of rustic life.

In the 1850s Millet's work attracted genuine hostility. In part, this was due to fears that his paintings were political. Memories of the 1848 Revolution were still very fresh, and the authorities were nervous about any images with socialist overtones. Millet declined to express his political views, but *The Gleaners*, for example, was a compelling portrait of rural poverty. Some critics also linked his work with the Realist movement, launched by Courbet, which was widely seen as an attack on the academic establishment.

After 1849, Millet was mainly based at Barbizon, where he befriended Rousseau and other members of the Barbizon School. Under their influence, he devoted the latter part of his career to landscape painting.

MOVEMENTS

Naturalism, Barbizon School

OTHER WORKS

The Winnower; Man with a Hoe

INFLUENCES

Rousseau, the Le Nain brothers, Gustave Courbert

Jean-François Millet Born 1814 France

Painted in France

Died 1875 France

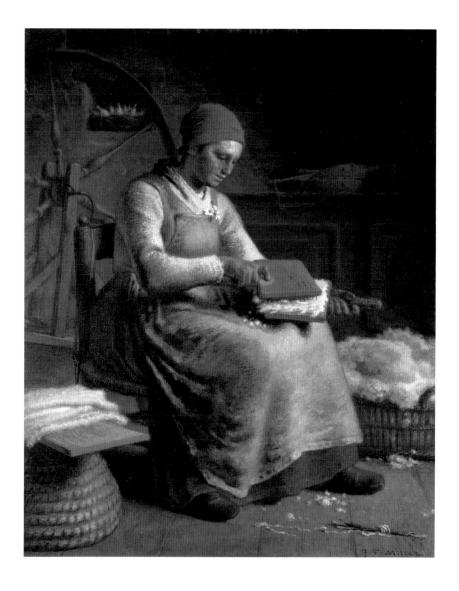

Brown, Grafton Tyler

(after) Gold Mining in California, 1861

Courtesy of Private Collection/Bridgeman Art Library

Grafton Tyler Brown was the first African American to work as a professional artist in California, where he settled in the 1850s. He worked as a draughtsman and later a lithographer for Kuchel & Dressel of San Francisco, but established his own company in 1867, producing lithographic views of buildings and landmarks, many of which appeared on stock certificates. In 1882 he took part in the Bowman geological survey of British Columbia, producing numerous sketches which he later reworked as watercolours. He lived in Portland, Oregon (1886–90) and from 1892 to 1897 was employed as a draughtsman by the United States Army Engineers in St Paul, Minnesota, where he died in 1918. His landscapes are very realistic and packed with detail, well deserving the comment by one early critic that he was 'the originator of intellectual and refined art'.

MOVEMENT

American Realism

OTHER WORKS

San Francisco

INFLUENCES

Northern Sung landscape artists of China

Grafton Tuler Brown Born 1841 Harrisburg, USA

Painted in San Francisco and St Paul USA

Died 1918 St Paul

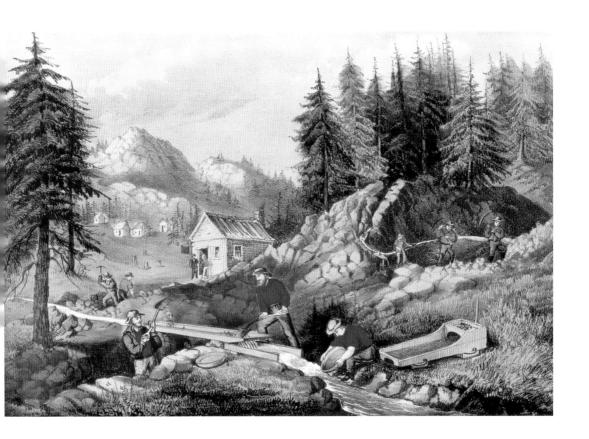

Linnell, John

Country Road, 1864

Courtesy of Private Collection/Christie's Images

John Linnell studied in London under John Varley and was also influenced by the Irish portraitist William Mulready, a fellow pupil though seven years older. In the early part of his career he worked mainly as a painter of portraits but later he turned to landscapes, especially after 1852 when he moved from London to Redhill in Surrey, where he spent the last 30 years of his long and very productive life. A prolific artist, his work often suffered from repetitiveness, largely due to his method of painting from various sketches and studies rather than direct from nature. But at his best, his landscapes remarkably evoked the spirit and atmosphere of the English countryside, especially his series of paintings showing harvesters towards sunset, when the skies were brilliantly lit by his bold use of colour. Skies are what Linnell did best and they give his landscapes their distinctive and immediately recognizable character.

MOVEMENT

English School

OTHER WORKS

The Last Gleam Before the Storm; View of Hanson Toot

INFLUENCES

John Varley, William Mulready

John Linnell Born 1792 London, England

Painted in London and Redhill

Died 1882 Redhill, England

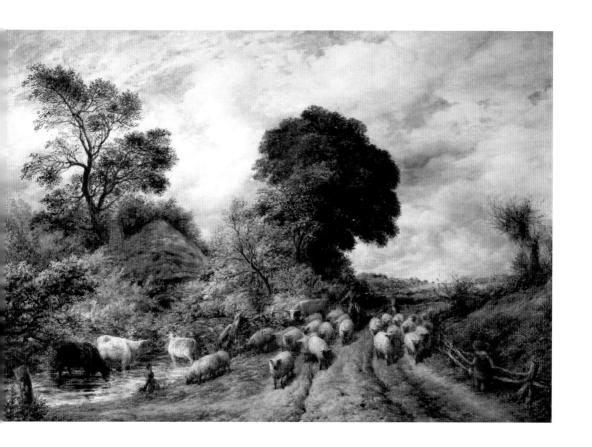

Palmer, Samuel

Illustrations to Milton's Lycidas, c. 1864

Courtesy of Private Collection/Christie's Images

Born in London, the son of an eccentric bookseller, Palmer revealed his artistic talent at a very early stage. In 1819, aged just 14, he exhibited at the Royal Academy and the British Institution, selling a painting at the latter. Three years later he met the painter John Linnell, who gave him some instruction. More importantly, perhaps, Linnell also introduced Palmer to William Blake – a meeting which only served to intensify the youngster's mystical outlook.

In 1824, the same year as his encounter with Blake, Palmer started painting at Shoreham in Kent. In this rural retreat, he began to produce the strange, pastoral idylls, which made his name. Using nothing more than ink and a sepia wash, he conjured up a worldly paradise, stocked with dozing shepherds, carefree animals and luxuriant foliage. In 1826, Palmer settled in Shoreham, where he was soon joined by a group of like-minded artists, who came to be known as the Ancients. Sadly, Palmer's period of poetic inspiration was short-lived. By the mid-1830s, his paintings had become disappointingly conventional, although his etchings retained some of his earlier, lyrical power.

MOVEMENTS

Romanticism, the Ancients

OTHER WORKS

The Sleeping Shepherd; Coming from Evening Church

INFLUENCES

William Blake, John Linnell, Edward Calvert

Samuel Palmer Born 1805 London, England

Painted in England and Italy

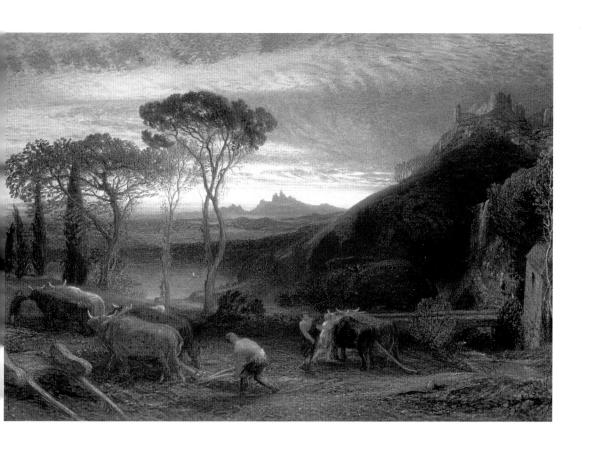

Rossetti, Dante Gabriel

Reverie, 1868

Courtesy of Christie's Images

Rossetti came from a hugely talented family. His father was a noted scholar while his sister Christina became a celebrated poet. For years Dante wavered between a career in art or literature, before devoting himself to painting. While still only 20, he helped to found the Pre-Raphaelite Brotherhood, the radical group that shook the Victorian art world with their controversial exhibits at the Royal Academy in 1848. The Pre-Raphaelites were appalled by the dominant influence of sterile, academic art, which they linked with the teachings of Raphael – then regarded as the greatest Western painter. In its place, they called for a return to the purity and simplicity of medieval and early Renaissance art.

Although championed by the critic Ruskin the Pre-Raphaelites' efforts were greeted with derision and this discouraged Rossetti from exhibiting again. During the 1850s, he concentrated largely on watercolours, but in the following decade he began producing sensuous oils of women. These were given exotic and mysterious titles, such as *Monna Vanna* and were effectively the precursors of the *femmes fatales*, which were so admired by the Symbolists.

MOVEMENT

Pre-Raphaelite Brotherhood

OTHER WORKS

Beata Beatrix; Proserpine

INFLUENCES

Ford Madox Brown, William Bell Scott

Dante Gabriel Rossetti Born 1828

Painted in England

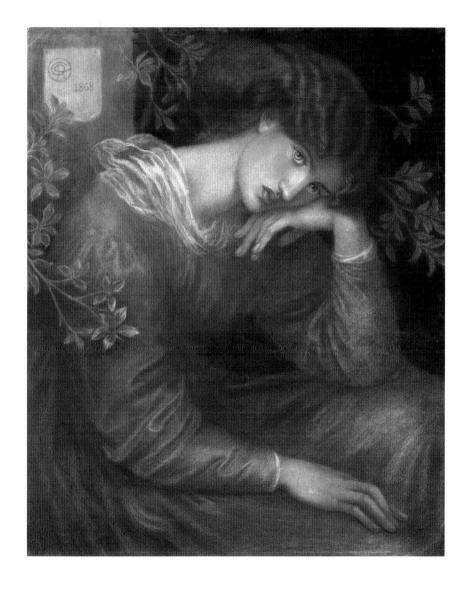

Burne-Jones, Sir Edward

The Prince Enters the Briar Wood, 1869

Courtesy of Private Collection/Christie's Images

Edward Coley Burne-Jones studied at Oxford where he met William Morris and Dante Gabriel Rossetti, who persuaded him to give up his original intention of entering holy orders and concentrate on painting instead. He was also heavily influenced by the art critic John Ruskin, who introduced him to the paintings of the Pre-Raphaelites and with whom he travelled to Italy in 1862. On his return to England he embarked on a series of canvasses that echoed the styles of Botticelli and Mantegna, adapted to his own brand of dreamy mysticism in subjects derived from Greek mythology, Arthurian legend and medieval romance. Burne-Jones, made a baronet in 1894, was closely associated with the Arts and Crafts movement, designing tapestries and stained glass for William Morris, as well as being a prolific book illustrator.

MOVEMENT

Romanticism and Mannerism

OTHER WORKS

King Cophetua and the Beggar Maid; The Beguiling of Merlin

INFLUENCES

Botticelli, Mantegna, Pre-Raphaelites

Sir Edward Burne-Jones Born 1833 Birmingham, England

Painted in England

Died 1898 London, England

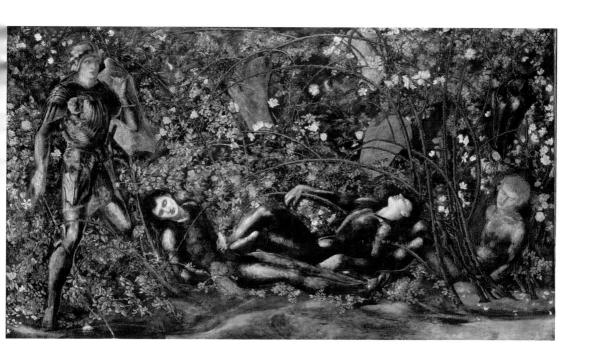

Whistler, James

Arrangement in Flesh Colour and Grey

Courtesy of Christie's Images

James Abbott McNeill Whistler was originally intended for a career in the army and studied at West Point from 1851 to 1854, then worked for a year as a Navy map-maker before going to Paris to take up art instead. He met Courbet and Fantin-Latour, and joined their group of Realist painters. He copied paintings in the Louvre and fell in love with Japanese art, which was then a novelty. In 1859 he settled in London, where he began painting in a style which combined these influences rather than following the English narrative convention. He strove to present a harmonious composition of tone and colour, doing in paint what a composer might do in music. This analogy was evident in the titles of these paintings, which Whistler called *Nocturnes*. Not surprisingly, his work got a very mixed reception, John Ruskin being his most vociferous critic and accusing him of "flinging a pot of paint in the public's face". Nevertheless his views gradually gained ground and influenced the next generation of British artists.

MOVEMENT

Realism

OTHER WORKS

Nocturne in Blue and Gold; Old Battersea Bridge

INFLUENCES

Gustave Courbet, Henri Fantin-Latour

James Whistler Born 1834 Massachusetts, USA

Painted in Paris and London

Died 1903 London

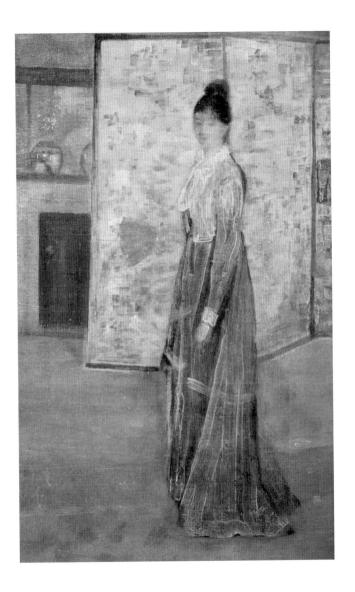

Homer, Winslow

Picking Flowers

Courtesy of Private Collection/Christie's Images

Born at Boston, Massachusetts, Winslow Homer served his apprenticeship there as a lithographer, but following the outbreak of the American Civil War he accompanied the Union forces and contributed sketches from the battlefront to Harper's Weekly as well as executing his earliest full-scale paintings, Home Sweet Home and Prisoners from the Front. He spent two years (1881–83) in England, mainly at Tynemouth, painting nautical subjects. Following his return to the USA he continued to paint the sea – apart from occasional genre subjects such as The Fox Hunt. During the last two decades of his life he lived at Prout's Neck on the coast of Maine, where he concentrated on watercolours of fishermen in the eternal struggle against the elements. Occasional forays to Florida, the Bahamas and Bermuda provided more exatic material but invariably with a maritime theme.

MOVEMENT

American School

OTHER WORKS

The Gulf Stream; Fishing Boats at Key West; Bearing Up

INFLUENCES

John Frederick Kensett, Fitz Hugh Lane

Winslow Homer Born 1836 Boston, USA

Painted in USA and England

Died 1910 Maine, USA

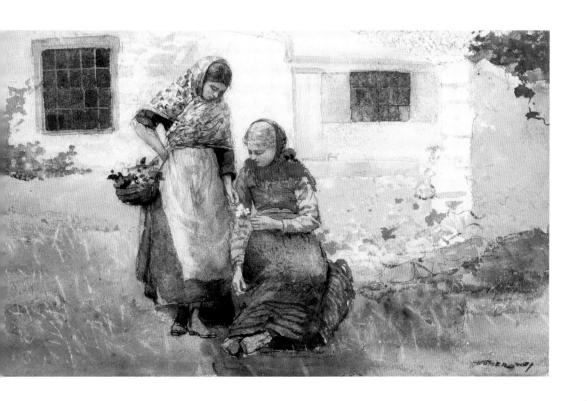

Morisot, Berthe

Enfant dans les Roses Trémières

Courtesy of Private Collection/Christie's Images

One of the leading female Impressionists. The daughter of a high-ranking civil servant, Morisot received art lessons from Corot. Then in 1859, she met Fantin-Latour, who would later introduce her to future members of the Impressionist circle. Before this, she had already made her mark at the Salon, winning favourable reviews for two landscapes shown at the 1864 exhibition. Conventional success beckoned, but a meeting with Manet in 1868 altered the course of Morisot's career. She was strongly influenced by his radical style, and appeared as a model in several of his paintings. For her part, she also had an impact on Manet's art, by persuading him to experiment with *plein-air* painting. The close links between the two artists were further reinforced when Morisot married Manet's brother in 1874.

Morisot proved to be one of the most committed members of the Impressionist group, exhibiting in all but one of their shows. She concentrated principally on quiet, domestic scenes, typified by *The Cradle*, which depicts her sister Edma with her newborn child. These canvasses displayed Morisot's gift for spontaneous brushwork and her feeling for the different nuances of light.

MOVEMENT

Impressionism

OTHER WORKS

Summer's Day; The Lake in the Bois de Boulogne

INFLUENCES

Manet, Renoir, Corot

Berthe Morisot Born 1841

Painted in France and England

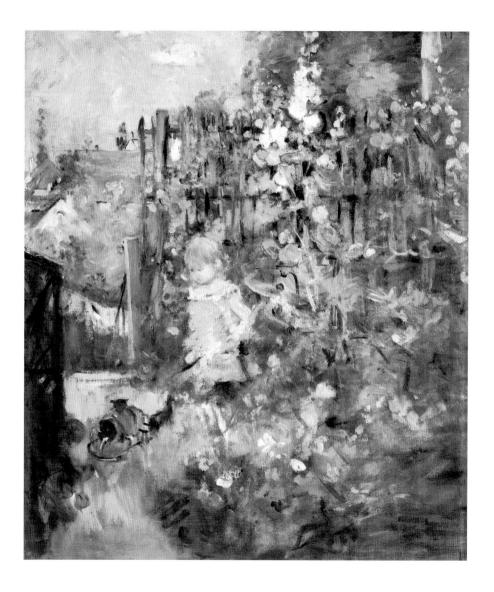

Eakins, Thomas

The Gross Clinic, 1875

Courtesy of Jefferson College, Philadelphia, PA, USA/Bridgeman Art Library

Thomas Eakins studied at the Pennsylvania Academy of Fine Arts and took anatomy at Jefferson Medical College before going to Paris to study under J. L. Gérôme and Léon Bonnat at the École des Beaux-Arts. On his return to Philadelphia in 1870 he established his studio, later working as Professor of Anatomy at the Pennsylvania Academy of Fine Arts. In addition to figures, he painted numerous genre scenes, such as *Chess Players*, which was critically acclaimed when exhibited at the Centennial Exposition of 1876. His greatest masterpiece, illustrated here, shows his mastery of portraiture and anatomy as the eminent surgeon Professor Gross demonstrates an operation to a group of medical students. Eakins also excelled as a sculptor and many of his paintings have a sculptural quality. He painted athletes and sportsmen, African Americans and rural subjects.

MOVEMENT

American School

OTHER WORKS

The Swimming Hole; Max Schmitt in a Single Scull

INFLUENCES

Jean Léon Gérôme, Léon Bonnat

Thomas Eakins Born 1844, Philadelphia, USA

Painted in Philadelphia and France

Bannister, Edward M.

Oak Trees, 1876

© Smithsonian American Art Museum, Washington, DC / Art Resource, New York

The son of a West Indian and a woman from Canada's Maritime provinces, Edward Mitchell Bannister moved to Boston in 1848, working as a ship's cook and then as a barber. In the 1850s he joined the Crispus Attucks Choir and the Histrionics Club, a black drama group. His marriage to Christiana Carteaux, who owned a chain of high-class hair salons, gave him the financial freedom to pursue his artistic interests and he became the first African American to attend art classes at the Lowell Institute. In 1870 the Bannisters moved to Providence, Rhode Island, where Bannister took a prominent role in the circle of artists influenced by the Barbizon School. He regarded the rural landscape as an affirmation of harmony and spirituality, although he did not carp at the advances of industrialization and painted such subjects with equal enthusiasm. In the last years of his life he produced a number of paintings of rural scenes and genre subjects.

MOVEMENT

American School

OTHER WORKS

Seaweed Gatherers; Dorchester, Massachusetts

INFLUENCES

Corot, Millet

Edward M. Bannister Born 1828 Canada

Painted in Boston, Providence and Rhode Island, USA

Died 1901 Providence

Rousseau, Henri

Vue de L'isle Saint-Louis, Prise du Port Saint-Nicolas Le Soir

Courtesy of Private Collection/Christie's Images

French painter, perhaps the most famous of all Noïve artists. Rousseau came from a poor background and he went through a succession of menial jobs, before turning to art late in life. Among other things he was a clerk, a soldier and a toll-collector. While working as the latter, he began painting as a hobby and, in 1893, he took early retirement, in order to pursue his artistic ambitions. Rousseau was entirely self-taught, although he did take advice from academic artists such as Clément and Gérôme. He copied many of the individual elements in his pictures from book illustrations, using a mechanical device called a pantograph. But it was his dreamlike combination of images and his intuitive sense of colour which gave his art its unique appeal. Rousseau began exhibiting his paintings from the mid-1880s, using avant-garde bodies such as the Salon des Indépendants, for the simple reason that they had no selection committee. He never achieved great success, but his guileless personality won him many friends in the art world, among them Picasso, Apollinaire and Delaunay. Posthumously, his work was an important influence on the Surrealists.

MOVEMENT

Naive Art

OTHER WORKS

Surprised! (Tropical Storm with a Tiger); The Sleeping Gypsy

INFLUENCES

Jean-Léon Gérôme, Félix Clément

Henri Rousseau Born 1844 France

Pointed in France

Died 1910 Paris, France

Degas, Edgar

Danseuses Vertes, 1878

Courtesy of Private Collection/Christie's Images

French painter and graphic artist, one of the leading members of the Impressionist circle. Originally destined for the law, Degas' early artistic inspiration came from the Neoclassical painter Ingres – who taught him the value of sound draughtsmanship – and from his study of the old masters. However, he changed direction dramatically after a chance meeting with Manet in 1861. Manet introduced him to the Impressionist circle and, in spite of his somewhat aloof manner, Degas was welcomed into the group, participating in most of their shows.

Degas was not a typical Impressionist, having little enthusiasm for either landscape or *plein-air* painting but he was, nevertheless, extremely interested in capturing the spontaneity of a momentary image. Where most artists sought to present a well-constructed composition, Degas wanted his pictures to look like an uncomposed snapshot; he often showed figures from behind or bisected by the picture frame. Similarly, when using models, he tried to avoid aesthetic, classical poses, preferring to show them yawning, stretching or carrying out mundane tasks. These techniques are seen to best effect in Degas' two favourite subjects: scenes from the ballet and horse-racing.

MOVEMENT

Impressionism

OTHER WORKS

The Dancing Class; Carriage at the Races; Absinthe

INFLUENCES

Jean-Auguste-Dominique Ingres, Edouard Manet

Edgar Degas Born 1834 France

Painted in France, USA and Italy

Manet, Edouard

La Rue Mosnier aux Drapeaux, 1878

Courtesy of Getty Museum/Christie's Images

Influential French painter, regarded by many as the inspirational force behind the Impressionist movement. Coming from a wealthy family, Manet trained under the history painter Couture, but was chiefly influenced by his study of the Old Masters, particularly Velázquez. His aim was to achieve conventional success through the Salon, but ironically two controversial pictures cast him in the role of artistic rebel. Le Déjeuner sur l'Herbe and Olympia were both updated versions of Renaissance masterpieces, but the combination of classical nudes and a modern context scandalized Parisian critics. This very modernity, however, appealed strongly to a group of younger artists, who were determined to paint scenes of modern life, rather than subjects from the past. This circle of friends who gathered around Manet at the Café Guerbois were to become the Impressionists.

Manet was equivocal about the new movement. He enjoyed the attention of his protégés, but still hoped for official success and, as a result, did not participate in the Impressionist exhibitions. Even so, he was eventually persuaded to try open-air painting, and his later pictures display a lighter palette and a freer touch.

MOVEMENTS

Realism, Impressionism

OTHER WORKS

A Bar at the Folies-Bergère

INFLUENCES

Velázquez, Gustave Courbet

Edouard Manet Born 1832 France

Painted in France

Died 1883 France

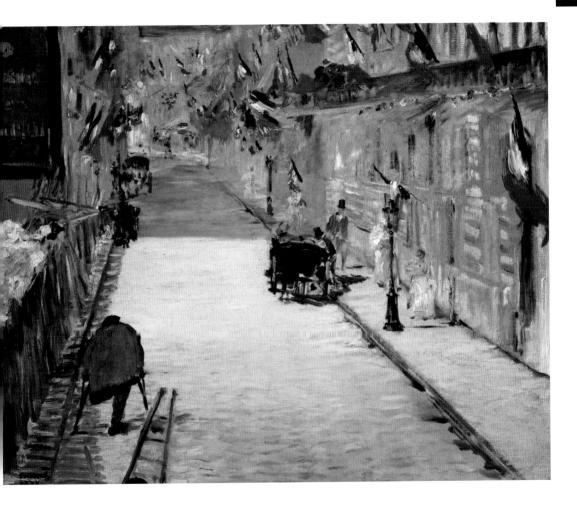

Renoir, Pierre-Auguste

Les Baigneuses

Courtesy of Private Collection/Christie's Images

French Impressionist. Born in Limoges, Renoir trained as a parcelain-painter before entering the studio of Gleyre in I 862. He learnt little from this master, but did meet future members of the Impressionist circle who were fellow-pupils. Together they attended the meetings at the Café Guerbois, where Manet held court. Initially, Renoir was particularly close to Monet and the pair often painted side by side on the River Seine. Although both were desperately poor, these early, apparently carefree pictures are often cited as the purest distillation of Impressionist principles.

Renoir participated at four of the Impressionist shows, but gradually distanced himself from the movement. This was partly because of his growing success as a portraitist, and partly because he had never lost his affection for Old Masters such as Rubens and Boucher. In the early 1880s, he reached a watershed in his career. He married Aline Charigot, one of his models, and travelled widely in Europe and North Africa, reaffirming his taste for the art of the past. In his subsequent work, he moved away from traditional Impressionist themes, concentrating instead on sumptuous nudes.

MOVEMENT

Impressionism

OTHER WORKS

The Luncheon of the Boating Party; The Bathers; The Umbrellas,

INFLUENCES

Monet, François Boucher, Rubens

Pierre-Auguste Renoir Born 1841 France

Painted in France

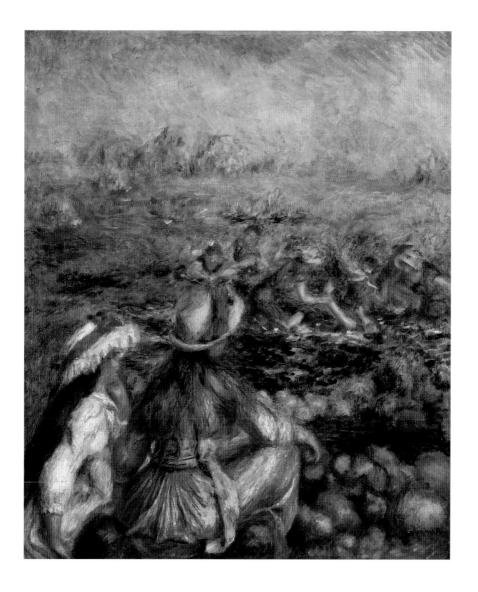

Ryder, Albert Pinkham

Sundown, 1880

Courtesy of Private Collection/Christie's Images

Albert Pinkham Ryder came from a long line of seafarers and whalers, but his formal education was terminated as a result of an illness which gravely affected his eyesight. It has been suggested that his dark, moonlit pictures and vague forms may have resulted from his impaired vision. To while away the time his father bought him paints and a few lessons from a local amateur got him started. Not until he moved to New York in 1867 was he able to improve his skills under William Edgar Marshall and four years later he succeeded at the second attempt in enrolling at the National Academy of Design. Although he visited Europe several times, neither the old masters nor contemporary artists had any influence on his work, which consisted mostly of small landscapes. In the 1880s he turned to more metaphysical paintings inspired by poetry and the Bible, becoming a recluse in his last years.

MOVEMENT

American Expressionism

OTHER WORKS

The Watering Place

INFLUENCES

William Edgar Marshall

Albert Pinkham Ryder Born 1847 USA

Painted in New Bedford and New York, USA

Died 1917 New Bedford

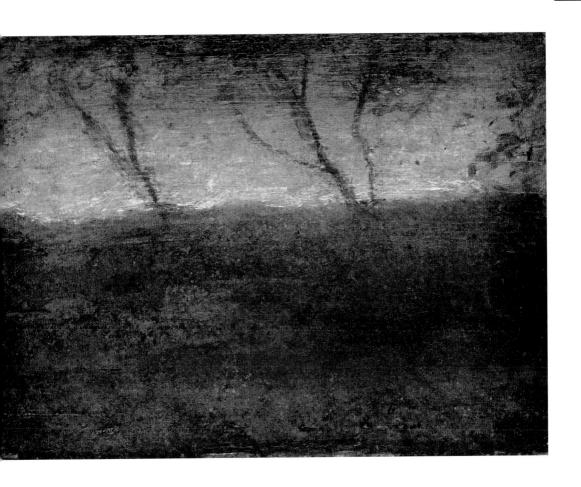

Sisley, Alfred

Le Barrage de Saint Mammes, 1885

Courtesy of Private Collection/Christie's Images

Born in Paris of English parents, Alfred Sisley had a conventional art education in Paris and at first was strongly influenced by Corot. In 1862 he entered the studio of Charles Gleyre, where he was a fellow pupil with Monet and Renoir, whom he joined on sketching and painting expeditions to Fontainebleau. The range of colours employed by Sisley lightened significantly under the influence of his companions. From 1874 onwards he exhibited regularly with the Impressionists and is regarded as the painter who remained most steadfast to the aims and ideals of that movement. The vast majority of his works are landscapes, drawing on the valleys of the Loire, Seine and Thames for most of his subjects. Sisley revelled in the subtleties of cloud formations and the effects of light, especially in the darting reflection of water. Hopeless at the business aspects of his art and largely dependent on his father for money, Sisley spent his last years in great poverty. Like Van Gogh, interest in his paintings only developed after his death.

MOVEMENT

Impressionism

OTHER WORKS

Wooden Bridge at Argenteuil; Snow at Veneux-Nadon

INFLUENCES

Corot, Paul Renoir, Monet, Charles Gleyre

Alfred Sisley Born 1839 Paris, France

Painted in France and England

Died 1899 Moret-sur-Loing, France

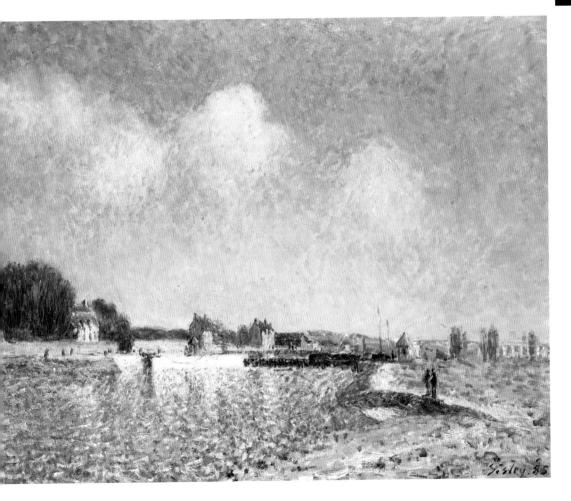

Alma-Tadema, Sir Lawrence

Roses of Heliogabalus, 1888

Courtesy of Private Collection/Christie's Images

Lawrence Alma-Tadema trained at the Antwerp Academy of Art and later studied under Baron Hendryk Leys, an artist noted for his large historical paintings. In 1863 Alma-Tadema went to Italy, whose classical remains, notably at Pompeii, exerted a great influence on him. He moved to England in 1870, where he built up a reputation for narrative paintings in the Classical style. He was knighted in 1899. Three years later he visited Egypt and the impact of Pharaonic civilization had a major impact on the works of his last years. His large paintings brought everyday scenes of long-dead civilizations vividly to life through his extraordinary mastery of detail. He amassed a vast collection of ancient artefacts, photographs and sketches from his travels; the visual aids that enabled him to recreate the ancient world.

MOVEMENT

Neoclassical

OTHER WORKS

The Finding of Moses; The Conversion of Paula

INFLUENCES

Baron Hendryk Leys

Sir Lawrence Alma-Tadema Born 1836 Dronrijp, Holland

Painted in Holland, England

Died 1912 Wiesbaden, Germany

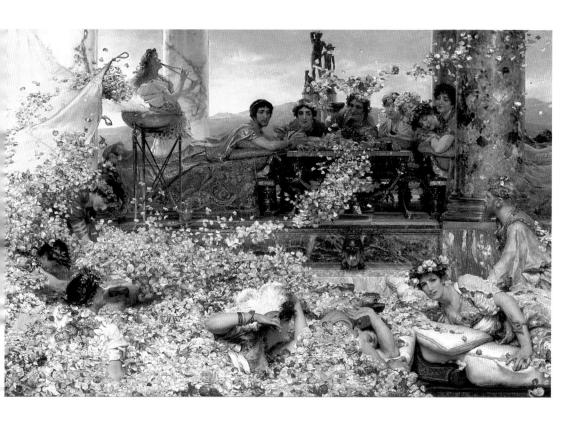

Pissarro, Camille

Jeune Paysanne à sa Toilette, 1888

Courtesy of Private Collection/Christie's Images

French painter, one of the founding fathers of Impressionism. Born at St Thomas in the West Indies, Pissarro was schooled in Paris and enjoyed a brief interlude in Venezuela, before eventually settling in France in 1855. There, he was initially influenced by Corot, whose landscapes he admired at the Universal Exhibition. He also studied at the Académie Suisse, where he met Monet, who introduced him to the future Impressionist circle at the Café Guerbois. Pissarro remained in close contact with Monet in 1870-71, when both men took refuge in London during the Franco-Prussian War.

Pissarro was slightly older than the other Impressionists and this, together with his ability as a teacher, enabled him to assume a guru-like authority within the group. In the mid-I 880s, Pissarro flirted briefly with Seurat's Neo-Impressionist techniques, before reverting to his traditional style. In later years, he had increasing trouble with his eyesight and could no longer paint out of doors. Instead, he took to painting lively street scenes from rented hotel rooms. His son Lucien also became a successful artist.

MOVEMENT

Impressionism

OTHER WORKS

View of Pontoise: A Road in Louveciennes: Red Roofs

INFLUENCES

Corot, Monet, Seurat

Camille Pissarro Born 1830

Painted in France, England and Venezuela

Sargent, John Singer

Women at Work

Courtesy of Private Collection/Christie's Images

Born of American parents in Florence, Italy, John Singer Sargent was brought up in Nice, Rome and Dresden – giving him a rather sporadic education but a very cosmopolitan outlook. He studied painting and drawing in each of these cities, but his only formal schooling came at the Accademia in Florence, where he won a prize in 1873, and in the studio of Carolus-Duran in Paris (1874). In 1876 he paid the first of many trips to the USA, re-affirming his American citizenship in that Centennial year. He painted landscapes, but it was his early portraits that earned him acclaim. However, the scurrilous treatment of him by the French press over a décolleté portrait of Madame Gautreau induced him to leave France in 1885 and settle in London, where he spent most of his life. As well as portraits he produced large decorative works for public buildings from 1910 onwards. Some of his most evocative paintings were produced as a war artist in 1914–18.

MOVEMENT

Anglo-American School

OTHER WORKS

The Lady of the Rose; Carmencita; Gassed

INFLUENCES

Carolus-Duran, Frans Hals, Velázquez

John Singer Sargent Born 1856 Florence, Italy

Painted in France, England and USA

Died 1925 London, England

Millais, Sir John Everett

Sweet Emma Morland, 1892

Courtesy of Private Collection/Christie's Images

English painter and illustrator, a founding member of the Pre-Raphaelite Brotherhood. Born in Southampton, Millais was a child prodigy and, at the age of 11 became the youngest-ever pupil at the Royal Academy Schools. With Rossetti and Hunt, he formed the nucleus of the Pre-Raphaelite Brotherhood. His *Christ in the Carpenter's Shop* was pilloried by the critics, although his work was vigorously defended by John Ruskin. Millais' relations with this influential critic were initially very cordial, until he fell in love with Ruskin's wife, Effie.

Millais' rift with the art establishment did not last long. He continued painting dreamy Pre-Raphaelite themes until around 1860, but found that they did not sell well and took too long to complete. So gradually he adopted a more commercial style and subject matter, specializing in imposing portraits, sentimental narrative pictures and mawkish studies of children. He also became a prolific book illustrator. This approach won Millais many honours – he was raised to the peerage and became President of the Royal Academy – but damaged his long-term artistic reputation.

MOVEMENT

Pre-Raphaelite Brotherhood

OTHER WORKS

Ophelia; Sir Isumbras at the Ford; Bubbles

INFLUENCES

William Holman Hunt, Dante Gabriel Rossetti

Sir John Everett Millais Born 1829 England

Painted in England and Scotland

Died 1896 London, England

Von Menzel, Adolph

Auf der Fahrt durch Schone Natur, 1892

Courtesy of Private Collection/Christie's Images

The son of a schoolmaster and lithographer, Adolph von Menzel was taught by his father and made his debut at an exhibition in Breslau in 1828 with a drawing of a tigress. The family moved to Berlin in 1830, where Adolph was employed in his father's business as a draughtsman and book illustrator. At the Berlin Academy show (1833) he exhibited illustrations for the works of Goethe. Later he produced a series showing the uniforms of the Prussian army and woodcut engravings of historical subjects. Inspired by the French Revolution of 1848 he painted his first great historic work, *The Lying in State of the March Fallen* – the first German political painting. Later he produced numerous portraits and historical scenes and was employed as a war artist during the Seven Weeks' War (1866) and the Franco-German War (1870–71), for which he was awarded the Ordre Pour le Mérite, Prussia's highest decoration. A pillar of the establishment, he influenced the heroic style of German pointing in the late nineteenth century.

MOVEMENT

German Romanticism

OTHER WORKS

Chess Players; Coronation of Wilhelm I in Königsberg

INFLUENCES

Claude Monet

Adolph von Menzel Born 1815 Breslau, Germany (now Wroclaw, Poland)

Painted in Berlin

Died 1905 Berlin

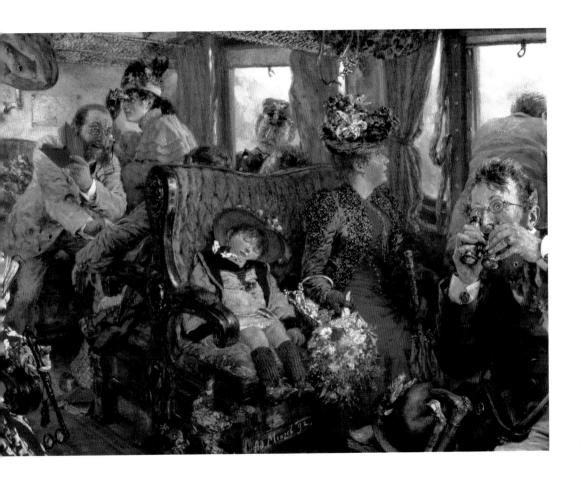

Waterhouse, John William

Ophelia, c. 1894

Courtesy of Private Collection/Christie's Images

An English painter, John Waterhouse's dreamy mythological paintings represent one of the last flowerings of Romanticism in Britain. Born in Rome, the son of a minor artist, Waterhouse moved to England with his family in 1854. He trained at the Royal Academy Schools and began exhibiting there in 1874. Initially, he painted in a traditional, academic vein, specializing in decorative, classical themes, which recall the work of Alma-Tadema and Leighton. By the late 1880s, however, elements of Symbolism and plein-air painting began to enter his work.

The pivotal work in Waterhouse's career was *The Lady of Shalott*. Painted in 1888, this was a typically Pre-Raphaelite subject – the kind of theme which he favoured increasingly, in his later years. The style, however, was more modern. The landscape background, in particular, displays a freshness and a robust handling, which underlines Waterhouse's links with the Newlyn School and his debt to continental, *plein-air* painting. During the same period, he also began to paint sirens, mermaids and other *femmes fatales*, drawing his inspiration from the French Symbolists.

MOVEMENTS

Late Romantic, Symbolism

OTHER WORKS

Hylas and the Nymphs; St Eulalia; Echo and Narcissus

INFLUENCES

Frederic Leighton, Alma-Tadema, Sir Edward Burne-Jones

John William Waterhouse Born 1849

Painted in England and Italy

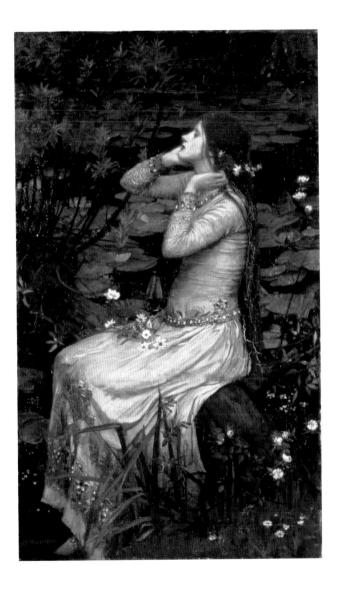

Liebermann, Max

Bathers on the Beach at Scheveningen, c. 1897–98

Courtesy of Private Collection/Christie's Images/© DACS 2002

After his early training in Weimar, Germany, Max Liebermann continued his studies in Amsterdam and Paris, one of the first German artists of his generation to go abroad and come under the influence of foreign painters – in his case Courbet, Millet and the Barbizon School. Returning to Germany in 1878 Liebermann quickly established himself as the leading Impressionist, noted for his canvasses of mundane subjects in which elderly people and peasants predominate, although he also produced some noteworthy paintings of more sophisticated subjects, especially the outdoor cafés.

Liebermann played a major role in the establishment of the Berlin Secession in 1899. A major innovator in his heyday, he failed to move with the times and was later eclipsed by the younger avant-garde artists, led by Emil Nolde. Nevertheless, he remained a highly influential figure in German art, where the fashion for the heroic and romantic assured his works a substantial following.

MOVEMENT

German Impressionism

OTHER WORKS

The Parrot Keeper; Haarlem Pig Market

INFLUENCES

Courbet, Millet

Max Liebermann Born 1847 Berlin, Germany

Painted in France, Holland and Germany

Died 1935 Berlin

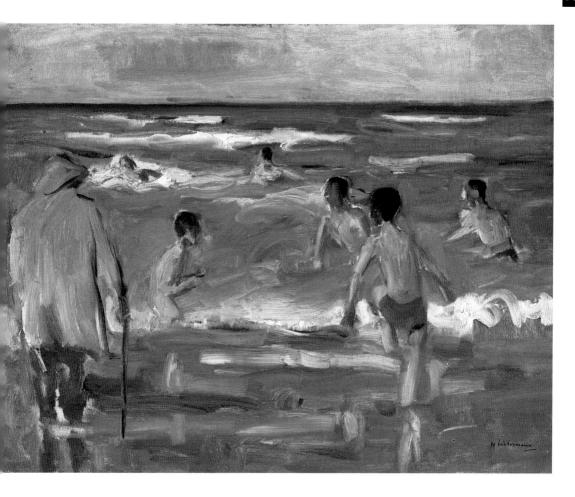

Tanner, Henry Ossawa

Moroccan Man

Courtesy of Private Collection/Christie's Images

Henry Ossawa Tanner was educated in Philadelphia, where his father was bishop of the African Methodist Church. Against strong parental opposition he decided to pursue a career in art, enrolling at the Pennsylvania Academy of Fine Arts and studying under Thomas Eakins, who also taught him photography. In 1888 Tanner moved to Atlanta, Georgia and opened a photographic studio, but the business failed and he scraped a living as a part-time art teacher, supplementing his meagre salary by painting portraits. In 1891 he moved to Paris, where he continued his studies at the Académie Julien and later travelled round the Middle East gaining material for his religious paintings. He continued to live mainly in Paris, working for the Red Cross in World War I and becoming a Chevalier of the Legion d'Honneur.

MOVEMENT

Modern American School

OTHER WORKS

Daniel in the Lions' Den; The Disciples of Emmaus

INFLUENCES

Thomas Eakins, Benjamin Constant, Jean-Paul Laurens

Henry Ossawa Tanner Born 1859 USA

Painted in USA, France and Middle East

Died 1937 Paris, France

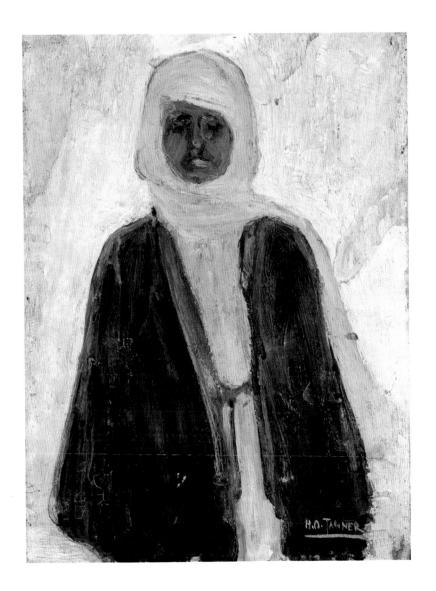

Lavery, Sir John

The French Consulate, The Grand Canal, Venice

Courtesu of Private Collection/Christie's Images/Bu Courtesu of Felix Rosentiel's Widow & Son Ltd, London on behalf of the Estate of Sir John Lavery

Orphaned at the age of three, John Lavery, born in Belfast, was raised by relatives in Scotland and began his artistic career retouching photographs. When his studio burned down he used the insurance money to acquire an artistic education in London and Paris. Returning to Glasgow in 1885 he founded the group known as the Glasgow School, which promoted the techniques of French Impressionism in Britain. He excelled in landscapes and genre subjects but it was his skill as a portraitist that earned him his biggest commission, to paint the visit of Queen Victoria in 1888, a task that involved over 250 sitters and took two years to complete. The most cosmopolitan British artist of his generation, he spent much of his time in Brittany. He was knighted in 1918 but later devoted much of his energies to promoting better relations between Ireland and Britain. His portrait of his wife Hazel adorned Irish banknotes for many years.

MOVEMENT

Modern British School

OTHER WORKS

The Unfinished Harmony; George Bernard Shaw

INFLUENCES

Pre-Raphaelites, French Impressionists

Sir John Lavery Born 1856 Belfast, Ireland

Painted in Britain, France, Ireland and USA

Died 1941 Kilkenny, Ireland

Cassatt, Mary

The Young Mother, 1900

Courtesy of Private Collection/Christie's Images

Mary Cassatt studied art at the Pennsylvania Academy of Art in Philadelphia from 1861 to 1865, but after the American Civil War she travelled to Europe, continuing her studies in Spain, Italy and the Netherlands before settling in Paris, where she became a pupil of Edgar Degas. Her main work consisted of lithographs, etchings and drypoint studies of genre and domestic subjects which often reflect her interest in Japanese prints; but her reputation now rests on her larger works, executed in pastels or oils, which explore the tender relationship between mother and child, although her mastery of technique (which owed much to her original teacher, Thomas Eakins) prevented her from descending into the banal or mawkish. After her death in Paris in 1926 her work was neglected for some time, but in more recent years it has been the subject of re-appraisal and her realistic but sensitive portraiture of women, girls and young children is now more fully appreciated.

MOVEMENT

Impressionism

OTHER WORKS

Mother and Child; Woman Sewing

INFLUENCES

Thomas Eakins, Degas

Mary Cassatt Born 1844 Pennsylvania, USA

Painted in USA and France

Died 1926 Paris, France

Hunt, William Holman

Master Hilary – The Tracer, 1900

Courtesy of Private Collection/Christie's Images

English painter; one of the founders of the Pre-Raphaelite movement. Born in London, the son of a warehouse manager, Hunt worked as a clerk before entering the Royal Academy School in 1844. There, he met Millais and, together with Rossetti, they formed the core of the Pre-Raphaelite Brotherhood. Hunt's meticulous attention to detail and his fondness for symbolism accorded well with the aims of the group, but his deeply felt religious convictions led him away from the British art scene. In January 1854, he embarked on a two-year expedition to Egypt and the Holy Land, believing that this was the only way to produce realistic images of biblical themes.

The critical response to this enterprise was mixed. The Scapegoot was greeted with puzzlement, but The Finding of the Saviour in the Temple was received far more enthusiastically, securing Hunt's reputation as a religious painter. Further trips to the East followed, although these were not always happy affairs. In 1866, his wife died in Florence, shortly after giving birth to their son. Hunt later married her sister. In 1905, he wrote his memoirs, which have become a primary source document for the Pre-Raphaelite movement.

MOVEMENT

Pre-Raphaelite Brotherhood

OTHER WORKS

The Hireling Shepherd; The Light of the World

INFLUENCES

Dante Gabriel Rossetti, Augustus Egg, John Everett Millais

William Holman Hunt Born 1827

Painted in England, Egypt and the Holy Land

Late 19th Century

The Era of Post-Impressionism

Seurat, Georges

Les Poseuses, 1887-88

Courtesy of Private Collection/Christie's Images

Georges Pierre Seurat studied at the École des Beaux-Arts and was influenced by the precise draughtsmanship of Ingres, as well as with Chevreul's theories on colour. He combined the Classicist tradition with the newer ideas of the Impressionists. In particular, he painted in a very distinctive style using a multitude of different coloured dots to build up the impression of the subject, much as the half-tone process or multicolour photogravure use a screen of dots of varying intensity and depth to achieve the overall image. This extremely precise method he termed divisionism, and it was instrumental in the subsequent development of pointillism. There is not much evidence of this technique, however, in his first major work depicting bathers at Asnières (1884), but it became almost a trade mark in his later paintings. Always meticulous in the execution of his work, Seurat was also painstaking in the preparation, often spending months on preliminary sketches for each canvas.

MOVEMENT

French Impressionism

OTHER WORKS

The Can-Can; Sunday Afternoon on the Island of the Grande Jatte

INFLUENCES

Ingres, Eugène Chevreul

Georges Seurat Born 1859 Paris, France

Painted in France

Died | 89 | Paris

Gogh, Vincent van

Portrait de L'artiste sans Barbe, 1889

Courtesy of Private Collection/Christie's Images

A leading Post-Impressionist and forerunner of Expressionism. Vincent's first job was for a firm of art dealers, but he was sacked after a failed affair affected his ability to work. After a brief stint as a teacher, he became a lay preacher in a Belgian mining district. Here again he was fired when the Church became concerned at his over-zealous attempts to help the poor. Vincent had at least found his true vocation: illustrating the plight of the local peasantry.

Previously influenced by Millet, in 1886 Van Gogh went to Paris where his style changed dramatically. Under the combined impact of Impressionism and Japanese prints, his palette lightened and he began to employ bold simplifications of form. Like Gauguin, he also used colours symbolically, rather than naturalistically. With financial help from his brother, Theo, Vincent moved to the south of France. Gauguin joined him but the pair soon clashed, hastening Van Gogh's mental collapse. Despite his illness he continued working at a frenzied pace until his suicide in July 1890. Van Gogh sold only one painting in his lifetime, but his work has since become the most popular and sought-after of any modern artist.

MOVEMENT

Post-Impressionism

OTHER WORKS

A Starry Night; Sunflowers; The Potato Eaters

INFLUENCES

Jean-François Millet, Louis Anquetin, Gauguin

Vincent van Gogh Born 1853

Painted in France, Holland and Belgium

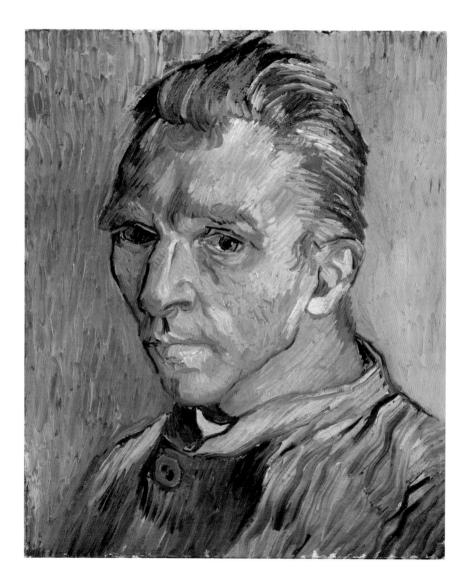

Toulouse-Lautrec, Henri de

Moulin Rouge - La Goulue, 1891

Courtesy of Christie's Images

Henri Marie Raymond de Toulouse-Lautrec-Monfa was the scion of one of France's oldest noble families who had been rulers of Navarre in the Middle Ages. Henri was a chronically sick child whose legs, broken at the age of 14, stopped growing and left him physically deformed. In 1882 he went to Paris to study art and settled in Montmartre, where he sketched and painted the cabaret performers, can-can dancers, clowns, barmaids and prostitutes, although occasionally he painted more conventional subjects as well. He played a prominent part in raising the lithographic poster to a recognized art form. He worked rapidly and feverishly from life, seldom using posed models. He belonged to the artistic milieu in which Impressionists and Post-Impressionists mingled and both schools left their mark on his work. Alcoholism led to a complete breakdown and confinement in a sanatorium (1899) but he recovered sufficiently for a last frenzied bout of hard work.

MOVEMENT

Post-Impressionism

OTHER WORKS

At the Moulin Rouge; The Bar; At the Races; Jane Avril

INFLUENCES

Degas

Henri de Toulouse-Lautrec Born 1864 France

Painted in Paris

Died 1901 Paris

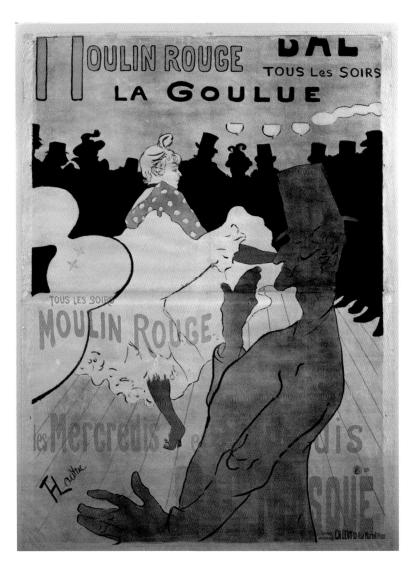

Cézanne, Paul

Still Life with Apples, 1893-94

Courtesy of Private Collection/Bridgeman Art Gallery/Christie's Images

French painter, a leading member of the Post-Impressionists. Born in Aix-en-Provence, the son of a banker, Cézanne's prosperous background enabled him to endure the long struggle for recognition. He studied in Paris, where he met the future members of the Impressionist circle, although his own work at this time was full of violent, Romantic imagery. Cézanne did not mix easily with the group; he was withdrawn, suspicious and prey to sudden rages. Gradually, with Pissarro's encouragement, he tried *plein-air* painting and participated at two of the Impressionist exhibitions. But, in art as in life, Cézanne was a solitary figure and he soon found the principles of the movement too restricting.

After his father's death in 1886, Cézanne returned to Aix, where he brought his style to maturity. His aim was to produce 'constructions after nature'. He followed the Impressionist practice of painting outdoors but, instead of the transient effects which they sought, he tried to capture the underlying geometry of the natural world. This was to make him a fertile source of inspiration for the Cubists.

MOVEMENT

Post-Impressionism

OTHER WORKS

Mont Sainte-Victoire; Apples and Oranges; The Card Players

INFLUENCES

Delacroix, Courbet, Pissarro

Paul Cézanne Born 1839 France

Painted in France

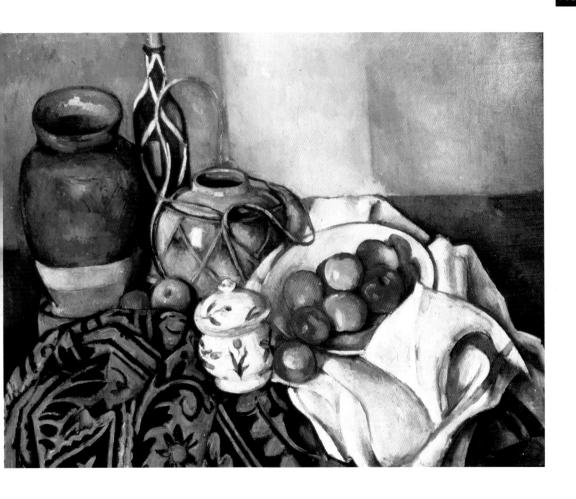

Munch, Edvard

The Scream, 1893

Courtosy of Nasuonal Galleriet, Oslo/Bridgeman/Christie's Images/@ Munch Museum/Munch - Ellingsen Group; BONO, Oslo and DACS, London 2002

Edvard Munch studied in Christiania (now Oslo) and travelled in Germany, Italy and France before settling in Oslo. During his time in Paris (1908) he came under the influence of Gauguin and had immense sympathy for Van Gogh due to the bouts of mental illness from which both suffered. In fact, this would have a profound effect on the development of Munch as an artist and explains the extraordinary passion that pervades his work. Life, love and death are the themes that he endlessly explored in his paintings, rendered in an Expressionist symbolic style. His use of swirling lines and strident colours emphasize the angst that lies behind his paintings. He also produced etchings, lithographs and woodcut engravings which influenced the German artists of the movement known as Die Brücke.

MOVEMENT

Expressionism

OTHER WORKS

Puberty, The Dance of Life; The Madonna; Ashes

INFLUENCES

Gauguin, Van Gogh

Edvard Munch Born 1863 Loten, Norway

Painted in Oslo, Norway

Died 1944 Oslo

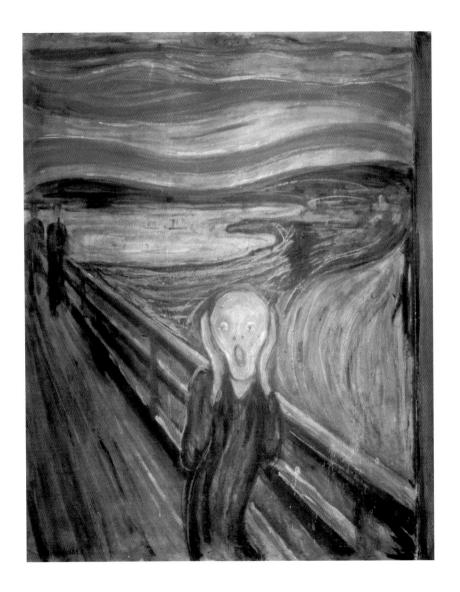

Beardsley, Aubrey

The Peacock Skirt, illustration for Oscar Wilde's play, 'Salome', 1894

Courtesy of Fogg Art Museum, Harvard University Art Museums, USA/Bridgeman Art Library

English graphic artist, the epitome of *fin-de-siècle* decadence. Born in Brighton, Beardsley was a frail child and suffered his first attack of tuberculosis in 1879. He left for London at the age of 16, working initially in an insurance office, while attending art classes in the evening. In 1891 Edward Burne-Jones persuaded him to become a professional artist and, two years later, Beardsley received his first major commission, when J. M. Dent engaged him to illustrate Malory's *Morte d'Arthur*. The success of this venture gave him the opportunity to work on an even more prestigious project, the illustration of Wilde's *Solome*, while also producing images for a new journal, *The Yellow Book*.

Soon Beardsley developed a unique style, combining the bold compositional devices used in Japanese prints; the erotic, sometimes perverse imagery of the Symbolists; and an effortless mastery of sinuous, linear design, which prefigured Art Nouveau. A glittering career seemed to beckon, but in 1895 the scandal surrounding the Wilde trial led to his sacking from *The Yellow Book*. His tubercular condition flared up again and within three years he was dead.

MOVEMENTS

Symbolism, Decadence, Art Nouveau

OTHER WORKS

The Toilet of Salome; How King Arthur saw the Questing Beast

INFLUENCES

Sir Edward Burne-Jones, Kitagawa Utamaro, Toulouse-Lautrec

Aubrey Beardsley Born 1872 Brighton, England

Worked in England and France

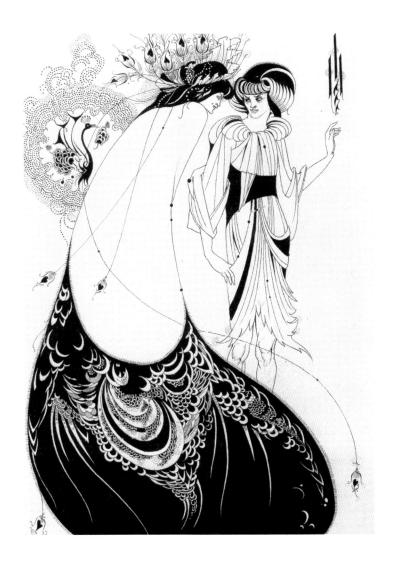

Gauguin, Paul

Nave Nave Moe, 1894

Courtesy of Hermitage, St Petersburg/Bridgeman/Christie's Images

Although he was born in Paris, Gauguin spent his early childhood in Peru, returning to France in 1855. He worked for a time as a stockbroker, painting only as a hobby, until the stock market crash of 1882 prompted a dramatic change of career. His first pictures were in the Impressionist style, influenced in particular by his friend, Camille Pissarro. Increasingly, though, Gauguin became dissatisfied with the purely visual emphasis of the movement, and tried to introduce a greater degree of symbolism and spirituality into his work. Inspired by Japanese prints, he also developed a new style, coupling bold splashes of bright, unmixed colour with simplified, linear designs. At the same time, haunted by memories of his Peruvian childhood, Gauguin developed a growing fascination for exotic and primitive cultures. Initially, he was able to satisfy this need in Brittany where, inspired by the region's distinctive Celtic traditions, he produced *The Vision after the Sermon*, his first great masterpiece. Then in 1891, he moved to the French colony of Tahiti. Dogged by poverty and ill health, he spent most of his later life in this area producing the paintings for which he is best known today.

MOVEMENTS

Post-Impressionism, Impressionism, Symbolism

OTHER WORKS

Where Do We Come From? What Are We? Where Are We Going To?

INFLUENCES

Camille Pissarro, Emile Bernard, Vincent Van Gogh

Paul Gauquin Born 1848 Paris, France

Painted in France, Denmark, Martinique Tahiti

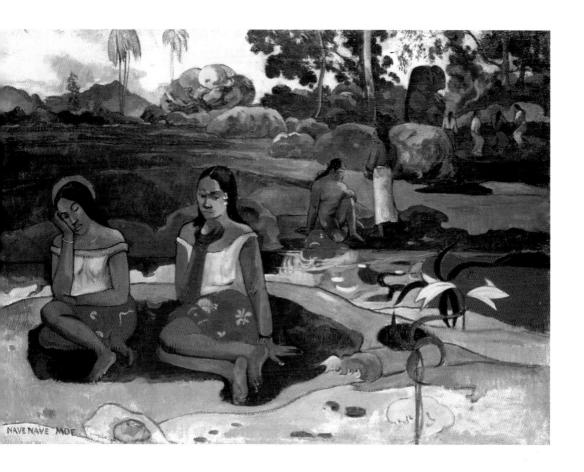

Sickert, Walter

L'Hotel Royal Dieppe, c. 1894

Courtesy of Private Collection/Christie's Images/© Estate of Walter R. Sickert 2002. All Rights Reserved, DACS

Born in Munich, Bavaria, Walter Richard Sickert was the son of the painter Oswald Adalbert Sickert and grandson of the painter and lithographer Johannes Sickert. With such an artistic pedigree it was almost inevitable that he should follow the family tradition. In 1868 his parents moved to London, where he later studied at the Slade School of Art and took lessons from Whistler, whose limited tonal range is reflected in much of Sickert's work. On the advice of Degas – whom he met while studying in Paris – he made detailed preliminary drawings for his paintings rather than paint from life. As a youth, Sickert had been an actor and he had a lifelong interest in the theater, reflected in many of his paintings. He was a competent all-rounder, painting portraits, rather seedy genre subjects and murky landscapes, and as a teacher he wielded enormous influence on the British artists of the early twentieth century.

MOVEMENT

British Impressionism

OTHER WORKS

Mornington Crescent Nude; La Hollandaise Nude

INFLUENCES

James McNeill Whistler, Degas

Sickert, Walter Born 1860 Munich, Germany

Painted in London, Dieppe, and Venice

Died 1942 Bathampton, Avon, England

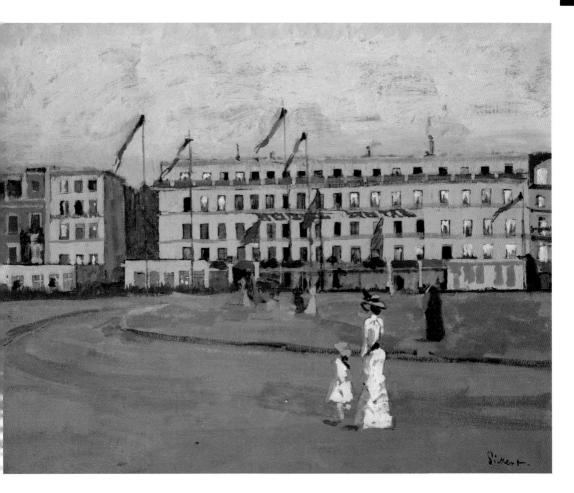

Redon, Odilon

La Mort D'Ophelie, 1900-05

Courtesy of Private Collection/Christie's Images

Odilon Redon's ambitions to become an architect were thwarted by ill health; instead he became apprenticed to Rodolphe Bresdin, a moster lithographer and engraver. The first 20 years of Redon's career were almost entirely devoted to working in monochrome, producing a vast number of charcoal drawings and lithographs, and it was not until the late 1870s that he turned to colour, mainly using pastels. He was very friendly with a botanist named Clavand, whose microscopic researches on plant structures fired his imagination and encouraged him to explore their artistic potential. These Redon later utilized in his Symbolist paintings. From about 1900 these developed a dreamlike quality, which is regarded as a precursor of the Surrealists. In his later years Redon also produced portraits that were a riot of colour. A recluse who shunned the limelight, Redon nevertheless became a role model for the next generation of French artists.

MOVEMENTS

Symbolism, Surrealism

OTHER WORKS

Portrait of Gauguin; The Marsh Flower; The Red Sphinx

INFLUENCES

Rodolphe Bresdin, Gauguin, Gustave Moreau

Odilon Redon Born 1840 Bordeaux, France

Painted in Paris

Died 1916 Paris

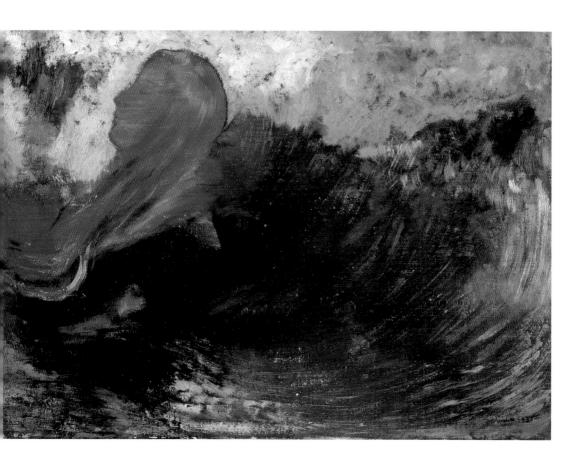

Vuillard, Edouard

Causerie chez les Fontaines

Courtesy of Christie's Images @ ADAGP, Paris and DACS, London 2002

Jean Edouard Vuillard studied at the Académie Julien in Paris and shared a studio with Pierre Bonnard. Both artists were inspired by Sérusier's theories derived from the works of Gauguin and became founder members of Les Nabis in 1889. Vuillard was also influenced by the fashion for Japanese prints and this was reflected in his paintings of flowers and domestic interiors, executed with a keen sense of tone, colour and light. He was also a prolific designer of textiles, wallpaper and decorative features for public buildings. His paintings of cozy domestic subjects show a tremendous feeling for texture and patterning, a skill he picked up from his mother who was a dressmaker. The bolts of brightly coloured cloth that surrounded him as a child found an echo in his own textile designs. His later paintings were more naturalistic, aided by photography, which he employed to capture the fleeting moment.

MOVEMENT

Les Nobis

OTHER WORKS

Femme Lisant; Le Soir; Two Schoolboys; Mother and Child

INFLUENCES

Paul Sérusier, Gauguin

Edouard Vuillard Born 1868 Cuiseaux, France

Painted in France

Died 1940 La Baule, France

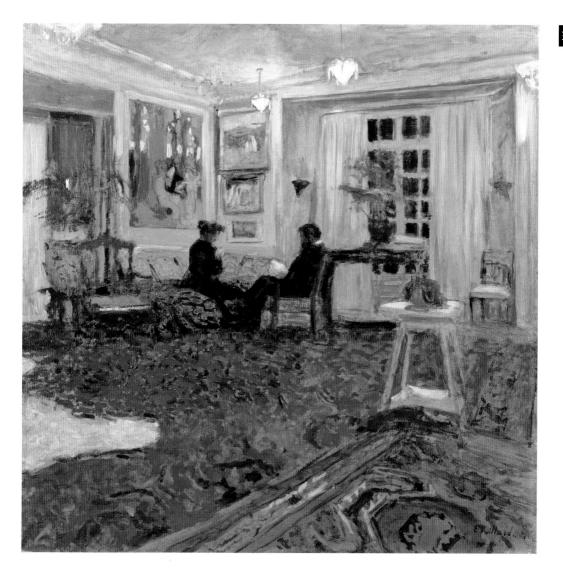

Modersohn-Becker, Paula

Brustbild einer Jungen Frau mit offenem Haar

Courtesy of Private Collection/Christie's Images

Born Paula Becker, she was largely self-taught although she was encouraged by her parents to develop her art by sending her to Paris on several occasions, during which she became familiar with the works of Cézanne, Gauguin and Van Gogh. What formal training she had she received at the classes held by the Association of Berlin Women Artists in 1893–95, but three years later she joined the artists' colony at Worpswede, where she spent most of the last nine years of her short life. Her early paintings concentrated largely on landscapes and peasant genre subjects. In 1901 she married Otto Modersohn, a widower 11 years her senior, and the more mature style of her later paintings may owe something to his advice and example. To her last years belong a number of portraits which reflect the influence of the Expressionists. Unable to cope with her domineering husband she fled to Paris in 1906 and died early the following year while giving birth to her daughter Mathilde.

MOVEMENT

German Expressionism

OTHER WORKS

Old Poorhouse Woman with a Glass Bottle

INFLUENCES

Cézanne, Gauguin, Van Gogh

Paula Modersohn-Becker Born 1876 Germany

Painted in Dresden, Berlin and Worpswede

Died 1907 Worpswede, Germany

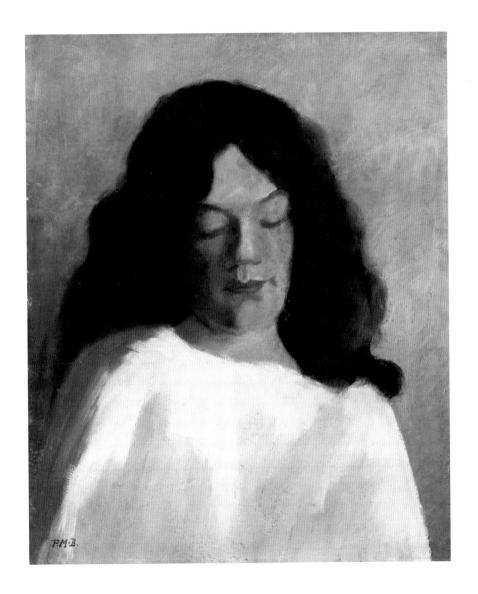

Klimt, Gustav

The Kiss, 1907-08

Courtesy of Osterreichische Galerie, Vienna, Austria/Bridgeman Art Library

Klimt was born in Vienna and became one of the leading lights in the city's most dazzling, artistic period. The son of a goldsmith, he trained at the School of Applied Arts and started work as a decorative painter. He achieved early success with the schemes at the Burgtheater and the Kunsthistorisches Museum, but future commissions were threatened by his growing fascination with avant-garde art. Faced with official opposition, Klimt resigned from the Viennese Artists' Association in 1897 and founded the Vienna Sezession, becoming its first president. This coincided with protracted disputes about his decorations for the university, a project that he abandoned in 1905.

Klimt's style was a compelling blend of Art Nouveau and Symbolist elements. From the former, he derived his taste for sinuous, decorative lines, while from the latter he borrowed his erotic subject matter and, in particular, his interest in the theme of the femme fatale. It was this blatant eroticism which troubled the authorities, though it did not seriously damage Klimt's career. He was always in great demand as a portraitist, and he continued to receive private commissions for decorative schemes.

MOVEMENT

Vienna Sezession

OTHER WORKS

Judith I: The Beethoven Frieze

INFLUENCES

Hans Makart, Edvard Munch, Franz von Stuck

Gustav Klimt Born 1862 Vienna, Austria

Painted in Austria-Hungary, Belgium

Died 1918

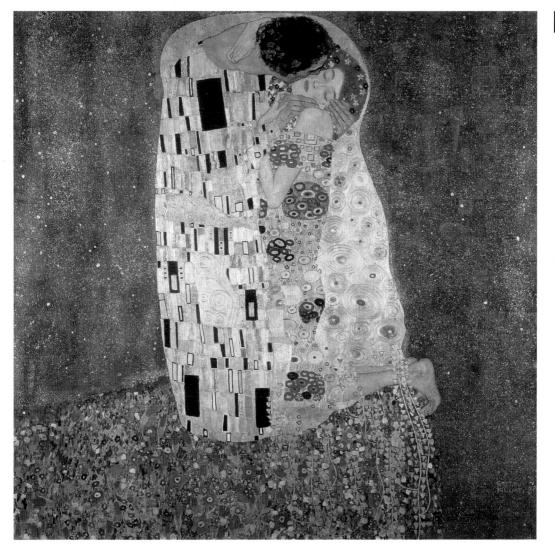

400

20th–21st Centuries

The Modern Era

Henri, Robert

Grace - Chinese Girl

Courtesy of Private Collection/Christie's Images

Born in Cincinnati, Ohio in 1865, Robert Henri enrolled at the Pennsylvania Academy of Fine Arts, Philadelphia, in 1886 and two years later went to Paris where he studied at the École des Beaux Arts. His formal training was rounded off by extensive travels in Italy and Spain. On his return to the USA in 1891 he became a teacher at the Women's School of Design, Philadelphia. He worked in Paris again from 1896 to 1901, but later settled in New York where he taught at the Art Students' League. He was a fervent believer in realism, which led critics to deride his 'Ashcan School', but he wielded enormous influence on the next generation of American artists. Despite his teaching commitments he was a prolific artist. In 1908 he founded his own art school in New York and formed the group known as 'The Eight'.

MOVEMENT

American Realism

OTHER WORKS

La Neige; The Equestrian; Young Woman in Black

INFLUENCES

Manet, Renoir

Robert Henri Born 1865 Cincinnati, Ohio, USA

Painted in Paris, Philadelphia and New York, USA

Died 1929 New York

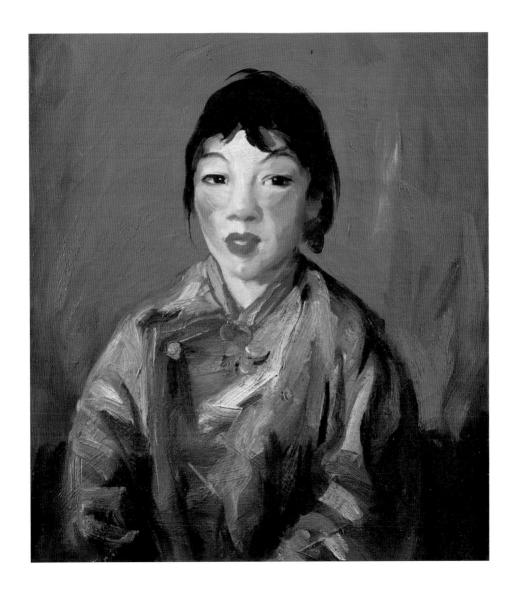

Gallen-Kallela, Akseli

Autumn, the Five Crosses

Courtesy of Christie's Images/Bridgeman Art Library

In the period before Finland gained its independence at the end of World War I, Akseli Valdemar Gallen-Kallela played a major role in the revival of the national spirit, especially among the Finnish-speaking population. Hitherto, the art establishment of the Grand Duchy was predominantly Swedish speaking and culturally oriented to Sweden. Gallen-Kallela studied in Paris from 1884 onwards and spent much of his life there prior to 1920, but throughout this period took a keen interest in the rebirth of Finnish culture. Although he is best known for his paintings of scenes from the great epic poem *Kalevala*, he produced numerous landscapes, the most evocative being of the lakes and forests of Finland in winter. He was also an accomplished portraitist and painted one of the best likenesses of Maxim Gorky. The disparate strands of his artistry came together in his great masterpiece, the triptych telling the story of Aino and Väinämöinen from Finnish mythology. He executed works in black and white, notably the sensitive and lively illustrations for the writings of Aleksis Kivi (1906–07).

MOVEMENT

Finnish School

OTHER WORKS

Head of a Young Girl; The Fratricide; Peace

INFLUENCES

August Ahlstedt, Karl Peter Mazer, Gustaf Albert Edelfelt

Akseli Gallen-Kallela Born 1865 Pori, Finland

Painted in France and Finland

Died 1931 Helsinki, Finland

Repin, Ilya

Portrait of a Lady in a Yellow and Black Gown, 1901

Courtesy of Private Collection/Christie's Images

Born at Chuguyev near Kharkov of poor, peasant parents, Ilya Yefimovich Repin learned his trade under Bunakov, a painter of icons. In 1863 he won a scholarship to the Academy of Fine Arts in St Petersburg, where he remained for six years, winning the gold medal and a travelling scholarship which enabled him to continue his studies in France and Italy. On his return, he concentrated on paintings in the heroic mold and was appointed Professor of Historical Painting at St Petersburg in 1894. Moving with the times, he later painted large canvasses with a strong social message and, with his peasant background, he thus fitted the ideals expressed by the Revolution. Even his historical paintings struck a chord with the strongly nationalist feelings of Russians in the early 1920s. His social realism was much admired by both Lenin and Stalin and influenced the artists working in the Soviet Union throughout the 1930s and 1940s.

MOVEMENT

Russian School

OTHER WORKS

Procession in the Government of Kiev

INFLUENCES

Alexei Venetsianov, Grigori Soroka

Ilya Repin Born 1844 Chuguyev, Kharkov, Russia

Painted in St Petersburg, Russia

Died 1930 St Petersburg

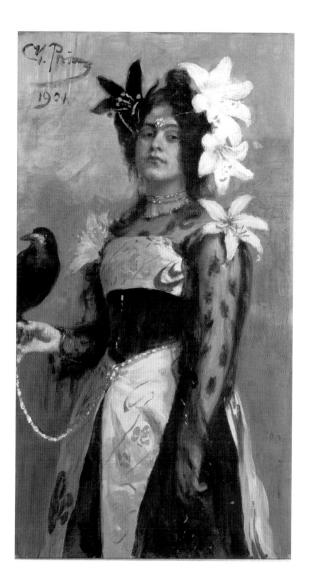

Zorn, Anders

Nudes, 1902

Courtesy of Private Collection/Christie's Images

Anders Leonhard Zorn began as a watercolourist in the manner of Egron Lundgren, under whom he studied. He achieved instant fame with the portrait of a girl entitled *Mourning*, which was exhibited in 1880, after which he received numerous commissions for portraits. His fortune assured, he travelled widely, studying the art of England, Spain, Eastern Europe and North Africa – experiences which resulted in some of his finest landscapes and genre pointings. He resided in Paris from 1887 to 1893 and switched direction by taking up oil painting and rejecting his early realism in favour of Impressionism. From 1893 onwards he made frequent trips to the United States and specialized in portraits of American tycoons and leading political figures. In his later years he spent more time in the Swedish countryside concentrating on landscapes and genre scenes. He was also one of the most accomplished etchers of the turn of the century, as well as a fine sculptor.

MOVEMENT

Modern Swedish School

OTHER WORKS

Our Daily Bread; Mona; Self Portrait; Dagmar; By Lake Siljan

INFLUENCES

Max Liebermann

Anders Zorn Born 1860 Mora, Sweden

Painted in Sweden, England, Spain, Algiers and USA

Died 1920 Mora

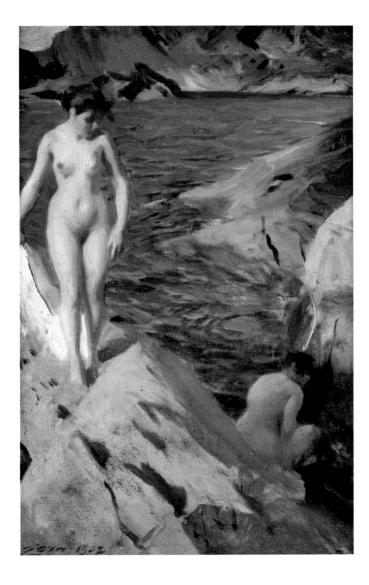

Kandinsky, Wassily

Die Nacht - Grosse Fassung, 1903

Courtesy of Private Collection/Christie's Images/© ADAGP, Paris and DACS, London 2002

Born in Moscow, Kandinsky trained as a lawyer, but turned to art after visiting an exhibition of Monet's work. He moved to Munich, where he studied under Franz von Stuck. Here, he demonstrated his talent for organizing groups of artists, when he founded influential Der Blaue Reiter ('The Blue Rider'), an association of Expressionist artists, which included Franz Marc, August Macke and Paul Klee.

Kandinsky's personal style went through many phases, ranging from Jugenstil (the German equivalent of Art Nouveau) to Fauvism and Expressionism. He is most celebrated, however, for his advances towards abstraction. This came about after he returned to his studio one evening, and was enchanted by a picture he did not recognize. It turned out to be one of his own paintings lying on its side. Kandinsky immediately realized that subject matter lessened the impact of his pictures and he strove to remove this from future compositions.

In later life, Kandinsky taught at the Bauhaus, until it was closed down by the Nazis in 1933. He spent his final years in France, becoming a French citizen in 1939.

MOVEMENTS

Expressionism, Abstract Art

OTHER WORKS

Swinging; Composition IV (Battle); Cossacks

INFLUENCES

Claude Monet, Paul Klee, Franz Marc

Wassily Kandinsky Born 1866 Moscow, Russia

Painted in Russia, Germany, France and Holland

Died 1944 Neuilly-sur-Seine, France

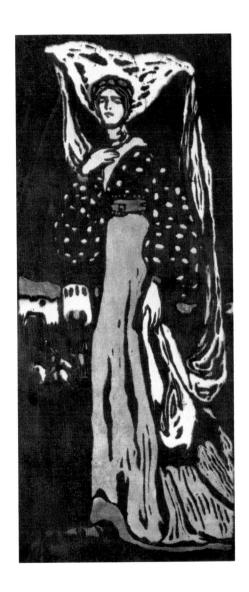

Streeton, Sir Arthur

Buffalo Mountains

Courtesy of The Art Archive

Arthur Ernest Streeton studied at the National Gallery School in Melbourne and worked as a lithographer. In 1885 Tom Roberts returned from Europe and together with Frederick McCubbin and Streeton, founded the Heidelberg School of artists, who painted from nature. Later Streeton founded a permanent artists' colony at Eaglemont, where he perfected his techniques of landscape painting, noted for its realism and sense of atmosphere. He travelled extensively in Egypt and Europe and worked in London (1898–1906), where he studied the works of Turner and Constable and exhibited at the Royal Academy. He was back in Australia in 1906–07, then worked in England and became a war artist on the Western Front. From 1919 onwards he lived mainly in Australia, travelling all over the country and painting prolifically. He was knighted in 1937. As well as landscapes he painted powerful scenes of men at work, making a major contribution to the art of social realism.

MOVEMENT

Modern Australian School

OTHER WORKS

Still Glides the Stream; Fire's On

INFLUENCES

J.M.W. Turner, John Constable, Philip Wilson Steer

Sir Arthur Streeton Born 1867 Australia

Painted in Australia and Europe

Died 1943 Olinda, Victoria, Australia

Derain, André

La Tamise et Tower Bridge, 1906

Courtesy of Private Collection/Christie's Images @ ADAGP, Paris and DACS, London 2002

While studying art in Paris, André Derain teamed up with fellow student Maurice de Vlaminck with whom he shared a studio. Although very different in temperament they sparked radical ideas off each other regarding the use of colour and, encouraged by Matisse whom they met in 1899, they gradually evolved the style known as Fauvism, distinguished by its often violent and savage use of contrasting colours. In 1905 Ambroise Vollard, a prominent art dealer, encouraged Derain to travel to England and try to capture the strange lighting effects in the Pool of London. The results were startling but considered to be some of his greatest masterpieces. Later he toned down the adventurous use of colour and, under the influence of Cézanne, painted landscapes in a more Impressionist style. He also designed theatre sets, notably for Diaghilev, as well as working as a book illustrator.

MOVEMENT

Fauvism

OTHER WORKS

Houses of Parliament; Barges on the Thames; The Pool of London

INFLUENCES

Maurice de Vlaminck, Henri Matisse, Paul Cézanne

André Derain Born 1880 Chatou, France

Painted in France and England

Died 1954

Utrillo, Maurice

Bancs à Montmagny (Val d'Oise), c. 1906-7

Courtesy of Private Collection/Christie's Images © ADAGP, Paris and DACS, London 2002/ © by Jean Fabris 2002

The illegimitate son of the painter Suzanne Valadon, Maurice Utrillo led an extremely bohemian life. Despite alcoholism and drug addiction, however, he was a prolific painter, turning out vast numbers of Parisian street scenes, especially in and around Montmartre, where he lived. Except what he learned from his mother, he had no formal art training and, in fact, only took up painting as a form of therapy during one of his periodic spells in a detoxification clinic. He started off by making copies of Parisian picture postcards and this is reflected in the meticulous, almost photographic, quality of all his work. He began exhibiting in 1909 and thereafter was closely associated with the Impressionists, especially Camille Pissarro, although Utrillo left his own indelible mark — 'a wild thirst for reality' was how he succinctly described it himself. In his 'white period' (1909–16) his palette consisted of very light colours, but thereafter they became much deeper and richer in tone. A reformed alcoholic, Utrillo became extremely devout in old age.

MOVEMENT

Impressionism

OTHER WORKS

La Place du Tertre; Street in a Paris Suburb with Trees

INFLUENCES

Suzanne Valadon, Camille Pissarro

Maurice Utrillo Born 1883 Paris, France

Painted in Paris

Died 1955 Dax, France

John, Gwen

A Corner of the Artist's Room in Paris, c. 1907

Courtesy of Private Collection/Christie's Images © Estate of Gwen John 2002. All Rights Reserved, DACS 2002

A Welsh pointer and the greatest female artist of her age, John trained at the Slade School in London together with her brother Augustus, who also went on to become a famous artist. She then moved to Paris to study under Whistler, from whom she derived her delicate sense of tonality. In 1903, John planned to walk to Rome with a friend, but they only got as far as France, where she decided to settle. For a time she worked as a model in Paris and, through this, met the sculptor Rodin, who became her lover. He urged her to paint more, but John's output was small and it was only through the generosity of her chief patron, an American lawyer named John Quinn, that she was able to give up modelling and devote herself to her art.

Quiet and retiring, John lived alone and rarely exhibited her work. In her solitude, she developed a unique style, painting intimate, small-scale subjects — usually female portraits or corners of her studio — in thin layers of exquisitely muted colours. At first glance, these often appear frail and insubstantial but, like the artist herself, they also exude an inner calm and strength.

MOVEMENT

Intimism

OTHER WORKS

The Convalescent; Girl Reading at the Window; Nude Girl

INFLUENCES

James Whistler, Henry Tonks

Gwen John Born 1876 Wales

Painted in England and France

Died 1939 Dieppe, France

Monet, Claude

Nymphéas, 1907

Courtesy of Private Collection/Christie's Images

French painter; a founding member of the Impressionist circle. Monet was born in Paris, but grew up on the Normandy coast, where he developed an early interest in landscape painting. His early mentors were Jongkind and Boudin, and the latter encouraged Claude to paint outdoors rather than in the studio. This was to be one of the key principles of Impressionism.

While a student in Paris he met Pissarro, Renoir and Sisley, and together they formulated the basic ideas of the movement. One of Monet's paintings, *Impression: Sunrise* gave the group its name.

The Impressionists staged their own shows, holding eight exhibitions between 1874 and 1886. Initially, these attracted savage criticism, causing genuine financial hardship to Monet and his friends. His most distinctive innovation was the 'series' painting. Here, Monet depicted the same subject again and again, at different times of the day or in different seasons. In these pictures, his real aim was not to portray a physical object – whether a row of poplars or the façade of Rouen cathedral – but to capture the changing light and atmospheric conditions.

MOVEMENT

Impressionism

OTHER WORKS

Waterlilies; Wild Poppies; Rouen Cathedral

INFLUENCES

Eugène Boudin, Johan Barthold Jongkind, Pierre-Auguste Renoir

Claude Monet Born 1840 Paris, France

Painted in France, England and Italy

Died 1926 Givernay, France

Ensor, James

La Mangeuse D'Huitres, 1908

Courtesy of Private Collection/Christie's Images/© DACS 2002

Born in Ostend, Belgium, of English parents, James Sydney Ensor is one of those painters whose art seems to have been wholly his own, with very little discernible influence from his contemporaries or predecessors, apart from some slight echoes of the Symbolists. In 1884 he founded the group known as Les Vingt (The Twenty), but he soon broke away from them. Essentially a loner, he reacted violently to the comments of art critics and the general public alike, who regarded his pictures as disturbed and macabre. Their obsession with corpses, grotesque masks and skeletons painted in garish colours, symbolized the corruption of society and the world around him. From about 1900, when he was no longer an 'angry young man', his paintings mellowed and became more conventional, and eventually he was back in the mainstream of Belgian art, recognized by his peerage in 1929 shortly after taking Belgian nationality. Nevertheless, it is for his satirical painting that he is remembered today, marking the transition from Symbolism to Expressionism and anticipating the Surrealism of Magritte.

MOVEMENT

Expressionism

OTHER WORKS

Death and the Masks; Entry of Christ into Brussels

INFLUENCES

Odilon, Redon

James Ensor Born 1860 Ostend, Belgium

Painted in Ostend and Brussels

Died 1949 Ostend

Hodgkins, Frances Mary

A Peasant Family

Courtesy of Private Collection/Christie's Images

Frances Mary Hodgkins studied art in Dunedin, New Zealand and achieved a high reputation in her native country with charming genre studies of Maori life as well as landscapes and still life studies. Her early success enabled her to travel all over the world, especially throughout Europe, spending considerable periods furthering her studies and perfecting her technique in Paris and London, where she eventually settled. At the beginning of the twentieth century she came under the influence of Henri Matisse in his Impressionistic period and this is reflected in her paintings which explored the harmonious use of flat colours. Although much older than most of her contemporaries in English art circles between the World Wars she was regarded as one of the leading figures in the Romanticism of that period.

MOVEMENT

Romanticism

OTHER WORKS

Maori Woman and Child; Hilltop; Barn in Picardy

INFLUENCES

Matisse

Frances Mary Hodgkins Born 1869 Dunedin, New Zealand

Painted in New Zealand, France and England

Died 1947 Dorset, England

Heckel, Erich

Windmill, Dangast, 1909

Courtesy of Wilhelm Lehmbruck Museum, Duisburg, Germany/Bridgeman Art Library/® DACS 2002

Erich Heckel studied architecture in Dresden from 1904 to 1906 and it was during this period that he met Ernst Ludwig Kirchner and Karl Schmidt-Rottluf, with whom he formed the avant-garde group known as Die Brücke (The Bridge). They were strongly influenced by Edvard Munch, Cézanne and Van Gogh, and this was reflected in the vigorous quasi-primitive approach which they adopted in their paintings and prints – well suited to works which invariably had a strongly radical character. The group was dissolved in 1913 and the following year Heckel was drafted into the German army, serving as a medical orderly throughout the war. Like many of his contemporaries, his wartime experiences influenced his paintings in the postwar period. Vilified by the Nazis when they came to power, he continued to live in Berlin but from 1949 to 1956 he was professor at the Karlsruhe Academy of Art. He was noted for his nudes, his style mellowing and becoming more decorative in his later years.

MOVEMENT

German Expressionism

OTHER WORKS

Bathers; Sleeping Negress; Landscape in Thunderstorm

INFLUENCES

Ernst Ludwig Kirchner, Edvard Munch

Erich Heckel Born 1883 Döbeln, Germany

Painted in Dresden, Berlin and Karlsruhe

Died 1970 Hemmenhofen, Switzerland

Kollwitz, Käthe

Mother and Child, 1910

Courtesy of Private Collection/Christie's Images/© DACS 2002

Born Käthe Schmidt at Königsberg, East Prussia (now Kaliningrad, Russia), she studied there and later in Berlin, where she married Karl Kollwitz, a doctor who ran a children's clinic in a slum district. Through this connection the artist witnessed at close quarters the poverty and deprivation of the Berlin poor at the turn of the century. This influenced her painting and sculpture, in which she concentrated on subjects with a strong social message. After her youngest son was killed in World War I she sculpted a large granite memorial, later erected at Dixmuiden in Flanders as a monument to all the young men who fell in battle. In 1928 she became the first woman elected to the Prussian Academy of Arts, but she was expelled by the Nazis in 1933. Her home, studio and most of her works were destroyed in an air raid in 1943. Although best known for her stone carvings and bronze sculptures, she also produced paintings, posters and lithographs with a powerful social message.

MOVEMENT

German Realism

OTHER WORKS

Weavers' Revolt; No More War

INFLUENCES

Otto Nagel

Käthe Kollwitz Born 1867 Königsberg, East Prussia

Painted in Berlin, Germany

Died 1945 Berlin

MacDonald, J. E. H.

Clearing after Rain, Maganatawan River, Ontario, 1910

Courtesy of Christie's Images, London, UK/Bridgeman Art Library

James Edward Hervey MacDonald was born in England of Scottish-Canadian parents, and at the age of 14 he settled with them in Hamilton, Ontario. He studied art there and later in Toronto, and in 1894 joined the leading Toronto graphic art company Grip, where he remained until 1912. He was the doyen of the extremely talented group of artists working for this firm, including Tom Thomson, Arthur Lismer, Frederick Varley and Franklin Carmichael. MacDonald was a founder member of the Arts and Letters Club (1908) which, under his leadership, rapidly became the forum for Canadian avant-garde artists. Notoriety came his way in 1916 when he exhibited seven paintings at the Toronto annual show; his painting *The Tangled Garden* was ferociously attacked by the newspaper critics. After Thomson's untimely death in 1917, MacDonald continued to be the guiding light and the prime mover in establishing the 'Group of Seven' in 1920, Significantly, the Group broke up after his death.

MOVEMENT

Modern Canadian School

OTHER WORKS

Mist Fantasy; Autumn, Algoma

INFLUENCES

Henry Thoreau, Walt Whitman

J. E. H. MacDonald Born 1873 London, England

Painted in Canada

Died 1932 Toronto, Ontario, Canada

Malevich, Kasimir

The Carpenter III, 1910

Courtesy of State Russian Museum, St Petersburg, Russia/Bridgeman Art Library

Kasimir Severinovich Malevich studied in Moscow from 1902 to 1905 and came under the influence of the French Impressionists. In 1912 Mikhail Larionov invited him to take part in the inaugural Knave of Diamonds exhibition. Later the same year he visited Paris and immediately converted to Cubism, attacking this new style with zeal and improving and refining it in a style which he called Suprematism. His exhibition of Suprematist art in 1915 gained a mixed reception and he subsequently modified his style, rejecting the stark minimalism of such works as *Black Square* and injecting a great deal of colour. But he reverted to his ideals in 1918 with a series of paintings entitled *White on White*, the ultimate example of minimalism. Thereafter he abandoned painting and concentrated on sculpture, becoming one of the leading Constructivists of the early Soviet era.

MOVEMENTS

Cubism, Suprematism

OTHER WORKS

Dynamic Suprematism; Woman with Buckets

INFLUENCES

Mikhail Larionov, Pablo Picasso

Kasimir Malevich Born 1878 Kiev, Ukraine

Painted in Moscow, Russia

Died 1935 Leningrad (now St Petersburg), Russia

Marin, John

Brooklyn Bridge Series, 1910

Courtesy of Private Collection/Christie's Images @ ARS, New York and DACS, London 2002

John Marin studied architecture at the Pennsylvania Academy in Philadelphia and the Art Students' League of New York and subsequently pursued this profession, while gradually becoming involved in painting under the influence of James McNeill Whistler. Between 1905 and 1910 he travelled extensively in Europe, continuing his art studies in Paris, Rome and London. In 1909 he exhibited his work for the first time at the 291 Gallery in New York – run by Alfred Stieglitz – and as a result he came into contact with the Stieglitz Circle, an avant–garde group. Subsequently he went through phases of flirting with Fauvism and Cubism, both of which left their mark on his later paintings, although interpreted from a purely American standpoint. Although he occasionally worked in oils on canvas his preferred medium was watercolours. He was also a prolific etcher, his landscapes rendered in a highly individualistic style.

MOVEMENTS

Fauvism, Cubism

OTHER WORKS

Maine Islands; Four-Master off the Cape Maine Coast

INFLUENCES

James McNeill Whistler, Raoul Dufy, Emil Nolde

John Marin Born 1870 New York, USA

Painted in USA

Died 1953 Addison, Maine, USA

Schiele, Egon

Liegender Halbakt Mit Rolem, 1910

Courtesy of Private Collection/Christie's Images

Egon Schiele studied at the Vienna Academy of Fine Arts in 1906 and the following year he met Gustave Klimt, whose Vienna Sezession movement he joined in 1908. A disciple of Sigmund Freud, Schiele sought to explore the deeper recesses of the human psyche, especially the sexual aspects. He developed a particularly stark style of Expressionism – distinguished by figures, often naked and usually emaciated – with harsh outlines, filling the canvas with contorted limbs and anguished features. Long before the Nazis were denouncing his paintings as degenerate art, the Austrian authorities were confiscating and destroying his works. In 1912 he was actually arrested, convicted of offences against public morals and briefly imprisoned. After his marriage in 1915 his art mellowed, taking on a brighter and more sensuous form, and it is interesting to conjecture how this trend might have developed had he not died in the influenza pandemic of 1918.

MOVEMENT

Austrian Expressionism

OTHER WORKS

The Embrace; Recumbent Female Nude with Legs Apart

INFLUENCES

Gustav Klimt

Egon Schiele Born 1890 Tulln, Austria

Painted in Vienna, Austria

Died 1918 Vienna

Pechstein, Max

Rote Kirche, 1911

Courtesy of Private Collection/Christie's Images/© DACS 2002

Max Hermann Pechstein studied art in Dresden, where he joined Die Brücke (The Bridge) in 1906. The only member of this avant-garde group to have received a formal art education, he had a formulative influence on his contemporaries. Later he co-founded the Neue Sezession in Berlin and was the first of that group to achieve widespread popularity, mainly because his paintings were more decorative than those of his fellow artists. He was profoundly influenced by Van Gogh, Matisse and the Fauves, reflected in his vibrant colours and dramatic composition. Later he was also attracted to primitive art, evident in the greater angularity of his figures in the 1920s and 1930s. Bright, contrasting colours are emphasized by thick black lines creating an almost stained-glass effect. Pechstein taught at the Berlin Academy from 1923 until 1933, when he was dismissed by the Nazis, but he survived the Third Reich and was reinstated in 1945.

MOVEMENT

German Expressionism

OTHER WORKS

Meadow at Moritzburg; Tale of the Sea; Seated Female Nude

INFLUENCES

Vincent Van Gogh, Henri Matisse

Max Pechstein Born 1881 Zwickau, Germany

Painted in Dresden and Berlin

Died 1955 Berlin, Germany

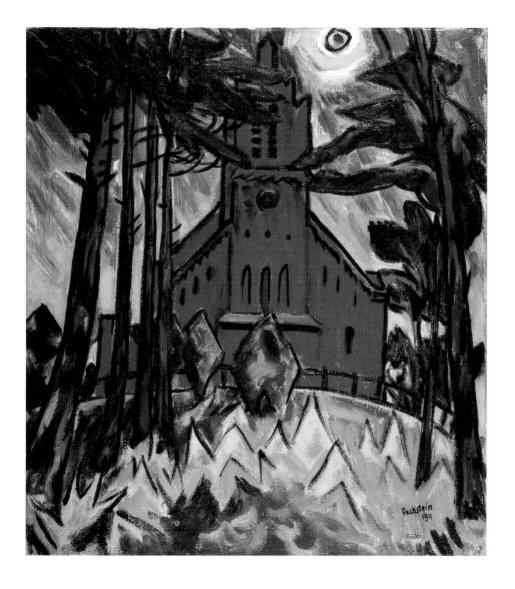

Duchamp, Marcel

Nude Descending a Staircase, No 2, 1912

Courtesy of Philadelphia Museum of Art, Pennsylvania, PA, USA/Bridgeman Art Library/© Succession Marcel Duchamp/ADAGP, Paris and DACS, London 2002

Although he produced relatively few artworks, Duchamp was a key figure in twentieth century art, playing a seminal role in the development of several different movements. Duchamp trained in Paris, and was briefly influenced by Cézanne and the Fauves. His first real masterpiece — *Nude Descending a Staircase* — was a potent blend of Cubism and Futurism, In 1913 he invented the 'ready-made' — an everyday object, divorced from its normal context and presented as a work of art in its own right. Two years later, Duchamp moved to the US, where he became a leading light of the New York Dada movement. His work from this period displayed a mischievous sense of humour, whilst also challenging existing preconceptions about the nature of art. In *L.H.O.O.Q.*, for example, he added a moustache and a smutty inscription to the *Mona Lisa*. His most notorious ready-made was a urinal, which he exhibited under the title of *Fountain*. After receiving a legacy, Duchamp's output slowed dramatically but his later work has been seen as a foretaste of Kinetic art and Conceptual art.

MOVEMENTS

Cubism, Dada, Conceptual Art

OTHER WORKS

Fountain; The Bride Stripped Bare by her Bachelors Even

INFLUENCES

Francis Picabia, Paul Cézanne, Man Ray

Marcel Duchamp Born 1887 Normandy, France

Worked in France and the USA

Died 1968 Paris, France

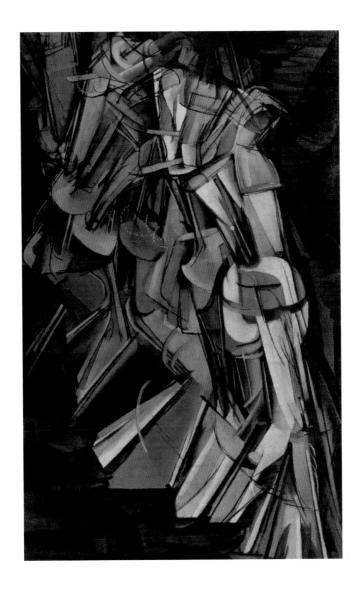

Jawlensky, Alexei

Spaneteru mit Roten Schal, 1912

Courtesy of Private Collection/Christie's Images/© DACS 2002

The scion of a Russian aristocratic family, Alexei Jowlensky served as an officer in the Imperial Guard before abandoning a military career in favour of art. He enrolled at the St Petersburg Academy and then moved to Germany in 1896, completing his education in Munich, where he met fellow Russian Wassily Kandinsky: under his guidance evolved his own highly distinctive brand of Fauvism. He spent some time painting in Brittany and Provence in about 1905. During a visit to Paris in 1913, however, he came under the influence of Matisse and Picasso and embraced Cubism, initially adapting it to his style of portraiture, which owed much to the religious icons of his native country. Later, however, his paintings became much less figurative and gradually switched to a more overtly abstract character, relying on simple geometric patterns in more muted colours than those that had been the hallmark of his Fauvist period. After World War I he settled in Wiesbaden, Germany, where he joined the group known as the Blaue Vier (Blue Four) with Kandinsky, Klee and Feininger. Jawlensky used colour in a lyrical sense, believing that tones and shades corresponded to notes and chords.

MOVEMENT

Fauvism, Cubism

OTHER WORKS

The White Feather; Abstract Head

INFLUENCES

Wassily Kandinsky, Henri Matisse, Paul Klee

Alexei Jawlensky Born 1864 Kuslovo, Russia

Painted in Russia, France and Germany

Died 1941 Wiesbaden, Germany

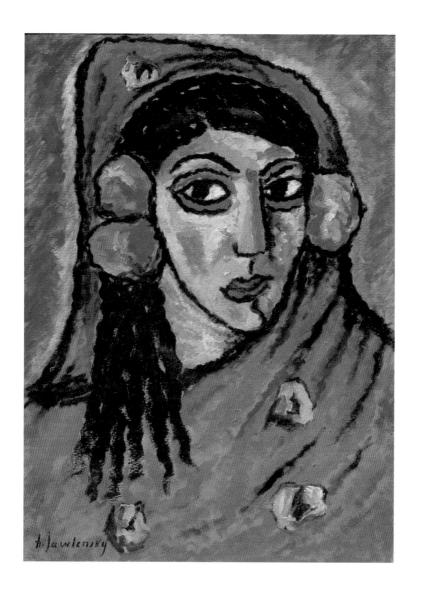

Bonnard, Pierre

Intérieur, 1913

Courtesy of Private Collection/Christie's Images @ ADAGP, Paris and DACS, London 2002

Pierre Bonnard settled in Paris in 1888, where he studied at the Académie Julien and the École des Beaux-Arts. With Maurice Denis and Edouard Vuillard, with whom he shared a studio, he was influenced by Paul Gauguin's expressive use of colour and formed the group known as Les Nabis (from the Hebrew word for prophet) and later the Intimists. While other artists at the end of the nineteenth century were tending towards abstraction, Bonnard was influenced by Japanese prints and concentrated on landscapes and interiors which strove after subtle effects in light and colour at the expense of perspective. At the turn of the century he was moved by the intensity and passion in the paintings of Van Gogh and this led him to become a founder member of the Salon d'Automne in 1903. Thereafter he was influenced by Les Fauves (literally 'the wild beasts'), whose strident colours and distorted images he tamed and harnessed to his own style.

MOVEMENTS

Les Nabis, Intimism, Fauvism

OTHER WORKS

Mirror on the Washstand; The Open Window; The Table

INFLUENCES

Paul Gauguin, Vincent Van Gogh

Pierre Bonnard Born 1867 Fontena-aux-Roses, France

Painted in Paris, France

Died 1947 Le Cannet, France

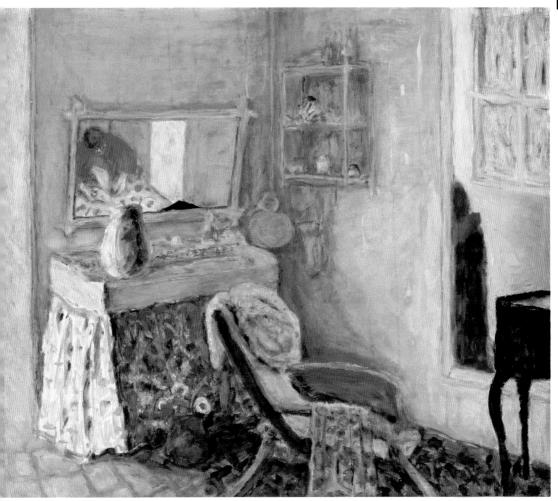

Marc, Franz

Spingendes Pferd, 1913

Courtesy of Private Collection/Christie's Images

Franz Marc studied theology in Munich intending to enter the Church, but switched to art, which he regarded as an intensely spiritual activity. He studied painting in Italy and France before returning to Munich where, with Kandinsky, he founded the Blaue Reiter group in 1911. An intensely religious man, he believed that animals were more in harmony with nature than human beings and therefore he concentrated on paintings in which animals, notably horses and foxes, featured prominently. In his earlier works the animals form the dominant subject but later they merged into the landscape as though an integral part of it. He speculated on how animals perceived the world and this influenced his later Expressionist work, which was almost devoid of figurative motifs and explored the emotional potential of colour. He returned to Germany on the outbreak of World War I; his death in action brought to an abrupt end one of the most promising artists of the early twentieth century.

MOVEMENTS

Impressionism, Expressionism

OTHER WORKS

Tiger; Deer in Wood; Foxes; Tower of the Blue Horses

INFLUENCES

August Macke, Kandinsky

Franz Marc Born 1880 Munich, Germany

Painted in Munich and Paris

Died 1916 Verdun, France

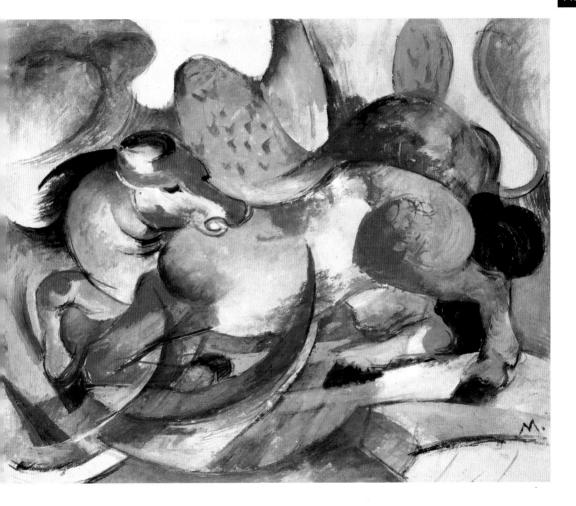

Balla, Giacomo

Grand Fiore Futurista

Courtesy of Private Collection/Christie's Images/Bridgeman Art Library/® DACS 2002

After a conventional art training in his native Turin, Giacomo Balla went to Paris in 1901 where he was strongly influenced by Impressionism and Divisionism. In 1910 he signed the Futurist Manifesto, publicizing his commitment to a form of art that would express the vibrant dynamism of the twentieth century. In his paintings Balla tried to convey the impression of speed through the use of overlapping images like time-lapse photographs. Futurism lost its freshness and idealism during World War I and in the 1920s it became increasingly stereotyped and associated with Fascism. As a result, Balla turned to more abstract forms and from 1930 onwards tended to return to the more mainstream styles of figurative painting. Nevertheless, echoes of Balla's technique may be found in many works of the late twentieth century which use blurred or overlapping images to suggest rapid movement.

MOVEMENT

Futurism

OTHER WORKS

Girl Running on the Balcony; Dog on a Leash; Flight of Swallows

INFLUENCES

Umberto Boccioni, Carlo Carrà

Giacomo Balla Born 1871 Turin, Italy

Painted in Italy

Died 1958 Rome, Italy

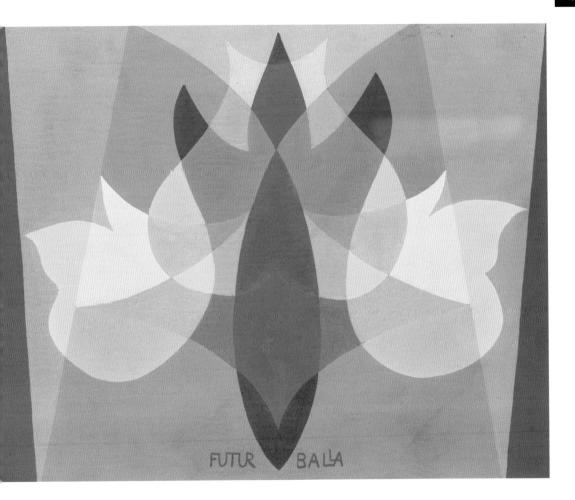

Chirico, Giorgio de

Piazza d'Italia, c. 1915

Courtesy of Private Collection/Christie's Images/© DACS 2002

Born in north-western Greece of Venetian descent, Giorgio de Chirico studied in Athens and Munich, then worked in Paris and finally collaborated with Carrà in Italy, founding Pittura Metaphisica. About 1910 he began painting a series of pictures of deserted town squares, imbued with a dreamlike quality, characterized by incongruous figures and strange shadows which anticipated the style of the Surrealists, on whom he exerted tremendous influence. After suffering a breakdown during World War I he developed his metaphysical style of painting, which conveyed an intensely claustrophobic impression. In the 1920s, however, his paintings often verged on the abstract before he returned to a more traditional style shortly before World War II – the complete antithesis of all he had done up to that time. He continued to embrace academic naturalism in the postwar period.

MOVEMENT

Metaphysical painting, Surrealism

OTHER WORKS

The Uncertainty of the Poet; The Archaeologists

INFLUENCES

Carlo Carrà

Giorgio de Chirico Born 1888 Volo, Greece

Painted in France and Italy

Died 1978 Rome

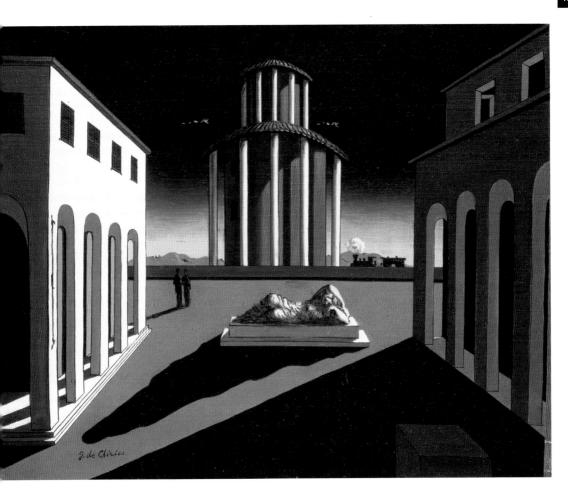

Modigliani, Amedeo

Beatrice Hastings Assise, 1915

Courtesy of Private Collection/Christie's Images

Modigliani was born into a Jewish family in Livorno, Italy. Although educated in Florence and Venice he spent most of his career in France. His highly individual style combined the linear elegance of Botticelli, whose work he had studied in Italy, with the avant-garde ideas that were circulating in pre-war Paris. His key influence was the Romanian sculptor Brancusi, whom he met in 1909. Under his guidance, Modigliani produced an impressive series of African-influenced stone figures.

After the outbreak of war, the raw materials for sculpture became scarce, so Modigliani turned to painting. Most of his subjects were sensual nudes or portraits, featuring slender, elongated figures. These received little attention from the critics; he was better known for his self-destructive, bohemian lifestyle, a lifestyle which caused the breakdown of his health – he died of tuberculosis at the age of 35. Tragically, Jeanne Hébuterne, his mistress and favourite model, committed suicide on the following day while pregnant with the artist's child. Modigliani's reputation was only secured posthumously, through a retrospective exhibition in Paris in 1922.

MOVEMENT

School of Paris

OTHER WORKS

Seated Nude; The Little Peasant; Portrait of Jeanne Hébuterne

INFLUENCES

Sandro Botticelli, Paul Cézanne, Constantin Brancusi

Amedeo Modigliani Born 1884, Livorno, Italy

Painted in Italy and France

Died 1920 Paris, France

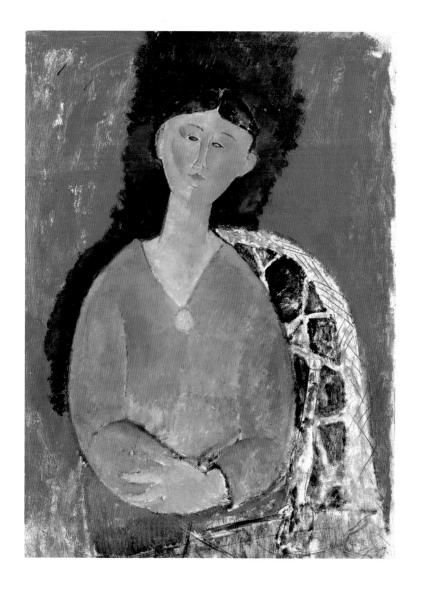

Kirchner, Ernst Ludwig

Königstein Mit Roter Kirche, 1916

Courtesy of Private Collection/Christie's Images/o by Dr. Wolfgang Henze and Ingeborg Heuze-Ketterer, Wichtrach, Bern, Switzerland

Born in Aschaffenburg, Germany in 1880, Kirchner studied architecture in Dresden before turning to painting as a result of encouragement from fellow students Erich Heckel and Karl Schmidt-Ruttluf. In 1905 these three artists formed the movement known as Die Brücke (The Bridge), which continued until 1913. The name signified the fact that they spanned the art of the past and present and derived inspiration from a variety of disparate sources, from primitive tribal art to Van Gogh. Kirchner was the dominant personality in this group, which sought to give direct expression to human feelings. Kirchner evolved a distinctly angular style highlighted by bold, contrasting colours. Like so many other artists drafted into the infantry, Kirchner suffered a severe nervous breakdown and while convalescing in Switzerland he concentrated on Alpine landscapes as an antidate to the horrors of trench warfare. His postwar paintings grew more abstract in the time leading up to his suicide in 1938.

MOVEMENTS

Die Brücke, Expressionism

OTHER WORKS

Striding Into the Sea; Berlin Street Scene; The Red Tower in Halle

INFLUENCES

Vincent Van Gogh, Edvard Munch, Paul Gauguin

Ernst Ludwig Kirchner Born 1880 Aschaftenburg, Germany

Painted in Germany and Switzerland

Died 1938 Davos, Switzerland

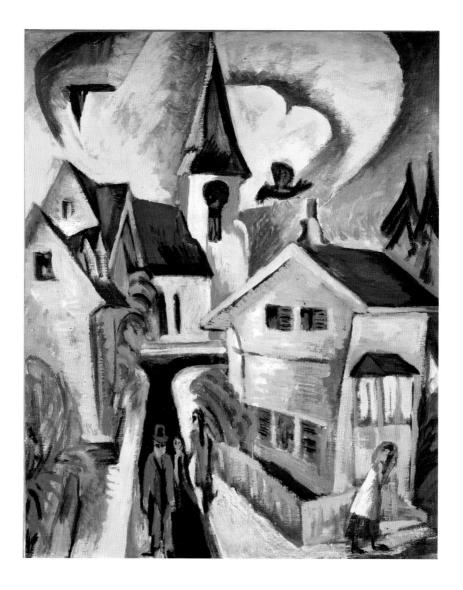

Orozco, José Clemente

Caballo Salvajes

Courtesy of Private Collection/Christie's Images © DACS 2002

José Clemente Orozco studied engineering and architecture in Mexico City and later art at the Academia San Carlos. Although schooled in the Spanish classical tradition, Orozco was strongly influenced by his studies of the art and architecture of the Toltecs and Mayas and this was reflected in his paintings, which also imbibed much from the European Expressionists. At the same time, he was an ardent revolutionary and a lifelong political activist - as a result his canvasses often have an emphatic social message. Many of his paintings deal with dramatic events in Mexico's turbulent history – the revolution of 1911 and the subsequent civil war providing a fertile source of material. Orozco's passion for the sweeping social and economic changes wrought in the 1920s and 1930s also comes across very vividly in his work. He worked at various times between 1917 and 1934 in the United States and painted murals and other decorations for several public buildings.

MOVEMENTS

Expressionism, Social Realism

OTHER WORKS

Table of Universal Brotherhood; Modern Migration of the Spirit

INFLUENCES

Diego Rivera

José Clemente Orozco Born 1883 Qudad Guzman, Mexico

Painted in Mexico and USA

Died 1949 Mexico City

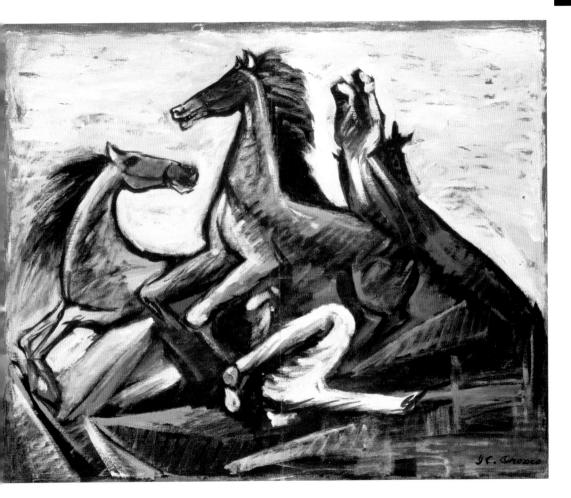

Thomson, Tom

The Jack Pine, 1916-17

O National Gallery of Canada, Ottawa, Purchased 1918

Thomas John Thomson originally worked as an engraver and draughtsman at Grip Limited in Toronto, illustrating books and periodicals, and it was not until 1906 that he took up painting seriously. While working at Grip he was encouraged by co-workers J. E. H. MacDonald and Arthur Lismer to develop his painting. Other artists who were subsequently employed as graphic designers at Grip included Frederick Varley, Frank Johnston and Franklin Carmichael, who all made their name as painters; never before or since has any commercial firm employed such a talented group. While many of his younger colleagues became official war artists, Thomson remained behind, but it was his tragic death in mysterious circumstances – drowned near Wapomeo Island on Canoe Lake in 1917 – which had a major impact on the post-war development of Canadian art. His death shocked his friends but increased their determination to paint Canada their way. A. Y. Jackson summed this up when he wrote, 'he was the guide, the interpreter, and we the guests partaking of his hospitality so generously given'.

MOVEMENT

Modern Canadian School

OTHER WORKS

Pine Island; Snow in the Woods; Sunrise

INFLUENCES

A. Y. Jackson, J. E. H. MacDonald, Arthur Lismer

Tom Thomson Born 1877 Ontario, Canada

Painted in Canada

Died 1917 Wapomeo Island on Canoe Lake, Ontario

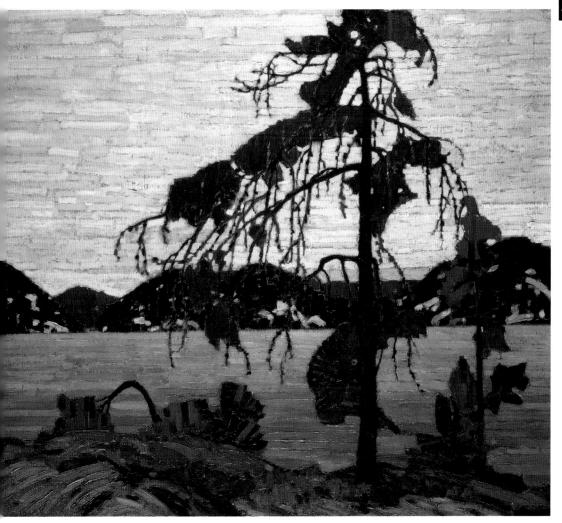

Braque, Georges

Verre et as de Trefle, 1917

Courtesy of Private Collection/Christie's Images @ ADAGP, Paris and DACS, London 2002

Born in Argenteuil, the son of a house-painter, Braque was initially trained to carry on the family business. In 1902 he switched to art, but retained a profound respect for craftsmanship and always ground his own pigments. Initially, he joined the Fauvist group, but his style altered radically after two key events in 1907. Firstly he was overwhelmed by an exhibition of Cézanne's work, then, later in the year, he saw *Les Demoiselles d'Avignon* in Picasso's studio and embarked on a unique collaboration with the Spaniard. Working, in Braque's words, 'like two mountaineers roped together', they created Cubism. This artistic partnership was halted by the war, when Braque was called to the Front. He was decorated for bravery before being discharged with serious wounds in 1916. Unlike Picasso, who changed direction completely, Braque spent the remainder of his career refining his experiments with Cubism. These culminated in a magnificent cycle of paintings on *The Studio*, which he began in 1947. Braque also diversified into design work, producing ballet décors, stained-glass windows, book illustrations and, most notable of all, a ceiling for the Etruscan Gallery in the Louvre.

MOVEMENT

Cubism

OTHER WORKS

The Round Table; Guitar and Fruit Dish; Still Life with Violin

INFLUENCES

Pablo Picasso, Paul Cézanne, Juan Gris

Georges Braque Born 1882, Argeuteille-sur-Seine, France

Painted in France

Died 1963 Paris, France

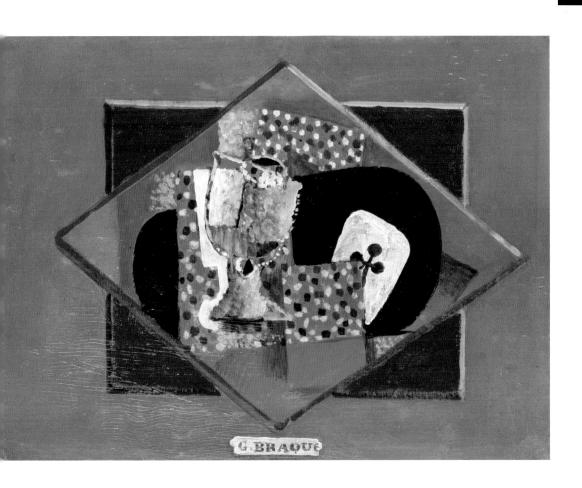

Pierneef, Jacob Hendrik

Mountainous Landscape, 1917

Courtesy of Bonhams, UK/Bridgeman Art Library

Caught up in the struggle of the Anglo-Boer War, Jacob Hendrik Pierneef fled from the Transvaal and went into exile in Holland in 1900–02, and it was there that he began attending evening classes in drawing at Hilversum, followed by a year at the Rotterdam Academy. Returning to Pretoria, he began working as a painter and printmaker in his spare time, but became a full-time artist in 1924. A second visit to Holland (1925–26) acquainted him with the art theories of Willem van Konijnenburg, which led him to apply geometric principles to his own highly formalized landscapes, as exemplified in the series of 32 large murals commissioned for Johannesburg Railway Station. In these he created a stylization bordering on the abstract, to which the vast panoramic landscapes of the Transvaal were ideally suited. These qualities are also evident in his easel paintings of the veld.

MOVEMENT

Modern South African School

OTHER WORKS

Composition in Blue; The Bushveld; Cape Homestead

INFLUENCES

Willem van Konijnenburg

Jacob Hendrik Pierneef Born 1886, Pretoria, South Africa

Painted in Holland and South Africa

Died 1957 Pretoria

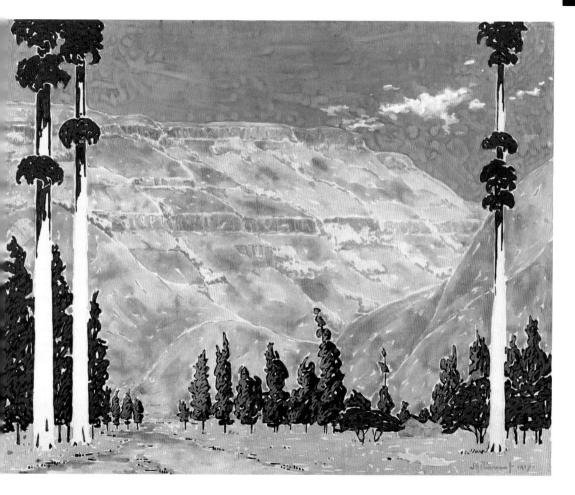

Pippin, Horace

Flowers with Doilies and Two Chairs

Courtesy of Private Collection/Christie's Images

Horace Pippin began drawing at the age of seven, but in his youth he held a variety of menial jobs before joining the army in 1917. He returned to West Chester in 1920, his right arm badly damaged by a sniper's bullet and as part of his therapy he began executing pictures in pokerwork on wood panels. In 1929 he took up painting and without any formal training developed into one of America's leading primitive painters, his work being compared to that of Henri 'Douanier' Rousseau. He started by painting the grim scenes from his experiences on the Western Front, vividly conveying the psychological trauma of trench warfare. Later he turned to historic events, biblical subjects and genre paintings derived from childhood incidents. A recurring feature of his work is his own highly personal interpretation of events and personalities. His last paintings were the *Holy Mountain* series, four versions of the same subject, painted in 1944.

MOVEMENT

African American School

OTHER WORKS

The End of War: Starting Home; Night Call; Buffalo Hunt

INFLUENCES

Pierre-Auguste Renoir

Horace Pippin Born I 888 Pennsylvania USA

Painted in West Chester, Pennsylvania

Died 1946 West Chester

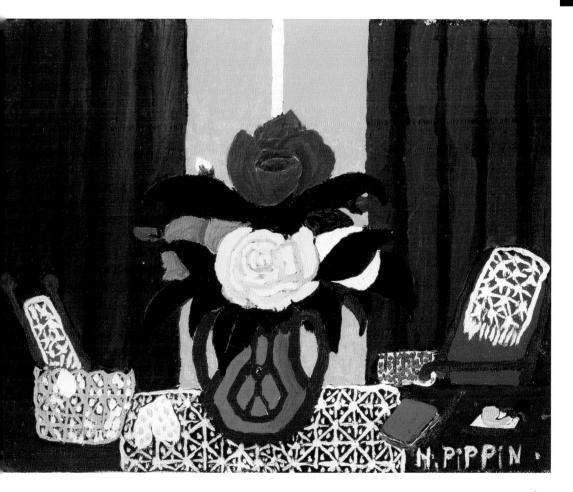

Vlaminck, Maurice de

Paysage

Courtesy of Private Collection/Christie's Images/© ADAGP, Paris and DACS, London 2002

Although largely self-taught, this exuberant, highly extrovert artist wielded a considerable influence over the development of avant-garde styles at the beginning of the twentieth century. Influenced by the expressive quality in the paintings of Van Gogh and Gauguin, he was later closely associated with André Derain and Henri Matisse, with whom he established Fauvism, painting flat patterns in the most extravagantly brilliant colours. Subsequently he came under the influence of Paul Cézanne and between 1908 and World War I produced landscapes that were more in the mainstream Realist manner and much more restrained in their use of colour. War service left its mark on him and in his later years he withdrew to a remote part of the country, where he developed a form of brooding Expressionism characterized by more sombre colours.

MOVEMENTS

Fauvism, Realism

OTHER WORKS

Landscape with Red Trees; The River; Summer Landscape

INFLUENCES

André Derain, Henri Matisse, Paul Cézanne

Maurice de Vlaminck Born 1876 Paris, France

Painted in France

Died 1958 Rueil-la-Gadelière, France

Popova, Liubov

Pictorial Architectonic, 1918

Courtesy of Private Collection/Christie's Images

Born Liubov Sergeyevna Eding on the outskirts of Moscow, Popova studied in Paris shortly before the outbreak of World War I. On her return to Russia in 1914 she met Vladimir Tatlin, who would later become the founder of Soviet Constructivism, and whose principles are very evident in her paintings immediately after the Revolution. In the last years of her life she designed costumes and sets for the theatre as well as patterns for the First State Textile Factory in Moscow, which put on a major retrospective exhibition of her works shortly after her sudden death from scarlet fever in 1924. Her paintings broke new ground in their exploration of spatial possibilities and in their colour values, characterized by overlapping circles, curved, diagonal lines and geometric shapes in which the colours merge or contrast sharply. She fervently believed that art should not be merely decorative but should serve some useful purpose and, but for her untimely death, she would undoubtedly have become one of the major forces in Soviet art.

MOVEMENT

Constructivism

OTHER WORKS

Space-Force Construction; Cubist Nude

INFLUENCES

Vladimir Tatlin, Alexander Archipenko

Liubov Popova Born 1889 Moscow, Russia

Painted in Moscow

Died 1924 Moscow

Klee, Paul

Moonshine, 1919

Courtesy of Private Collection/Christie's Images © DACS 2002

Paul Klee studied in Munich and worked there as an etcher. In 1911 he joined with Feininger, Kandinsky and Jawlensky in the Blaue Reiter group founded by August Macke; up to that time he had worked mainly in watercolours, painting in an Expressionist manner with overtones of Blake and Beardsley, but subsequently he veered towards Cubism under the influence of Robert Delaunay and from 1919 onwards painted mostly in oils. In 1920 he became a teacher at the Bauhaus and in the ensuing period his paintings mingled the figural with the abstract as he explored subtle combinations of colours and shapes, often deriving elements from folk art and even children's drawings. He severed his connections with the Bauhaus and returned to Switzerland when the Nazis came to power in 1933 and condemned his works as degenerate art.

MOVEMENTS

Expressionism, Cubism

OTHER WORKS

The Castle in a Garden; At the Sign of the Hunter's Tree

INFLUENCES

August Macke, Robert Delaunay

Paul Klee Born 1879 Münchenbuschsee, Switzerland

Painted in Berne and Munich

Died 1940 Muralto-Locarno, Switzerland

John, Augustus

Meditation at Ischia, Portrait of Thomas Earp

Courtesy of The Artists' Estate/Bridgeman Art Library/Christie's Images

Augustus Edwin John studied at the Slade School of Art and the University of London under Fred Brown and Henry Tonks, winning a scholarship with his *Moses and the Brazen Serpent* (1896). He went to Paris in 1900 and later travelled in the Netherlands, Belgium and Provence. His early work was influenced by Rembrandt, El Greco and the Post-Impressionists. A colourful, larger-than-life character, John hit the headlines when he roamed around England in a horse and cart, painting gypsy scenes. His later style was marked by the use of bold, bright colours, his first major oil being *The Smiling Woman* (1908) the first of many paintings in which his wife Dorelia was the model. During World War I he served as a war artist with the Canadians. From the 1920s onwards he painted numerous portraits. He became a member of the Royal Academy in 1928, resigned in protest in 1938, was re-elected in 1940 and in 1942 was awarded the Order of Merit. His genre scenes are full of wry humour.

MOVEMENT

English School

OTHER WORKS

Canadians Opposite Lens; The Smiling Woman

INFLUENCES

Rembrandt, El Greco

Augustus John Born 1878 Tenby, Wales

Painted in England

Died 1961 Hampshire, England

Léger, Fernand

Le Petit Déjeuner, 1921-22

Courtesy of Private Collection/Christie's Images @ ADAGP, Paris and DACS, London 2002

Fernand Léger studied architecture in Caen and painting at the Académie Julien in Paris from 1903. Through Braque and Picasso he was introduced to Cubism in around 1910, but he soon developed his own distinctive brand of art described as the 'aesthetic of the machine', already evident in his work by 1913 but more fully developed after World War I. In this period he designed costumes and sets for the Swedish Ballet and collaborated with Man Ray on the first abstract film, *Le Ballet Mécanique* (1924). During World War II he lived in the USA where he taught at Yale and pointed mainly acrobats and cyclists as well as working on the murals for the UN headquarters building in New York. After returning to France he concentrated on large paintings of men and machinery, earning the epithet of the 'Primitive of the Machine Age'.

MOVEMENT

Cubism

OTHER WORKS

The Construction Workers; The Builders; Still Life with a Beer Mug

INFLUENCES

Georges Braque, Pablo Picasso

Fernand Léger Born 1881 Argentan, France

Painted in France and USA

Died 1955 Gif-sur-Yvette, France

Gontcharova, Natalia

Le Printemps

Courtesy of Private Collection/Christie's Images @ ADAGP, Paris and DACS, London 2002

Natalia Gontcharova originally studied science but later changed direction and enrolled at the Moscow Academy of Art and trained as a sculptor. She turned to painting in 1904, attracted to the naïve folk art of Russia and emulating the flat colours and primitive forms in which these paintings were expressed, combined with concepts borrowed from the Fauves and Cubists. All the elements in these pictures were reduced to simple circles and rectangles or flat shapes that complemented each other, as seen in the woman's hat and the back of the carriage in her most famous painting. From 1911 she was a member of the German avant-garde movement known as Der Blaue Reiter. In 1915 she and her husband Mikhail Larionov moved to Geneva in order to design ballet costumes and sets for Diaghilev and never returned to Russia after the Revolution. Instead, she settled in Paris in 1921 where she continued to work mainly as a designer and became a naturalized French citizen in 1938.

MOVEMENT

Der Blaue Reiter

OTHER WORKS

The Cyclist; The Ice Cutters

INFLUENCES

Mikhail Larionov, Pablo Picasso

Natalia Gontcharova Born 1881 Nagayevo, Russia

Painted in Moscow and Paris, France

Died 1962 Paris

Harris, Lawren

Above Lake Superior, c. 1922

Courtesy of Art Gallery of Ontario, Toronto, Canada/Bridgeman Art Library

One of the leaders of the modern Canadian movement, Lawren Harris worked as a commercial artist in Toronto. In 1908 he joined the newly formed Arts and Letters Club, which brought him into contact with other graphic designers and would-be artists, such as Arthur Lismer, Tom Thomson and J. E. H. MacDonald. But it was Harris who apparently took the lead in proposing that they should adopt a distinctive Canadian style — abandoning preconceived ideas, especially the classicism of English and European art — and paint nature as they found it. With the help of an art patron, Dr James McCallum, Harris founded the Studio Building for Canadian Art, to encourage graphic artists to concentrate on landscape painting. He also organized painting expeditions to Algonquin Park, Georgian Bay and the Laurentian Highlands. Though derided as the 'Hot Mush School', out of this eventually emerged the Group of Seven which revolutionized Canadian art. Later he joined the Theosophical Society, believing that art must express spiritual values as well as depicting the visual world.

MOVEMENT

Modern Canadian School

OTHER WORKS

Northern Lake; Kempenfelt Bay; Early Houses

INFLUENCES

J. E. H. MacDonald, Tom Thomson

Lawren Harris Born 1885, Ontario, Canada

Painted in Canada

Died 1970 Toronto, Ontario

Dix, Otto

Kupplerin – A Woman Smoking, 1923

Courtesy of Private Collection/Christie's Images © DACS 2002

Otto Dix studied art in Dresden, where he developed an intense interest in realism. Drafted into the infantry on the outbreak of World War I he experienced at first hand the horrors of trench warfare, and this was to have a profound effect on his work. After the war he continued his studies at Dresden and Düsseldorf, producing grimly shocking collages and etchings. Around 1925 he turned from these strident anti-war messages to social realism, producing paintings of beggars, the war-maimed and prostitutes, which earned him his place in the New Objectivity. Brilliant but devastating in his merciless criticism of the Weimar Republic's social and political shortcomings, he was intensely reviled by the Nazis, who dismissed him from his teaching post and condemned his works as degenerate. Persecuted by the Gestapo, he turned to romanticism and religious art and in his later years painted in an Expressionist style.

MOVEMENTS

New Objectivity, Expressionism

OTHER WORKS

Die Grosstadt; Homage to Beauty; The War

INFLUENCES

George Grosz, Max Beckmann

Otto Dix Born 1891 Gera-Unternhaus, Germany

Painted in Dresden, Germany

Died 1969 Konstanz, Germany

Amaral, Tarsila do

Central Railroad of Brazil, 1924

Courtesy of Museu de Arte Contemporaneo, São Paulo, Brazil/Index/Bridgeman Art Library

Born near Capivari, São Paulo State, Brazil in 1886, Tarsilo do Amaral was the daughter of a wealthy businessman and travelled to Europe several times in her childhood. She began studying art in São Paulo in 1916 under Pedro Alexandrino and Fischer Elpons. She studied at the Académie Julien in Paris (1920–22) and on her return to Brazil became a prominent member of the short-lived art circle known as the Grupo dos Cinco. She then returned to Paris with Oswald de Andrade, where they were influnced by Picasso and Chirico. She later divided her time between Paris and Rio de Janeiro, bringing Brazilian art to Europe and taking Modernist ideas back to Brazil. Her paintings, in a style she dubbed 'Pau-Brazil', are an unusual blend of native Brazilian art forms, notably from the Tupi-Guarani tradition, with a geometric style influenced by Fernand Léger. Later she created a movement known as Antropofagia, which sought to replace the Portuguese colonial tradition with an indigenous style that was primitive and earthy.

MOVEMENT

Modern Brazilian School

OTHER WORKS

A Negra (The Black Woman)

INFLUENCES

Albert Gleizes, Pablo Picasso, Fernand Léger, Giorgio de Chirico

Tarsila do Amaral Born 1886 São Paulo, Brazil

Painted in São Paulo, Rio de Janeiro, Paris

Died 1973 São Paulo

Carrà, Carlo

Lot's Daughters

Courtesy of Private Collection, Switzerland/Bridgeman Art Library/® DACS 2002

Carlo Carrà was largely self-taught, but at the beginning of the twentieth century he came under the influence of Giacomo Balla and signed the Futurist Manifesto of 1910. His paintings of this period show the futurist preoccupation with speed and movement. For a time, however, he also studied the works of Giotto. He served in the Italian army during World War I and while recuperating in a military hospital in 1917 he met Giorgio de Chirico, with whom he evolved a metaphysical style which in fact bordered on Surrealism. From 1921 onwards, however, he switched to a more reflective mode into which he injected notions of heightened realism which he imbibed from his friend Giorgio Morandi. Back in the mainstream of Italian art, he taught at the Milan Academy and influenced the interwar generation of painters.

MOVEMENTS

Futurism, Metaphysical Painting

OTHER WORKS

Le Canal; Lot's Daughters

INFLUENCES

Giacoma Balla, Giorgio de Chirico, Giorgio Morandi

Carlo Carrà Born 1881 Quargnento, Italy

Painted in Milan, Italy

Died 1966 Milan

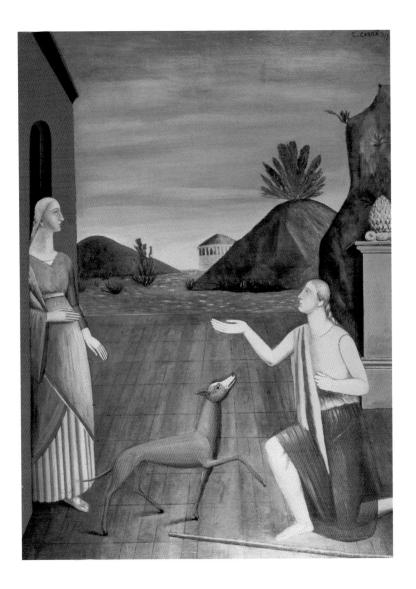

Grosz, George

Amor, Lichtspiele, 1924

Courtesy of Private Collection/Christie's Images © DACS 2002

George Grosz studied in Dresden and Berlin before being drafted into the army at the outbreak of World War I. In 1917 he was discharged as permanently unfit for service, traumatized by the horrors of trench warfare. In the same year he became associated with the German Dadaists and was an eye-witness of the moral disintegration of Germany through the Spartacist uprising of 1918–19 and the violent street battles between Communists and Nazis in the 1920s. These events, combined with the corruption of the Weimar Republic, provided Grosz with endless material for his ruthlessly satirical and savage attacks on German militarism and the decadence of the middle classes. Garish colours and grossly distorted images, especially faces, were his main weapons. Grosz left Germany in 1932 and settled in the USA where he became naturalized in 1938. In his American period he concentrated on paintings of a more symbolic, less strident, nature. He returned to Germany in 1959, shortly before his death.

MOVEMENT

Dada

OTHER WORKS

Pillars of Society; Suicide

INFLUENCES

Giorgio de Chirico, Carlo Carrà

George Grosz Born 1893 Berlin, Germany

Painted in Berlin and USA

Died 1959 Berlin

Gris, Juan

La Grappe de Raisins, 1925

Courtesy of Private Collection/Christie's Images

Born José Victoriano Gonzalez, Gris began his art studies in Madrid before going to Paris in 1906 to work as a magazine illustrator. An early associate of Picasso and Matisse, he became one of the leading exponents of Synthetic Cubism from 1912 onwards, the majority of his paintings involving the deliberate distortion and rearrangement of the elements. He also made extensive use of collage, such as strips of newspaper cut up and rearranged. He moved to Boulogne after World War I and in the 1920s designed costumes and sets for several of Diaghilev's Ballets Russes as well as working as a book illustrator. In his later years he experimented with brighter, contrasting colours and also produced a number of multicoloured sculptures.

MOVEMENT

Synthetic Cubism

OTHER WORKS

Glasses; Newspaper and a Bottle of Wine; The Bay

INFLUENCES

Henri Matisse, Pablo Picasso

Juan Gris Born 1887 Madrid, Spain

Painted in Paris and Boulogne

Died 1927 Paris, France

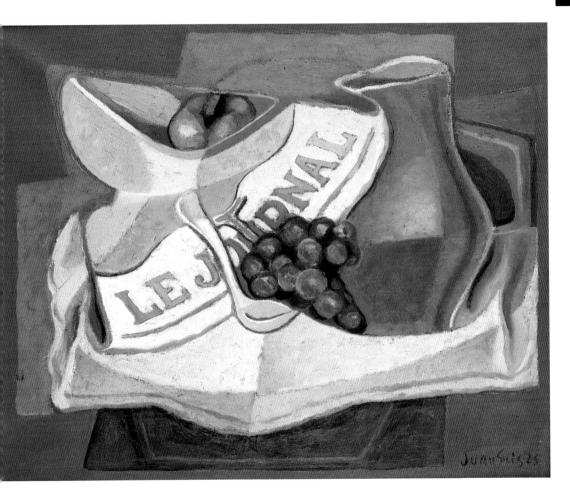

Moholy-Nagy, László

CH Beata 2

Courtesy of Christie's Images/© DACS 2002

László Moholy-Nagy studied law in Budapest, but never practiced. Instead, he dabbled in photography and turned to painting after World War I, associating with Dadaists and Constructivists in Vienna and Berlin and constructing what he termed 'photograms': non-representational photographic images made directly from the subject without a camera. In 1925 he joined the Bauhaus under Gropius and established his reputation in the ensuing decade as the foremost exponent of the New Photographers' movement. In 1935 he moved to London, where he designed the futuristic sets for fellow-Hungarian Alexander Korda's film, *Things to Come*. In 1937 he went to the USA where he was appointed head of the Bauhaus School in Chicago, later renamed the Institute of Design. He became an American citizen at the end of World War II. Although primarily associated with photography, he also worked as a sculptor, designer and painter, often using collage and photo-montage.

MOVEMENT

Constructivism

OTHER WORKS

CHX; Composition A II; Jealousy

INFLUENCES

Naum Gabo, Kasimir Malevich

László Moholy-Nagy Born 1895 Hungary

Painted in Vienna, Berlin, Weimar, London and Chicago

Died 1946 Chicago, USA

Ozenfant, Amédée

Nature Morte aux Verres, Bouteilles et Pot Blanc

Courtesy of Private Collection/Christie's Images/© ADAGP, Paris and DACS, London 2002

Amédée Ozenfant was not only a painter, but also a very articulate propagandist for modern art and a prolific writer on the subject. After a conventional art education he collaborated in Paris with Le Corbusier in the development of a post-Cubist style known as Purism, and together they published the Purist manifesto entitled *Après le Cubisme* (After Cubism) in 1919. Later they published an avant-garde art periodical *Esprit nouveau* (New Spirit) from 1921 to 1925 and co-authored *La Peinture Moderne* in 1925. An English translation under the title *Foundations of Modern Art* appeared in 1931 and was widely acclaimed as an imaginative account by a practicing artist. Ozenfant spread the gospel of Purism abroad, founding art schools in London (1935) and New York (1938) for this purpose. His paintings were mainly of still life, characterized by sinuous curvilinear elements reduced to their bare essentials, revealing his gradual departure from an early decorative style to the clear-cut forms of Purism.

MOVEMENT

Purism

OTHER WORKS

Smoking Room

INFLUENCES

Le Corbusier

Amédée Ozenfant Born 1886 Saint-Quentine, Aisne, France

Painted in France

Died 1966 Cannes, France

Waring, Laura Wheeler

Anna Washington Derry, 1927

© Smithsonian American Art Museum, Washington, DC/Art Resource New York

A native of Connecticut, Laura Wheeler Waring attended art school in Hartford before going to the Pennsylvania Academy of Fine Arts in Philadelphia from which she won a travelling scholarship in 1914. Her studies were interrupted by World War I, but in 1924–25 she attended classes at the Académie de la Grande Chaumière in Paris. Later she taught art in the Cheney State Teachers College, Pennsylvania. Her portraiture contained elements of Expressionism but she was also influenced by the Romantics, resulting in an unusual blend of the two styles, which had a much livelier appearance than normally associated with wholly representational portraits of the interwar period. At the same time, although her portraits are sensitive, they manage to avoid the cloying sentimentality often associated with the Romantics. She also worked as an illustrator.

MOVEMENT

African American School

OTHER WORKS

Portrait of a Child: Frankie

INFLUENCES

Henry Ossawa Tanner

Laura Wheeler Waring Born 1887 USA

Painted in Pennsylvania and Paris

Died 1948 Philadelphia, Pennsylvania, USA

Delaunay, Robert

Triomphe de Paris, 1928-29

Courtesy of Private Collection/Christie's Images/DACS 2002 © L & M Services B. V. Amsterdam 20020512

After a conventional art training in Paris, Robert Delaunay worked as a designer of sets for the theatre and did not take up painting seriously until 1905–06, when he came under the influence of the Neo-Impressionists. Over the ensuing decade he was also closely associated in turn with the Fauves, the Cubists and especially Der Blaue Reiter in 1911–12. In the latter years, however, his experimentation with contrasting colour patterns resulted in the development of a distinctive style which his friend, the poet Guillaume Apollinaire, dubbed Orphism because of its lyrical, almost musical, harmony. In his initial period, Delaunay painted numerous landscapes in and around Paris – the Eiffel Tower being a favourite subject – but gradually he moved towards a more non-figurative style. In his organization of contrasting colours he had a profound influence on the development of Abstract art in the 1920s. He collaborated with his wife Sonia, especially from 1918 onwards when he returned mainly to stage design.

MOVEMENT

Orphism

OTHER WORKS

Eiffel Tower: Sainte Severin: Political Drama

INFLUENCES

Pablo Picasso, Otto Freundlich, Franz Marc, Wassily Kandinsky

Robert Delaunay Born 1885 Paris, France

Painted in Paris

Died 1941 Montpellier, France

Lempicka, Tamara de

Les Deux Amies, c. 1928

Courtesy of Private Collection/Christie's Images/@ ADAGP, Paris and DACS, London 2002

Tamara de Lempicka came from a Polish upper-class family, which gave her an excellent all-round international education. In 1918 she and her Russian husband fled the Russian Revolution to Paris. Here Lempicka came under the influence of the avant-garde artists, notably Fernand Léger. However, the painter whose work most impressed her and whose style is reflected in her own female nudes was Paul Cézanne, then near the end of his long career. Lempicka became one of the most fashionable portrait painters in Paris in the interwar period, her work emphasizing the glamour and ostentatious wealth of her patrons, idealizing their beauty and elegance. The other side of Lempicka, however, was her homosexuality – which was reflected in her extraordinary studies of female nudes, always fully representational (and often devastatingly so) yet with overtones of Cubism in the use of simplified anatomy and the geometric patterns of the background. The result was electrifying and highly distinctive.

MOVEMENT

Cubism

INFLUENCES

Paul Cézanne, Fernand Léger

Tamara de Lempicka Born 1898 Warsaw, Poland

Painted in Paris and Mexico

Died 1980 Cuernavaca, Mexico

O'Keeffe, Georgia

Red Gladiola in White Vase, 1928

Courtesy of Private Collection/Christie's Images/© ARS, New York and DACS, London 2002

Georgia O'Keeffe studied at the Art Institute of Chicago in 1905–06 and then the Art Students' League in New York City (1907–08), where she met her future husband Alfred Stieglitz, the founder of the avant-garde circle that bears his name. She was an early convert to Abstract Art and, with Stieglitz, did much to spread the gospel among American artists from 1915 onwards. In the 1920s, however, she developed a more figurative style, concentrating on architectural or floral motifs but injecting a note of Surrealism into her paintings. Her work was characterized by sharply defined images that explored geometric patterns and earned for her work the epithet of Precisionism. She travelled all over the world, drawing on her experiences in many of her later works. In her last years she resided in New Mexico, whose monumental scenery found expression in a number of her landscapes.

MOVEMENT

Modern American School

OTHER WORKS

Radiator Building; Cow's Skull with Calico Roses

INFLUENCES

Alfred Stieglitz

Georgia O'Keeffe Born 1887 Wisconsin, USA

Painted in USA

Died 1986 Santa Fé, New Mexico, USA

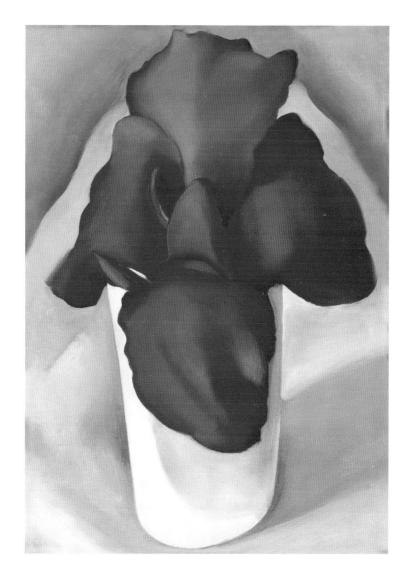

Hopper, Edward

Chop Suey, 1929

Courtesy of Whitney Museum of American Art, New York, USA/Bridgeman Art Library

Edward Hopper studied in New York City under Robert Henri between 1900 and 1906 and then travelled in Europe over the ensuing four years. The artistic atmosphere in Paris (1909–10) had a major impact on him and his paintings up to the mid-1920s reflect the influence of the French Impressionists. In this period he worked mainly as an illustrator, but from 1924 he concentrated on large-scale works which drew upon contemporary American life for their inspiration, from diners and gas stations to hotel lobbies and late-night bars. This emphasis on scenes which were instantly recognizable, coupled with the strong interplay of light and shadow, left an indelible impression – so much so that Hopper's art has come to represent urban America of the interwar years and had a major impact on the Pop Art of more recent years.

MOVEMENT

American School

OTHER WORKS

Room in New York; People in the Sun

INFLUENCES

Robert Henri

Edward Hopper Born 1882 New York, USA

Painted in New York

Died 1967 New York

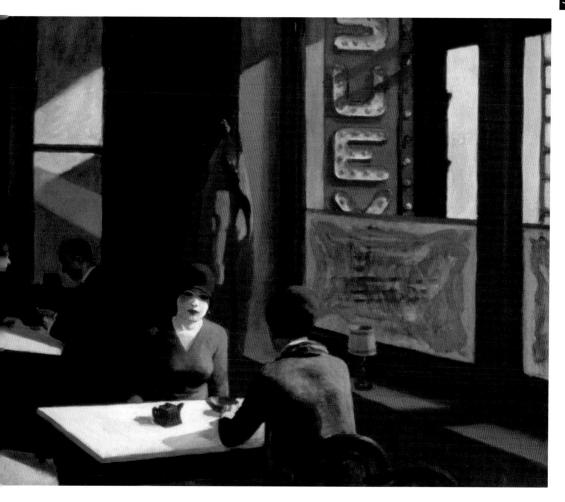

Roualt, Georges

Danseuse, 1929

Courtesy of Private Collection/Christie's Images/@ ADAGP, Paris and DACS, London 2002

Georges Henri Roualt was originally apprenticed to a stained-glass designer and the vivid colours of this material left their mark on his later work as a painter, in which forms and shapes were sharply outlined in black, rather like leaded windows. In 1892 he took up painting, studying under Gustave Moreau at the École des Beaux-Arts, where he met Matisse. About 1904 he joined the Fauves, but their violent colours were at odds with Roualt's preference for strong, dark shades. He had his first one-man show six years later. Apart from painting, he designed ballet sets and costumes and textiles, notably tapestry. Brought up in a staunchly Catholic environment, Roualt had a crisis of faith in about 1902, which led him to paint somber pictures with harsh motifs that symbolized man's fall from grace. He returned to a much purer form of religious art during World War I and this dominated his output during the global conflict of the 1940s. A prolific artist, he also illustrated books and designed ceramics.

MOVEMENT

French Expressionism

OTHER WORKS

Bust of a Woman Wearing a Necklace; The Three Judges

INFLUENCES

Gustave Moreau, Henri Matisse

Georges Roualt Born 1871 Paris, France

Painted in Paris

Died 1958 Paris

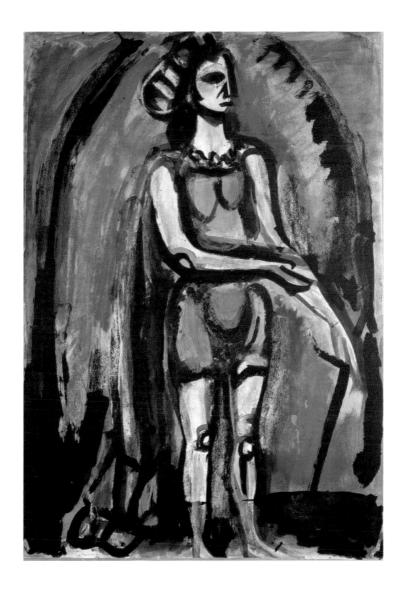

Dufy, Raoul

Large Blue Nude, 1930

Courtesy of Galerie Daniel Malingue, Paris, France/Bridgeman Art Library/© ADAGP, Paris and DACS, London 2002

Although he had a conventional training at the École des Beaux Arts in Paris, Raoul Dufy was attracted to the radical ideas of Matisse and Derain and for some time flirted with Impressionism, Cubism and Fauvism. In 1907 he turned away from painting to concentrate on textile patterns, graphic design and book illustrations, but in 1919 he took up painting again and settled on the French Riviera. There he was encouraged by his friend, the couturier Paul Poiret, to embark on a prolific series of paintings executed swiftly, characterized by large areas of flat colour and sharply incised black lines after the manner of the Chinese calligraphic artists. He created a kind of *ukiyo-e*, pictures of transient scenes, on promenades and beaches, at regattas and race meetings. His greatest masterpiece was the vast mural for the Exposition Universelle in Paris, 1938, one of the largest works ever painted.

MOVEMENT

Modern French School

OTHER WORKS

The Paddock: The Pier and Promenade at Nice

INFLUENCES

Henri Matisse, André Derain, Maurice de Vlaminck

Raoul Dufy Born 1877 Le Havre, France

Painted in Paris and the French Riviera

Died 1953 Forcalquier, France

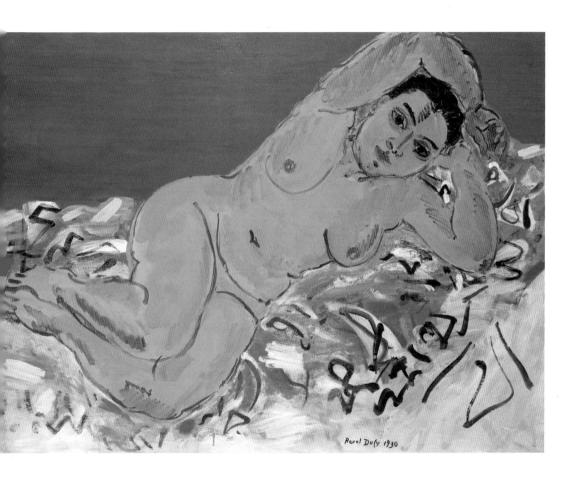

Mondrian, Piet

Composition with Red, Blue and Yellow, 1930

Courtesy of Private Collection/Christie's Images/® Piet Mondrian 2002 Mondrian/Holtzman Trust c/o Beeldrecht, Hoofddorp and DACS, Landon

Born Pieter Cornelis Mondriaan, he simplified his name in 1909 when he moved to Paris, where he came under the influence of the Cubists, notably Henri Matisse. From still life, his work became progressively more abstract, his paintings distinguished by tightly regimented geometric shape and contrasting bright colours. In 1917 he became a founder member of De Stijl, the movement which derived its name from the journal which provided a forum for the Dutch avant-garde artists. Through this medium he propounded the theories which had a profound effect on a later generation as well as his contemporaries, and led to the development of the movement known as Neoplasticism. Mondrian was the arch-apostle of the abstract in its purest, simplest form. He moved to London in 1938, but after his studio was destroyed in the Blitz he settled in New York.

MOVEMENTS

De Stijl, Neoplasticism

OTHER WORKS

Composition with Red, Yellow and Blue; Broadway Boogie Woogie

INFLUENCES

Henri Matisse

Piet Mondrian Born 1872 Amersfoot, Holland

Painted in Holland, London, England and New York

Died 1944 New York

Carr, Emily

Western Forest, c. 1931

Courtesy of Art Gallery of Ontario, Toronto, Canada/Bridgeman Art Library

Emily Carr received her art education at the California School of Design in San Francisco (1891–94) and then went to England where she continued her studies at the Westminster School of Art (1899). She returned to Vancouver in 1904 to explore Indian sites in British Columbia, but a period in Paris (1910–11) had a profound effect on her art. She exhibited at the Salon d'Automne of 1911 and studied the works of the Impressionists, Post-Impressionists and Fauvists in particular. On her return to Vancouver she resumed her study of the art of the Indian communities of the north-west Pacific Coast and devoted much of her life to salvaging the remnants of their civilization, which permeated her later paintings. She painted nothing from 1912 until 1927 when she met the Group of Seven artists in Ottawa and was inspired by them to resume her artistic career. Her best work belonged to the ensuing decade. Following a heart attack in 1937 she spent the last years of her life mainly writing books.

MOVEMENT

Modern Canadian School

OTHER WORKS

Skidegate; British Columbian Indian Village

INFLUENCES

A. Y. Jackson, Lawren Harris

Emily Carr Born 1871 Victoria, British Columbia, Canada

Painted in British Columbia

Died 1945 Victoria

Tagore, Rabindranath

Head of a Woman, 1931

Courtesy of National Museum of India, New Delhi, India/Bridgeman Giraudon/Lauros

Born in Calcutta of a princely family, Rabindranath Tagore was educated privately in India, then sent to England to study law, but before 1900 he began writing poetry and essays for Bengali periodicals. In 1901 he established the Santineketan at Bolpur, an unconventional educational institute. A prolific writer of poetry, novels and plays, he was awarded the Nobel Prize for literature in 1913 and was knighted in 1915. Tagore took up painting in 1929, and in the decade preceding his death he produced a number of major works which influenced a later generation of Indian artists. Like his writings, his paintings are suffused by a visionary quality. Although his work is executed in a Western style, it contains elements derived from Bengali art, a delicate blend of East and West. He worked mainly in ink on paper, building up an image from lines, doodles, smudges and blots with minimal use of secondary colours. His work suggests the influence of Symbolism.

MOVEMENT

Symbolism

OTHER WORKS

Untitled Portraits

INFLUENCES

Bengali art

Rabindranath Tagore Born 1861 Calcutta, India

Painted in Bengal, India

Died 1941 Calcutta

Kahlo, Frida

Autoretrato en la Frontera entre Mexico y los Estados, 1932

Courtesy of Private Collection/Christie's Images/© Banco de Mexico Diego Rivera and Frida Kahla Museums Trust Av. Cinco de Mayo No. 2, Col. Centro, Del. Cuauhtemoc 06059. Mexico. D.F.

Born at Coyoicoan near Mexico City, Frida Kahlo had the misfortune to be in a streetcar crash at the age of 15. During the long convalescence from her terrible injuries she took up painting and submitted samples of her work to Diego Rivera, whom she married in 1928. Artistic temperament resulted in a stormy relationship that ended in divorce in 1939; many of Kahlo's self-portraits in this period are wracked with the pain she suffered all her adult life, as well as reflecting anger at her husband's numerous infidelities. Indeed, pain and the suffering of women in general were dominant features of her paintings, endlessly explored and revisited in canvasses that verge on the surreal and often shock with their savage intensity. André Breton, the arch-apostle of Surrealism, neatly described her art as "like a ribbon tied around a bomb".

MOVEMENT

Surrealism

OTHER WORKS

Self Portrait with Cropped Hair; Self Portrait with Monkey

INFLUENCES

Diego Rivera

Frida Kahlo Born 1907 Coyoicoan, Mexico

Painted in Mexico City

Died 1954 Mexico City

Picasso, Pablo

Le Repos, 1932

Courtesy of Christie's Images © Succession Picasso/DACS 2002

Spanish painter, sculptor, draughtsman and ceramicist; the most versatile and influential artist of the twentieth century. Having studied in Barcelona, Picasso finally settled in Paris in 1904. His Blue (1901–04) and Rose (1904–06) periods produced his popular scenes of vagrants and circus performers, which were loosely inspired by Puvis and the Symbolists. Then, in 1907, he produced *Les Demoiselles d'Avignon*, the most influential painting of the twentieth century. Named after the red-light district in Barcelona and drawing inspiration from African sculpture, it opened the way for the Cubist movement, which Picasso spearheaded with Braque.

In the 1920s he ushered in a Classical revival, while also being hailed as an inspiration by the Surrealists. Increasingly, though, his paintings displayed a pessimistic strain, brought on by the collapse of his marriage and the deteriorating political situation. This culminated in his most celebrated picture, *Guernica*, which commemorated an atrocity in the Spanish Civil War. Picasso's ongoing hostility to the Franco regime led him to make France, rather than Spain, the hose for his later artistic activities.

MOVEMENTS

Cubism, Surrealism, Classical Revival

OTHER WORKS

Three Musicians

INFLUENCES

Paul Cézanne, Georges Braque, Toulouse-Lautrec

Pablo Picasso Born 1881 Malaga, Spain

Painted in Spain, France and Italy

Died 1973 Aix-en-Provence, France

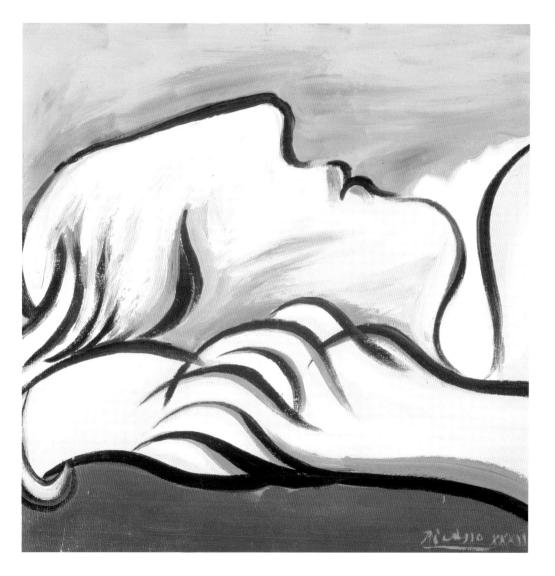

Fairweather, Ian

Roi Soleil (Sun King)

Courtesy of The Art Archive/© Estate of Ian Fairweather 2002. All Rights Reserved, DACS

Regarded as an Australian painter of Scottish birth, Ian Fairweather trained at the Slade School of Art in London. In 1924 he began wandering normalized place of the world, living and working in Germany, Canada, India, China and Japan before settling in Australia. During World War II he served as a captain with the British Army in India, but returned to his adopted land in 1943 after being invalided out. An eccentric loner, in 1952 he hit the headlines when he sailed from Darwin to Indonesia on a home-made raft and a year later settled on Bribie Island off northern Australia. His paintings range from portraits to landscapes but he is particularly noted for genre subjects. Relatively few of his paintings have an Australian theme – the majority of his works being Chinese scenes decorated with calligraphy in the Oriental manner. After World War II he worked mainly in gouache before turning to synthetic polymers in 1958. His best work consists of the virtually monochrome abstracts of 1959–61.

MOVEMENT

Australian School

OTHER WORKS

Kite Flying; Monastery; Monsoon; Bathing Scene Bali

INFLUENCES

Chinese traditional art

Ian Fairweather Born 1891 Scotland

Painted in Australia

Died 1974 Brisbane, Australia

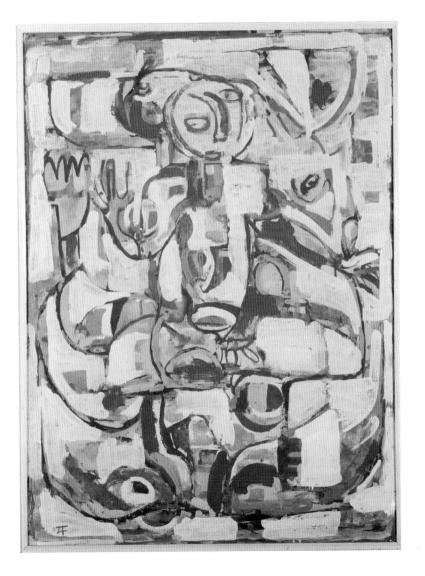

Jackson, A. Y.

Winter, Charlevoix County, 1933

Courtesy of Art Gallery of Ontario, Toronto, Canada/Bridgeman Art Library

One of the most influential Canadian artists of the twentieth century, Alexander Young Jackson originally worked as a commercial artist in Montreal (1895–1906), before moving to Chicago. While continuing in the same profession, he attended classes at the Art Institute of Chicago and then went to Paris in 1907, where he studied under Jean-Paul Laurens at the Académie Julian. He returned to Canada in 1909 and settled in Toronto in 1913, where he became one of the leaders of the Group of Seven, founded in 1920. In World War I he was wounded in action but later became a war artist. He resumed his work as a landscape painter in 1919, becoming the leading advocate for a distinctive Canadian style of painting, his words as eloquent as his paintings were striking. He travelled to every part of Canada, including the Arctic, to record the rich variety of landscape.

MOVEMENT

Modern Canadian School

OTHER WORKS

Terre Sauvage; Springtime in Picardy; First Snow

INFLUENCES

Jean-Paul Lauren, Lawren Harris, Tom Thomson

A. Y. Jackson Born 1882 Montreal, Canada

Painted in Canada and France

Died 1974 Kleinburg, Ontario, Canada

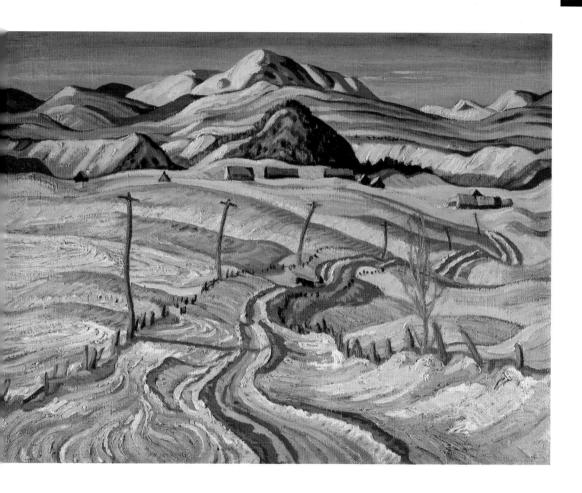

Magritte, René

Le Chef d'Oeuvre ou Les Mystères de l'Horizon

Courtesy of Christie's Images @ ADAGP, Paris and DACS, London 2002

The great Surrealist master René François Ghislain Magritte studied at the Académie Royale des Beaux-Arts in Brussels (1916–18) and became a commercial artist for fashion magazines and a designer of wallpaper. His paintings were initially influenced by Futurism and Cubism, but later he was attracted to the work of Giorgio de Chirico. In 1924 he became a founder member of the Belgian Surrealist group, which provided an escape from the dull routine of his everyday work. From 1927 to 1930 he lived in Paris to better continue his study of the Surrealists, then returned to Brussels where he built his reputation for paintings of dreamlike incongruity, in which themes and objects are jumbled in bizarre, nonsensical situations, often showing paintings within paintings. He is regarded in the United States as a forerunner of Pop Art.

MOVEMENT

Surrealism

OTHER WORKS

Rape; The Reckless Sleeper; The Treachery of Images

INFLUENCES

Giorgio de Chirico

René Magritte Born 1898 Lessines, Belgium

Painted in Belgium

Died 1967 Brussels, Belgium

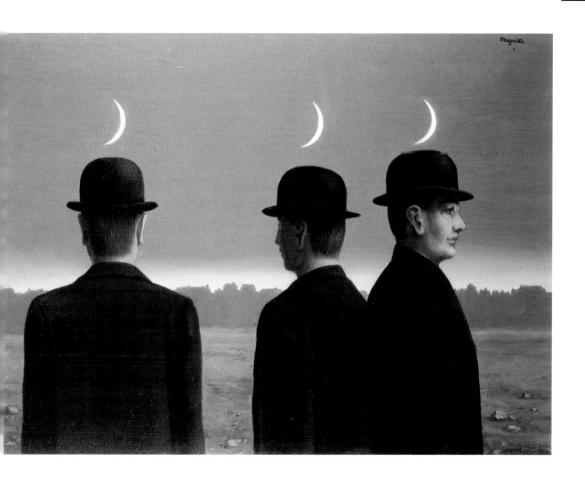

Soutine, Chaim

Les Escaliers à Chartres, c. 1933

Courtesy of Private Collection/Christie's Images/© ADAGP, Paris and DACS, London 2002

Born at Smilovich, Russian Poland (now Belarus), Chaim Soutine studied in Vilnius and travelled to Paris in 1911, where he was befriended by fellow Russian Jew Marc Chagall. Modigliani introduced him to the Expressionist school in Paris and he, in turn, exerted an exotic influence on its development, adding a dash of Fauvism and the German approach to Expressionism. Soutine delighted in painting the carcasses of animals, much to the disgust and annoyance of neighbours, who habitually complained of the stench of rotting flesh that emanated from his studio. Apart from studies of dead birds and decomposing sides of beef, Soutine painted portraits whose emaciated features and deathly expression bear a gruesome resemblance to the living dead of Belsen and Auschwitz. Soutine, who continued to live in Paris after the fall of France, managed to evade deportation to the camps and died in Paris in 1943.

MOVEMENT

French Expressionism

OTHER WORKS

The Boy in Black; Pageboy at Maxim's; Portrait of Modigliani

INFLUENCES

Emil Nolde, Henri Matisse, Marc Chagall

Chaim Soutine Born 1893 Smilovich, Russia

Painted in Paris, France

Died 1943 Paris

Wood, Grant

Adolescence, 1933

Courtesy of Private Collection/Christie's Images © Estate of Grant Wood/VAGA, New York/DACS, London 2002

Born at Anamosa, Iowa, Grant Wood spent his entire life in this small town in the American Midwest, and his paintings are a chronicle of the people and the scenery of the district. In the 1920s, however, he travelled to France and the Netherlands where he studied the works of the old masters, especially the Gothic, Romanesque, Renaissance and Flemish School, all of which had a strong influence on his own paintings. His best-known painting, *American Gothic*, is aptly named, for in it Wood depicts a cottage in his home town whose Gothic window appealed to him. In the foreground stands a typical Midwestern farmer and his wife, actually Wood's sister and his dentist, who served as his models. He was severely criticized at the time for lampooning the values of Middle America but he defended himself, insisting that the painting was intended as a sincere tribute to the simple dignity of rural communities. Wood was the foremost of the Regionalists, a group of American artists who rejected the abstract in favour of the realism of ordinary people and their locale.

MOVEMENT

Regionalism

OTHER WORKS

Haying

INFLUENCES

Jan Van Eyck, Rogier van der Weyden

Grant Wood Born 1892 Anamosa, Iowa, USA

Painted in lowa

Died 1942 Anamosa

Douglas, Aaron

Aspects of Negro Life: Song of the Towers, 1934

O Schomberg Center, The New York Public Library/Art Resource, New York

The leading exponent of the Harlem Renaissance, Aaron Douglas studied at the University of Kansas and from 1925 to 1927 studied art in New York under Winold Reiss, who encouraged him to accept and celebrate his African American heritage. Throughout the 1920s he illustrated a number of books by emerging African American authors, while drawings contributed to a number of magazines of the period show the influence of African art forms, putting Douglas in the forefront of the Harlem Renaissance. In 1931 he went to Paris and studied at the Académie Scandinave under Despiau, and in 1938 he travelled all over the American South and Haiti. He later taught at Fisk University in Nashville, Tennessee. In the 1930s he executed a number of large murals for public buildings in Nashville and New York which drew on the African American cultural tradition and history. He played a prominent role in the development of modern African American consciousness.

MOVEMENT

Modern American School

OTHER WORKS

Aspects of Negro Life, From Slavery through Reconstruction

INFLUENCES

Winold Reiss, Charles Despiau

Aaron Douglas Born 1899 Topeka, Kansas, USA

Painted in New York, Nashville and Paris

Died 1979 Nashville, Tennessee

Kokoschka, Oskar

Zwei Madchen, 1934

Courtesy of Christie's Images/© DACS 2002

Oskar Kokoschka studied at the Vienna School of Arts and Crafts (1905–09) and joined the Wiener Werkstätte, where he produced lithographs distinguished by their strong graphic sense. His drawings contributed to the German avant-garde magazine *Der Sturm* reveal a highly original approach to Expressionism. After military service in World War I, in which he was seriously wounded, he taught at the Dresden Academy of Art from 1919 until 1924 but subsequently he travelled extensively in Europe and North America before settling in Prague. When the Nazis dismembered Czechoslovakia in 1938 he moved to England, becoming naturalized in 1947, but six years later he settled in Switzerland, where he died in 1980. A versatile artist, he painted landscapes and urban scenes but it is for his very expressive portraits, in which disparate colours bring out the psychological profile of the sitter, that he will be remembered.

MOVEMENT

Expressionism

OTHER WORKS

Portrait of a 'Degenerate Artist'; Children Playing

INFLUENCES

Gustav Klimt, Max Beckmann

Oskar Kokoschka Born 1886 Pöchlarn, Austria

Painted in Vienna, Dresden, Prague and London

Died 1980 Montreux, Switzerland

Siqueiros, David Alfaro

El Botero

Courtesy of Private Collection/Christie's Images © DACS 2002

Mexican pointer and political activist, best known for his murals. Siqueiros was born in Chihuahua, the son of a lawyer. In his youth, he became involved in the Mexican Revolution and, as a reward, was given a scholarship to study in Europe (1919–22). There he met Rivera, a fellow muralist and future rival. The revival of mural painting was a deliberate government policy, aimed at bringing art to the people. Siqueiros received a commission to decorate the Preparatoria, but work was halted by student riots and, in fact, he did not complete a mural in his homeland until 1939.

Although a late developer, Siqueiros proved hugely influential as a teacher. In 1936, he ran an experimental workshop in New York, which did much to shape the Abstract Expressionism of Jackson Pollock. The latter was particularly impressed by Siqueiros's theories about the potential of 'pictorial accidents' and his use of industrial materials. These included spray-guns, blow-torches and the pyroxylin paints used in car manufacture. In the artist's own work, these were seen to best effect in the massive *March of Humanity in Latin America* and his extraordinary, multimedia creation the *Polyforum Siqueiros*.

MOVEMENT

Mexican Muralists

OTHER WORKS

Portrait of the Bourgeoisie; The Victory of Science over Cancer

INFLUENCES

Diego Rivera, Amado de la Cueva

David Alfaro Siqueiros Born 1896 Mexico

Painted in Mexico, USA, Uruguay and Chile

Died 1974 Mexico City

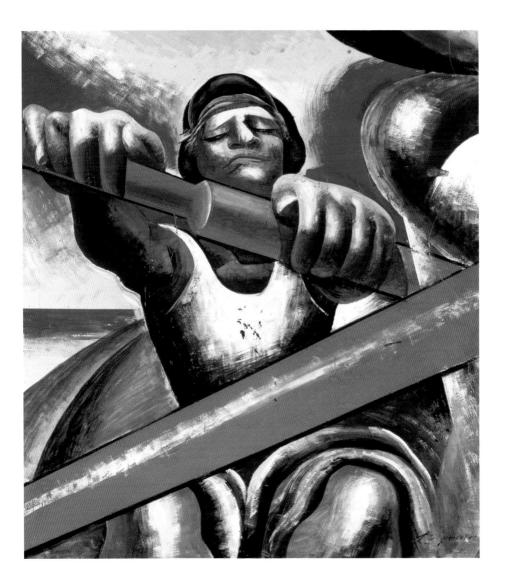

Hitchens, Ivon

Black Down 2

Courtesy of Christie's Images

Ivon Hitchens studied at the Royal Academy in London and had his first one-man exhibition in 1925. In the early part of his career his painting showed some Cubist influence from Cezanne. From 1936 he started developing panoramic landscapes, combining natural forms with a more abstract quality and the freer approach of Matisse. In 1940 he settled near Petworth in West Sussex, an area near the South Down hills that would provide him with the inspiration and subject matter for most of his later paintings. This gave him the opportunity to explore ways and means of interpreting the subject, conjuring up mood and atmosphere rather than a purely objective view. The 'tone poems' which he created have a timeless quality, transcending time and place.

MOVEMENT

Modern English School

OTHER WORKS

Garden Cove; Flower Piece; Winter Lawn and Fir Trees

INFLUENCES

Paul Cézanne, Henri Matisse

Ivon Hitchens Born 1893 London, England

Painted in London and Sussex

Died 1979 Petworth, West Sussex, England

Lewis, Percy Wyndham

Sheik's Wife, 1936

Courtesy of Private Collection/Christie's Images/© Estate of Mrs G. A. Wyndham Lewis

Percy Wyndham Lewis was born in Canada, but following the break-up of his parents' marriage when he was 10 years old he moved with his mother to England, where he enrolled at the Slade School of Art (1898–1901). For six years he travelled extensively in Europe, painting and continuing his studies before settling in London, where he joined the Camden Group of avant-garde artists in 1911 and the Omega Workshops in 1913. One of the most articulate and intellectual painters of his group, he edited their magazine *Blast*, in which he published his Vorticist Manifesto in 1914. This, the only distinctively British art movement to emerge in the early twentieth century, was short-lived. Lewis volunteered for active service on the outbreak of World War I and subsequently became an official war artist. Nevertheless, there are echoes of Vorticism in his powerful war paintings as well as in the great series of canvasses in the postwar period inspired by characters from classical mythology. In 1939 he returned to Canada and also worked for a time in the USA before going back to England in the lost years of his life. Although blind in his old age he continued to teach and write.

MOVEMENT

Vorticism

OTHER WORKS

The Dancers; A Battery Shelled; A Reading of Ovid

INFLUENCES

Albert Gleizes, George Grosz

Percy Wyndham Lewis Born 1882 Canada

Painted in England, Canada and USA

Died 1957 London, England

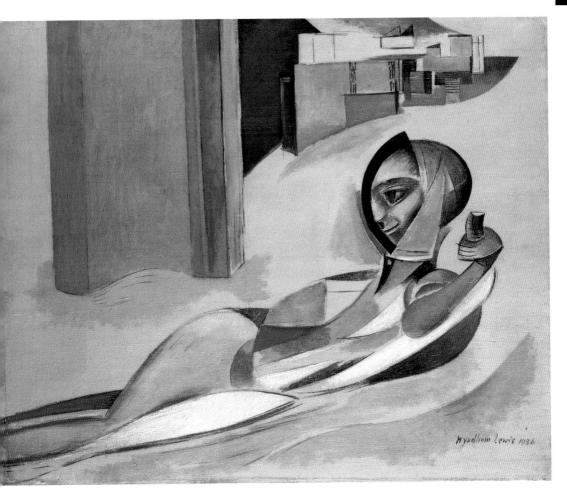

Dalí, Salvador

Le Sommeil, 1937

Courtesy of Private Collection/Christie's Images/© Salvador Dali; Gala-Salvador Dali Foundation;;DACS, London 2002

Spanish painter, graphic artist and film-maker – the most controversial member of the Surrealists. Dalí was born in Catalonia and studied at the Academy of Fine Arts in Madrid, until his outrageous behaviour caused his expulsion. Before this, he had already made contact with the poet Lorca and the film-director Buñuel. In the early 1920s, he dabbled in a variety of styles, including Futurism and Cubism, although it was the metaphysical paintings of de Chirico which made the deepest impact on him.

The key stage in Dali's career came in 1929, when he made *Un Chien Andalou* with Buñuel, met his future wife Gala and allied himself with the Surrealists. His relationship with the latter was rarely smooth and, after several clashes with Breton, he was forced out of the group in 1939. In the interim, he produced some of the most memorable and hallucinatory images associated with the movement, describing them as 'hand-painted dream photographs'. Dali' remained very much in the public eye in later years, gaining great celebrity and wealth in the US, but for many critics his showmanship overshadowed his art.

MOVEMENT

Surrealism

OTHER WORKS

The Metamorphosis of Narcissus; The Persistence of Memory

INFLUENCES

Pablo Picasso, Giorgio de Chirico, Yves Tanguy

Salvador Dalí Born 1904 Catalonia, Spain

Painted in Spain, France, USA and Italy

Died 1989

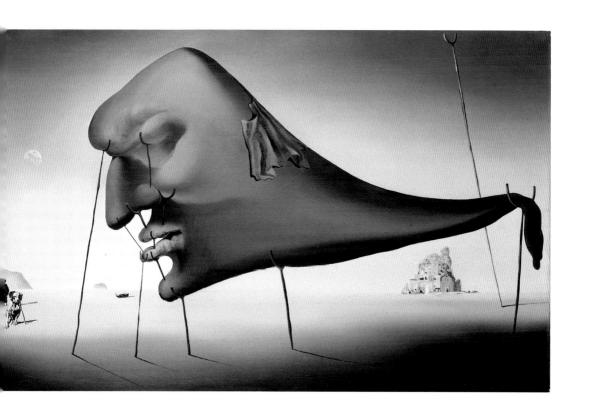

Feininger, Lyonel

Four-Masted Barque, 1937

Courtesy of Private Collection/Christie's Images/© DACS 2002

Lyonel Charles Adrian Feininger was born and died in New York City, but he is regarded more as a European than as an American artist. The son of German Jewish parents, he was educated in Germany and studied art in Munich, where he joined the Blaue Reiter group in 1913 and associated with Wassily Kandinsky, with whom he worked at the Bauhaus in Weimar and later Dessau. Following the advent of the Nazi regime he returned to the United States in 1935 and there helped establish the New Bauhaus in Chicago. His artistic career was very varied. Having started as a political cartoonist in the 1890s, he only turned to painting in 1907 when he moved to Paris. There he came under the influence of Cubism and was closely associated with Robert Delaunay, whose Orphism is reflected in Feininger's intense interest in the emotional qualities of colour.

MOVEMENTS

Cubism, Orphism, Bauhaus

OTHER WORKS

Sailing Boats; Village Church; Gelmeroda

INFLUENCES

Pablo Picasso, Juan Gris, Robert Delaunay, Wassily Kandinsky, Giacomo Balla

Lyonel Feininger Born 1871 New York, USA

Painted in Paris, Weimar, Dessau, Germany, Chicago and New York

Died 1956 New York

Tanguy, Yves

Paysage Surréaliste, 1937

Courtesy of Private Collection/Christie's Images/© ARS, New York and DACS, London, 2002

Going to sea as a teenager and later serving in the French army, Yves Tanguy did not take up painting until his return to Paris in 1922. Without any formal training, he was influenced by the work of Giorgio de Chirico and joined the Surrealists in 1925, subsequently concentrating on that style known as Biomorphism because its images were derived from living organisms. Inevitably, Tanguy's paintings in the ensuing period drew heavily on memories of naval and military service. In 1939 he immigrated to the United States, where he married fellow-artist Kay Sage and settled in Woodbury, Connecticut. In his last years his work took on a darker character, suggestive of dream sequences which reflected his fascination with the Freudian theories of psychoanalysis. His paintings were non-figurative, inhabited by small objects, often boney-like but defying description and suggestive of some other world.

MOVEMENTS

Biomorphism, Surrealism

OTHER WORKS

Dehors; The Invisible; The Rapidity of Sleep

INFLUENCES

Giorgio de Chirico, Salvador Dalí

Yves Tanguy Born 1900, Paris, France

Painted in Paris, France and Woodbury, Connecticut, USA

Died 1955, Woodbury

Ernst, Max

Forêt et Soleil, 1938

Courtesy of Private Collection/Christie's Images/@ ADAGP, Paris and DACS, London 2002

German painter and a leading Surrealist. Born near Cologne, Ernst studied psychology at Bonn University, taking a particular interest in the art of the insane. Before the war he befriended Arp and Macke and mixed with the Blaue Reiter (Blue Rider) group. Then, in 1919, he staged the first Dada exhibition in Cologne. Typically for this movement, visitors had to enter the show through a public urinal and were handed axes, in case they wished to destroy any of the exhibits. In 1922, Ernst moved to Paris and joined the Surrealist circle. His work in this style was incredibly varied. He made considerable use of the chance images, which were suggested by automatic techniques, such as *frottage* (rubbings of textured surfaces). At the same time, he exploited the 'poetic sparks', which were created by the juxtaposition of totally unrelated objects. These sometimes took the form of paintings, but were also produced as collages, drawn from popular magazines.

Ernst was interned during World War II and spent much of his later career in America.

MOVEMENTS

Surrealism, Dada

OTHER WORKS

The Robing of the Bride; Europe after the Rain

INFLUENCES

August Macke, Hans Arp, Giorgio de Chirico

Max Ernst Born 1891, Cologne, Germany
Painted in Germany, France and the USA
Died 1976

Lawrence, Jacob

The Diner, 1938

Courtesy of Private Collection, New York; Christie's Images:. Artwork @ Gwendolyn Knight Lawrence, Courtesy of the Jacob and Gwendolyn Lawrence Foundation

Jacob Lawrence was brought up in Harlem, New York City, where he attended the Harlem Art Workshop and studied under Charles Alston. In 1937 he went to the American Artists' School and the following year became a painter in the WPA Federal Art Project. In the 1930s and 1940s Lawrence painted a series of portraits of historical scenes illustrating the lives of African American personalities such as Frederick Douglass and Harriet Tubman, and traced the migration northward of African Americans after the Civil War. Wartime service in the Coast Guard provided material for paintings in the late 1940s, but in the ensuing decades he has dedicated his art to the civil rights movement and such causes as the desegregation of the South. A visit to Nigeria in 1964 enabled him to explore a purely African idiom. His late work was less explicit in its social commentary and more engaged with universal concerns and abstract ideals.

MOVEMENT

American Modernism

OTHER WORKS

The Migration of the Negro

INFLUENCES

Charles Alston, Augusta Savage, José Clemente Orozco, Giotto, Giovanni Cimabue

Jacob Lawrence Born 1917 New Jersey, USA

Painted in New York and Seattle

Died 2000 Seattle

Maeda, Seison

Wild Goose Calling its Mate

Courtesu of Private Collection/Bridgeman Art Library

After a conventional education Seison Maeda went to Tokyo in 1901, where he enrolled at the art school run by Hanko Kajita and formed a close friendship with Kokei Kobayashi, whose style influenced his own painting. From 1914 onwards Maeda was a prominent figure in the Inten (Japan Art Institute exhibitions). In 1922 he travelled to Italy where he was fascinated by the frescoes of the early Renaissance which left an indelible mark on his later work, although Maeda continued to paint in the traditional Japanese style. He was a prolific and versatile artist, excelling in landscapes and genre scenes, although his reputation rests mainly on his mastery of figures. He was very highly regarded by his contemporaries, being appointed to the Imperial Art Academy in 1935 and awarded the Order of Cultural Merit in 1955. He published his autobiography in 1969.

MOVEMENT

Modern Japanese School

OTHER WORKS

Yoritomo in the Cave; Awaiting the Outset

INFLUENCES

Hank Kajita, Kokei Kobayashi, Tommaso Masaccio, Fra Angelico

Seison Maeda Born 1901 Gifu, Japan

Painted in Japan

Died 1977 Kanagawa, Japan

Traylor, Bill

Untitled (pig with corkscrew tail), c. 1939-42

© Smithsonian American Art Museum, Washington, DC / Art Resource, New York

One of the earliest artists belonging to the American Vernacular and Outsider tradition, without any training or outside influences whatsoever. Bill Traylor was born a slave and for many years after Emancipation continued to work as a field hand on a plantation in rural Alabama. Later he moved to Montgomery as an unskilled factory worker and latterly was a homeless down-and-out, an outsider both artistically and in reality, sleeping rough and existing on welfare hand-outs. He took up drawing and painting in 1939 and in three years he produced over 1,800 pictures, executed on cardboard. His technique developed rapidly from simple geometric shapes to complex abstract constructions inhabited by tiny moving figures. He drew on his memories and imagination as well as keenly observing the people and scenes around him. Although his work had come to the notice of the Museum of Modern Art in 1941, it is only within more recent years that it has been recognized as one of the major triumphs of self-taught art.

MOVEMENT

American Vernacular and Outsider School

OTHER WORKS

Fish; Cat; Man; Plant Pot; Dog and Figures

INFLUENCES

None

Bill Traylor Born c. 1854 Benton, Alabama, USA

Painted in Montgomery, Alabama

Died 1946 Montgomery

Johnson, William H.

Going to Church, c. 1940-01

Courtesy of Smithsonian American Art Museum, Washington, DC/Art Resource, NY

Born in South Carolina in 1901, William Henry Johnson migrated to New York in 1918 and settled in Harlem. For five years he studied art at the National Academy of Design and later moved to Denmark, after marrying the Danish weaver and potter Holche Krake in 1930. He later spent some time in Norway before returning to the USA shortly before World War II. In 1943 they lost everything as a result of a house fire, and soon afterwards his wife died. Johnson had a mental breakdown and by 1947 had to be committed to an institution. In 1967 he gave his collected works, amounting to some 800 oils and watercolours and about 400 sketches and drawings, to the National Museum of American Art. He died three years later, and it is only since the 1970s that his achievement has been fully recognized and his importance in the development of contemporary American art fully appreciated. His paintings are characterized by their passion and exuberance, with echoes of Van Gogh and the Constructivists as well as the influence of African tribal sculpture and textile patterns.

MOVEMENT

African American School

OTHER WORKS

Lamentation; Cagnes-sur-Mer; Minnie; Jacobia Hotel; Jitterbugs

INFLUENCES

Van Gogh, Kasimir Malevich

William H. Johnson Born 1901 South Carolina, USA

Painted in Denmark, Norway and USA

Died 1970 Long Island, New York

Burra, Edward

Salome

Courtesy of Private Collection/Christie's Images

Edward Burra was mainly educated at home on account of chronic ill health as a child, but in 1921 he enrolled at the Chelsea Polytechnic and later studied at the Royal College of Art. Later he travelled widely in Europe and America where he imbibed the ideas and techniques of the Surrealists and Dadaists, as well as German painters such as George Grosz. Bouts of ill health dogged him throughout his career and may explain the frenetic activity in his paintings and the exceptionally vivid colours, often placing his figures against exotic backgrounds. He had a keen eye for the absurd, the offbeat and the louche, and delighted in recreating scenes of low life in bars, brothels and nightclubs. By contrast, his pictures relating to the Spanish Civil War (1936–9) are stark and sombre, a prelude to his grim paintings of World War II. In the postwar period he turned to landscapes and still-life compositions. Burra also designed sets for ballet.

MOVEMENT

Surrealism

OTHER WORKS

The Snack Bar, Harlem; Soldiers

INFLUENCES

George Grosz, Dadaism, Surrealism

Edward Burra Born 1905 London, England

Painted in London

Died 1976 Rye, Sussex, England

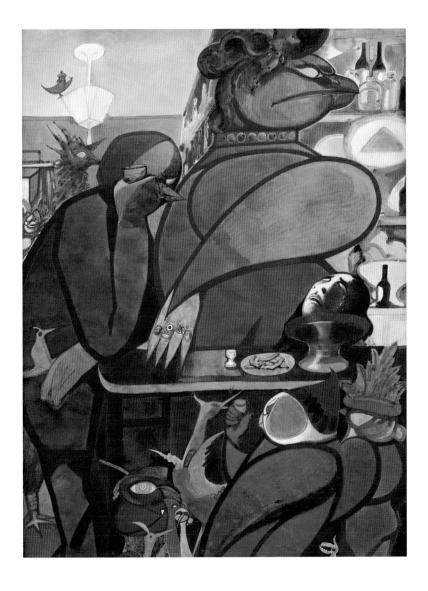

Delvaux, Paul

La Ville Inquiete, 1941

Courtesy of Private Collection/Christie's Images/® Foundations P. Delvaux-St Idesbald, Belgium/DACS, London 2002

Born near Liège in Belgium Delvaux studied architecture then painting in Brussels, where he established his studio. In his early career he dabbled in Expressionism and Impressionism but later came under the influence of Giorgio de Chirico and especially his fellow-countryman René Magritte. He evolved his own distinctive style of Surrealism in which somnambulatory nudes and doe-eyed semi-nude figures are set alongside skeletons amid classical ruins while the artist, in conventional modern dress, looks on. This largest and most ambitious painting features the arrival of the artist, alighting from a ghostly train in silent cities in the dead of night, illumined only by the moon, in which bodies sleep-walk or flit languorously. This combination of the classical and the contemporary gives these dreamlike paintings a timeless quality. Between 1950 and 1962 he was professor of painting at the École Nationale Supérieure d'Art et d'Architecture in Brussels. In 1982 the Paul Delvaux Museum was established at Sint-Idesbald.

MOVEMENT

Surrealism

OTHER WORKS

The Sleeping Town; The Call of the Night

INFLUENCES

Giorgio de Chirico, René Magritte

Paul Delvaux Born 1894 Antheit-lez-Huy, Belgium

Painted in Brussels, Belgium

Died 1994 Knokke-Heist, Belgium

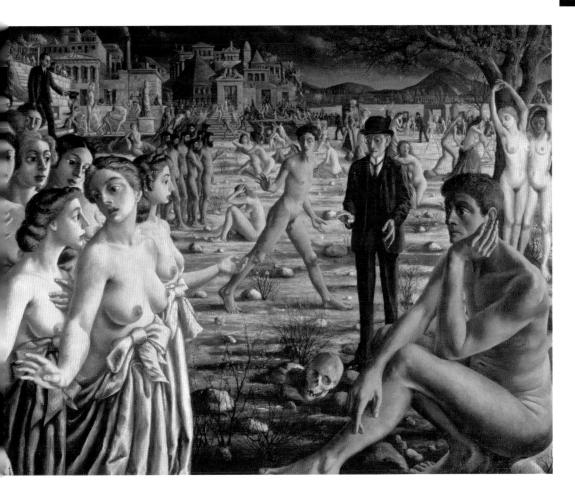

Rivera, Diego

Vendedora de Flores, 1942

Courtesy of Private Collection/Christie's Images/2002 Banco de Mexico Diego Rivero & Frido Kohlo Museums Trust, Av. Cinco de Mayo No. 2, Col. Centro, Del. Cuauhtemoc 06059, Mexico, D.F.

The outstanding muralist of Latin America, Diego Rivera studied art in Mexico City and Madrid; he went to Paris in 1911, where he met Picasso and began painting Cubist works, which were strongly influenced by Gris and Braque. By contrast, a sojourn in Italy studying the frescoes of the Renaissance masters made such an impact on him that, on his return to Mexico in 1921, he concentrated on large murals decorating the walls of public buildings. These depicted every aspect of life in Mexico and drew on the turbulent history of its people. Rivera's best work was carried out during a period when Mexico was dominated by left-wing, anti-clerical governments, which regarded Rivera as the leading revolutionary artist. He also worked in the USA where he pointed murals extolling the industrial proletariat and preaching social messages. He evolved his own brand of folk art with overtones of such disparate elements as Aztec symbolism and Byzantine icons.

MOVEMENT

Mexican Modernism

OTHER WORKS

Court of the Inquisition; Workers of the Revolution

INFLUENCES

Juan Gris, Georges Braque

Diego Rivera Born 1886 Guanajuato, Mexico

Pointed in Mexico and USA

Died 1957 Mexico City

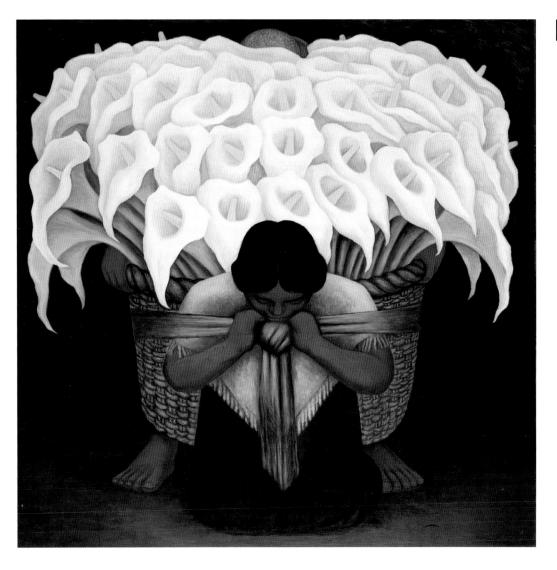

Schwitters, Kurt

Roter Kreis, 1942

Courtesy of Private Collection/Christie's Images/© DACS 2002

Kurt Schwitters studied at the Dresden Academy and worked as a painter, designer, architect, typographer, writer and publisher, disparate occupations and disciplines which he combined with remarkable flair. He was intrigued by Cubism very early on and produced a number of abstract paintings in this style, but was then attracted to Dadaism and strongly influenced by Hausmann, Arp and other leading exponents. During this phase he produced montages of totally unrelated objects and incongruous fragments of junk and ephemera, such as discarded leaflets, bus tickets and used stamps torn off envelopes. After 1920 he took this notion a step further, incorporating street rubbish in enormous three-dimensional collages which he termed Merzbau ('cast-off construction'). This led to the Dadaist magazine Merz, which he ran from 1923 until 1932. When the Nazis came to power he fled to Norway and from there moved in 1940 to England, where he died in 1948.

MOVEMENT

Dada

OTHER WORKS

Chocolate; Spring Picture; Circle

INFLUENCES

Jean Arp, Marcel Duchamp, Raoul Hausmann

Kurt Schwitters Born 1887 Hanover, Germany

Painted in Germany, Norway and England

Died 1948 Ambleside, Cumbria, England

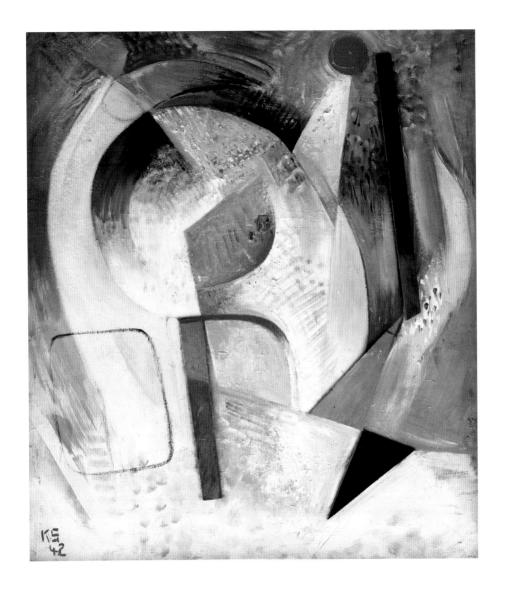

Lam, Wifredo

Forêt Tropicale, 1943

Courtesy of Private Collection/Christie's Images/© ADAGP, Paris and DACS, London 2002

Wifredo Oscar de la Concepcion Lam y Castilla was the son of a Chinese immigrant and a woman of Afro-Cuban origin. In his art he strove to combine the disparate elements in the artistic traditions of these three different cultures. He enrolled at the Escuela de Bellas Artes in Havana and went to Madrid in 1923, where he studied under Fernandez Alvarez de Sotomayor and at the Academia Libre. Caught up in the Spanish Civil War, Lam fought with the Republicans in the defence of Madrid (1937). Escaping to Paris, he met Picasso and joined the Surrealists in 1940. On his return to Cuba in 1942 he began pointing pictures that combined the dreamlike qualities of Surrealism with elements derived from Cubism and indigenous Afro-Cuban art. For a time he lived in Haiti before settling in Paris again in 1952, though continuing to travel back and forth between Europe and the Caribbean. His greatest masterpiece, *The Jungle* (1943) draws on Afro-Cuban myth and ritual, sugar cane stalks merging with human limbs in a hallucinatory effect.

MOVEMENT

Surrealism

OTHER WORKS

All Souls

INFLUENCES

Pablo Picasso, Michel Leiris, André Breton

Wifredo Lam Born 1902 Sagua la Granda, Cuba

Painted in Cuba, France and Spain

Died 1992 Havana, Cuba

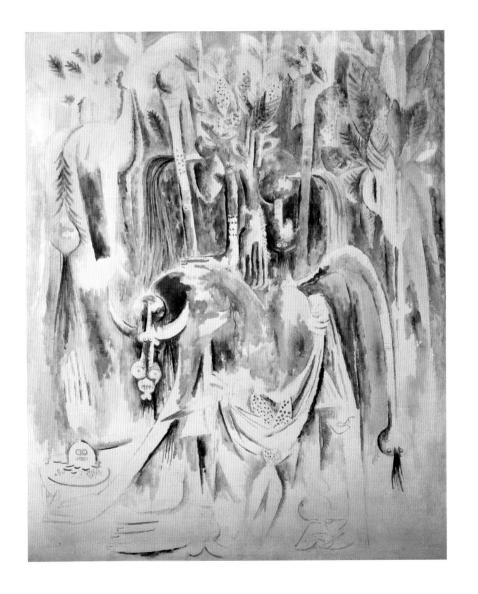

Motley Jr, Archibald

Nightlife, 1943

Courtesy of The Art Institute of Chicago, Mary Leigh Block Fund for Acquisitions, 1977.27

Archibald Motley Jr moved from New Orleans to Chicago in his youth and took various labouring occupations. Largely self-taught, he won a Guggenheim Fellowship in 1929 which enabled him to travel and study in Paris, where he also produced a number of paintings of the lively black music scene. A one-man show in New York in 1928 showed his deep interest in African American culture, tinged with mysticism, voodoo and the spirit world, but after his Paris sojourn he concentrated on living subjects and genre scenes crammed with figures, full of action and movement, with a lively portrayal of the gambling and illegal drinking in the Prohibition era. Unlike many other African American artists, Motley was not concerned so much with the racial consciousness of the Harlem Renaissance, but belonged more to the Ashcan School in his depiction of ordinary, often seedy, activities of people regardless of ethnic origin.

MOVEMENT

Modern American School

OTHER WORKS

Old Snuff Dipper; The Picnic in the Green; Chicken Shack

INFLUENCES

Ashcan School

Archibald Motley Jr Born 1891 USA

Painted in Chicago, USA

Died 1980 Chicago

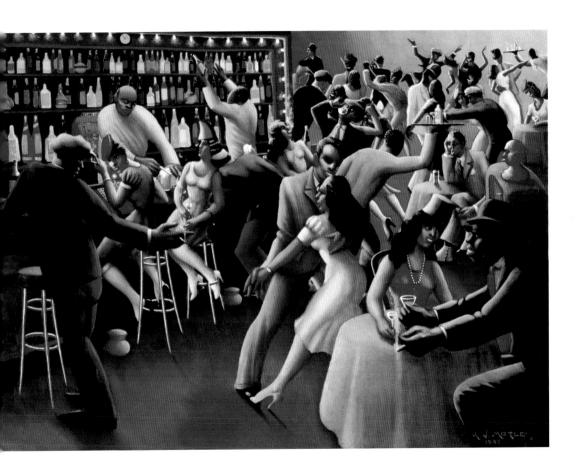

Sekoto, Gerard

Girl with Orange, 1943

Courtesy of Johannesburg Art Gallery, South Africa/Bridgeman Art Library/® The Gerard Sekoto Foundation

Gerard Sekoto trained as a school teacher, and it was in the course of his training that he was introduced to painting and drawing. Although this instruction was quite rudimentary it was sufficient to launch him on an artistic career. Within a few years he gave up teaching and moved to Johannesburg to concentrate on painting full-time. His early landscapes and genre scenes drew on the everyday life of the black townships. One of these, exhibited in the South African Academy show of 1940, was purchased by the Johannesburg Art Gallery — the one and only painting by a black African artist in any South African museum for more than two decades. Sekoto went to Paris in 1947 to further his education, but settled in France where he spent the rest of life. Nevertheless, his subjects remained firmly South African, although his interpretation of them showed the influence of the various art movements with which he now came into contact, from Impressionism to Cubism and Orphism.

MOVEMENT

Black South African School

OTHER WORKS

Yellow Houses: a Street in Sophiatown; Eastwood Memories

INFLUENCES

Paul Cézanne, Pablo Picasso, Robert Delaunay

Gerard Sekoto Born 1913 South Africa

Painted in Johannesburg, Eastwood, Transvaal and Paris

Died 1993 Paris

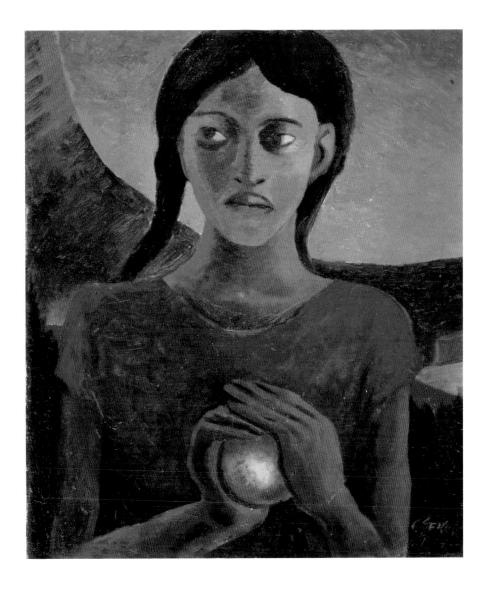

Lowry, L. S. (Laurence Stephen)

Industrial Landscape, 1944

Courtesy of Private Collection/Christie's Images/Reproduced by kind permission of Carol Lowry, copyright proprietor

Distinctive British painter, famous for his pictures of 'matchstick men'. Lowry was born in Old Trafford, Manchester, and lived in or near the city throughout his life. He failed to gain entry to the local art school and, instead, took on office work and painted in the evenings. Initially, he was employed by an insurance company and, after 1910, as a rent collector for a property firm. In later years, much of his time was also devoted to the care of his invalid mother. They were very close and Lowry was devastated when she died in 1939.

The childlike qualities of Lowry art have often been classified as naïve, but technically this is untrue, since he had a succession of teachers at evening school. The most significant of these was Adolphe Valette, who also painted urban townscapes. From an early stage, Lowry began producing unglamorous views of the local, industrial scene, focusing in particular on details of everyday life. These ranged from the grotesque to the humorous. Lowry's style baffled the art establishment – he was conspicuously omitted from the Royal Academy's survey of twentieth century British art – but his paintings sold well and he has remained unfailingly popular with the public.

MOVEMENT

Naïve Art

OTHER WORKS

Our Town; Man Lying on a Wall; Sudden Illness; The Pond

INFLUENCES

Adolphe Valette, Camden Town School

L. S. Lowry Born 1887 Manchester, England

Painted in England

Died 1976 Glossop, England

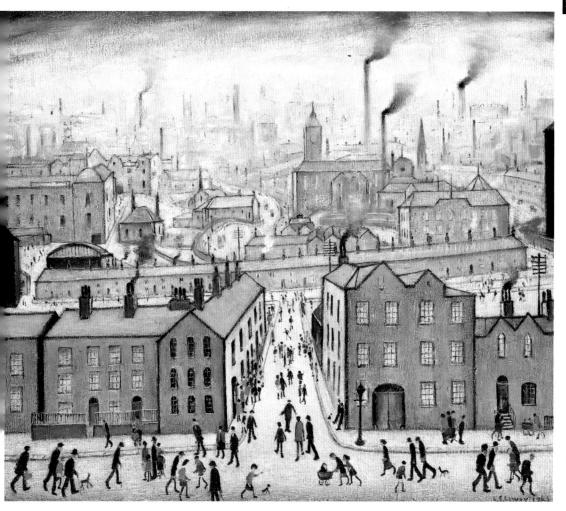

Still, Clyfford

Jamais, 1944

Courtesy of Peggy Guggenheim Foundation, Venice, Italy/Bridgeman Art Library

Raised in the American Midwest, Clyfford Still studied art at Spokane University, Washington, graduating in 1933 when the United States was still recovering from the Depression. Eschewing the social realism of his contemporaries, he strove to evolve his own distinctive style, embracing elements of Biomorphism in which organic forms predominated. In 1941 he settled in San Francisco and subsequently taught at the California School of Fine Arts (1946–50). During this period he emerged as one of the leading exponents of Abstract Expressionism. Heavily influenced by Barnett Newman and Mark Rothko, he favoured large canvasses in which a single colour predominated; the variations in colour, form and content being largely confined to the periphery. Interest and variety in the principal colour was imparted by its rich texture and brushwork. Many of his works were either completely untitled or only given the most cryptic of titles. Thus it was mainly left to the viewer to divine the significance of the detail at the edges of his canvas, although Still himself was a past-master in the art of making pretentious statements that allegedly explained the metaphor of his work.

MOVEMENT

Abstract Expressionism

OTHER WORKS

Untitled, No1; Untitled 1953

INFLUENCES

Barnett Newman, Mark Rothko

Clyfford Still Born 1904

Painted in Spokane, Washington, San Francisco, California, USA

Died 1980 New Windsor, Maryland, USA

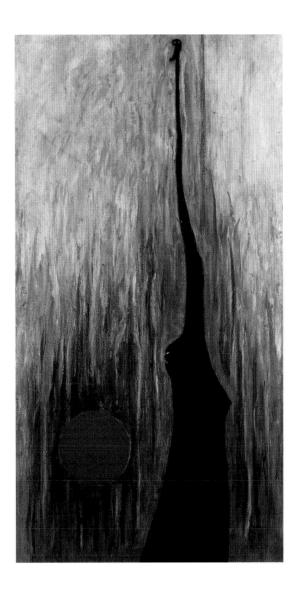

Nicholson, Ben

1945 (Airmail Letter)

Courtesy of Private Collection/Christie's Images @ Angela Verren-Taunt 2002 All rights reserved, DACS

A pioneering figure in the development of British Abstract Art. Both of Nicholson's parents were artists, but he was slow to discover his own vocation. He studied briefly at the Slade School, but did not begin painting seriously until 1920. Initially, he painted naïve landscapes and sturdy still lifes, which were reminiscent of his father's work. Increasingly, though, he turned to abstraction, joining a number of avant-garde groups. These included the Seven and Five Society, Unit One and the Abstraction-Création circle.

The primary influence on Nicholson's abstracts came from Cubism. Early examples featured motifs – guitars, jars, glasses – used by Picasso and Braque. After visiting Mondrian's studio in Paris, however, he began to banish figurative objects from his pictures, echoing the austere, geometric style favoured by the Dutchman.

Nicholson married three times, and two of his wives – Winifred Nicholson and Barbara Hepworth – were distinguished artists in their own right. With the latter, he moved down to St Ives in Cornwall in 1939, where they became the focus of a farmous artists' colony, until 1958 when he left for Switzerland.

MOVEMENT

Abstract Art, Cubism, St Ives School

OTHER WORKS

1928 (Cornwall); 1933 (milk and plain chocolate)

INFLUENCES

Sir William Nicholson, Piet Mondrian, Georges Braque

Ben Nicholson Born 1894 Denham, Buckinghamshire, England

Painted in England, France and Switzerland

Died 1982 London

Tanning, Dorothea

The Truth about Comets and Little Girls

Courtesy of Private Collection/Christie's Images/@ ADAGP, Paris and DACS, London 2002

Dorothea Tanning worked as a librarian in her home town of Galesburg, Illinois. In 1930 she went to work in Chicago and attended a two-week course of evening classes in art at the Academy of Fine Art, before going to New York in 1936, where she found employment as a commercial artist. Her earliest paintings drew on childhood nostalgia interpreted in a surreal manner, and this brought her to the attention of the American Surrealists. In 1946 she married Max Ernst, the German Dadaist then living in exile in the USA, and together they settled in France, where she worked as a painter, graphic artist and designer of theatrical sets and costumes. Tanning's later work has a more fully rounded character but still essentially explores the female psyche and sexuality through the medium of dreams. Her paintings often combine a superficial childhood innocence with rather disturbing sexual undertones and morbid symbolism.

MOVEMENT

Surrealism

OTHER WORKS

Born; Eine Kleine Nachtmusik; A Very Happy Picture; A Family Portrait

INFLUENCES

Max Ernst

Dorothea Tanning Born 1910 Galesburg, Illinois, USA

Painted in Chicago, New York and Paris

Colville, Alex

The Horses, 1946

Courtesy of Art Gallery of Ontario, Toronto/Bridgeman Art Library

Although born in Toronto, David Alexander Colville was raised in Amherst, Nova Scotia. At the age of nine he suffered a bout of pneumonia and during a long convalescence was encouraged to draw and paint. Later he studied under Stanley Royle, who persuaded him to abandon his plans for a career in law and politics and concentrate on art. In 1942 he was one of the first graduates in Fine Arts anywhere in Canada and spent three years as an official war artist, an experience that shaped his later career. After the war he taught art at Mount Allison University until 1963, when he retired to paint full-time. A versatile artist, he has designed everything from Canadian coins and medals to album sleeves for folk singers. His realist style is executed in the manner of the French pointillists, using thousands of tiny brushstrokes to create an almost sculptural effect.

MOVEMENT

Modern Canadian School

OTHER WORKS

Horse and Train

INFLUENCES

Camille Pissarro, Georges Seurat

Alex Colville Born 1920 Toronto, Ontario, Canada

Painted in Amherst and Wolfville, Nova Scotia

Matta, Roberto

Abstracto

Courtesy of Christie's Images/Private Collection @ ADAGP, Paris and DACS, London 2002

Born Roberto Sebastian Matta Echaurren, he trained as an architect in his native city of Santiago and continued his studies under Le Corbusier in Paris. He took up painting in 1937 and was immediately attracted to Surrealism, of which he became one of the outstanding figures over the ensuing decade. He moved to the United States in 1939 and made his debut at the Julien Levy Gallery the following year. His work had an enormous impact on the younger generation of American artists, his approach to Surrealism being markedly different from that of Dali and the other main European exponents. His technique of apparently random brushstrokes without rational control influenced such painters as Arshile Gorky and Jackson Pollock. From Abstract Expressionism he gradually moved towards what he termed as 'transparent Cubism' in the late 1940s, bringing back figural elements.

MOVEMENTS

Surrealism, Abstract Expressionism

OTHER WORKS

Invasion of the Night; Disasters of Mysticism; Abstraction; Untitled

INFLUENCES

Hans Bellmer

Roberto Matta Born 1911 Santiago, Chile

Painted in Chile and US

Died 2002 Civitavecchia, Italy

Pollock, Jackson

Something of the Past, 1946

Courtesy of Private Collection/Christie's Images/@ ARS, New York and DACS, London 2002

Pollock grew up in the American West, becoming familiar with Native American art at an early age. He was briefly influenced by Benton and the Regionalists, but learned more from Siqueiros and the Mexican muralists. He was impressed by their expressive, almost violent use of paint. Pollock also began to explore the possibilities of Jungian psychology. This started as an aspect of his private life – psychotherapy was one of the many treatments he tried for his long-term alcoholism – but it also fuelled his art. For, like the Surrealists, he adopted the idea of automatic painting, as a mirror of the subconscious.

After years of isolation and critical neglect, Pollock's experiments bore fruit in the late 1940s. By 1947, he had perfected the 'drip' technique which made him famous. He placed his canvas on the floor and covered it in trails of paint, poured directly from the can. This process was carried out in an artistic frenzy, comparable with the Indian ritual dances which he had witnessed as a boy. Pollock's output slowed in the 1950s and he was killed in a car crash in 1956.

MOVEMENT

Abstract Expressionism

OTHER WORKS

Convergence; Autumn Rhythm; Lavender Mist

INFLUENCES

André Masson, Thomas Hart Benton, David Siqueiros

Jackson Pollock Born 1912 USA

Painted in USA

Carrington, Leonora

The Temptation of Saint Anthony, 1947

Courtesy of Private Collection, Christie's Images/© ARS, New York and DACS, London 2002

Born in Lancashire but brought up in London, Leonora Carrington came under the influence of the Surrealists in the 1930s and produced a number of paintings which combined scenes and images from her childhood with mystical and fairytale themes. In 1942 she crossed the Atlantic and settled in Mexico, where she shared a studio with Remedios Varo, a Spanish female painter of similar outlook, who shared her enthusiasm for the occult, alchemy and other magical subjects.

A feminist ahead of her time, Carrington attempted to explore and analyse the female psyche through the medium of painting. A recurring theme was woman as the life force at the heart of all creativity contrasted by malign forces in nature, which often gives her paintings a rather sinister undertone. There are echoes of the early Renaissance religious artists in her work, especially in the use of allegory and mythology, but these are often mingled with weird and bizarre elements that owe more to the Surrealists.

MOVEMENT

Surrealism

OTHER WORKS

Baby Giant; The Magic Works of the Mayas

INFLUENCES

Hieronymus Bosch, Salvador Dalì

Leonora Carrington Born 1917 Clayton Green, Lancashire, England

Painted in England and Mexico

Drysdale, Sir George Russell

Bob and Mandie

Courtesy of Christie's Images/Bridgeman Art Library

Born at Bognor, Sussex, where he received his early education, George Russell Drysdale emigrated with his parents to Australia in 1923 and settled in Melbourne, Victoria. He took up sketching while recovering from an eye operation as a boy and this led him to enrol at the George Bell Art School. He continued his studies at the Royal Academy School in London and then went to Paris, where he came under the influence of the Surrealists. On his return to Australia he began painting and drawing the desolate scenes of the Outback, drawing upon the styles and techniques of contemporary British artists in depicting the Australian wilderness with a rugged realism. His work was first exhibited in London in 1950 and immediately established him as one of the most promising Australian artists of his generation. Over the ensuing three decades he was the most influential figure in Australian art.He was knighted in 1969 and became a Companion of the Order of Australia in 1980.

MOVEMENT

Modern Australian School

OTHER WORKS

Back Verandah; The Walls of China

INFLUENCES

Surrealism

Sir George Russell Drysdale Born 1912 Sussex, England

Painted in Australia

Died 1981 Sydney, Australia

Gorky, Arshile

Year after Year, 1947

Courtesy of Private Collection/Christie's Images @ ADAGP, Paris and DACS, London 2002

Originally named Vosdanig Manoog Adoian, Gorky was born at Khorkom Vari in Turkish Armenia. He survived the genocide perpetrated on the Armenians by the Turks during World War I and escaped to the West, settling in the USA in 1920. The death of his mother during one of the Turkish atrocities had a profound influence on his art. It was at this time that he adopted his new name, taking the surname from the celebrated Russian writer Maxim Gorky. In America he trained at the Rhode Island School of Design and continued his studies in Boston. For several years his style was a heady but eclectic mixture of elements drawn from Miró, Cezanne, Picasso, Motta and André Breton, and it was from the latter that he was attracted to Surrealism, concentrating on biomorphism (the creation of organic abstracts), but later he developed his own distinctive style which promoted Abstract Expressionism.

MOVEMENT

Abstract Expressionism

OTHER WORKS

Agony; Waterfall

INFLUENCES

Joan Miró, Pablo Picasso, Paul Cézanne

Arshile Gorky Born 1904 Khorkom Vari, Turkey

Pointed in USA

Died 1948 Sherman, Connecticut, USA

Nolde, Emil

Lichtzauber, 1947

Courtesy of Private Collection/Christie's Images/© The Nolde-Foundation 2002/© Nolde-Stiftung Seebüll

Born Emil Hansen in Nolde, Germany, he later adopted the name of his birthplace. He trained as a wood-carver but later studied painting in Munich, where he was briefly a member of the Expressionist group known as Die Brücke (The Bridge) in 1906–07 as well as Die Blaue Reiter (The Blue Rider). He was, however far too rugged an individualist ever to conform too closely to any particular movement, and developed his own distinctive Blut und Boden (blood and soil) style of painting, originally confined largely to religious themes expressed with distorted images and violent brushstrokes, but later extended to landscapes, seascapes, still life and flowers. Most of his work was done in a remote area of the German North Sea coast where he lived increasingly as a recluse. His last work, a series entitled Unpainted Pictures, was completed in secrecy as he suffered the delusion of still being harassed by the Nazis. He was also a prolific producer of etchings, lithographs and woodcuts.

MOVEMENT

Expressionism

OTHER WORKS

The Life of Christ; Meeting on the Beach; Red Poppies

INFLUENCES

James Ensor, Maurice de Vlaminck

Emil Nolde Born 1867 Nolde, Germany

Painted in Germany

Died 1956 Seebüll, Germany

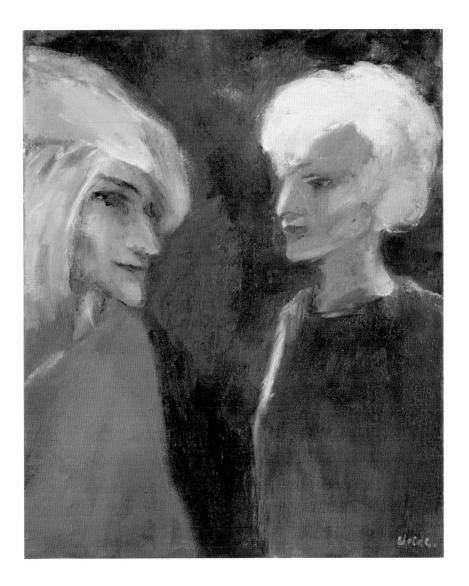

Yeats, Jack B.

The Race, 1947

Courtesy of Private Collection/Christie's Images

John Butler Yeats was the son of an Irish painter and younger brother of the celebrated Irish poet and playwright William Butler Yeats. Though born in London, he was raised in Co. Sligo and spent most of his life in Ireland. His earliest artistic efforts were strip cartoons and illustrations for children's comics, but he did not turn to painting until 1915. In the aftermath of the Easter Rising the following year, his art took on a much more serious tone; his style became increasingly violent and revelling in strident colours as he strove to give an Expressionist interpretation to the Irish Troubles, often using religious metaphors. Unlike his brother, he did not involve himself in Irish politics, but his passionate loyalty to his country leaps off the canvas. Later he adapted his Expressionism to mellower subjects that chronicled life in rural Ireland, and he also went back to the roots of Irish culture, exploring scenes from Celtic myths and legends.

MOVEMENT

Modern Irish School

OTHER WORKS

Waiting for the Long Car; The Rogues' March

INFLUENCES

Oskar Kokoschka

Jack B. Yeats Born 1871 London, England

Painted in Ireland

Died 1957 Dublin, Ireland

Beckmann, Max

Artisten, 1948

Courtesy of Private Collection/Christie's Images/© DACS 2002

Max Beckmann is regarded as one of the greatest figurative artists of the twentieth century. He studied in Weimar and worked as a draughtsman and printmaker before moving to Berlin in 1904, where he embarked on large-scale paintings. During World War I he worked as a hospital orderly — a terrifying experience that shaped his subsequent art. There are Gothic overtones in his canvasses which starkly depict the hopeless struggle of the individual against evil. Not surprisingly, his work was dismissed by the Nazis as degenerate. In 1937 he fled to Holland and spent the last years of his life in the USA, a period in which his paintings expressed a new hope for the world. He was both prolific and versatile, his work ranging from still life and formal portraits to landscapes, abstracts and symbolic compositions, often bizarre and monstrous but always thought-provoking.

MOVEMENT

Expressionism

OTHER WORKS

Departure; Quappi with Parrot; The Night

INFLUENCES

George Grosz

Max Beckmann Born 1884 Leipzig, Germany

Painted in Germany, Holland and USA

Died 1950 New York, USA

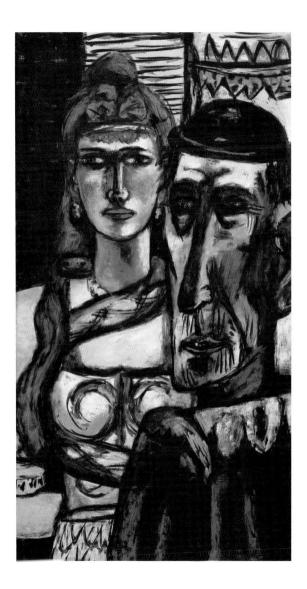

Coldstream, Sir William

Street Scene, Dieppe

Courtesy of Private Collection/Christie's Images

English painter, teacher and administrator, a leading member of the Euston Road School. Coldstream was born in Northumberland, the son of a doctor, and moved to London with his family in 1910. He trained at the Slade School and joined the London Group (a spin-off from the Camden Town Group), but remained uncertain about the direction of his art. For three years (1934–37), Coldstream turned to film-making until Kenneth Clark coaxed him back to full-time painting. At this stage, he joined the Euston Road School, which had recently been founded by Victor Pasmore and Claude Rogers. This group rejected the more radical elements of avant-garde art, preferring to teach and practice a figurative style of painting, which took account of social realities. This accorded well with Coldstream's own choice of subject matter: urban landscapes, portraits and nudes.

The school closed with the outbreak of war and, after a brief stint in the Royal Artillery, Coldstream became a war artist, based in Cairo and Italy. Subsequently, he distinguished himself in arts administration. The Coldstream Report (1960) reshaped the structure of art school teaching in the UK.

MOVEMENT

Euston Road School

OTHER WORKS

St. Pancras Station; Mrs. Winifred Burger; Bolton

INFLUENCES

Walter Sickert, Graham Bell, Claude Rogers

Sir William Coldstream Born 1908, Northumberland, England

Painted in England, Italy and Egypt

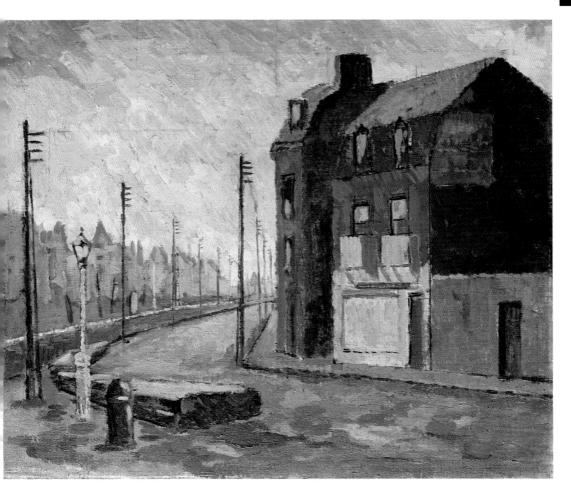

Newman, Barnett

Untitled, 1948

Courtesy of Private Collection/Christie's Images/© ARS, New York and DACS, London 2002

Barnett Newman trained at the Art Students' League in New York City while also studying at the City College in the early 1920s. Many years later, in the last decade of his life, he taught at the universities of Saskatchewan and Pennsylvania. In between he began his professional career as an Abstract Expressionist about 1930, but gradually developed his own highly distinctive style which eschewed the loose techniques of Expressionism for a more disciplined, rigorous approach. At the same time, the range of his palette gradually decreased as he moved towards a more monochrome treatment, relieved only by one or two vertical bands of contrasting colour which Newman styled as 'zips' from their resemblance to zip-fasteners on clothing. Ultimately, between 1952 and 1962, Newman painted in black and white, the minimalism of his pictures relieved only by the subtleties of shade and density, but in his last years he utilized colours of extraordinary depth and tone. From about 1965 he also produced a number of steel sculptures.

MOVEMENT

Abstract Expressionism

OTHER WORKS

Moment; Adam; Covenant; Onement III

INFLUENCES

Piet Mondrian, Mark Rothko

Barnett Newman Born 1905 New York, USA

Painted in New York

Died 1970 New York

Piper, John

Palazzo in Vicenza

Courtesy of Private Collection/Christie's Images/The Piper Estate

English painter, graphic artist, writer and designer. The son of a solicitor, Piper only turned to art after his father's death in 1926. After training at the Royal College of Art, his early work was predominantly abstract. He joined the London Group (1933) and the Seven and Five Society (1934), while also working on the avant-garde journal Axis with his future wife, Myfanwy Evans. But, in common with other Neo-Romantic painters, Piper found abstraction an artistic cul-de-sac. Instead, inspired by the late works of Turner, he began to celebrate the glories of the English countryside and its architecture.

In part, the visionary landscapes produced by Piper and his Neo-Romantic colleagues were prompted by the threat of wartime destruction. Accordingly, Piper became a war artist and contributed to the 'Recording Britain' scheme by painting war-damaged buildings. He also produced marvellous, brooding studies of Renishaw and Windsor Castle. In later years, Piper's interests diversified. He designed stained-glass windows for Coventry Cathedral, devised stage sets for Benjamin Britten and created a notable tapestry for Chichester Cathedral.

MOVEMENT

Neo-Romanticism

OTHER WORKS

Forms on Dark Blue; Seaton Delaval; The Gothic Archway

INFLUENCES

J.M.W. Turner, Georges Braque, Pablo Picasso, John Sell Cotman

John Piper Born 1903 Surrey, England

Painted in England, Wales, Italy and France

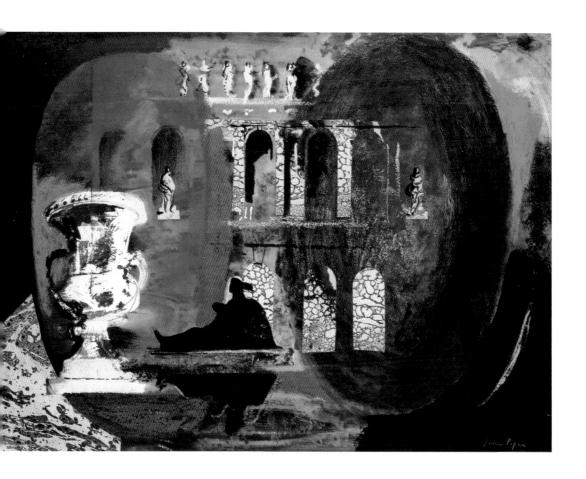

Reinhardt, Ad

Untitled Gouache on Paper, 1949

Courtesy of Private Collection/Christie's Images @ ARS, NY and DACS, London 2002

Born Adolph Frederick Reinhardt, he studied at the National Academy of Design in New York City (1936) before joining the American Abstract Artists, an avant-garde group which advocated hard-edged abstraction. He soon broke away from this New York group, whose brand of Abstract Expressionism he found alien to him. Instead he was attracted to the art of India, seeking to develop a style that would be "breathless, timeless, styleless, lifeless, deathless, endless". To his way of thinking, Oriental art rejected anything that was "irrational, momentary, spontaneous, primitive, expressionist..." Consequently he developed a geometric form of abstraction, but contact with Rothko and Newman in the 1940s led him to concentrate on canvasses covered with paint on which he worked up rectangles of different sizes. Out of this arose his Minimalist art, which would be highly influential in the 1960s.

MOVEMENT

Minimalism

OTHER WORKS

Painting; Abstract Painting; Black Painting No 34

INFLUENCES

Mark Rothko, Barnett Newman, Constantin Brancusi

Ad Reinhardt Born 1913, New York, USA

Painted in New York

Died 1967 New York

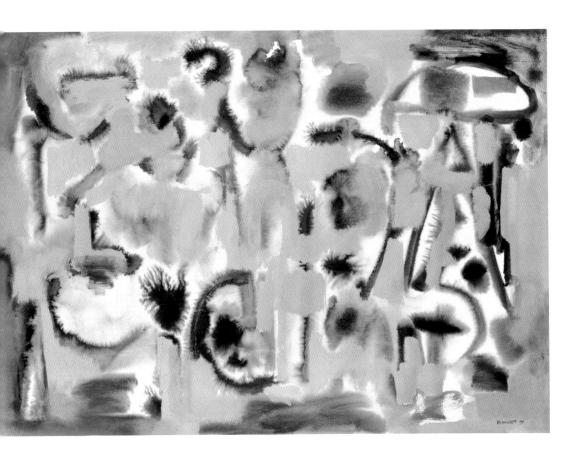

Spencer, Sir Stanley

Angels of the Apocalypse, 1949

Courtesy of Private Collection/Christie's Images/© Estate Stanley Spencer 2002. All Rights Reserved, DACS

Stanley Spencer spent most of his life in the Berkshire village of Cookham, which provided him with most of his inspiration. He studied at the Slade School of Art in London from 1909 to 1912 but does not appear to have been affected by any of the avant-garde developments in that period. Apart from military service in World War I, and a period during World War II spent on Clydeside recording the toil of shipyards, he remained very close to his roots — a familiar sight in Cookham, painting or sketching. Often dismissed as an eccentric, he worked outside the artistic mainstream, but inevitably some trends in art found a reflection in his paintings, notably his use of distorted anatomy and space. A profoundly religious man, his paintings often have biblical connotations, although events such as the Resurrection are placed in the context of Cookham or Clydeside. He covered his enormous canvasses with drawings of the subjects, which were then painted over. He was knighted shortly before he died.

MOVEMENT

Modern English School

OTHER WORKS

The Resurrection; The Crucifixion; Self-Portrait with Patricia

INFLUENCES

Pre-Raphaelites

Sir Stanley Spencer Born 1891 Cookham, Berkshire, England

Painted in Cookham and Port Glasgow, Scotland

Died 1959 Cookham

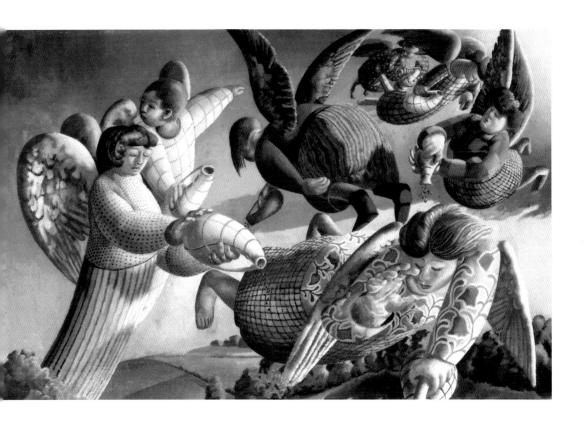

Fontana, Lucio

Spatial Concept, 1950

Courtesy of Hamburg Kunsthalle, Hamburg, Germany/Bridgeman Art Library

Born in Argentina of Italian parents, Lucio Fontana was raised in Milan, where he studied art at the Brera Academy from 1927 to 1930. Five years later he was a signatory of the First Manifesto of Italian Abstract Artists. In the early part of his artistic career he concentrated on sculpture and did not turn to painting until after World War II, when he began producing canvasses in which he used a very restricted range of colours, verging on monochrome effects. In 1946 he produced his White Manifesto, launching a series of paintings in shades of white. He really came to prominence a year later when he developed a style which he called Spatialism, in which cuts and slashes in the canvas were combined with a plain painted surface, bringing a new dimension to bear on Minimal Art. The apparent simplicity of his paintings was deceptive and they had a profound influence on a later generation of conceptual artists.

MOVEMENT

Italian Abstract School

OTHER WORKS

Spatial Concept; New York 15; The End of God

INFLUENCES

Yves Klein, Mark Rothko

Lucio Fontana Born 1899 Argentina

Painted in Italy

Died 1968 Varese, Italy

Kooning, Willem De

Woman, 1950

Courtesy of Private Collection/Christie's Images/® Willem de Kooning Revocable Trust/ARS, New York and DACS, London 2002

Born in the Netherlands, Willem de Kooning was apprenticed to a firm of commercial artists at the tender age of 12 but shortly after receiving his diploma from the Rotterdam Academy of Fine Arts in 1925 he emigrated to the United States and settled in New York, where he worked as a house painter and commercial artist. From the early 1930s he shared a studio with Arshile Gorky and made painting a full-time career from about 1936. Through Gorky he was introduced to Surrealism, reflected in the predominantly black and white paintings of his early period. In the immediate postwar period, under the influence of Adolph Gottlieb, he turned to colour and painted female figures, tending towards Abstract Expressionism. He became one of the foremost exponents of this movement, especially as expressed in his action paintings. In the last years of his long life, however, he turned to modelling figures in clay.

MOVEMENT

Abstract Expressionism

OTHER WORKS

The Visit; Marilyn Monroe

INFLUENCES

Arshile Gorky, Adolph Gottlieb

Willem de Kooning Born 1904 Holland

Painted in New York, USA

Died 1997 New York

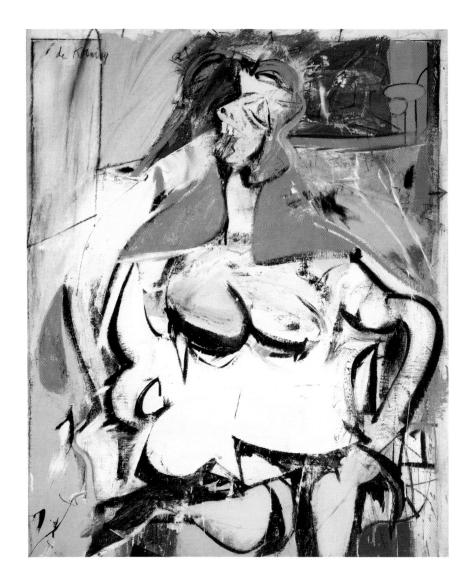

Woodruff, Hale

Afro Emblems, 1950

© Smithsonian American Art Museum, Washington, DC / Art Resource, NY

Although born in Illinois, Hale Woodruff was raised in Tennessee and witnessed the persecution of African Americans at close quarters. He studied at the John Herron Art Institute in Indianapolis and won a Harmon scholarship that enabled him to continue his studies at the Académie de la Grande Chaumière in Paris (1927–31). His later Expressionist paintings reflect the influence of this period. On his return to America he taught at Atlanta and New York Universities. He was one of the foremost creators of large murals on an epic scale, illustrating episodes in the history of African Americans, notably the Amistad Mutiny panels for the Savery Library of Talladega College, Alabama. The Amistad mutiny was a defining moment in the history of African Americans and it was the turning point in Woodruff's career. Subsequent murals were commissioned for Atlanta University but in the latter part of his working life Woodruff turned from representational painting to Abstract Expressionism.

MOVEMENT

African American School

OTHER WORKS

The Mutiny Aboard the Amistad; Leda; Landscape with Green Sun

INFLUENCES

Diego Rivera, José Clemente Orozco

Hale Woodruff Born 1900 Cairo, Illinois, USA

Painted in Alabama, Georgia and Tennessee

Died 1980 USA

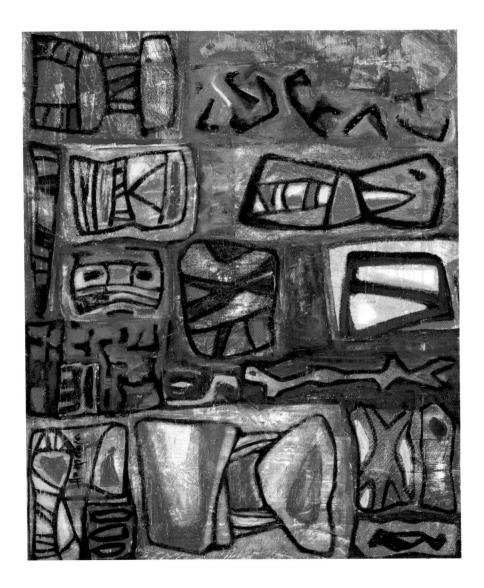

Hofmann, Hans

The Veil in the Mirror, 1952

Courtesy of Metropolitan Museum of Art, New York, USA/Bridgeman Art Library/@ ARS, New York and DACS, London 2002

Hans Hofmann studied art in Munich before settling in Paris at the beginning of the twentieth century. Here he came under the influence of the Impressionists, Fauves and Cubists in turn, imbibing their ideas and selecting the aspects of their art which suited him best. On the outbreak of World War I he returned to Munich, where he established his own art school in 1915. In 1930 he immigrated to the United States where, the following year, he opened the Hofmann School of Fine Art in New York City. He introduced to America the techniques of improvisation, which he had pioneered in Germany. He strove to translate the feelings of the artist into light, colour and form; texture was of major importance and he revelled in exploring this aspect of painting. These experiments conducted over many years finally evolved in the distinctive style which he practiced in America and was to have a profound influence on the development of Abstract Expressionism in his adopted country.

MOVEMENT

Abstract Expressionism

OTHER WORKS

Apparition; Nulli Secundus; The Prey; Exuberance

INFLUENCES

Henri Matisse, Pablo Picasso

Hans Hoffman Born 1880, Weissenburg, Germany

Pointed in Munich, Paris and New York, USA

Died 1966, New York

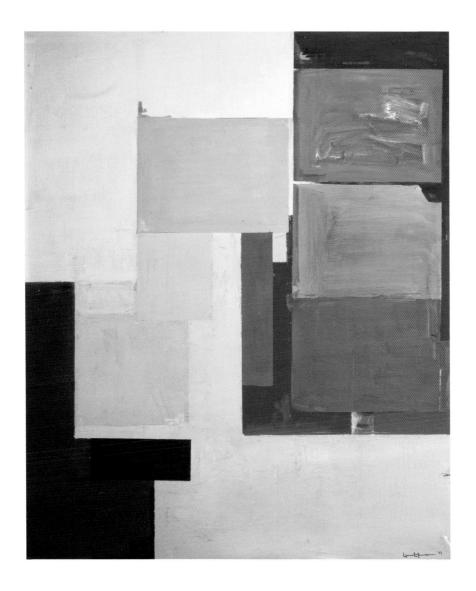

Matisse, Henri

The Snail, 1953

© Succession H. Matisse/DACS 2004/Tate, London 2004

French painter, printmaker and designer; the dominant figure in the Fauvist movement. Initially a lawyer's clerk, Matisse turned to art in 1890. His first teacher, Bouguereau, was a disappointment, but he learned a great deal from his second master, Gustave Moreau, a Symbolist painter with a taste for exotic colouring. Matisse's early works were mainly Impressionist or Neo-Impressionist in character but, after painting trips to the Mediterranean, he began to employ more vivid colours; using them to create an emotional impact, rather than simply to transcribe nature.

After years of failure, Matisse and his friends made their breakthrough at the Salon d'Automne of 1905. Critics were overwhelmed by the dazzling canvasses on display and dubbed the group *Les Fauves* ("The wild beasts").

Matisse continued to find his greatest inspiration from painting on the Riviera, but he also travelled widely, visiting Morocco, America and Spain. He decorated a chapel in Vence in southern France, in gratitude for a nun who had nursed him, and experimented with 'cut-outs' (pictures formed from coloured paper shapes, rather than paint).

MOVEMENT

Fauvism

OTHER WORKS

The Dance; Luxe; Calme et Volupte; The Blue Window

INFLUENCES

Paul Signac, Henri-Edmond Cross, Gustave Moreau, Paul Cézanne

Henri Matisse Born 1869 France

Painted in France and Morocco

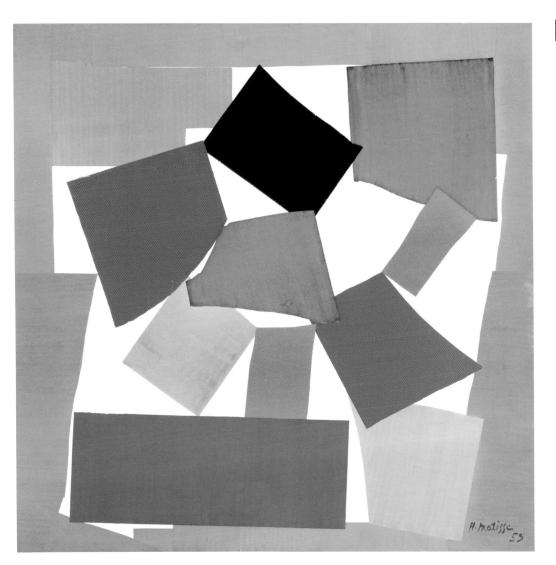

Albers, Josef

Homage, 1954

Courtesy of Private Collection/Christie's Images © DACS 2002

Albers trained in the prevailing German academic tradition, at the art schools of Berlin, Essen and Munich. He combined their discipline in draughtsmanship with his own imaginative flair and innovative approach when he continued his studies at the Bauhaus in Weimar, subsequently working as an abstract painter and furniture designer. The advent of the Nazi regime forced him to leave Germany and settle in the United States, where he developed a style that gave free rein to the exploration of colours and their relationship to each other. He held a series of important academic appointments, at the avant-garde Black Mountain College, North Carolina (1933–49) and at Yale University (1950–60). His work became increasingly non-figurative and in the 1950s culminated in purely geometric canvasses, notably in his series entitled *Homage to the Square*. He was also one of the foremost colour theorists of the immediate post-war period, publishing a seminal work on the subject in 1963 which was influential in the subsequent rise of geometric abstract painting.

MOVEMENT

Abstract Expressionism

OTHER WORKS

Skyscrapers; Homage to the Square: Blue Climate; Apparition

INFLUENCES

Walter Gropius, Wassily Kandinsky

Josef Albers Born 1888 Bottrup, Germany

Painted in Germany, USA

Died 1976 New Haven, Connecticut, USA

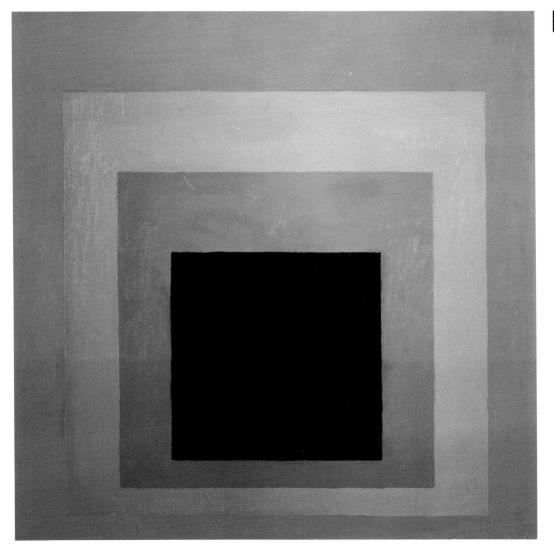

Giacometti, Alberto

Annette Assise, 1954

Courtesy of Private Collection/Bridgeman Art Library/® ADAGP, Paris and DACS, London 2002

Alberto Giacometti studied in Geneva but worked mostly in Paris, where he settled in 1922, working for some time primarily as a sculptor with Antoine Bourdelle. He moved in the intellectual circle dominated by Jean-Paul Sartre and was an enthusiastic disciple of Existentialism. In his painting he was originally drawn to the Cubists but in 1930 he embraced Surrealism as preached by André Breton, although he was expelled from the movement five years later. This was a defining moment, which resulted in a radical departure from previous styles and the evolution of strange, wraith-like figures. Although he is best remembered as a sculptor for his semi-abstract bronzes such as the *Thin Man* series and even more skeletal, spidery figures of the immediate postwar period, the same qualities are evident in his paintings – mostly portraits of real people executed in an abstract fashion.

MOVEMENT

Surrealism

OTHER WORKS

Jean Genet: Portrait of Yanaihara

INFLUENCES

Antoine Bourdelle: Andre Breton

Alberto Giacometti Born 1901 Switzerland

Painted in Paris

Died 1966 Chur, Switzerland

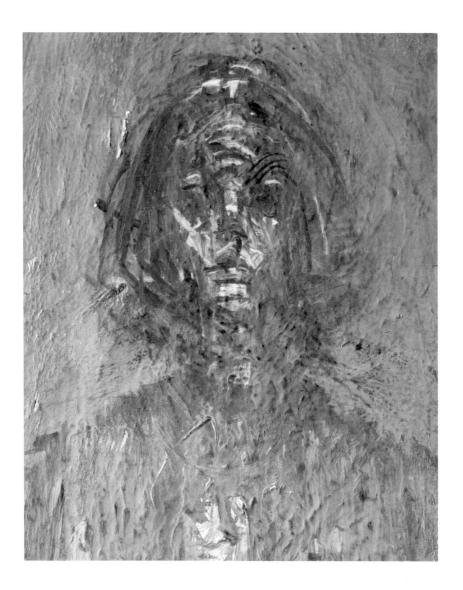

Nolan, Sir Sidney

Ned Kelly, 1955

Courtesy of Private Collection/Christie's Images

Sidney Robert Nolan had no formal art training. A self-taught amateur, he took up full-time professional painting in 1938, experimenting with abstract forms before turning in the early 1940s to the subject which would make him famous, the exploits of the bush-ranger Ned Kelly and his gang. This series of paintings, executed in a naïve style, was followed by canvasses charting the exploits of the explorers Burke and Wills in the mid-nineteenth century. He travelled to Europe in 1950, studying the art of Italy and working in Greece and North Africa before settling in London where he continued to paint, developing a more mature style which combined figuration with the abstract. He designed sets for a number of Covent Garden operas and ballets from 1962 onwards. He also worked as a book illustrator and in 1972 published a volume of his own poetry illustrated with drawings and paintings. He was knighted in 1981.

MOVEMENT

Modern Australian School

OTHER WORKS

Burke and Wills Expedition 'Gray Sick'; The Leda Suite

INFLUENCES

R. B. Kitaj, Arthur Boyd

Sir Sidney Nolan Born 1917 Australia

Painted in Australia, Greece, North Africa and England

Died 1992 London, England

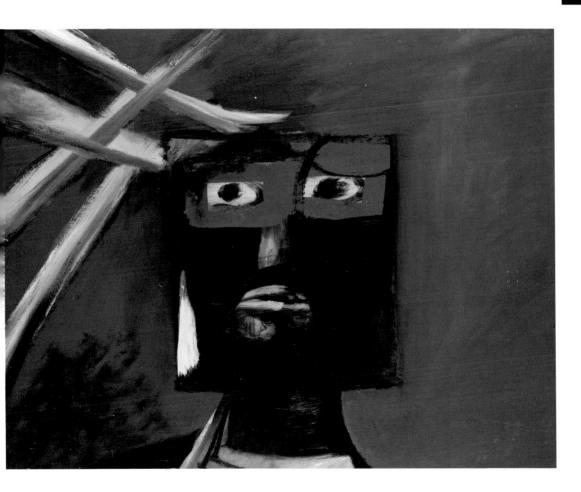

Salim, Jawad

Malaria

Courtesy of Sotheby's Picture Library

Jawad Salim hailed from a family of painters, which included his father Muhammad, brother Nizar and sister Naziha. The family came from the village of Mosul, which became part of Iraq on the break-up of the Ottoman Empire. He trained under his father and then continued his studies in Paris and Rome (1938–40). During World War II he was employed in the Archaeological Museum in Baghdad, where he gained an abiding interest in sculpture. From 1946 to 1949 he studied painting and sculpture at the Slade School of Art in London and on his return to Iraq was appointed head of the sculpture department at the Institute of Fine Arts. When Iraq became a republic in 1958 he was commissioned to create the Monument to Liberty – one of the largest sculptures in the Middle East. This has tended to overshadow his achievement as a painter, but he strove to create a distinctive Iraqi idiom that combined modern styles with ancient Mesopotamian symbols and mythology. He also worked as a graphic artist and book illustrator.

MOVEMENT

Modern Iraqi School

OTHER WORKS

Fishermen Hauling Boat; Festive Crowd; Bazaar

INFLUENCES

Haji Muhammad Salim al-Mosuli

Jawad Salim Born 1920 Ankara, Turkey

Painted in Baghdad, Iraq

Died 1961 Baghdad

Berni, Antonio

Los Emigrantes, 1956

Courtesy of Private Collection/Christie's Images

After a conventional art training in Buenos Aires, Antonio Berni travelled to Paris, where he continued his studies under Othon Friesz and André Lhote. With a number of other young Argentinian artists in the late 1920s formed the Grupo de Paris, through whom he also came under the influence of the Surrealists, de Chirico's Pittura Metafisica and the Italian muralists of the fifteenth century. More importantly, perhaps, he also imbibed the Marxist politics of the inter-war period and the course of the Spanish Civil War left a deep impression on him. On his return to Argentina he embarked on Surrealist works that concentrated on social themes ideally suited to the rugged material and technique. For these he used burlap (rough canvas) painted with distemper. The unusual perspective, foreshortened figures and a technique borrowed from film stills and religious icons combined to make his paintings truly distinctive.

MOVEMENT

Modern Latin American School

OTHER WORKS

Desocupados (Unemployed); Manifestación (Demonstration)

INFLUENCES

Giorgio de Chirico, Surrealism

Antonio Berni Born 1907 Buenos Aires, Argentina

Painted in France and Argentina

Died 1981 Buenos Aires

Moudarres, Fateh

Prayer for the Rain

Courtesy of Sotheby's Picture Library

Originally a self-taught painter working in a realistic style, Fateh Moudarres subsequently came under the spell of the Surrealists and took part in public exhibitions, at which he explained his paintings in verse. Between 1954 and 1960 he studied at the Accademia di Belle Arti in Rome and on returning to Syria he developed a style which he describes as 'surrealistic and figurative with a strong element of abstraction'. Powerful influences in his work are the icons of the Orthodox Church and Syriac art, but from the early 1960s onwards his painting became increasingly abstract. Due to contemporary events, however, he returned to a more representational style from 1967 onwards, painting works with a strong political theme. A period in Paris (1969–72) studying at the École des Beaux Arts has resulted in a much more confident touch, with greater technical mastery of composition and colour. As Professor of Fine Arts in the University of Damascus, Moudarres has been a major influence over the rising generation of Syrian artists.

MOVEMENT

Modern Syrian School

OTHER WORKS

Christ the Child of Palestine

INFLUENCES

Salvador Dali

Fateh Moudarres Born 1922 Aleppo, Syria

Painted in Damascus, Rome and Paris

Mukarobgwa, Thomas

Landscape

Courtesy of Private Collection/Bridgeman Art Library

Entirely self-taught, Thomas Mukarobgwa worked as an attendant in the Rhodesian National Gallery; surrounded by so many pointings in different styles and from different periods he was encouraged to try his hand. His early drawings were childlike and ill-executed, but Frank McEwen, the Director of the Gallery, felt that they showed promise. Under McEwen's guidance, Mukarobgwa emerged in the early 1960s as one of the most important painters in Africa, his mature paintings a far cry from his 'adult child art' of the 1950s and since hailed as 'masterly and involved sophistication'. He paints in an almost abstract style in which the shapes of trees are simplified and the contours of landscapes rounded. Human figures are seldom encountered and when they appear they are clumsy little men in shadowy form, giving the impression of having strayed on to the canvas. His work has been likened to that of Nolde and the German Expressionists.

MOVEMENT

Modern African School

OTHER WORKS

Very Important Bush; Enemy People; Old Man Afraid to Cross

INFLUENCES

Frank McEwen

Thomas Mukarobgwa Born 1924 Rhodesia (now Zimbabwe)

Painted in 7imbabwe

Riopelle, Jean-Paul

Composition (non-representational), 1958

Courtesy of Private Collection/Christie's Images/@ ADAGP, Paris and DACS, London 2002

Although he painted landscapes from early childhood, Riopelle studied at the Montreal Polytechnic (1939–41), but later concentrated for some time on architecture. In 1943 he resumed his art studies at the Montreal École des Beaux-Arts and the École du Meuble, where he studied furniture design. Under the influence of Paul-Emile Borduas he developed an interest in Abstraction, Surrealism and mechanical techniques used by the group of French-Canadian artists known as Les Automatistes. In 1947 he settled in Paris, where he came into close contact with Duchamp and the other Surrealists. For a time he painted in the tachiste manner, but after 1950 he evolved a technique in which blobs of paint were squeezed directly from the tube onto the canvas, then in about 1953 he turned to the palette knife to create almost sculptural effects. In turn this was followed by a fragmented, mosaic effect, which eventually gave way to a more representational style. From 1958 anwards he also modelled figures, cast in bronze. Since 1970 he has experimented with collages, employing a wide range of materials and techniques.

MOVEMENT

Modern Canadian School

OTHER WORKS

Green Parrot; Composition; Blue Night; Pavane

INFLUENCES

Paul-Emile Borduas, Marcel Duchamp

Jean-Paul Riopelle Born 1923 Montreal, Quebec, Canada

Painted in Canada and France

Amighetti, Francisco

El Monge, c. 1960s

Courtesy of Pinacoteca Digital- de Floria Barrionuevoy Maria Enriqueta Guardia

Costa Rica was not a country with a rich artistic tradition and something like a national school did not emerge till the end of the nineteenth century, when the development of the coffee trade gave rise to an affluent middle class, stimulated by contact with North America and Europe. At first, painting tended to follow Neoclassicist lines, influenced by Spanish and German artists who taught in San José. The dead hand of the stereotyped Classicism was not removed until the 1920s when the so-called 'nationalist generation' of artists received their training at the Escuela de Bellas Artes. Amighetti, however, is largely self-taught but absorbed the stylistic development from Mexico, the United States and Europe (notably German Expressionism) as well as Japanese prints, evolving his own regional brand of painting to chronicle the everyday life of the Costa Rican peasantry in a luminous style which has been dubbed Creole Impressionism. Figures, animals and colourful adobe houses are painted in a style that mirrors his preoccupation with social problems.

MOVEMENT

Modern Latin American School

OTHER WORKS

Toro y Gente (Bull and People)

INFLUENCES

Japanese ukiyo-e prints

Francisco Amighetti Born 1907 San José, Costa Rica

Painted in Costa Rica

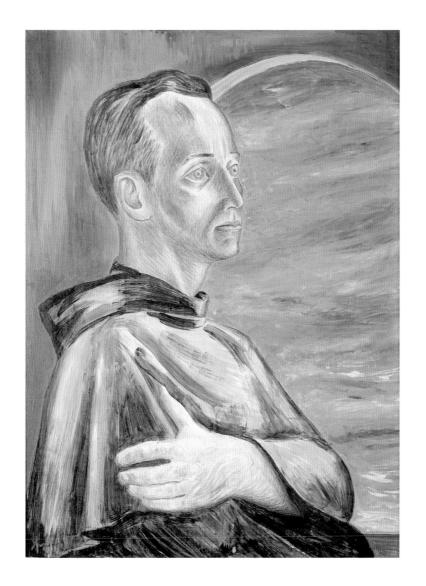

Bacon, Francis

Seated Figure (Red Cardinal), 1960

Courtesy of Private Collection/Christie's Images/© Estate of Francis Bacon 2002. All rights reserved, DACS

Born in Dublin of English parents, Bacon left home at the age of 15, travelling to London, Berlin and Paris. In Paris he visited a Picasso exhibition, which inspired him to paint. In 1929, Bacon settled in London, where he designed Bauhaus-style furnishings and later, during wartime, joined the Civil Defence. His breakthrough as an artist came in 1945, when his *Three Studies for Figures at the Base of a Crucifixion* caused a sensation at the Lefevre Gallery. In this, as in many of his future works, elements of mutilation, pain and claustrophobia combined to create a highly disturbing effect.

From 1946 to 1950, Bacon resided in Monte Carlo, partly to satisfy his passion for gambling. His international reputation growing, he returned to London. His source material was very diverse, ranging from the work of other artists (Velázquez, Van Gogh) to films and photographs (Muybridge, Eisenstein) and autobiographical details. His studies of caged, screaming figures, for example, are often viewed as a reference to his asthma. Bacon's prevailing theme, however, is the vulnerability and solitude of the human condition.

MOVEMENT

School of London

OTHER WORKS

Sleeping Figure; Man with Dog

INFLUENCES

Pablo Picasso, Diego Velázquez, Mathis Grünewald, Eadweard Muybridge

Francis Bacon Born 1909 Dublin

Painted in Britain, France and South Africa

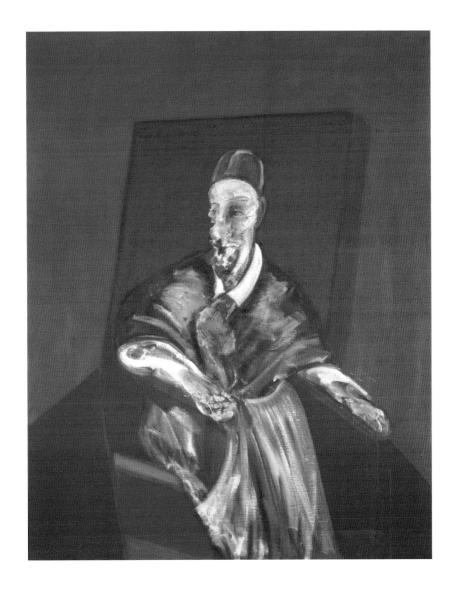

Boyd, Arthur

Expulsion, 1960

Courtesy of Private Collection/Bridgeman Art Library

Arthur Merric Bloomfield Boyd was born at Murrumbeena, Victoria, the younger son of the New Zealand-born painter Merric Boyd (1862-1940). He studied at the National Gallery of Victoria Art School, Melbourne, and at the Rosebud, Victoria. After war service he returned to Murrumbeena to work with his father and brother-in-law, John Perceval. From 1959 to 1972 he worked in London before becoming Fellow in Creative Arts at the University of Canberra. Although schooled in the Australian tradition, he came under European influence at an early age, both Van Gogh and Kokoschka being major sources of inspiration, which have given Boyd's paintings a more cosmopolitan character. Some of his more radical, avant-garde paintings were even confiscated by the Australian authorities during World War II. Later he concentrated on religious works, mixing the landscapes of Victoria with the imagery of Brueahel, Bosch and Stanley Spencer.

MOVEMENT

Australian Realism

OTHER WORKS

Shearers Playing for a Bride; The Mockers

INFLUENCES

Vincent Van Gogh, Oskar Kokoschka, Pieter Brueghel

Arthur Boyd Born 1920 Victoria, Australia

Painted in Australia and England

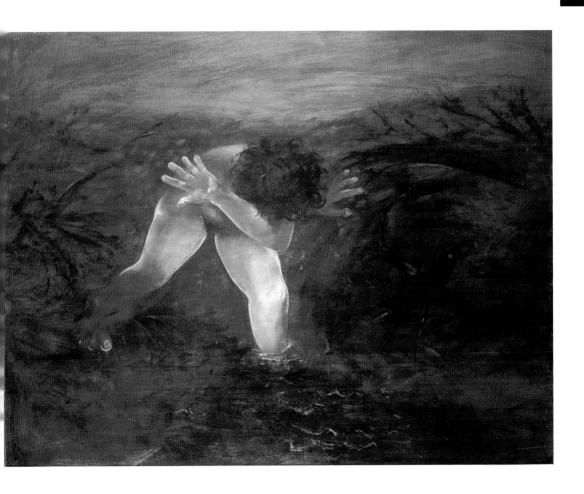

Lichtenstein, Roy

Kiss II

Courtesy of Private Collection/Christie's Images/© The Estate of Roy Lichtenstein/DACS 2002

Roy Lichtenstein enrolled at the Art Students' League (1939) and later studied at Ohio State College. After military service (1943–46) he returned to Ohio State as a teacher, and later taught at New York State and Rutgers Universities. He began exhibiting in 1949, his early works inspired by aspects of American history, strongly influenced by Cubism, though later he tended towards Abstract Expressionism. While teaching at Rutgers he met Allan Kaprow, who opened his eyes to the artistic possibilities inherent in consumerism and from about 1960 he developed what later came to be known as Pop Art, in which images are painted in the style of the comic strip. Even the dots of the screening process used in the production of comic books is meticulously reproduced in Lichtenstein's highly stylized paintings.

MOVEMENT

Pop Art

OTHER WORKS

In the Car; M-Maybe; Whaam!

INFLUENCES

Allan Kaprow

Roy Lichtenstein Born 1923 New York, USA

Painted in USA

Died 1997 New York

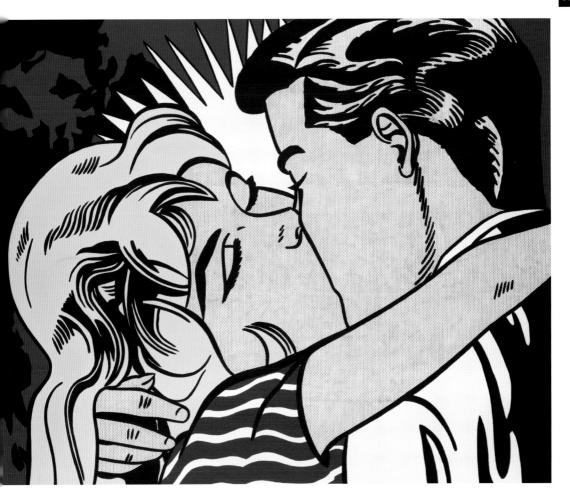

Tàpies, Antoni

Black with Four Grey Corners, 1960

Courtesy of Private Collection/Christie's Images/© Foundation Antoni Tapies, Barcelona/ADAGP, Paris and DACS, London 2002

Antoni Tapies studied law in Barcelona in 1943–46 but then gave up his studies to concentrate on painting, in which he was almost entirely self-taught. He became a founder member of the Catalan group of avant-garde writers and artists known as Dau al Set (Seven on the Die). His paintings reflect a diversity of influences, from the abstract radicalism of Catalonia in the Civil War period to the philosophy of the Surrealists and the lyrical qualities of Robert Motherwell and Joan Miró. He had his first one-man show in America in 1953 and thereafter made an impact on the international scene, winning many prizes. Since 1955 he has concentrated on 'matter' painting, influenced by such French artists as Fautrier. At first this consisted of mixing paints and varnish with unusual substances such as marble dust, pieces of cloth, straw and strips of metal. Taking this to its logical conclusion he eventually replaced canvas with solid objects, as in his Desk with Straw.

MOVEMENT

Modern Spanish School

OTHER WORKS

Violet Grey with Wrinkles; Perforated Body; Peintre Grise et Verte

INFLUENCES

Alberto Burri, Robert Motherwell, Joan Miró, Jean Fautrier

Antoni Tàpies Born 1923 Barcelona, Spain

Painted in Barcelona

Delaunay, Sonia

Rythme Couleur, 1961

Courtesy of Private Collection/Christie's Images/DACS 2002 @ L & M Services B. V. Amsterdam 20020512

Born Sonia Terk Stern at Gradizhsk in the Ukraine, she was raised in St Petersburg and studied art in Karlsruhe, Germany and then, in 1905, attended the Académie de la Palette in Paris. In order to remain in France, in 1909 she contracted a marriage of convenience with the art critic Wilhelm Uhde but it was dissolved after a few months. In 1910 she married the French painter Robert Delaunay (1885–1941) with whom she founded the movement known as Orphism. Together they designed and painted sets and costumes for Diaghilev's Ballets Russes. Robert is chiefly remembered for his endless experiments in colour orchestration, which had a profound effect on abstract art, while Sonia concentrated on Art Deco textile designs. In the interwar period she also evolved a purity of expression using brightly contrasting colours in her paintings, mainly in watercolours, that influenced her textile designs and vice versa.

MOVEMENTS

Orphism, Cubism

OTHER WORKS

Girls in Swimming Costumes

INFLUENCES

Robert Delaunay, Wassily Kandinsky

Sonia Delaunay Born 1885 Gradizhsk, Ukraine

Pointed in France

Died 1979 Paris, France

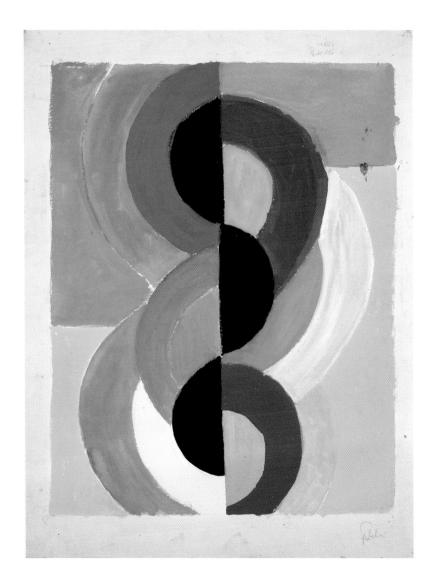

Diebenkorn, Richard

Seated Nude Black Background, 1961

Courtesy of Private Collection/Christie's Images/Bridgeman Art Library

Living and working on America's West Coast, well away from the mainstream of post-war artistic development, Richard Diebenkorn remained aloof and unaffected by the greatest fashions of the period, Abstract Expressionism and Pop Art. In 1946 he enrolled at the California School of Fine Arts in San Francisco and subsequently taught there for some time. It would be more accurate to say that he was influenced by the Modernist trends coming from Europe in evolving his distinctive approach to landscape, reduced by broad swathes of thick colour to a semi-abstract form. Thus, although never losing sight of the landscape form, his paintings are imbued with his own passion and sensitivity. Latterly he came under the influence of the colour-field painters and produced canvasses that echoed the Symbolists in his mastery of sensation through the medium of colour and form.

MOVEMENT

Modern American School

OTHER WORKS

Ocean Park series; Berkeley series; City Scape

INFLUENCES

Henri Matisse, Willem de Kooning, Piet Mondrian

Richard Diebenkorn Born 1922, Portland, Oregon, USA

Painted in Oregon and California

Died 1993, Portland

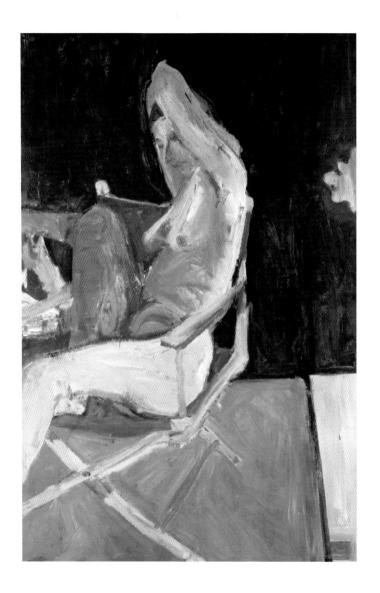

Khadda, Muhammad

Untitled

Courtesy of Sotheby's Picture Library

Though born in Algeria, Muhammad Khadda lived in France, where he worked as a printer. His employment in the artisticmilieu of Paris inevitably brought him into contact with a number of painters from whom he picked up techniques and ideas on form, colour and composition, although he never had any formal art training. He made his debut in 1955 at the Jeune Peintre Exhibition and also at the Salon des Réalités Nouvelles (1955–58). Two years later he returned to Algeria, where he established himself as a full-time painter, graphic designer and engraver. As well as painting he has designed theater sets in recent years. In his work he explores traditional Berber-Arab art forms of North Africa and the Middle East, often incorporating calligraphy in the manner of the medieval Arab artists, although more figural and representational and with a highly developed sense of colour, reflecting the French influence.

MOVEMENT

Modern Algerian School

OTHER WORKS

Kabylie; Mediterranean Olive Tree

INFLUENCES

Traditional Arab-Berber art

Muhammad Khadda Born 1930 Mostaganem, Algeria

Painted in France and Algeria

Lewis, Norman

Evening Rendezvous, 1962

© Smithsonian American Art Museum, Washington, DC/Art Resource, New York

Born in New York Norman Lewis was one of the few natives of that city to gain early prominence as the artistic chronicler of African American life in Harlem. Under the WPA (Works Project Administration) scheme of the 1930s, he was able to study at Columbia University and was later a pupil of Augusta Savage. His WPA assignment consisted of the decorations of the Harlem Art Centre, which put him in touch with other black American artists. In the late 1930s he began painting in a semi-abstract manner, reducing the human figure to geometric lines. Later he veered towards Abstract Expressionism. In the 1960s he belonged to the Spiral Group, which gave artistic interpretation to the civil rights movement. In 1971, while working at the Art Students' League, he formed the Cinque Gallery with Ernie Crichlow and Romare Bearden, with the aim of exhibiting the art of young people from ethnic minorities.

MOVEMENT

Abstract Expressionism

OTHER WORK

Yellow Hat; Ovum; Processional; Every Atom Glows

INFLUENCES

Augusta Savage

Norman Lewis Born 1909 New York, USA

Painted in New York

Died 1979 New York

Warhol, Andy

Shot Red Marilyn, 1964

Courtesy of Christie's Images/® The Andy Warhol Foundation for the Visual Arts, Inc./ARS, New York and DACS, London 2002

American artist specializing in printmaking and films. Warhol was born in Pittsburgh, the son of Czech immigrants. In 1949 he moved to New York, where he became a successful commercial artist. This gave him a solid grounding in silkscreen printing techniques and taught him the value of self-promotion — both of which were to feature heavily in his art. Warhol's breakthrough came when he began to make paintings of familiar, everyday objects, such as soup cans, dollar bills and Brillo pads. Early examples were hand-painted, but Warhol soon decided to use mechanical processes as far as possible. His aim, in this respect, was to free the image from any connotations of craftsmanship, aesthetics or individuality. He further emphasized this by describing his studio as 'The Factory'.

Warhol rapidly extended his references to popular culture by portraying celebrities (Marilyn Monroe, Marlon Brando), as well as more sinister items, such as news clippings with car crashes or the electric chair. He also associated himself with other branches of the mass media, notably through his links with the rock band The Velvet Underground, and through his controversial films.

MOVEMENT

Pop Art

OTHER WORKS

Campbell's Soup Can; Marilyn Monroe; Brillo

INFLUENCES

Roy Lichtenstein, Jasper Johns

Andy Warhol Born 1928 Pittsburgh, USA

Painted in USA

Died 1987 New York, USA

Dubuffet, Jean

Cortège, 1965

Courtesy of Private Collection/Christie's Images/@ ADAGP, Paris and DACS, London 2002

Jean Dubuffet studied at the Académie Julien in Paris but, dissatisfied with the styles in 'new art' then being taught, branched out on his own and began exploring unusual materials and the deliberate use of coarse canvas and paint applied roughly. He believed that there was more truth in the art produced by the untrained, the childish or the psychotic and strove to recreate such effects. The synthesis of rough materials with discarded rubbish such as pieces of old newspapers and broken glass resulted in what he termed Art Brut (raw art), which was the antithesis of painterly perfection and aesthetic sensitivity. By this means Dubuffet confronted the spectator with the seamier side of life and nature in the raw. Though often derided, he exerted a tremendous influence on the next generation of artists and anticipated the Pop Art and neo-Dadaism of the 1960s.

MOVEMENT

Abstract Expressionism

OTHER WORKS

Man with a Hod; Villa sur la Route; Jazz Band

INFLUENCES

Antoni Tapiès, Alberto Giacometti

Jean Dubuffet Born 1901 Le Havre, France

Painted in France

Died 1985 Paris, France

Olitski, Jules

Non-Stop, 1965

Courtesy of Private Collection/Christie's Images/© Jules Olitski/VAGA, New York/DACS, London 2002

Born in Russia, Jules Olitski studied art in Paris before immigrating to the United States and continuing his studies in New York, where he subsequently taught and worked as a sculptor. By his background and training he thus combined elements of the avant-garde from both sides of the Atlantic. Originally he was strongly influenced by the colour-field painters and the vigorous abstracts of Hans Hoffman. In the 1960s, as many of his contemporaries were turning to Pop Art, he remained true to Abstract Expressionism while, along with Helen Frankenthaler, developing the style which came to be known as Post-Painterly Abstraction. This involved the staining of the canvas with paint in order to avoid brush-strokes. From this he moved on to spraying the canvas with acrylics to achieve a completely smooth surface with central abstract motifs of stridently contrasting colours, often with a narrow surround of bare canvas. Since the late 1970s, however, he has returned to the mainstream, producing thickly textured abstracts more reminiscent of the works of Hoffmann.

MOVEMENT

Post-Painterly Abstraction

OTHER WORKS

Yaksi Juice; Thigh Smoke; Green Jazz

INFLUENCES

Hans Hoffman, Helen Frankenthaler

Jules Olitski Born 1922, Gomel, Russia

Painted in Paris and New York

Sugai, Kumi

Matin de l'Autoroute No 2, 1966

Courtesy of Private Collection/Christie's Images

Kumi Sugai received his early art education in his home town of Kobe, Japan, but after military service in World War II he resumed his studies and travelled to Europe, where he eventually settled in Paris and worked from 1952 onwards as a painter, print-maker and sculptor. After a period producing conventional oils on canvas he concentrated on prints, combining the traditional techniques of the *ukiyo-e* school of Japan with Western ideas and modern materials. Over a period of three decades he produced over 400 different prints. From about 1962 there was a noticeable change in his style, as he adopted the hard-edge geometric imagery of Max Pechstein, a marked contrast to the softer style of his earlier prints, reflecting the influence of the great Japanese masters of the eighteenth and nineteenth centuries.

MOVEMENT

Modern Japanese School

OTHER WORKS

The Flying Deer; Devil's Chain; Alea; Printemps

INFLUENCES

Ukiyo-e, Max Pechstein

Kumi Sugai Born 1919 Kobe, Japan

Painted in Kobe, Tokyo and Paris

Died 1996 Paris

Chagall, Marc

Le Repos, 1967-8

Courtesy of Private Collection/Christie's Images/@ ADAGP, Paris and DACS, London 2002

Born into an Orthodox Jewish family in what was then known as Russian Poland, Marc Chagall studied in St Petersburg and Paris and returned to his native city on the eve of World War I. Initially he worked as a sign-writer but on his return to Russia he joined the Knave of Diamonds group and participated in their 1917 exhibition, which was intended as an attack on the stuffy classicism of the Moscow School of Art. The Revolution broke out shortly afterwards and Chagall was appointed Director of the Vitebsk Art School before being summoned to Moscow to design sets for the Jewish Theatre. He left Russia in 1922 and settled near Paris. On the outbreak of World War II he moved to the USA where he designed sets and costumes for the ballet, as well as illustrating books and producing stained-glass windows, notably for the UN Building in New York and the Hadassah Hospital in Jerusalem. He also painted the murals for the Knesset (Israeli parliament). His paintings combine fantasy, folklore and biblical themes with an intensely surreal quality. Indeed, it is claimed that Guillaume Apollinaire originally coined the term 'Surrealist' to describe Chagall's paintings.

MOVEMENT

Surrealism

OTHER WORKS

Above the Town; I and the Village

INFLUENCES

Gauguin, The Fauves

Marc Chagall Born 1887 Vitebsk, Russia

Painted in Russia, France and USA

Died 1985 Saint Paul-de-Vence, France

Drubi, Hafiz

The Family, 1967

Courtesy of Sotheby's Picture Library

Born into a mercantile family in what was then a provincial backwater of the crumbling Ottoman Empire, Hafiz Drubi had a conventional art education but later came under the influence of the European avant-garde artists of the 1930s and 1940s. He gradually developed his own distinctive style, showing the influence of the Cubists. His paintings reflect his cultural roots in the exuberant display of colour and tone, although the composition is usually in the Western idiom. Little-known outside Iraq, he came to international prominence in the early 1960s, when his paintings were exhibited at Gallery One in Beirut. This gallery, founded by the poet Yusuf al Khal and his Lebanese-American wife Helen, gave many Middle Eastern artists their first real break and established Beirut as the art centre of the Arab world.

MOVEMENT

Modern Islamic Art

OTHER WORKS

Still Life

INFLUENCES

Pablo Picasso, Robert Delaunay, Max Beckmann

Hafiz Drubi Born 1914 Baghdad, Iraq

Painted in Baghdad

Died 1991 Iraq

Hassan, Faik

Two Women, 1967

Courtesy of Sotheby's Picture Library

Faik Hassan studied at the Institute of Fine Arts in Baghdad, Iraq, then won a scholarship to the École des Beaux-Arts in Paris, from which he graduated in 1938. On his return to Iraq he established and directed the department of painting and sculpture at the Institute of Fine Arts. During his time in France he came under the influence of the Cubists and Impressionists, which are reflected in many of his own paintings, although he also explored abstract art and painted landscapes and genre scenes in a relatively conventional style. He established the Pioneers Group in 1950 but withdrew from it in 1962 and five years later formed the Corners Group (Al Zawiya), whose aim was to serve the nation through their art, hence his many pictures with a strong social or political theme. After Iraq became a republic in 1958 he created the colossal mosaic mural entitled *Celebration of Victory* located in Tiran Square. In the last decade of his life he resumed painting in the Impressionist style.

MOVEMENT

Modern Iraqi School

OTHER WORKS

Celebration of Victory

INFLUENCES

Pablo Picasso, Pierre Bonnard

Faik Hassan Born 1914 Baghdad, Iraq

Painted in Baghdad and Paris

Died 1992 Baghdad

Botero, Fernando

La Visita, 1968

Courtesy of Private Collection/Christie's Images

The outstanding Colombian artist of the twentieth century is Fernando Botero, who has attained a universal reputation in recent years. He studied the great masters of European art and the influence of such disparate artists as Uccello, Piero della Francesca, Mantegna, Velázquez and Rubens is discernible in his work, which exalts form while exploring new realities. His work is by no means rigidly classicist, but he has combined his studies of the old masters with a detailed examination of the popular indigenous art of Colombia. The extraordinary range of his work, encompassing figures, portraits, landscapes and genre subjects, is characterized by ironic humour and warm humanity, coupled with wry, shrewd observation of the scenes and people around him. Figures are often depicted in a curious pneumatic fashion with fixed expressions on their grossly inflated faces, deliberately producing a naïve style. Botero has also produced a number of monumental sculptures, chiefly of female nudes.

MOVEMENT

Modern Latin American School

OTHER WORKS

Sunday Afternoon; Colombian Woman

INFLUENCES

Paolo Uccello, Piero della Francesca, Diego Velázquez, Paul Rubens, Francisco Goya

Fernando Botero Born 1932 Medellin, Colombia

Paints in Colombia

Rothko, Mark

Untitled, 1968

Courtesy of Private Collection/Christie's Images/® Kate Rothko Prizel and Christopher Rothko/DACS 2002

Born Marcus Rothkovitch in Dvinsk, Russia, Rothko emigrated to the US in 1913. He studied briefly at Yale and in New York, although he considered this to have had little influence on his painting. Rothko's style took many years to evolve. His early figurative works included portraits and psychologically-infused urban scenes, which he exhibited with the American expressionist group, The Ten. Rothko embraced ancient myth as he moved into a surrealist phase in the late 1930s, drawing on them as subjects for his increasingly abstract works. By 1946, he moved into pure abstraction, painting amorphous shapes, or 'Multiforms', that would coalesce into his familiar rectangles on fields of colour by 1949. Although the works were formally quite simple, Rothko executed them with a meticulous eye for colour, balance and brushwork that give them a dramatic presence beyond their initial appearance. He was pleased that viewers often found looking at his paintings a deeply emotional experience. While he maintained the essential elements of his signature style, Rothko's paintings became generally larger, darker and more meditative in the last dozen years of his life.

MOVEMENTS

Abstract Expressionism, Colour Field Painting

OTHER WORKS

Central Green; Blue; Orange; Red; Number 118

INFLUENCES

Henri Matisse, Arshile Gorky, Clyfford Still

Mark Rothko Born 1903 Drinsk, Russia

Painted in New York, USA

Died 1970 New York

Stella, Frank

Agbatana II, 1968

Courtesy of Musée d'Art et d'Industrie, St Etienne, France/Bridgeman Giraudon/@ ARS, New York and DACS, London 2002

Frank Philip Stella studied at Phillips Academy in Andover, Maine (1950–54) and Princeton University (1954–58). After university he went to New York City, where he worked as a house painter, an experience which influenced his art. He began painting in the Minimalist style in 1959, using a broad brush in order to eliminate the brushstrokes typical of art, and created works which were often virtually solid blocks of black, relieved only by a few contrasting stripes. Later he evolved polychrome patterns of straight lines or concentric rings and curves using the same technique of eliminating brushstrokes, which would have detracted from the overall effect. These paintings have a decidedly Art Deco character, reflecting Stella's admiration of the Bauhaus designs of the 1920s. His method is to cut templates and assemble them in reliefs painted in day-glo and metallic paints. His more recent work, in fact, verges on the sculptural, with its multicoloured, three-dimensional effects.

MOVEMENTS

Minimalism, Abstract Expressionism

OTHER WORKS

Tuxedo Park Junction; Harewa; Jarama II

INFLUENCES

Josef Albers, Gwen John

Frank Stella Born 1936 Malden, Massachusetts, USA

Paints in New York

Bearden, Romare H.

Sunday after the Sermon, 1969

Courtesy of Art Resource, New York/© Romare Bearden Foundation/VAGA, New York/DACS, London 2002

Born in Charlotte, North Carolina, in 1914, Romare Howard Bearden moved with his family to New York when he was three and eventually settled in Harlem. He began drawing cartoons at New York University, where he was also art editor of the student magazine *Medley*. Although originally intending a career in medicine, he switched to art and enrolled for evening classes at the Art Students' League where he studied under George Grosz. After military service in World War II the GI Bill enabled him to pursue his art studies at the Sorbanne, being particularly drawn to such masters as Duccio, De Hooch, Rembrandt and Manet. When he returned to the United States in 1952 he did not immediately take up creative painting, but from 1964 onwards he began producing collages. He is a versatile painter of landscapes and urban scenes, figures and abstracts, bringing to bear a highly intellectual approach in his work and drawing upon his southern roots for inspiration.

MOVEMENT

Modern American School

OTHER WORKS

Sunday After Sermon; Before the Dark; The Visitation

INFLUENCES

George Grosz

Romare Bearden Born 1914 Charlotte, North Carolina, USA

Paints in New York and Paris

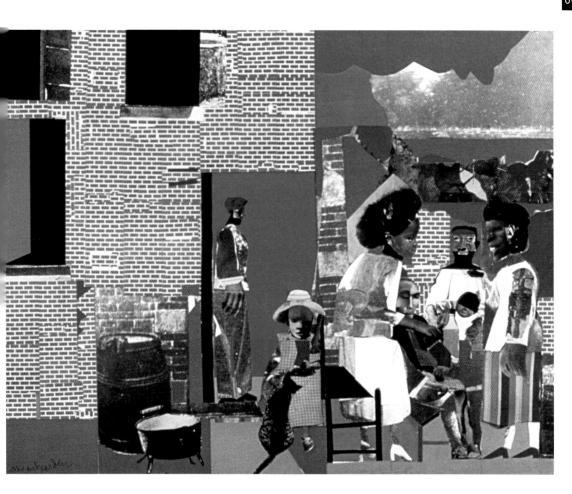

Oppenheim, Meret

Blaues Auge, 1969

Courtesy of AKG, London © DACS 2002

Meret Oppenheim was raised by her grandparents in Switzerland during World War I. At the age of 18 she went to Paris, where she enrolled at the Académie de la Grande Chaumière. She met Giacometti and Arp, who introduced her to Surrealism and she even modelled for Man Ray. Oppenheim began contributing her own three-dimensional objects to the Surrealist exhibitions in 1933 and achieved critical acclaim three years later with *Object, Fur Breakfast*: a cup, saucer and teaspoon covered with gazelle fur. This typified much of her later work, in which ordinary, everyday objects were transformed into articles with fetishistic or sado-masochistic undertones. In her paintings and sculptures she explored female sexuality and woman's role as a male sex object. One of the few female Surrealists, she was certainly the most highly original of them. On one occasion she even staged a banquet in which a nude female formed the centrepiece of the table decoration.

MOVEMENT

Surrealism

OTHER WORKS

The Governess (My Nurse); Red Head; Blue Body; Influences

INFLUENCES

Marcel Duchamp, Louise Bourgeois

Meret Oppenheim Born 1913 Berlin, Germany

Painted in Switzerland

Died 1985 Basle, Switzerland

Rauschenberg, Robert

Sky Garden (F74) Rocket Space

Courtesy of Christie's Images/© Robert Rauschenberg/DACS, London/VAGA, New York 2002

Robert Rauschenberg studied at the Kansas City Art Institute and at Black Mountain College, North Carolina, where he was strongly influenced by Joseph Albers. In 1948 he crossed the Atlantic and enrolled at the Académie Julien in Paris (1948). His friendship with the avant-garde composer John Cage led to their collaboration in *Happenings*, in which Cage supplied the music and Rauschenberg the visual entertainment, later extended from collages to painting entirely in one colour – black, white or red. From such minimalism in the early 1950s he moved on to highly controversial pictures, which were not only unusual in colour and surface treatment, but also incorporated scraps of ephemera and even three-dimensional objects such as stuffed birds, rusty metal, rubber tyres, pieces of discarded clothing and any old junk, often dripping with paint. The results are unsettling and unnerving, but always thought-provoking.

MOVEMENTS

American Abstract, Pop Art

OTHER WORKS

The Red Painting; Canyon; Bed; Reservoir

INFLUENCES

Joseph Albers, Marcel Duchamp

Robert Rauschenberg Born 1925 Port Arthur, Texas, USA

Paints in France and USA

Richter, Gerhard

Wolken (Fenster), 1970

Courtesy of Private Collection/Christie's Images/© Gerhard Richter

Gerhard Richter studied in his native city of Dresden and Düsseldorf before engaging in a career as a designer of sets for the stage and then working as a commercial artist in advertising. His early paintings were mostly figurative, but from 1962 onwards he produced paintings that were derived from blurred photographic images. Many of his paintings have been produced in series, exploring particular themes that continually flit back and forward between the camera and the canvas, hovering between figuration and the abstract. In particular, he painted a series of oils derived from aerial photographs of cities. His most recent work has consisted of enormous canvasses, more purely abstract in character, with emphasis on the artist rather than the subject. Noted for his range and versatility, coupled with absolute mastery of his technique, he has an infinite capacity to rediscover or reinvent the medium. A great innovator, he has had a tremendous influence on postwar German art.

MOVEMENT

Modern German

OTHER WORKS

Abstraktes Bild; Stag; Betty; Colour Streaks; Townscape series

INFLUENCES

Otto Dix

Gerhard Richter Born 1932 Dresden, Germanu

Paints in Germany

Thomas, Alma

Snoopy - Early Sun Display on Earth, 1970

© Smithsonian American Art Museum, Washington, DC / Art Resource, New York

Alma Thomas moved with her family to Washington, DC in 1906 following race riots in the South. She came from a African American professional, middle class family and trained as a kindergarten teacher. After a spell in Wilmington, Delaware she returned to Washington in 1921 and became the first art graduate of Howard University. She taught art at Show Junior High School until her retirement in 1959. A spell in New York City, taking a teacher's postgraduate course at Columbia, brought her into contact with avant-garde art, but it was not until 1949 that she took a painting course at American University, and only when she retired in her sixties did she take up painting seriously. In the last decade of her life she painted prolifically in watercolours and acrylic, emerging as one of the greatest colourists of her generation. Always independent, she did not conform to any particular style but used colour in her own distinctive manner.

MOVEMENT

Abstract Art

OTHER WORKS

Pinks of Cherry Blossom; Light Blue Nursery

INFLUENCES

Wassily Kandinsky

Alma Thomas Born 1891 Columbia, Georgia, USA

Painted in Washington, DC, USA

Died 1978 Washington, DC

Arakawa, Shusaku

War of the Worlds

Courtesy of Private Collection/Christie's Images

Shusaku Arakawa studied medicine and mathematics at Tokyo University but later switched to painting at the Musashino College of Art, and staged his first one-man show in the National Museum of Modern Art in 1958. Strongly influenced by the Dadaists of the early 1920s, he revived this movement in Japan and staged a number of 'happenings' from 1960 onwards to satirize the sickness and corruption in contemporary Japanese society. These activities caused a furore and Arakawa moved to the USA in 1961, settling in New York where he has lived ever since, working as a performance artist and film-maker as well as continuing to paint. Sending up those artists who produced works entitled *Untitled*, he produced a series under the name *Untitledness*, where blank spaces had pin marks where the object should be. A series entitled *Diagrams* consisted of spray-painted silhouettes of everyday objects. Later works explored the relationship between different forms of representation.

MOVEMENT

Dadaism

OTHER WORKS

Diagrams; Webster's Dictionary; The Mechanism of Meaning

INFLUENCES

Jean Arp, Kurt Schwitters, Man Ray

Shusaku Arakawa Born 1936 Nagoya, Japan

Painted in Tokyo and New York

These are all the same size

These are all the same size ROOM FOR CORRECTION

These are all the same size DO NOT ALLOW FOR CORRECTION

WAR OF THE WORLDS

Scully, Sean

Untitled, 1971

Courtesy of Christie's Images

Although born in Dublin, Ireland, Sean Scully was raised in London, where he studied at the Croydon College of Art (1965–68) and Newcastle University (1968–72). He continued his art education at Harvard University before settling permanently in the United States in 1975. Such a rich and varied training is reflected in his paintings, which provide an interesting blend of elements derived from Minimalism and Conceptual Art on the one hand and the Abstract Expressionism of his adopted country. This is manifest in his most characteristic works, in which the dominant features are vertical or horizontal bands of contrasting colours, generally muted shades of brown, beige and deep reds alternating with black. At first glance they may appear Minimal, but closer examination reveals the rich textures and layers of colour. Scully styles these works triptychs, and this is true in so far as they comprise three pieces of canvas whose juxtaposition is deliberately uneven. The use of a term more commonly associated with medieval religious works is a reflection of Scully's regard for the spiritual qualities of abstract painting.

MOVEMENT

Abstract Expressionism

OTHER WORKS

Paul; The Fall; White Window; Why and What

INFLUENCES

Noel Foster, Mark Rothko, Barnett Newman

Sean Scully Born 1945 Dublin, Ireland

Paints in London and New York

Sutherland, Graham

Landscape Orange and Blue, 1971

Courtesy of Private Collection/Christie's Images

Graham Vivian Sutherland originally intended to become a railway engineer, but switched courses and studied art at Goldsmiths College in London. Influenced by the visionary artist Samuel Palmer, he worked mainly as an etcher, but the market for prints collapsed in the aftermath of the stock-market crash of 1929, and as a result Sutherland took up painting instead. A visit to south-west Wales in 1934 introduced him to the astonishing diversity of the Pembrokeshire scenery which would provide endless subject matter for his later pointings. Sutherland's great landscapes combined elements of the romantic with the abstract. From 1941 until 1945 he was employed as an official war artist, and in the postwar period he produced a number of memorable (if occasionally controversial) portraits, including that of Sir Winston Churchill (1955). True to his original training, Sutherland also produced posters, ceramic designs and textiles, the best known being the extraordinary tapestry *Christ in Majesty*, which he executed for the new Coventry Cathedral in 1962.

MOVEMENT

Modern English Landscape School

OTHER WORKS

Red Landscape; Entrance to a Lane; Devastation: House in Wales

INFLUENCES

Samuel Palmer, Pablo Picasso, Odilon Redon

Graham Sutherland Born 1903 London, England

Painted in England and Wales

Died 1980 London

Hockney, David

Sun from The Weather Series, 1973

Courtesy of Christie's Images @ David Hockney/Gemini G. E. L

British painter, photographer and designer Hockney was born in Bradford, Yorkshire and trained at the Royal College of Art. There, his fellow students included Allen Jones, Derek Boshier and R. B. Kitaj, and together they all exhibited at the Young Contemporaries exhibition of 1961, a landmark show which marked the arrival of British Pop Art. Hockney himself denies belonging to this movement, even though his early work contained many references to popular culture. Instead, his style may be better defined as New Figuration – a blanket term, relating to the revival of figurative art in the 1960s.

Hockney has travelled widely in Europe, but his main passion has been for the United States, especially Los Angeles where he settled in 1976. Throughout his career, autobiographical subjects have featured heavily in his paintings, ranging from friends, such as the Clarks and lovers sunbathing by swimming pools, to an entire book of pictures devoted to his dogs. Hockney has also been a prolific stage designer, creating sets and costumes for *The Roke's Progress, The Magic Flute* and *Parade*. In recent years, he has also experimented with photo-work, producing elaborate 'photocollages' from hundreds of photographic prints.

MOVEMENT

Pop Art, New Figuration

OTHER WORKS

A Bigger Splash; Mr and Mrs Clark and Percy; Influences

INFLUENCES

Pablo Picasso, Henri Matisse, Jean Dubuffet

David Hockney Born 1937 Bradford, Yorkshire, England

Painted in Britain, USA and France

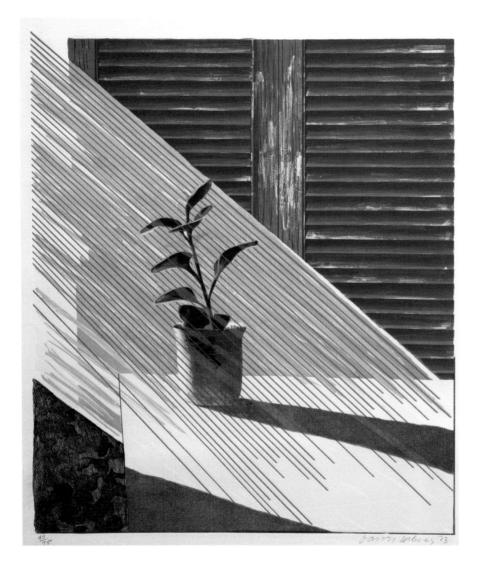

Johns, Jasper

Flags, 1973

Courtesy of Private Collection/Christie's Images © Jasper Johns/VAGA, New York/DACS, London 2002

Jasper Johns studied at the University of South Carolina, Columbia. In 1952 he settled in New York City and there he met Robert Rauschenberg, who shared his views on the brash banality of contemporary culture, which they exploited in the development of Pop Art. By taking the familiar, the mundane and everyday icons such as the Stars and Stripes and the numerals on football jerseys he created works of art that put them in an entirely new light. The influence of Dada is evident as he deliberately set himself against the tenets of conventional art. Thus, originality is eschewed by taking previously existing and immediately recognizable objects and emphasizing their very ordinariness. Johns is a versatile artist, working in oils, encaustic, plaster and other materials in various media.

MOVEMENT

Pop Art

OTHER WORKS

Device; Zero Through Nine; Zone

INFLUENCES

Marcel Duchamp

Jasper Johns Born 1930 Augusta, Georgia, USA

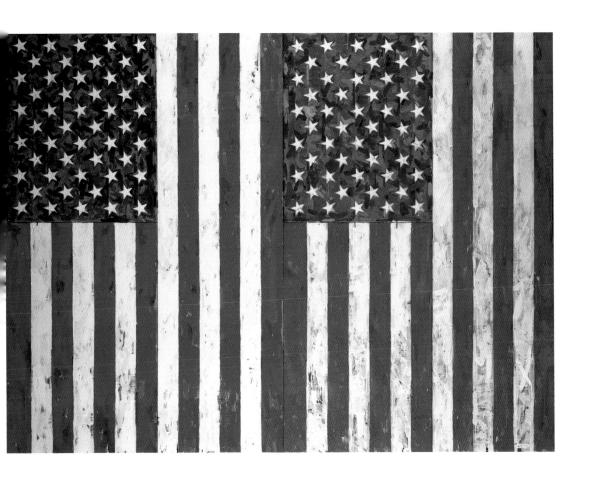

Al Attar, Suad

Paradise in Blue

Courtesy of Sotheby's Picture Library

Suad Al Attar studied at the University of Baghdad, the California Polytechnic State University in San Luis Obispo, the Wimbledon School of Art and the Central School of Art and Design, London where she took a degree in printmaking. In 1965 she became the first female Iraqi artist to have a solo exhibition in Baghdad and has since received numerous awards at international exhibitions in Cairo, Brazil, London, Madrid and Poland. She paints in oils on canvas or card laid down on board and her work ranges from figures and still life to landscapes and decorative works which combine the classical Islamic art forms of the Middle East with modern Western influences. In the past decade she has painted a number of semi-abstract works inspired by images in the love poems of Mahmoud Darwish. She also creates tapestries with traditional Arab motifs.

MOVEMENT

Modern Iraqi School

OTHER WORKS

Abacus; Birds of Paradise; Blue Sunset Birds; Bustan Guardian

INFLUENCES

Classical Islamic art forms of the Middle Fast

Suad Al Attar Born 1942 Baghdad, Iraq

Paints in Iraq

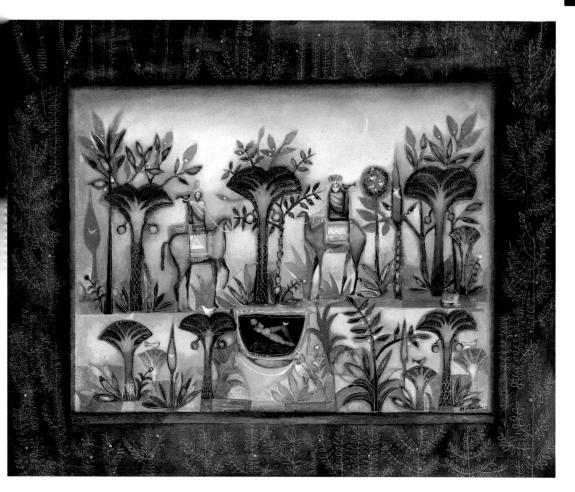

Frankenthaler, Helen

Sundowner, 1974

Courtesy of Private Collection/Christie's Images

After a college education at Bennington in Vermont, Helen Frankenthaler studied art under the abstract printmaker Hans Hoffman and the Mexican painter Rufino Tamayo. While still at Bennington, however, she evolved her own highly distinctive technique of applying very thin, diluted point to the unprimed canvas so that it soaked right through. These 'stain-soak' paintings were created with a series of applications in different colours and consistencies, the canvasses being laid flat on the studio floor. This technique created an unusual, atmospheric effect and the subtle blending of forms (not unlike that of certain watercolours, a medium in which she also worked) which form the basis for her large abstracts are vaguely suggestive of landscapes or the natural world. From 1958 to 1971 she was married to Robert Motherwell, whose influence can be discerned in her own brand of Abstract Expressionism. In her more recent paintings, acrylics have been applied to give greater depth to the principal details.

MOVEMENT

Abstract Expressionism

OTHER WORKS

Black Frame; Door; The Other Side of the Moon

INFLUENCES

Rufino Tamayo, Jackson Pollock, Robert Motherwell

Helen Frankenthaler Born 1928, New York, USA

Miró, Joan

Personnages, Oiseaux, Étoiles, 1974-6

Courtesy of Private Collection/Christie's Images @ ADAGP, Paris and DACS, London 2002

Spanish painter, ceramist and graphic artist; a key member of the Surrealists. Miró trained under Francisco Gali. His early work showed traces of Fauvism and Cubism, but his first one-man show was a disaster. Undeterred, Miró decided to travel to Paris, the acknowledged home of the avant-garde. There, he contacted Picasso, who introduced him to the most radical artists and poets of the day. These included the blossoming Surrealist group, which Miró joined in 1924.

Miró was fascinated by the challenge of using art as a channel to the subconscious and, from the mid-1920s, he began to fill his canvasses with biomorphic, semi-abstract forms. Nevertheless, he felt suspicious of some of the more outlandish, Surrealist doctrines and remained at the fringes of the group. He moved to France during the Spanish Civil War, producing patriotic material for the struggle against Franco, but was obliged to return south in 1940 after the Nazi invasion. By this stage, Miró's work was much in demand, particularly in the US, where he received commissions for large-scale murals. Increasingly, these featured ceramic elements, which played a growing part in the artist's later style.

MOVEMENT

Surrealism

OTHER WORKS

Dog Barking at the Moon; Aidez l'Espagne

INFLUENCES

Pablo Picasso, Hans Arp, Paul Klee

Joan Miró Born | 1893 Barcelona, Spain Painted in Spain, France, USA and Holland Died | 1983 Palma de Mallorca, Spain

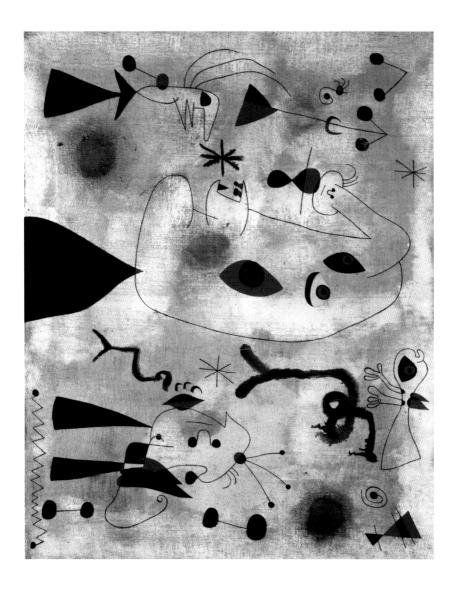

White, Charles

Mother Courage II, 1974

Courtesy of National Academy of Design, New York, USA/Bridgeman Art Library

Charles White was largely self-taught but from an early age he was imbued with the desire to depict the African American heroes whose exploits formed a large part of the folklore of the 1920s when he was growing up. His reputation was assured by one of his most ambitious early works, the mural entitled *Five Great American Negroes*, which was commissioned for the Chicago Public Library. In this great work can be seen the tension and emotion, the realistic depiction of persecution, injustice and struggle, that characterized much of his later work. The passion is more restrained in the tempera mural completed in 1943 for Hampton University illustrating the contribution of the Negro to American democracy – a mural whose vast expanse is crammed with portraits large and small. Features and forms are sharply outlined with a geometric, angular style that adds to their rugged character, and this intensely graphic quality came to fruition in White's later works, from murals to individual portraits.

MOVEMENT

African American School

OTHER WORKS

Frederick Douglass; Booker T. Washington; In Memoriam

INFLUENCES

Charles Alston, Hale Woodruff

Charles White Born 1918 Chicago, Illinois, USA

Painted in Chicago and Los Angeles

Died 1979

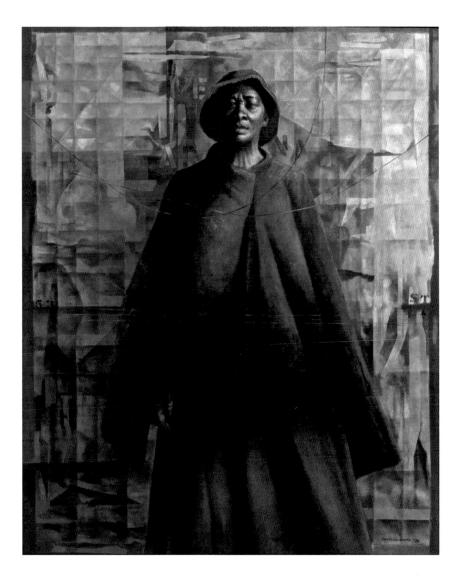

Hodgkin, Sir Howard

Dinner at the Grand Palais, 1975

Courtesy of Private Collection/Christie's Images

Howard Hodgkin studied at the Camberwell School of Art in London and then Bath Academy of Art, where he later taught (1956–66). Although his painting does not fit neatly into any particular movement he was influenced by William Scott, his teacher at Bath, to regard painting as a physical object. An early but lifelong attraction to the Mughal art of India is also evident in the range of brilliant, contrasting colour. His paintings have a superficial impression of being abstract, but a closer examination reveals that they are truly representational, mostly of interiors or encounters, with figures caught in a split second. These qualities are evoked strongly in his masterpiece *Dinner at Smith Square*, painted in oil on wood between 1975 and 1979, now in the Tate Gallery. He was awarded the Turner Prize for contemporary British art in 1985 and was knighted in 1992.

MOVEMENT

Modern English

OTHER WORKS

Lovers; Menswear; Interior at Oakwood Court

INFLUENCES

William Scott, Mughal art

Sir Howard Hodgkin Born 1932 London, England

Paints in London

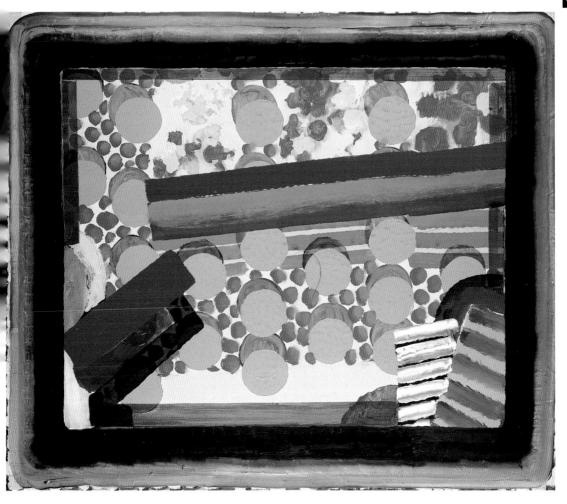

Maghubela, Louis Khela

Untitled, 1975

Image with permission of "The Haengai Foundation Inc. Johannesburg/Basel" (Gallery 21 London archives).

Louis Khela Maqhubela studied at the Polly Street Art Centre in Durban under Cecil Skomes and Sydney Kumalo, imbibing the disparate strands of conventional genre painting and the more symbolic, abstract style which was becoming very fashionable in South Africa in the 1950s. These influences melded in Maqhubela's lively depiction of everyday life in the black townships, and the exhibition of his paintings in the Johannesburg galleries was a way of breaking through the barrier of apartheid in the 1960s. A prize as one of the most promising young artists of his time enabled him to travel to England to study under the South African abstract painter Douglas Portway. Maqhubela later studied at Goldsmiths College and the Slade School of Art (1985–87). Since then he has had a studio in London and now commutes between there and Johannesburg, a prominent figure in the modern movement since the downfall of the apartheid system.

MOVEMENT

Modern South African School

OTHER WORKS

Equilibrium

INFLUENCES

Douglas Portway, Cecil Skomes, Sydney Kumalo

Louis Khela Maqhubela Born 1939 Durban, Natal, South Africa

Paints in South Africa and England

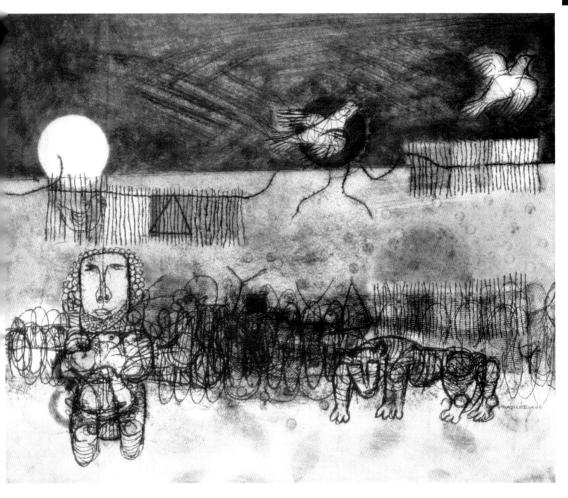

Morrisseau, Norval

Ojibway Headdress, 1975

Courtesy of Collection of the Dennos Museum Center, Northwestern Michigan College, Traverse City, Michigan

Native North American painter and graphic artist. Born in Fort William, Canada, Morrisseau hails from the Ojibwa tribe and has made this the focus of his art. Awareness of Native American traditions blossomed during the 1960s, as a by-product of the civil rights movement, and Morrisseau belonged to the generation that spearheaded this revival. He held his first one-man exhibition at the Pollock Gallery, Toronto, in 1962, and the success of this show established him as the leader of a new school. This has been variously described as the Woodlands or Algonquian school of legend pointing.

Morrisseau took his basic subject matter from Ojibwa folk traditions. Many of these had been preserved as pictographs on birchbark scrolls. Traditionally, non-Native Americans were not permitted to see these images, but Morrisseau broke this taboo. He also combined the legends with more universal, Native American symbolism and European forms. Much of his work has a strong, spiritual basis, dealing with such themes as soul travel and self-transformation. It reached its widest audience in Montreal, when Morrisseau and Carl Ray designed the Indian Pavilion for Expo 67.

MOVEMENT

Algonquian Legend Painters

OTHER WORKS

Thunderbird; Loon Totem and Evil Fish; The Creation of the Earth

INFLUENCES

Midewiwin birchbark scrolls, aboriginal rock art, Ojibwa folklore

Norval Morrisseau Born 1931

Paints in Canada, USA

Freundlich, Otto

Composition

Courtesy of Private Collection/Christie's Images

After art training in Munich and Berlin, Otto Freundlich settled in Paris in 1909, where he joined the avant-garde circle dominated by Picasso. In 1911 he exhibited at the Neue Sezession in Berlin, revealing the latest trends from France. He returned to Germany for military service in World War I, during which (1917) he joined the Aktion group of artists and between 1919–23 was associated with the Bauhaus. He returned to Paris in 1924 and latterly worked in Pontoise as a painter, graphic artist and sculptor. In 1929 he commenced the magazine A bis Z; a prolific writer, he was the intellectual voice of the avant-garde. In 1939 he was interned as an enemy alien, released on the intervention of Picasso and moved to the Pyrenees, where he spent the next two years repainting from memory all those works which had been destroyed by the Nazis as degenerate art. Betrayed to the Gestapo in 1943, he was transported to Majdanek concentration camp where he died soon afterwards. Work on the restoration of the stained glass in Chartres Cathedral (1914) inspired his kaleidoscopic paintings which anticipated the Op Art of the 1960s.

MOVEMENTS

Abstract Art, Orphism

OTHER WORKS

Diptych; La Rosace; Composition avec Trois Personnages

INFLUENCES

Pablo Picasso, Wassily Kandinsky, Paul Klee, Robert Delaunay, Max Ernst

Otto Freundlich Born 1878 Pomerania (now Poland)

Painted in Munich, Berlin, Paris, Pontoise and the Pyrenees

Died 1943 Majdanek, Lublin, Poland

Kiefer, Anselm

Noch Ist Poten Nicht Verloren IV, 1978

Courtesy of Private Collection/Christie's Images

One of the leading artists to emerge in Germany in recent years, Anselm Kiefer originally studied law, but switched to art around 1965 and had his first one-man show five years later. Between 1970 and 1972 he studied under Joseph Beuys, but did not embrace either Minimalism or Conceptual Art as did so many of his contemporaries. In subsequent years he developed large-scale paintings, executed on paper or burlap, mounted on canvas and using charcoal or black paint to create a starkly etched effect with muted tones of yellow and brown, which drew upon the myths and legends of Germany. Although controversial (and sometimes accused of fascist overtones) Kiefer's monumental paintings are inspired by the works of Caspar David Friedrich and the operas of Wagner. In addition to his paintings, Kiefer has produced numerous drawings and etchings and well as massive 'books' in wood or lead, engraved and worked over.

MOVEMENT

Neo-Expressionism

OTHER WORKS

Spiritual Heroes of Germany; Parsifal series; Lilith

INFLUENCES

Joseph Beuys, Caspar David Friedrich

Anselm Kiefer Born 1945, Donaueschingen, Germany

Paints in Germany

Oonark, Jessie

Angagok Conjuring Birds, 1979

Courtesy of Collection of the Dennos Museum Center, Northwestern Michigan College, Traverse City, Michigan/The Artist

Jessie Oonark spent her entire life in the Baker Lake community of Inuit in northern Canada, learning her skills in needlework from her mother. She excelled in the art of sewing duffel parkas intricately embroidered with figures, but it was not until 1963 that she was encouraged to apply these skills to wall-hangings. These are noted for the brilliant colours of the images and their striking resemblance to the frescoes of Pharaonic Egypt, although executed without any knowledge of Egyptian art. Jessie Oonark also produced a vast number of drawings, many of which began as preliminary sketches for her embroideries but were later regarded as works of art in their own right. Her large wall-hangings were worked in mixed media, involving duffel, felt and embroidery floss with strips of caribou hide to create an almost three-dimensional effect. She combined traditional Inuit images dating back many centuries with the changes wrought by exposure to twentieth century civilization, but always in a truly unique and individual manner.

MOVEMENT

Modern Canadian School

OTHER WORKS

What the Shaman Can Do; Angagok Conjuring; Day Spirit

INFLUENCES

Inuit Tribal Art

Jessie Oonark Born 1906 Canada

Painted in Baker Lake, Canada

Died 1985 Churchill, Manitoba, Canada

Fischl, Eric

Love

Courtesy of Private Collection/Christie's Images

Educated at the California Institute of the Arts (1969–72), Eric FischI led the reaction against Op Art and Minimalism in the late 1970s and 1980s, calling for a return to a more purely figurative and representational style of painting which had strong echoes of the Social Realism of the New Deal era. What has marked out his work from his predecessors of the 1930s, however, is the psycho-sexual undertones of his compositions, in which the spectator becomes a voyeur, looking at scenes which may appear relatively simple and straightforward on one level, but which reveal disturbing elements of anxieties, phobias, insecurities and a wide range of sexual hang-ups, invariably unexplained and thus open to individual interpretation. Although far less accomplished technically than the paintings of Tamara de Lempicka, for example, FischI's sly exploration of repressed or ambivalent sexuality invites obvious comparison.

MOVEMENT

Neo-Figurative School

OTHER WORKS

Bad Boy; Sleepwalker; Pizza Eater

INFLUENCES

Tamara de Lempicka, Norman Rockwell, Walter Sickert

Eric Fischl Born 1948 New York, USA

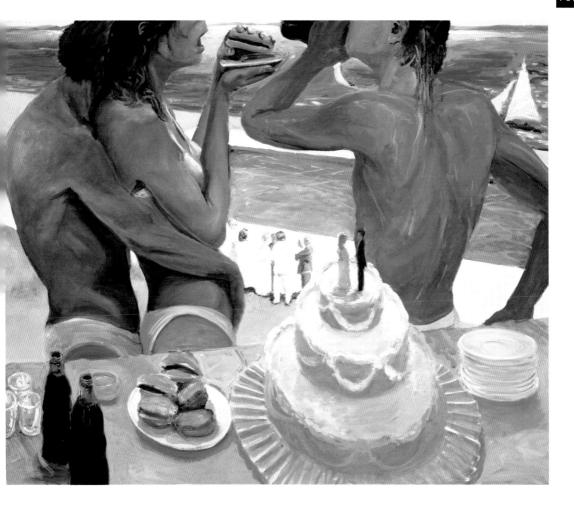

Gilbert and George

Helping Hands, 1982

Courtesy of Private Collection/Christie's Images

Italian-born Gilbert Proesch first met George Pasmore when they were both students at St Martin's School of Art in London and have worked together since graduating in 1969. George had previously studied at Dartington Hall and the Oxford School of Art, while Gilbert had attended the Academy of Art in Munich. Since the late 1960s they have worked as performance artists, principally as living sculptures, their faces and hands covered with gold paint and holding the same pose for hours on end. Subsequently they developed two-dimensional art, often comprising a series of framed photographs which are integrated to form a single entity. Their very conservative images in these collaborative works often clash with the subject matter, in which bodily functions and overt references to homosexuality feature prominently. Controversy surrounds their work, which is often seen as promoting rather than condemning fascist or racist attitudes, although they claim to be attempting to define the 'new morality'.

MOVEMENT

Modern British School

OTHER WORKS

Fear; Flying Shit; England; The Nature of Our Looking

INFLUENCES

Op Art, Performance Art

Gilbert Proesch Born 1942 Dolomites, Italy

Worked in Italy, Germany and England

George Pasmore Born 1943 Devon, England

Paints in England

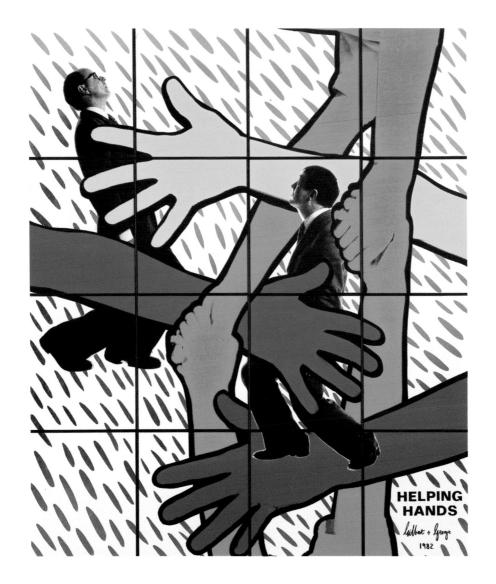

Kitaj, R. B.

Golem, 1982-3

Courtesy of Private Collection/Christie's Images/The Artist courtesy of Marlborough Fine Art

Born in Cleveland, Ohio, in 1932, Ronald Brooks Kitaj travelled the world as a merchant seaman (1951–55) but after service in the US Army he went to Oxford to study art. In 1960 he enrolled at the Royal College of Art in London. Older and infinitely more worldly wise that his fellow students, he was an outstanding figure with a charismatic personality who played a leading role in introducing Pop Art to Britain in the 1960s. An abiding friendship with David Hockney was forged in this period. The strident colours and brashness of Pop Art belie the intellectual depth of Kitaj's work, which draws on many disparate sources, from his Hungarian Jewish ancestry to the ethnic art of the countries he visited as a seaman. The result is often a riotously eclectic mixture of patterns and images. Most of his work up to 1975 was executed in ails but in more recent years he has concentrated on pastels, a trend encouraged by his second wife, Sandra Fisher. This is cleverly demonstrated in his masterpiece *The Wedding* which celebrates their marriage.

MOVEMENT

Pop Art

OTHER WORKS

If Not, Not

INFLUENCES

Arthur Boyd, Edward Burra

R. B. Kitaj Born 1932 Cleveland, Ohio

Paints in London, England

Schnabel, Julian

Hamid in a Suit of Light, 1982

Courtesy of Private Collection/Christie's Images

Although a native of New York City, Schnabel studied art at the University of Texas from 1969 to 1972. After moving back to New York, he began exhibiting in 1976, creating enormous canvasses in which layers of paint are applied in different ways in order to create interesting and unusual textures. A later development on these lines includes the use of shards of pottery to break up the surfaces and heighten dramatic effect. Unfortunately this combination of paint and crockery is friable and inherently unstable, creating numerous problems for curators and conservators of art galleries housing these monumental works. More recently he has also created paintings on velvet. Apart from re-inventing Action Painting, Schnabel has experimented with imagery on the grand scale, creating extraordinary works which incorporate numerous images and portraits mingled with allusions to history and emotions. Since the early 1980s he has enjoyed phenomenal commercial success.

MOVEMENT

Action Painting

OTHER WORKS

Blue Nude with Sword; Humanity Asleep; St Francis in Ecstasy

INFLUENCES

Robert Motherwell, Robert Rauschenberg

Julian Schnabel Born 1951 New York, USA

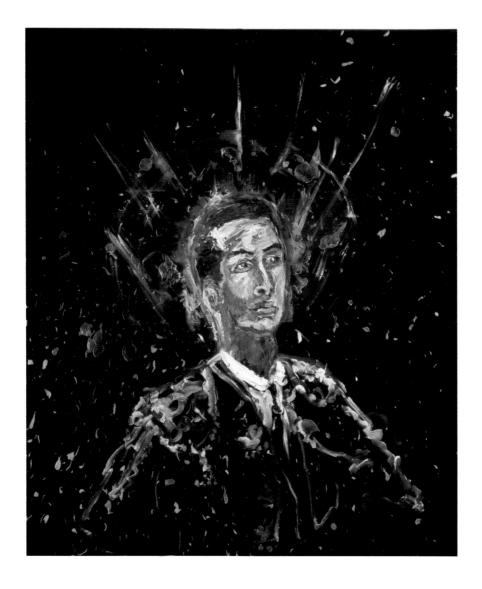

Tjapaltjarri, Clifford Possum

Water Dreaming, 1982

Courtesy of Corbally Stourton Contemporary Art, London, UK/Bridgeman Art Library @ Aborginal Artists Agency, Sydney, Australia

Clifford Possum Tjapaltjarri had no formal art training in the conventional Western sense, but he inherited an Aboriginal artistic and spiritual tradition stretching back thousands of years. He belongs to the group of Aboriginal artists known as the Western Desert Painters, who have adapted their tribal art forms to the Western world only in so far as they use westernized materials and techniques, instead of wood, bark, sand or indigenous dyes. Tjapaltjarri works in acrylic paints on canvas, but otherwise much of his work clings steadfastly to the imagery and expression practiced by his ancestors. A large part of his oeuvre centres on the Dreamtime, the sacred world of the tribe's ancestral spirits, whom the Aborigines regard as the creators of all living things. Superficially, his paintings may seem abstract, but they are actually a carefully constructed and systematized map or chart of a particular tribal or community site.

MOVEMENT

Australian Aboriginal

OTHER WORKS

Kangaroo Dreaming

INFLUENCES

Tribal art

Clifford Possum Tjapaltjarri Born 1932 Nabberby Creek, Central Australia

Painted in Central Australia

Died 2002 Australia

Dine, Jim

Townsend Monotype I (Heart), 1983

Courtesy of Private Collection/Christie's Images/© ARS, New York and DACS, London 2002

Trained at the University of Cincinnati, the Boston Museum of Fine Arts School and the University of Ohio, Jim Dine was one of the foremost exponents of Pop Art. He held his first exhibition of objects as images in 1959, alongside Claes Oldenburg, with whom he subsequently collaborated on a number of projects. Like the Dadaists, he believed in the combination of many different media and the use of ready-made objects or fragments of them in creating his compositions. Taking this process to its logical conclusion in the late 1950s he began organizing a series of 'happenings', live performances which combined his art with his experience of life. These, in effect, were the forerunners of the Performance Art that came to fruition a few years later. In more recent years, however Dine has returned to a more representational and figurative style of painting. He has combined oils with collage, or etching and printing on hand-coloured paper.

MOVEMENT

Performance Art, Pop Art

OTHER WORKS

The Toaster; Wiring the Unfinished Bathroom

INFLUENCES

Dadaism, Surrealism, Abstract Expressionism

Jim Dine Born 1935 Cincinnati, Ohio, USA

Paints in Cincinnati, Boston and New York

Thiebaud, Wayne

Free Way Traffic, 1983

Courtesy of Private Collection/Christie's Images/© DACS, London VAGA, New York 2002

Wayne Thiebaud originally worked as a sign-painter and later a freelance cartoonist in New York before turning to fine art in 1949. His expertise in his earlier vocations stood him in good stead, for his paintings are both witty and executed with a clarity and deftness that make them instantly recognizable. His reputation has been built largely on the series of paintings of American junk food, pies, cakes, sweets, ice-cream and other delicacies, which often strike a nostalgic note but are invariably presented in a humorously deadpan manner. He injects realism by laying on the paint in thick slabs so that the icing or frosting on cakes looks good enough to eat. More recently he has painted figures of women, harshly lit in artificial light or the bright sunlight of California where he now lives, but here again he incorporates a wide range of minor objects, all painted against severely plain backgrounds.

MOVEMENT

Pop Art

OTHER WORKS

Refrigerator Pies; Woman and Cosmetics; Various Cakes

INFLUENCES

Pierre Bonnard, Man Ray, Edward Ruscha

Wayne Thiebaud Born 1920 Mesa, Arizona, USA

Paints in New York, Sacramento and San Francisco

Motherwell, Robert

Chrome Yellow Elegy, 1984

Courtesy of Private Collection/Christie's Images @ Dedalus Foundation, Inc/VAGA, New York/DACS, London 2002

Robert Burns Motherwell briefly attended the California School of Fine Arts in San Francisco before studying philosophy at Stanford, Harvard, Grenoble and Columbia universities. This unusual combination of academic training enabled him to write authoritatively on various aspects and theories of modern art, more especially the American brand of Abstract Expressionism which he helped to formulate in the 1940s. He only took up painting professionally in 1941, due to the influence of Roberto Matta. Motherwell's large paintings were often characterized by unconscious doodles, a concept which arose from his interest in Freudian psychoanalysis and the interpretation of dreams. With Mark Rothko and others he founded the Subjects of the Artist movement to encourage the development of the next generation, and was also preoccupied with aspects of Symbolism.

MOVEMENT

Abstract Expressionism

OTHER WORKS

Elegies to the Spanish Republic; Bolton Landing Elegy Influences

INFLUENCES

Roberto Matta

Robert Motherwell Born 1915 Aberdeen, Washington, USA

Pointed in New York, USA

Died 1991 Cape Cod, Massachusetts, USA

Hawkins, William

Niagara Falls, 1986

© Ricco/Maresca Gallery/Art Resource, New York

One of the foremost practitioners of American Vernacular and Outsider Art to emerge in the late twentieth century, William Hawkins was barely able to read or write and had no art training at all. Despite this he produced an extraordinary range of paintings. He migrated to Columbus, Ohio in 1916, where he held a wide variety of jobs, from truck-driver to brothel-keeper. Although he began drawing in the 1930s, he did not begin painting in the style that made him famous until the late 1970s. His technique evolved naturally – dripping paint on to cardboard or plywood tilted to "watch the painting make itself". Vivid imagery combined motifs seen in newspapers with memories of his native Kentucky countryside. From his early years he had a deep knowledge of animals, an awareness that informs even his most fantastic dinosaur paintings. Latterly he combined paint with pieces of wood, gravel or found objects. His pictures often have elaborate borders including his full name with date and place of birth.

MOVEMENT

American Vernacular, Outsider School

OTHER WORKS

Abstract; The Last Supper; Prancing Horse; Country House

INFLUENCES

None

William Hawkins Born 1895 Kentucky, USA

Painted in Columbus, Ohio

Died 1990 Columbus, Ohio

Rapira-Davies, Shona

Song for 900 Children: Tautoko for the Black Womin, 1986

Courtesy of Collection of the Museum of New Zealand Te Papa Tongarewa @ The Artist

Born in the Northland province of New Zealand, Shona Rapira-Davies is one of the most promising of the younger female Maori artists, working as a painter and sculptor. Like several of her contemporaries she evinces a concern for contemporary social issues, particularly those that affect women and families and the problems of a Maori community struggling to retain its traditional culture and values in a rapidly changing world. Her paintings reflect her passionate interest in the traditions of rural communities and the deracinated Maori caught up in an increasingly urban environment. Her work is not afraid to tackle such matters as racism and sexism, while reflecting the revival of Maori pride in its distinctive culture.

MOVEMENT

Modern New Zealand School

OTHER WORKS

Nga Morehu; Taku Whanau Motvairhe Aotea

INFLUENCES

Kura Te Waru Rewiri, Emare Karaka

Shona Rapira-Davies Born 1951

Paints in New Zealand

Haring, Keith

Untitled

Courtesy of Private Collection/Christie's Images

Keith Haring received his formal training at the Ivy School of Art in Pittsburgh, followed in 1978 by a year at the New York School of Visual Arts. In this period he was influenced by Keith Sonnler and Joseph Kossuth, who encouraged him to experiment with form and colour, and to develop as a Conceptualist. His informal, though, in the long run the most influential, art education came through the medium of comic strips and television cartoons as well as the graffiti of the New York streets. He himself spent some time covering the commercial advertisements on the New York subway with flamboyant graffiti executed with coloured chalks and marker pens. Prolific and far-ranging, his work reflected the age in which he grew up. In the 1980s he graduated from the sidewalk to commercial art, producing motifs reproduced on T-shirts and badges, and then posters and murals, drawing on the fertile mix of cultures in his adopted city.

MOVEMENT

Conceptualism

OTHER WORKS

Ignorance-Fear; Silence-Death; Untitled

INFLUENCES

Keith Sonnler, Joseph Kossuth

Keith Haring Born 1958 Pennsylvania, USA

Painted in New York, USA

Died 1990 New York

Arikha, Avigdor

Alexander Frederick Douglas-Home, Lord Home of the Hirsel, 1988

© The Artist, Courtesy of Scottish National Portrait Gallery, Edinburgh

Avigdor Arikha was born in 1929 in Bukovina (Romania) and survived the Holocaust thanks to the boyhood drawings he had created in deportation. He arrived in Palestine in 1944 where he received a Bauhaus art-education at Bezalel, Jerusalem from 1946-1949, and where he was also severely wounded in Israel's war of Independence in 1948. He continued his art studies at the École des Beaux-Arts in Paris (1949-1951) where he still mainly resides. His style, which was at first figurative, had evolved into abstraction in the late 1950s. He renounced abstraction in 1965 in favour of drawing and painting from observation, treating all subjects, whether they be still lifes, landscapes, nudes or portraits (such as Lord Home and Queen Elizabeth the Queen Mother) in a single sitting. As an art historian, Arikha has curated exhibitions at the Louvre (Poussin, 1979) and the Frick Collection in New York (Ingres, 1986), among others. His writings include: Peinture et Regard, Paris, 1991 and On Depiction, London, 1995. Books about him include Arikha by Samuel Beckett, Robert Hughes et al., London, 1985 and Avigdor Arikha by Monica Ferrando and Arturo Schwarz, Bergamo, 2001.

MOVEMENT

International School

OTHER WORKS

Anne from the Back; The Square in June

INFLUENCES

Mondrian

Avigdor Arikha Born 1929 Bukovina, Romania

Paints in Israel, France, England and USA

Close, Chuck

Cindy II, 1988

Courtesy of Private Collection/Christie's Images/© Chuck Close

Chuck Close studied art at Yale from 1962 to 1964 and settled in New York City in 1967. In that year, influenced by the photographic self-portraits produced by Claude Cahun in the 1920s, he began painting photographs of portraits, meticulously reproducing the tiniest detail. Every line and wrinkle, every pore and individual strands of hair are carefully delineated. In fact, appearances can be deceptive; closer examination often reveals slight distortion or blurring around the ears or shoulders in order to convey the impression that the face is looming towards the viewer. In this way the artist remedies the shortcomings of the camera lens. In more recent years he has taken this a stage further, combining this photo-realism with such techniques as finger-painting, a microscopic stippled effect and collages.

MOVEMENT

Hyper-realism

OTHER WORKS

John

INFLUENCES

Claude Cahun

Chuck Close Born 1940 Monroe, Washington State, USA

Paints in New York

Onus, Lin

Jimmy's Billabong, 1988

Courtesy of National Gallery of Australia, Canberra, purchased from Gallery admission charges 1988/© DACS 2002

Lin Onus was completely self-taught and began painting full-time in 1974. He had his first one-man exhibition the following year at the Aborigines Advancement League in Melbourne and has since had regular shows in Melbourne, Canberra and Sydney. His work is represented in all the major Australian national and state art galleries and he has had many commissions from institutions and corporate collections. He is currently Chairman of the Aboriginal Arts Committee of the Australian Council, although he is at pains to stress that he should not be regarded purely as an Aboriginal artist and finds the labelling of his painting in this manner rather irksome. He is best known for his extraordinary blend of traditional Aboriginal imagery and photorealist landscapes, which he describes as 'a natural convergence of Aboriginal and non-Aboriginal techniques'. In more recent years he has also produced a series of fiberglass sculptures of dingoes.

MOVEMENT

Modern Australian School

OTHER WORKS

Arafura Swamp

INFLUENCES

Traditional Aboriginal art forms

Lin Onus Born 1948 Melbourne, Australia

Painted in Melbourne

Died 1996

Rego, Paula

The Cadet and his Sister, 1988

Courtesy of Private Collection/Bridgeman Art Library/® The Artist

Rego was born in Lisbon, but her father worked for Marconi in Essex and she was educated at an English school. In 1952, she entered the Slade School of Art, where she trained under Coldstream. There she met Victor Willing, a fellow painter, who became her husband in 1959. They lived in Portugal until 1963, after which they resided principally in England.

Rego's early work was strongly influenced by Dubuffet. She also produced semi-abstract collages, sometimes with political overtones. Increasingly, though, she turned to figurative painting, drawing much of her inspiration from children's illustration, nursery rhymes and her own memories of childhood. In mature works, such as *The Maids*, these playful elements are transposed into unsettling contexts, hinting at games of a very sinister kind. Rego's paintings have brought her success, both in Portugal and the UK. She has twice represented her native land at the Bienal in São Paolo, and on one occasion for Britain. In 1990, she became the first Associate Artist of the National Gallery in London.

MOVEMENT

Symbolist Figuration

OTHER WORKS

Crivelli's Garden; The Policeman's Daughter

INFLUENCES

Jean Dubuffet, Pablo Picasso, Walt Disney, James Gillray

Paula Rego Born 1935 Lisbon, Portugal

Paints in Britain and Portugal

Samba, Chéri

Mobali Ya Monyato, 1989

Courtesy of Galerie Peter Herrmann, Berlin/© Chéri Samba

In colonial times it was axiomatic that aspiring African artists had to receive a good grounding in European styles and techniques, but gradually it dawned that such an influence was often negative or counterproductive. Fortunately for Chéri Samba, he was entirely self-taught and if he had been influenced in any way by European art it was through the medium of the cartoons and graphic art in contemporary newspapers. In 1975 he graduated from drawing cartoons to painting them on canvas, but without compromising his direct, crystal-clear approach. Every painting tells a story, the images generally enhanced by words, an unconscious borrowing from the art of China and Japan. Detail is painstaking, brushwork is crisp and outlines are hard-edged, enhancing the impact of his work. One of the most prominent of the naive painters to emerge in post-colonial Africa, his paintings with their undertones of social realism are now in many international collections.

MOVEMENT

Modern African School

OTHER WORKS

Mr Poor's Family

INFLUENCES

Henri Rousseau, Gino Severini

Chéri Samba Born 1956 Kinto M'Vulia, Zaire (now Congo)

Paints in Congo

Abdulla, Ian

Sowing Seeds at Nite, 1990

Courtesy of National Gallery of Australia, Canberra, purchased with funds from the Moët & Chandon Australian Art Foundation/O The Artist

This Aboriginal artist spent his boyhood in an idyllic riverside setting in South Australia, and consequently the river in all its aspects is a recurring theme in his paintings. He studied art in Adelaide and had his first one-man show in the Tandanya National Aboriginal Culture Institute in that city in 1990. He has since had one-man shows in many other parts of Australia and was declared South Australian Aboriginal Artist of the Year in 1991, winning the National Aboriginal Award for best painting five years later. His paintings are in all the major Australian galleries, including the National Museum of Australia in Canberra. In more recent years he has achieved international fame with award-winning exhibits in Canada and Cuba. His paintings combine the traditional patterns and art forms of Aboriginal tribal culture stretching back thousands of years with Western techniques, creating both figurative and semi-abstract works in a highly distinctive style.

MOVEMENT

Modern Australian School

OTHER WORKS

Tyerabarrbowaryaou; I Shall Never Become a White Man

INFLUENCES

Aboriginal traditional art forms

Ian Abdulla Born 1947 Swan Reach, South Australia

Paints in Australia

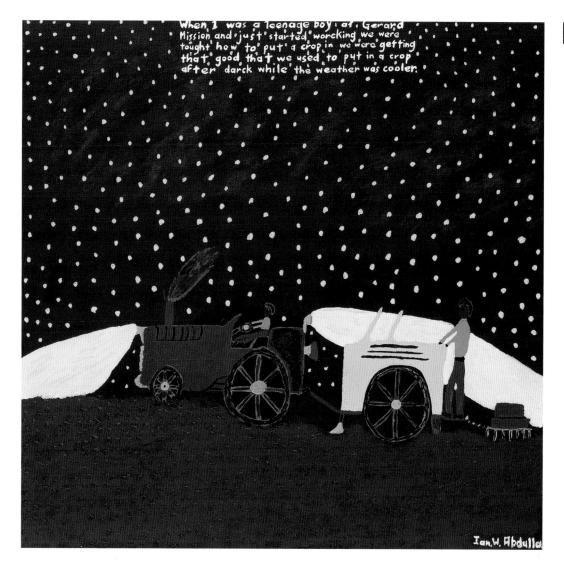

Freud, Lucian

Annabel, 1990

Courtesy of Private Collection/Christie's Images/© Lucian Freud

Naturalized British painter; a leading member of the School of London. Freud was born in Berlin, the grandson of the famous psychoanalyst Sigmund Freud. As a Jewish family living in the shadow of Nazism, the Freuds left Germany in the 1930s, settling in London. Lucian joined the Merchant Navy, becoming an artist after he was invalided out of the service in 1942. He trained under Cedric Morris, and the hallucinatory realism of his early style hints at an admiration for Surrealism and Neue Sachlichkeit. His greatest influence, however, was Ingres. Freud emulated the meticulous draughtsmanship of the Frenchman, apparently attempting to depict every strand of hair on his sitters. His virtuoso skill was recognized when in 1951, his remarkable *Interior at Paddington* won a prize at the Festival of Britain.

Freud's style changed in the late 1950s, when he replaced his fine sable brushes with stiffer, hog-hair ones which led to a more painterly approach, in which the artist conveyed his flesh-tones through thicker slabs of colour. Freud's favourite subject matter has been the 'naked portrait': starkly realistic nudes, devoid of any picturesque or idealizing elements.

MOVEMENT

Realism, School of London

OTHER WORKS

Hotel Bedroom: Francis Bacon

INFLUENCES

Cedric Morris, Jean-Auguste-Dominique Ingres, George Grosz

Lucian Freud Born 1922 Berlin, Germany

Paints in Britain

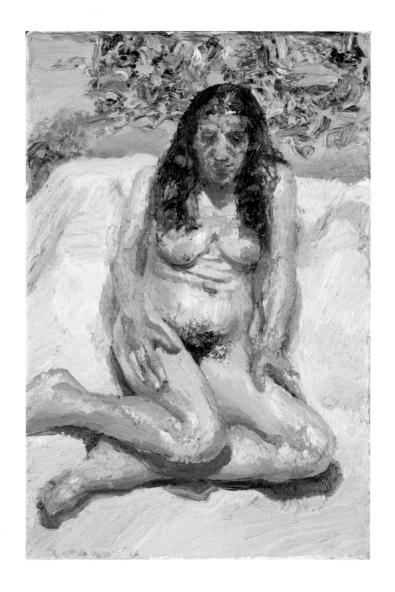

Riley, Bridget

Close by, 1992

Courtesy of Private Collection/Christie's Images 2002/© Bridget Riley, all rights reserved/Courtesy Karsten Schubert, London

Bridget Riley studied at Goldsmiths College of Art (1949–52) and the Royal College of Art (1952–55) in London. She had her first one-woman exhibition at Gallery One, London, in 1962 and has had many other shows all over the world in subsequent years. Influenced by the Futurists Giacomo Balla and Umberto Boccioni, she began to develop an optical style in the 1960s – now known as Op Art – in which hallucinatory images were created in black and white, in geometric or curvilinear patterns endlessly repeated to produce the illusion of rippling or undulating movement. By 1966 she had moved into colour, which enabled her to widen the scope of these images considerably; her colours vary in depth and tone and add subtlety to the overall pattern. Widely acclaimed in England, she made an impact on the international scene in 1968 when she became the first British artist to win the top award for painting at the Venice Biennale.

MOVEMENT

Op Art

OTHER WORKS

Cataract I; In Attendance; Fission; Fall

INFLUENCES

Giacomo Balla, Umberto Boccioni, Joseph Albers

Bridget Riley Born 1931 London, England

Paints in London

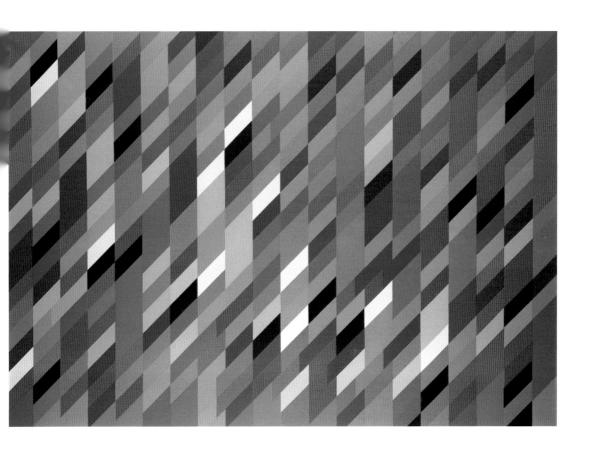

Smith, Jaune Quick-to-see

Modern Times on the Rez, c, 1992-93

Courtesy of Contemporary American Indian Art Collection, Art Museum of Missoula. Donated by the Artist/® The Artist

Jaune Smith derives her unusual name from her Shoshoni grandmother, being herself also of Cree and Métis descent. She followed the Famous American art course in high school then took degrees in fine art at Olympic College, Bremerton, Framingham State College and the University of New Mexico. Since the 1960s she has lived at Corrales, New Mexico, where she paints in a wide range of media, though preferring oils and acrylics. Her paintings, which she describes as 'nomad art' vary enormously in subject from figures and genre studies to landscapes and semi-abstract works. One of the most articulate of Native American artists, she emerged in the 1980s as one of the foremost Native American artists. Her paintings reflect a long-term commitment to feminist issues and the problems of the indigenous peoples of North America.

MOVEMENT

Native American School

OTHER WORKS

Ghost Dance Dress

INFLUENCES

Joan Miró, Wassily Kandinsky, Paul Klee

Jaune Quick-to-see Smith Born 1940 St Ignatius Flathead Reservation, Montana, USA

Points in New Mexico, USA

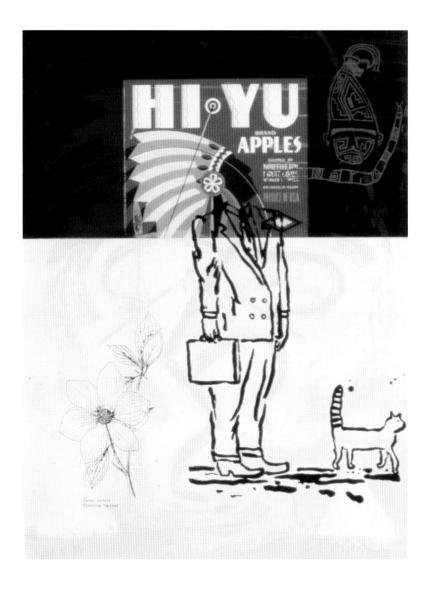

Howson, Peter

Study for the Bestiary, Fieldmouse

Courtesy of The Fleming-Wyfold Art Foundation/Bridgeman Art Library/Courtesy of Angela Flowers Gallery

Although born in London, Peter Howson trained at the Glasgow School of Art from 1975 to 1981 and has since lived in Scotland, apart from forays abroad as an official war artist. His style is essentially figurative, but he took the lead in creating the New Image, which has had a tremendous impact on British art since the late 1980s. Living and working in Glasgow – a city which was then in the process of re-inventing itself in the aftermath of post-industrial decay – he was strongly influenced by the prevailing socio-economic conditions and his paintings have echoes of the Social Realism of the 1930s. His figures, though recognizable, are often monstrous in appearance, reflecting the harshness of living and working conditions. This stark realism came to fruition in his paintings from the Balkan conflicts of the 1990s when, as a war artist, he did not pull his punches on the atrocities and appalling hardships he witnessed. An uncompromising, often fearful, reality pervades his work.

MOVEMENT

Modern British School

OTHER WORKS

A Night That Never Ends; Plum Grove; Patriots

INFLUENCES

Stanley Spencer

Peter Howson Born 1958, London, England

Paints in England, Scotland and the Balkans

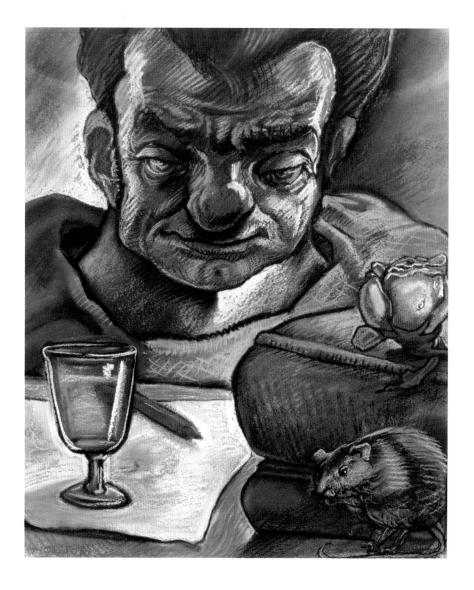

Kngwarreye, Emily Kame

Bush Yam Awelye, 1994

Courtesy of Private Collection/Dreamtime Gallery, London/Bridgeman Art Library/© DACS 2002

Emily Kame Kngwarreye was an elder of the Alhalkere tribe and did not take up painting until her seventies. About 1977 she became a member of the Utopia Women's Batik Group and showed artistic promise in her unusual treatment of traditional Aboriginal patterns. As a painter, she made her debut in the summer of 1988 with a series of pictures painted in acrylics on canvas and distinguished by their combination of traditional Amnatyerre ceremonial body designs and art forms. She used strong, linear designs, overlaid with fields of dots, in essence a miniaturization of the large ground paintings associated with tribal ceremonies. Although reduced to the confines of the canvas, however, her paintings possess great strength and vitality. Images are abstracted from several sources and coalesced in powerful motifs inspired by the mythological Aboriginal Dreamtime.

MOVEMENT

Utopia Australian School

OTHER WORKS

Emu Woman

INFLUENCES

Louie Pwerle

Emily Kame Kngwarreye Born c. 1910 Northern Territory, Australia

Painted in Australia

Died 1996 Northern Territory, Australia

Menon, Anjolie Ela

Still Life with Head, 1998

Courtesy of Private Collection/Christie's Images

Anjolie Ela Menon studied at the Sir J J School of Art in Mumbai (Bombay) before going on to Delhi University, where she majored in English Literature. As a result of highly successful exhibitions in Mumbai and Delhi in the late 1950s, she was awarded a French government scholarship and continued her studies at the École Nationale des Beaux-Arts in Paris. Before returning to India she travelled all over Europe and the Middle East, studying the classical art of Rome, Greece and Byzantium. One of the most cosmopolitan of modern Indian artists, she has since lived and worked in Britain, Germany, Russia and the USA, although she now resides in New Delhi, where she served on advisory committees of the National Gallery of Modern Art. She is regarded as India's foremost female painter of the present day; although renowned for her large murals she has also produced numerous easel paintings, landscapes, portraits and genre subjects – often reflecting traditional Indian motifs.

MOVEMENT

Modern Indian School

OTHER WORKS

Portrait; Malabar; The Fisherman's Tale

INFLUENCES

Amrita Sher-Gil, Rabindranath Tagore

Anjolie Ela Menon Born 1940, India

Paints in India, France, Britain, Russia and USA

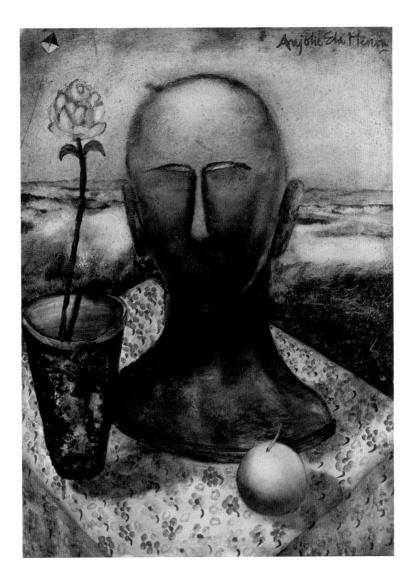

Pick, Seraphine

Love School, 1999

Courtesy of Collection of the Museum of New Zealand Te Papa Tongarewa/© The Artist

The Pakeha artist Seraphine Pick attended the Bay of Islands College from 1978 to 1982 before going to Christchurch to study at the Canterbury School of Fine Arts (1984–87), then trained as a teacher. She began pointing professionally in 1988 and won the Olivia Spencer Bower Foundation Art Award (1994) and was Rita Angus Artist in Residence at Wellington the following year. She then went on to work and teach in Auckland in 1997–98 and won the Frances Hodgkins Fellowship in Dunedin in 1999 – the country's most prestigious art award. Her earliest 'mature' works depict simple, domestic objects recalled in a dreamlike, almost naïve manner suggestive of childhood memories, creating an atmosphere that is somewhat nostalgic and somewhat surreal. Since then the surrealism has been fleshed out into dynamic, chaotic and strongly figurative paintings, more reminiscent of Hieronymous Bosch which explore themes of sexual playfulness and social confusion, with an emphasis on the acceptance of humankind's animal nature, alongside the 'higher' themes of traditional Western fine art.

MOVEMENT

Contemporary New Zealand School

OTHER WORKS

Sound; Space Junk; Riki & Ruru; Summer's Wind

INFLUENCES

Francisco Goya, Hieronymous Bosch, Sidney Nolan, Remedios Varo

Seraphine Pick Born 1964 New Zealand.

Paints in Christchurch, Wellington, Auckland and Dunedin, New Zealand

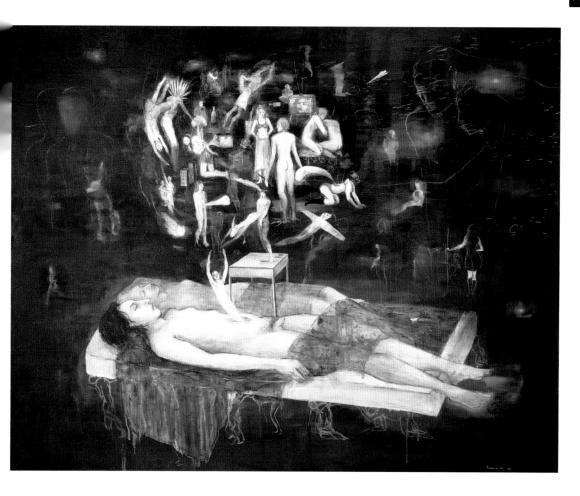

Matar, Joseph

Glow of Morning, 2001

All Joseph Matar works are © by the artist and LebanonArt - Germinal Itd

Joseph Matar was educated at the Marist Brothers' School in Jounieh and began working as an artist in Beirut. He received his art training under Omar Onsi, Rachid Webbe and George Corm between 1951 and 1957, while studying at the Italian Cultural Centre in Beirut (1955–57) and anatomy at the Beirut Faculty of Medicine (1958). Travelling scholarships enabled him to continue his studies at the San Fernando School of Fine Arts in Madrid (1961–63), Rome (1973) and the University of Paris (1963 and 1985). He began teaching art in 1954 at both high-school and university levels and has held a number of professorships since 1980. He has had more than 60 one-man shows around the world and his paintings are in major collections in many countries. Matar paints in oils and watercolours, both abstracts and landscapes. In addition to being the Lebanon's foremost contemporary painter he is a poet of considerable merit, recognized by an award for outstanding achievement from the International Library of Poetry, 2001.

MOVEMENT

Modern Lebanese School

OTHER WORKS

Corner of the Galaxy; Marriage Feast at Cana; Harvest; Temple

INFLUENCES

Omar Onsi, Rachid Wehbe, George Corm

Joseph Matar Born 1935 Ghadir, Lebanon

Paints in Lebanon, Spain, France and Italy

Rewiri, Kura Te Waru

I nga haerenga me nga hokinga mai (Coming and going), 200 I

Courtesy of Private Collection/Artist & Ferner Galleries - New Zealand

Kura Te Waru Rewiri studied at the Canterbury School of Fine Arts in Christchurch, from which she graduated in 1973. She had a conventional art training in Western Expressionism, but was strongly influenced by Rudolf Gopas, who told her that she should never forget that she was a Maori. This has shaped the pattern of her art in the subsequent period, both in subject matter and in the style of her painting. She uses strongly contrasting colours in vivid compositions which, while figural, have underlying symbolism and hidden meanings. A typical example of this is her great painting of the Treaty of Waitangi, negotiated between the British and the Maori chiefs in 1840. By placing the cross in the centre of the picture she suggests the sacrifice of her people and the role of the Christian missionaries in undermining Maori culture. In more recent years she has turned more and more to traditional art forms, notably godstick figures.

MOVEMENT

Modern Maori School, New Zealand

OTHER WORKS

Nga Tohu O Te Tiriti; Whenua Wahine Whenua

INFLUENCES

Rudolf Gopas

Kura Te Waru Rewiri Born 1950

Paints in New Zealand

Author Biographies

Dr Robert Belton (General Editor)

Author of *The Beribboned Bomb:The Image of Women in Male Surrealist Art, Sights of Resistance* and *The Theatre of the Self: The Life and Art of William Ronald,* Dr Robert Belton is the Associate Dean of Arts at Okanagan University College in Kelowna, British Columbia. He has received the Alma Mater Society Frank Knox Award for Teaching Excellence and the Arts and Science Undergraduate Award for Teaching Excellence.

Christopher Rothko

Christopher Rothko is Mark Rothko's second child. He holds a BA in Literature from Yale University and a PhD in Psychology from The University of Michigan. He has worked to organize and present most of his father's recent exhibitions around the globe. He has written extensively as a classical music critic and, when work and children allow. likes to write fiction.

Tom Middlemost

Tom Middlemost is an art curator who specialises in Australian art. In June 2001 he began a three month internship with the former director Lars Nittve, one of the world's leading art curators, at Tate Modern, London, to develop the Charles Sturt University's art collection. Tom is passionate about making art accessible to people in country regions of Australia.

Dr James Mackay

Dr James Mackay is a journalist and broadcaster, biographer and historian. A former salesroom correspondent for the *Financial Times*, he has also written numerous books on art, sculpture, antiques and collectables, including *Dictionary of Sculptures in Branze* and *Animaliers*. A graduate of Glasgow University, he is regarded as the world's leading authority on Robert Burns.

Jain Zaczek

Born in Dundee and educated at Wadham College, Oxford and the Courtauld Institute of Art in England, Ian Zaczek, has written numerous art books, some of which include *Lovers in Art, Impressionists* and *Celtic Art and Design*. His most recent book, published in 2002, is entitled *Women in Art.*

Dr Julia Kelly

Dr Julia Kelly is currently a lecturer at Manchester University. Educated at Oxford and the Courtauld Institute of Art in England, she specialises in twentieth-century art, with a particular interest in Surrealism and the inter-war period. Her PhD thesis was on the art writings of Michel Leiris and she has published works on Picasso and Francis Bacon.

William Matar

The son of the famous Lebanese artist, Joseph Matar, William is the site owner and director of LebanonArt.net He and his other experienced editorial staff have provided invaluable help in choosing the Middle Eastern Art represented in this book.

Bibliography

- Adams, S., The Barbizon School and the Origins of Impressionism, Phaidon Press, 1994 Akurgal, E., The Art of the
- Akurgal, E., *The Art of the Hittites*, Thames and Hudson, 1962
- Aldred, C., The Development of Ancient Egyptian Art from 3200 to 1315 Bc, 3 vols, Tiranti, 1973
- Ames-Lewis, F. and Rogers, M. eds., Concepts of Beauty in Renaissance Art, Ashgate Publishing Limited, 1998
- Amiet, P., Art of the Ancient Near East, New York, 1980
- Archer, M., Art since 1960, Thames and Hudson, 1997
- Arribas, A., *The Iberians*, Thames & Hudson, 1964
- Atil, Ed., *Turkish Art,* Smithsonian Institute Press, Washington DC/ New York, 1980
- Barnhart, R.M. et al., Three Thousand Years of Chinese Painting, Yale University Press, 1997

- Berenson, B., The Italian Painters of the Renaissance 1894–1907, Cornell University Press, 1980
- Berger, J., Ways of Seeing, Penguin Books, 1990
- Berlo, J.C. and Wilson L.A., Arts of Africa, Oceania and the Americas, Englewood Cliffs, NJ, 1993
- Berrin, K. and Pasztory, E. eds., *Teotihuocán: Art* from the City of the Gods, San Francisco/ London, 1993
- Blurton, T.R., *Hindu Art*, British Museum Press, 1992
- Boardman, J., *The Oxford*History of Classical Art,
 Oxford University Press,
 1993
- Boardman, J., *Greek Art*, Thames and Hudson, 1996
- Boardman, J., Pre-classical: From Crete to Archaic Greece, Penguin Books, 1967
- Boime, A., Art in the Age of Revolution 1750–1800, University of Chicago Press, 1987

- Bomford, D. et al., Impressionism, National Gallery Company Ltd. 1990
- Brilliant, R., Roman Art from the Republic to Constantine, Praeger Pub. Text, 1974
- Brown, J., The Golden Age of Painting in Spain, Yale University Press, 1991
- Buckton, D. ed.,

 Byzantium, London,
 1994
- Camille, M., Gothic Art, US Imports & PHIPEs, 1996
- Campbell, L., Renaissance Portraits, Yale University Press, 1990
- Canby, S.R., *Persian Painting*, British
 Museum Press, 1993
- Carpenter, R., *Greek Art*, Philadelphia, 1962 Caruana, W., *Aboriginal*
- Art, Thames and Hudson, 1993
- Charbonneaux, J., Hellenistic Art, George Braziller, 1973
- Chastel, A., French Art: The Renaissance 1430–1620, Paris, 1995

- Clorke, G., *The Photograph*, Oxford

 University Press, 1997
- Clunas, C., *Art in China*, Oxford Paperbacks, 1997
- Collon, D., Ancient Near Eastern Art, British Museum Press, 1995
- Craven, R.C., Indian Art (1976) Thames and Hudson, 1997
- Crichton, R.A., The Floating World: Japanese Popular Prints 1700–1900, London, 1973
- Cumming, R., Annotated Great Artist, Dorling Kindersley, 1998
- D'Alleva, A., Art of the Pacific, Weidenfeld Nicolson, London/New York, 1998
- Davies, D. ed., Harrap's Illustrated Dictionary of Art and Artists, Harrap Books Ltd. 1990
- Deepwell, K. ed. Women Artists and Modernism, Manchester/New York, 1998
- Duro, P. and Greenhalgh, M., Essential Art History, Bloomsbury, 1992

- Eisenman, S.E., Nineteenth Century Art: A Critical History, Thames and Hudson, 1994
- Evans, H.C. and Wixom, W.D. eds., *The Glory* of Byzantium, Harry N. Abrams, Inc., 1997
- Eyo, E. and Willett, F., Treasures of Ancient Niaeria, Collins, 1982
- Fer, B., On Abstract Art, Yale University Press, 2000
- Fong, Wen C., Beyond Representation, Yale University Press, 1992
- Frankfort, H., The Art and Architecture of the Ancient Orient, Yale University Press, 1996
- Fry, E.F., *Cubism*, Thames and Hudson, 1966
- Gale, M., Dada and Surrealism, Phaidon Press, 1997
- Gaze, D. ed., *Dictionary of Women Artists*, Fitzroy
 Dearborn, 1997
- Geidion, S., The Eternal Present: The Beginning of Art, Oxford University Press, 1962
- Gilbert, C., History of Renaissance Art throughout Europe, Abrams, 1973

- Gillon, W., A Short History of African Art, Penguin Books, 1991
- Godfrey, T., Conceptual Art, Phaidon Press, 1998
- Gombrich, E.H., Art and Illusion, Phaidon Press, 2002
- Goodman, C., *Digital Visions, Computers and Art*, Harry N. Abrams,
 1987
- Gordon, E.D., Expressionism, Art and Idea (1987) New Hayen/London, 1991
- Grabar, A., *Early Christian Art*, London, 1968
- Hanfmann, G., Roman Art, W.W. Norton, 1975
- Haskell, F., *History and its Images*, Yale University Press, 1993
- Hauser, A., The Social History of Art, Routledge, 1985
- Held, J. and Posner, D., 17th and 18th Century Art, Harry N. Abrams Inc. 1972
- Henderson, G., Early Medieval, University of Toronto Press Inc. 1993
- Hessel, I., Inuit Art: An Introduction, British Museum Press, 1998
- Honour, H., *Neoclassicism*, Penguin, 1968

- Honour, H., Romanticism, Viking, 1979
- Howard, J., Art Nouveau: International and National Styles in Europe, Manchester University Press, 1996
- Irwin, R., *Islamic Art*, Laurence King Publishing, 1997
- James, T.G.H., An Introduction to Ancient Egypt, British Museum Publications, 1979
- Jantzen, H., *High Gothic*, Princeton University Press, 1984
- Kaplan, P. and Manso, S. eds., Major European Art Movements 1900–1945, E. P. Dutton, 1977
- Kemp, M., *The Science of Art*, Yale University Press, 1990
- Klindt-Jensen, O., *Viking Art*, University of
 Minnesota Press, 1980
- Kramrisch, S., The Art of India through the Ages, Motilal Banarsidass, 2002
- Kubler, G., The Art and Architecture of Ancient America, Yale University Press, 1992
- Laing, L. and Laing, J., Art of the Celts, Thames and Hudson, 1992

- Lee, S.E. and Richard, N., A History of Far Eastern Art, Thames and Hudson, 1997
- Leroi-Gourhan, A., The Art of Prehistoric Man in Western Europe, Thames and Hudson, 1967
- Leroi-Gourhan, A., *The Dawn of European Art*,

 Cambridge University

 Press, 1982
- Levey, M., *High Renaissance*, Penguin, 1975
- Levey, M., *The Early Renaissance*,
 Harmondsworth, 1967
- Livingstone, M. ed., *Pop Art: A Continuing History*, Harry N. Abrams, 1990
- Lodder, C., Russian Constructivism, Yale University Press, 1998
- Loevren, S., *The Genesis of Modernism*, Hacker Art
 Books Inc. 1983
- Lowden, J., Early Christian and Byzantine Art, Phaidon Press, 1997
- Lynton, N., *The Story of Modern Art*, Phaidon Press, 1992
- Martin, J.R., Baroque, Westview Press, 1977 Mason, P., History of
 - Japanese Art, Harry N. Abrams, Inc., 1993

- Miller, M.E., *The Art of Mesoamerica*, Thames
 and Hudson, 2001
- Morphy, H., Aboriginal Art, Phaidon Press, 1998
- Nochlin, L., *Realism*, Penguin Books, 1991
- Noma, S., *The Arts of Japan*, Kodansha America, 1978
- Osborne, R., Archiac and Classical Greek Art, Oxford University Press, 1998
- Pächt, O. et al., *Book*Illumination in the

 Middle Ages, Harvey

 Miller Publishers, 1994
- Panofsky, E., Meaning in the Visual Arts, Peter Smith Pub. 1988
- Panofsky, E., Renaissance and Renascences in Western Art, Paladin, 1970
- Partridge, L., The Art of Renaissance Rome, US Imports & PHIPEs,
- Phillips, P., The Prehistory of Europe, Viking, 1980
- Phillips, T. ed., *Africa: The Art of a Continent*, Prestel Publishing Ltd, 1999
- Piotrovsky, B. et al., Scythian Art, Phaidon Press, 1993 Pollitt, J.J., Art and

- Experience in Classical Greece, Cambridge University Press, 1972
- University Press, 1972
 Powell, R.J., Black Art and
 Culture in the Twentieth
 Century, Thames and
 Hudson, 1997
- Rampage, N.H. and A., *The*Cambridge Illustrated

 History of Roman Art,

 Cambridae, 1991
- Rowson, J., The British Museum Book of Chinese Art, British
- Museum Press, 1992 Rewald, J., The History of Impressionism, Secker & Warburg, 1980
- Richter, G., A Handbook of Greek Art, Phaidon Press 1987
- Rosen, C. and Zerner, H., Romanticism and Realism, Faber and Faber, 1984
- Rosen, R. et al., Making Their Mark: Women Artists Move into the Mainstream, Abbeville Press, 1991
- Rosenblum, R. and Janson, H.W., 19th Century Art, Thames and Hudson, 1984
- Rosenblum, R., Transformations in Late Eighteenth Century Art, Princeton University Press. 1992

- Roskill, M., What is Art History? University of Massachusetts Press, 1989
- Rowland, B., The Evolution of the Buddha Image, Arno P, New York, 1976
- Sandler, I., Art of the Postmodern Era, Icon Editions, 1996
- Schäfer, H., *Principles of* Egyptian Art, Aris & Phillips, 1986
- Schapiro, M., Modern Art, 19th and 20th Centuries, George Broziller, 1978
- Singer, J.C. and Denwood, P. eds., Tibetan Art: Towards a Definition of Style, Laurence King Publishing, 1997
- Spivey, N., Etruscan Art, Thames and Hudson, 1997
- Stanley-Baker, J., *Japanese*Art, Thames and
 Hudson, 2000
- Starzecka, D.C. ed., *Maori:*Art and Culture, British
 Museum Press,
 1998
- Stone-Miller, R., Art of the Andes, Thames and Hudson, 1995
- Strong, D.E., *Roman Art*, Yale University Press, 1992

- Ucko, P. and Rosenfeld, A., Palaeolithic Cave Art, Weidenfeld & Nicolson, 1967
- Vermeule, C.V., Roman Art: Early Republic to Late Empire, Boston, 1979
- Watson, W., The Arts of China to AD 900, Yale University Press, 2000
- Welch, S.C., Art of Moghul India, Arno P, NewYork, 1976
- Whelte, K., The Materials and Techniques of Painting, Van Nost, Reinhold, New York, 1975
- Willett, F. African Art: An Introduction, Harcourt School Pub. 1971
- Wölfflin, G. *Principles of Art History*, G Bell. 1950
- Wollheim, H. *Painting as* an Art, Thames and Hudson, 1990
- Yonemura, A. et al., Twelve Centuries of Japanese Art from the Imperial Collections, Smithsonian Institution Press, 1998 Zarnecki, G. Romanesque,
- Zarnecki, G. *Komanesq*i Herbert Press, 1989

Index By Artist

Abdulla, Ian 740 Al Attar, Suad 688 Albers, Josef 614 Alma-Tadema, Sir Lawrence Altdorfer, Albrecht 82 Amaral, Tarsila do 482 Amiahetti, Francisco 630 Andrea del Sarto 84 Angelico, Fra 46 Anguissola, Sofonisba 102 Arakawa, Shusaku 678 Arcimboldo, Giuseppe 110 Arikha, Aviador 730 Bacon, Francis 632 Balla, Giacomo 448 Bannister, Edward M. 338 Basawan 112 Bearden, Romare H. 668 Beardsley, Aubrey 386 Beckmann, Max 592 Beg, Farrukh 258 Benoist, Marie-Guillemine 254 Berni, Antonio 622 Bingham, George Caleb 298 Blake, William 246 Bol. Ferdinand 150 Bonington, Richard Parkes 284 Bonnard, Pierre 444 Bosch, Hieronymus 40 Botero, Fernando 662 Botticelli, Sandro 60 Boucher, François 208 Boyd, Arthur 634 Braque, Georges 460 Bronzino, II 96 Brown, Grafton Tuler 320 Brueghel, Pieter 108 Burne-Jones, Sir Edward 328 Burra, Edward 554 Canaletto, Giovanni Antonio (Canale) 204 Caravaggio, Michelangelo Merisi do 114 Carr. Emily 510 Carrà, Carlo 484

Carracci, Annibale 120 Carriera, Rosalba 196 Carrington, Leonora 582 Cassatt, Mary 370 Cézanne, Paul 382 Chagall, Marc 656 Chardin, Jean-Baptiste-Siméon Chirico, Giorgio de 450 Cimabue, Giovanni 22 Claesz, Pieter 148 Close, Chuck 732 Coldstream, Sir William 594 Cole. Thomas 286 Colville, Alex 576 Constable John 266 Cooper, Samuel 180 Copley, John Singleton 230 Corot, Jean-Baptiste-Camille 312 Correggio 94 Cotmon John Sell 270 Courbet, Gustave 310 Cozens, John Robert 244 Cranach, Lucas 92 Crome, John 260 Cuup, Albert 170 Dalí, Salvador 538 Daumier, Honoré 314 David Jacques-Louis 248 Degas, Edgar 342 Delacroix, Eugène 292 Delaroche, Paul 304 Delaunau, Robert 496 Delaunay, Sonia 640 Delvaux, Paul 556 Dergin André 414 Diebenkorn, Richard 642 Dine. Jim 718 Dix. Otto 480 Doré, Gustave 316 Douglas, Aaron 528 Drubi Hofiz 658 Drysdale, Sir George Russell 584 Dubuffet, Jean 650 Duccio di Buonisegna 26 Duchamp, Marcel 440

Dufy, Raoul 506 Duncanson, Robert 302 Dürer, Albrecht 80 Eakins, Thomas 336 FI Greco 116 Ensor, James 422 Ernst, Max 544 Fabriano, Gentile Da 48 Fabritius, Carel 156 Fairweather, Ian 518 Feininger, Lyonel 540. Fischl. Eric 708 Fontana, Lucio 604 Fouquet, Jean 32 Fragonard, Jean-Honoré 214 Frankenthaler, Helen 690 Freud Lucian 742 Freundlich, Otto 702 Friedrich, Caspar David 274 Fuseli, Henry 232 Gainsborough, Thomas 212 Gallen-Kallela, Akseli 404 Gauguin, Paul 388 Gentileschi, Artemisia 130 Géricault, Théodore 278 Ghirlandaio, Domenico 62 Giacometti, Alberto 616 Gilbert and George 710 Giorgione 74 Giotto (di Bondone) 24 Girodet de Roussy-Trioson, Anne-Louis 276 Girtin, Thomas 252 Goah, Vincent van 378 Gontcharova, Natalia 476 Gorky, Arshile 586 Goua, Francisco 262 Gozzoli, Benozzo 56 Greuze, Jean-Baptiste 222 Gris Juan 488 Gros, Antoine-Jean 256 Grosz, George 486 Grünewold Motthias 42 Guardi, Francesco 206 Guercino, II 140 Hals Frans 158

Haring, Keith 728 Harris, Lawren 478 Hasan, Abul 126 Hassan, Faik 660 Hawkins, William 724 Heckel, Erich 426 Henri, Robert 402 Hiroshige, Ando 288 Hitchens, Ivon 534 Hobbema, Meindert 178 Hockney, David 684 Hodakin, Sir Howard 696 Hodakins, Frances Mary 424 Hofmann, Hans 610 Hogarth, William 200 Hokusai, Katsushika 282 Holbein, Hans 98 Homer Winslow 332 Honthorst Gerrit van 134 Hooch, Pieter de 172 Hopper, Edward 502 Howson, Peter 748 Hunt, William Holman 372 Ingres, Jean-Auguste-Dominique Jackson, A.Y. 520 Jawlensku, Alexei 442 John, Augustus 472 John, Gwen 418 Johns, Jasper 686 Johnson, William H. 552 Johnston, Joshua 296 Jordaens, Jakob 144 Kahlo, Frida 514 Kalf, Willem 174 Kandinsku, Wassilu 410 Kauffmann, Angelica 226 Khadda, Muhammad 644 Kiefer, Anselm 704 Kirchner, Ernst Ludwig 454 Kitaj, R.B. 712 Kiuonaga, Torii 238 Klee, Paul 470 Klimt, Gustav 398 Knawarreye, Emily Kame 750 Kokoschka, Oskar 530

Kollwitz, Käthe 428 Kooning, Willem De 606 Korin, Ogata 188 Krieghoff, Cornelius 308 Lam, Wifredo 562 Landseer, Sir Edwin 294 Lavery, Sir John 368 Lawrence, Jacob 546 Lawrence, Sir Thomas 264 Léaer, Fernand 474 Lely, Sir Peter 160 Lempicka, Tamara de 498 Leonardo da Vinci 70 Lewis, Norman 646 Lewis, Percy Wyndham 536 Leyster, Judith 154 Lichtenstein, Roy 636 Liebermann, Max 364 Linnell, John 322 Lowry, L.S. (Laurence Stephen) 568 Luc. Frère 166 MacDonald, J.E.H. 430 Maeda Seison 548 Magritte, René 522 Malevich, Kasimir 432 Manet Edouard 344 Mantegna, Andrea 68 Maghubela, Louis Khela 698 Marc, Franz 446 Marin, John 434 Martin, John 290 Masaccio, Tommaso 50 Matar, Joseph 756 Matisse, Henri 612 Matta, Roberto 578 Memling, Hans 36 Menon, Anjolie Ela 752 Messina, Antonello da 58 Michelangelo 76 Millais, Sir John Everett 358 Millet, Jean-François 318 Miró Joan 692 Modersohn-Becker, Paula 396 Modialiani, Amedeo 452 Moholy-Nagy, László 490 Mondrian, Piet 508 Monet, Claude 420

Morisot, Berthe 334

Morrisseau, Norval 700 Motherwell, Robert 722 Motley Jr, Archibald 564 Moudarres, Fateh 624 Mukarobawa, Thomas 626 Munch, Edvard 384 Murillo, Bartolomé Estebán 182 Newman, Barnett 596 Nicholson, Ben 572 Nolan, Sir Sidney 618 Nolde, Emil 588 O'Keeffe, Georgia 500 Olitski, Jules 652 Onus, Lin 734 Oonark, Jessie 706 Oppenheim, Meret 670 Orozco, José Clemente 456 Ozenfant, Amédée 492 Palmer, Samuel 324 Parmigiano 90 Pechstein, Max 438 Peruaino, Pietro 64 Picasso, Pablo 516 Pick. Serophine 754 Pierneef, Jacob Hendrik 462 Piero della Francesca 54 Piero di Cosimo 66 Piper, John 598 Pippin, Horace 464 Pissarro, Camille 354 Pollock, Jackson 580 Popova, Liubov 468 Poussin, Nicolas 138 Pozzo, Andrea 192 Qiu Ying 86 Raeburn, Sir Henry 236 Ramsay, Allan 218 Raphael 78 Rapira-Davies, Shona 726 Rauschenberg, Robert 672 Redon, Odilon 392 Rego, Paula 736 Reinhardt, Ad 600 Rembrandt, Harmensz van Rijn 176 Reni Guido 122 Renoir, Pierre-Auguste 346 Repin, Ilua 406

Rewiri, Kura Te Waru 758

Reynolds, Sir Joshua 220 Ribera, Jusepe 132 Richter, Gerhard 674 Riley, Bridget 744 Riopelle, Jean-Paul 628 Rivera, Diego 558 Robert, Hubert 224 Romney, George 240 Rossetti, Dante Gabriel 326 Rothko, Mark 664 Roualt, Georges 504 Rousseau, Henri 340 Rousseau, Théodore 300 Rubens, Peter Paul 124 Rublev, Andrei 28 Ruysch, Rachel 190 Ruysdael, Salomon 184 Ruder, Albert Pinkham 348 Salim Jawad 620 Samba, Chéri 738 Sargent, John Singer 356 Schiele, Egon 436 Schnabel, Julian 714 Schwitters, Kurt 560 Scully, Sean 680 Sekoto, Gerard 566 Seurat, Georges 376 Sharaku, Toshusai 250 Shouping, Yun 164 Sickert, Walter 390 Sigueiros, David Alfaro 532 Sisleu, Alfred 350 Smith, Jaune Quick-to-see 746 Sotatsu, Tawaraya 128 Soutine, Chaim 524 Spencer, Sir Stanley 602 Stella, Frank 666 Streeton, Sir Arthur 412 Sugai, Kumi 654 Sutherland, Graham 682 Tagore, Rabindranath 512 Tanguy, Yves 542 Tanner, Henry Ossawa 366 Tanning, Dorothea 574 Tàpies, Antoni 638 Terbrugghen, Hendrick 136 Thiebaud, Wayne 720 Thomas Alma 676

Thomson, Tom 458 Tintoretto 104 Tition 100 Tiapaltiarri, Clifford Possum 716 Toulouse-Lautrec, Henri de 380 Tour, Georges De La 152 Traulor, Bill 550 Turner, J.M.W. 272 Uccello, Paolo 52 Utamaro, Kitagawa 234 Utrillo, Maurice 416 Van der Goes, Hugo 38 Van der Weuden, Rogier 34 Van Dyck, Sir Anthony 142 Van Eyck, Jan 30 Van Gouen, Jan 146 Van Honthorst, Gerrit 134 Van Ruysdael, Salomon 184 Velázquez, Diego 162 Vermeer, Jan 186 Veronese, Paolo 106 Vigée-Lebrun, (Marie Louise) Elisabeth 242 Vlaminck, Maurice de 466 Von Menzel, Adolph 360 Vuillard, Edouard 394 Warhol, Andy 648 Waring, Laura Wheeler 494 Waterhouse, John William 362 Watteau, Jean-Antoine 194 Wen Zhengming 88 West, Benjamin 228 Whistler, James 330 White, Charles 694 Wilkie, Sir David 280 Wood, Grant 526 Woodruff, Hale 608 Wright, Joseph 210 Xian, Gong 168 Yan, Hua 198 Yeats, Jack B. 590 Yin, Tang 72 Zorn, Anders 408

Index By Painting

1945 (Airmail Letter) 573 Above Lake Superior 479 Abstracto 579 Act IX of Chusuqiwa 235 Adolescence 527 Adoration of the Magi (Andrea Mantegna) 69 Adoration of the Magi (Hans Memling) 37 Adoration of the Magi, The (Gentile Da Fabriano) 49 Afro Emblems 609 Agbatana II 667 Akbar Assisting in the Quarrel of the Ascetics 113 Alexander Frederick Douglas-Home, Lord Home of the Hirsel 731 America, A Prophesy 247 Amor, Lichtspiele 487 Angagok Conjuring Birds 707 Angels 57 Angels from the Sunta Trinita Altorpiece 23 Angels of the Apocalupse 603 Annabel 743 Anna Washington Derry 495 Annette Assise 617 Annunciation, The 47 Arcadian double portrait of two Ladies as Shepherdesses, An 135 Arrangement in Flesh Colour and Grey 331 Artisten 593 Artist in his Studio, An 157 Aspects of Negro Life: Song of the Towers 529 Auf der Fahrt durch Schone Natur 361 Autoretrato en la Frontera entre Mexico y los Estados 515

Autumn, the Five Crosses 405 Bancs à Montmagny Val d'Oise 417 Bathers on the Beach at Scheveningen 365 Beatrice Hastings Assise 453 Beggar Children, The 317 Beggars Opera 201 Birth of Sin, The 233 Birth of Venus, The 61 Black Down 2 535 Black with Four Grey Corners 639 Blaues Auge 671 Bob and Mandie 585 Bonjour Monsieur Courbet 311 Brooklyn Bridge Series 435 Brustbild einer Jungen Frau mit offenem Haar 397 Buffalo Mountains 413 Bush Yam Awelye 751 Caballo Salvujes 457 Cadet and his Sister, The 737 Carnation Morning Glory with Other Flowers, A 191 Carpenter III, The 433 Causerie chez les Fontaines 395 Central Railroad of Brazil 483 Cetaro, Gulf of Salerno 245 CH Beata 2 491 Chop Suey 503 Christ and the Widow of Nain Christ on the Cross 117 Chrome Yellow Elegy 723 Cindu II 733 Clearing after Rain, Maganatawan River, Ontario

Close by 745 Clothed Maja, The 263 Composition 703 Composition (non-representa-Composition with Red, Blue and Yellow 509 Concert of Muses. The 105 Corner of the Artist's Room in Paris, A 419 Cortège 651 Cottages by a Stream 285 Country Road 323 Courtuard of a House in Delft, The 173 Creation of Adam 77 Crucifixion 35 Donseuse 505 Danseuses Vertes 343 Death of Marat. The 249 Death of the Red Deer, The 281 Deux Buveurs 315 Die Nacht - Grosse Fassung 411 Diner, The 54/ Dinner at the Grand Palais 697 Dunstanborough Castle 253 El Botero 533 El Monge 631 Enfant dans les Roses Trémières Entry of Saint Ignatius into Paradise, The 193 Etretat Un Moulin à Vent 313 Evening Rendezvous 647 Experiment with an Air Pump Expulsion 635 Falcon Hunting Prey 199 Fall, The 39 Family. The 659

Fantastic Mountains 169 Farnley Hall from above Otley Fishing Boats off Yarmouth 271 Flags 687 Flood and the Subsidence of the Waters. The 53 Flowers with Doilies and two Chairs 465 Forêt et Soleil 545 Forêt Tropicale 563 Four Doctors of the Church, The Four-Masted Barque 541 Free Way Traffic 721 French Consulate, The Grand Conal Venice The 369 Fruit Piece 303 Fur Traders Descending the Missouri 299 Garden of Earthly Delights, The 41 George Townshend 221 Gibraltar Watering Place, Heigham 261 Girl with a Pearl Earring 187 Girl with Orange 567 Girl with Pet Dog 223 Glow of Morning 757 Going to Church 553 Gold Mining in California 321 Golem 713 Grace - Chinese Girl 403 Grand Canal 205 Grand Fiore Futurista 449 Gross Clinic, The 337 Group Portrait of a Lady and Her Two Children, A 229 Hamid in a Suit of Light 715 Head of a Woman 513

Helpina Hands 711 Landscape 627 Madonna and Child with Two Nudes 409 Henry VIII 99 Landscape Orange and Blue Angels 65 Numphéas 421 Herons and Grasses 129 Madonna Casini 51 Oak Trees 339 Holy Trinity, The 29 Landscape with Footbridge 83 Malaria 621 O iibwau Headdress 701 Homage 615 Large Blue Nude 507 Marie Antoinette and her Four Homme Nu a Mi-Corps 279 La Rue Mosnier aux Drapeaux Children 243 Palazza in Vicenza 599 Horses The 577 Mary Magdalene from the La Tamise et Tower Bridge 415 Humayun Hunting near Kabul Isenheim Altarpiece 43 Paradise in Blue 689 Laughing Children with Cat 155 Master Hilaru - The Tracer 373 Paysage 467 La Ville Inquiete 557 Hunters in the Snow 109 Matin de l'Autoroute No 2 655 Pausage Surréaliste 543 Illustrations to Milton's Lucidas Meditation at Ischia, Portrait of Peacock Skirt. The 387 Le Barrage de Saint Mammes Thomas Earp 473 Peasant Familu, A 425 Immaculate Conception 183 Melancholia 81 Personnages, Oiseaux, Etoiles Le Chef d'Oeuvre ou Les Mystères Immortal Ge Changgeng Sitting Miniature of James II as the Duke de l'Horizon 523 on his Three-leaged Toad. of York 181 Philosopher in his Study, A 151 Le Petit Déjeuner 475 The 73 Mobali Ya Monuato 739 Le Printemps 477 Indian Hunter in the Snow 309 Modern Times on the Rez 747 Le Puits de la Casbah Tanger Industrial Landscape 569 Mono Liso 71 I nga haerenga me nga hokinga Moonshine 471 Portrait de L'artiste sans Barbe Le Repos (Marc Chagall) 657 mai (Comina and aoina) Moroccan Man 367 Le Repos (Pablo Picasso) 517 Mother and Child 429 Portrait of a Gentleman 159 Les Baigneuses 347 Intérieur 445 Mother Courage II 695 Portrait of a Lady as the Muse Les Deux Amies 499 In the Well of the Great Wave Moulin Rouge - La Goulue 381 Les Escaliers à Chartres 525 Enterpe 227 283 Mountainous Landscape 463 Le Sommeil 539 Portrait of a Lady in a Yellow and Jack Pine. The 459 Mountain Sunrise 287 Les Plaisir du Bal 195 Black Gown 407 Nagakubo 289 Les Poseuses 377 Portrait of a Man 59 Jeune Paysanne à sa Toilette Napoleon Bonaparte Visiting the L'Hôtel Royal Dieppe 391 Portrait of a Negress 255 Plaque Stricken of Jaffa 257 Lichtzauber 589 Portrait of a Young Man 63 Jimmu's Billabona 735 Napoleon Crossing the Alps 305 Liegender Halbakt Mit Rolem Portrait of Colonel Baker 231 Judith Slaying Holofernes 131 Nativity, The 33 Portrait of David Garrick 213 Jupiter and Thetis 269 Nature Marte aux Verres Lock on the Stour 267 Portrait of Emma, Lady Hamilton Kiss. The 399 Bouteilles et Pot Blanc 493 Los Emigrantes 623 Nave Nave Moe 389 Lot's Daughters 485 Portrait of Giovanni Arnolfini and Kitchen with Vegetables, A 175 Ned Kelly 619 Lotus Flower 165 Wife 31 Königstein Mit Roter Kirche 455 Newborn Child, The 153 Love 709 Portrait of Henry Long 297 Kupplerin - A Woman Smoking Love School 755 Portrait of Hon Mary Wharton 481 Niahtlife 565 Lute Player, A 137 La Cardeuse 319 Noch Ist Poten Nicht Verloren IV Maas at Dordrecht with Fishing Portrait of Juan de Pareia 163 La Cible d'Amour 209 Boots, The 171 Portrait of Mademoiselle La Grappe de Raisins 489 Modonno and Child 27 Noli Me Tangere 95 Guimard as Terpsichore 215 La Mangeuse D'Huitres 423 Madanna and Child with Non-Stop 653 Lamentation of Christ 25 Portrait of Mrs Robert Burne-Nude Descending a Staircase, La Mort D'Ophelie 393 Baptist 97 No 2 441 Jones 265

(Index By Painting Continued)

Portrait of Mustapha 277 Portrait of Prince Charles Edward Stuart 197 Portrait of Sakata Hangoro III as Fujikawa Mizuema 251 Portrait of Sir Edward and Lady Turner 219 Prauer for the Rain 625 Prince Enters the Briar Wood. The 329 Race, The 591 Red Gladiola in White Vase 501 Reverend Robert Walker Skating on Duddington Loch, The 237 Reverie 327 River Landscape with a Ruined Building and Figures, A 179 River Landscape with Lime Kilns 147 Roi Soleil 519 Roses of Heliogabalus 353 Rote Kirche 439 Roter Kreis 561 Rythme Couleur 641 Saint Bernard Doas 295 Saint Bonaventure 167 Saint John the Baptist 123 Saint Luke 141 Saint Peter in Penitence 133 Salome 555 School of Athens 79 Scream. The 385 Seated Figure (Red Cardinal) Seated Nude Black Background Self Portrait (Rembrandt) 177 Self Portrait (Sofonisba

Anguissola) 103

Self Portrait at the Mirror 91

Self Portrait with a Sunflower 143 Sheik's Wife 537 Shot Red Marilyn 649 Sky Garden (F74) Rocket Space 673 Snail The 613 Snoopy - Early Sun Display on Earth 677 Something of the Past 581 Song for 900 Children: Tautoko for the Black Womin 727 Sowing Seeds at Nite 741 Spaneteru mit Roten Schol 443 Spatial Concept 605 Spingendes Pferd 447 Squirrels on a Plane Tree 127 Still Life 207 Still Life With Apples 383 Still Life with Head 753 Still Life with Ray and Basket of Onions 203 Street Scene, Dieppe 595 Student Chang bidding farewell to his lover Ying Ying at the Rest Pavilion, The 89 Study for the Bestiary, Fieldmouse 749 Sunday after the Sermon 669 Sundown 349 Sundowner 691 Sun from the Weather Series 685 Sunset over Rocky Bay 291 Sweet Emma Morland 359 Temptation of Saint Anthony, The 583 Three Philosophers, The 75 Townsend Monotype I (Heart) 719 Triomphe de Paris 497 Triumph of David, The 139 Truth about Comets and Little

Girls. The 575 Two Saints 125 Two Women 661 Un Paysage Montagneux avec un Obélisque 225 Untitled (Barnett Newman) 597 Untitled (Keith Haring) 729 Untitled (Louis Khela Maghubela) 699 Untitled (Mark Rothko) 665 Untitled (Muhammad Khadda) 645 Untitled (pig with corkscrew tail) (Bill Traulor) 551 Untitled (Sean Scully) 681 Untitled Gouache on Paper (Ad Reinhardt) 601 Vanitas Still Life, A 149 Veil in the Mirror, The 611 Veil of Saint Veronica, The 121 Vendedora de Flores 559 Venus and Adonis 101 Venus with Cupid the Honey Thief 93 Verre et as de Trefle 461 Viewing the Cherry Blossom at Asukayama 239 Virgin and Child with a Saint and on Angel, The 85 Vue de L'isle Saint-Louis, Prise du Port Saint-Nicolas Le Soir 341 Wanderer above the Sea of Clouds, The 275 War of the Worlds 679 Water Dreaming 717 Western Forest 511 Wild Goose Calling its Mate 549 Windmill, Dangast 427 Winter 111 Winter, Charlevoix County 521 Wolken (Fenster) 675 Woman 607

Women at Work 357 Wooded Landscape at Sunset with a Faggot Gatherer, A 301 Wooded Landscape with Cattle and Drovers on, A 185 Year after Year 587 Young Bacchus, The 115 Young Man, A 67 Young Mother, The 371 Zhao Mengfu Writing the Heart Sutra in Exchange for Tea 87 Zwei Madchen 531